UNIVERSITY OF S

S0-CQS-769

WITHDRAWN
UST
Libraries

CULTURAL POLITICS, SOCIOAESTHETICS, BEGINNINGS

3

MUSIC AND CULTURAL POLITICS

IN GREEK AND CHINESE SOCIETIES

CULTURAL POLITICS, SOCIOAESTHETICS, BEGINNINGS
HARVARD EARLY MODERN AND MODERN GREEK STUDIES

CULTURAL POLITICS, SOCIOAESTHETICS, BEGINNINGS publishes books on sociocultural history, anthropology, literature, and critical theory, focusing on European—mainly Greek—traditions across historical, geographic, or disciplinary boundaries.

SERIES EDITORS
Panagiotis Roilos, Dimitrios Yatromanolakis

ADVISORY BOARD

Margaret Alexiou
Harvard University

Wim Bakker
University of Amsterdam

Andrew Barker
University of Birmingham

Roderick Beaton
University of London

Homi Bhabha
Harvard University

Jacques Bouchard
University of Montreal

Claude Calame
École des hautes études en sciences sociales

Kathleen Coleman
Harvard University

Veena Das
The Johns Hopkins University

Emma Dench
Harvard University

Hent de Vries
The Johns Hopkins University

John Duffy
Harvard University

Alessandro Duranti
University of California, Los Angeles

Edith Hall
University of London

Albert Henrichs
Harvard University

Michael Herzfeld
Harvard University

Elizabeth Jeffreys
University of Oxford

François Lissarrague
École des hautes études en sciences sociales

Paul Magdalino
University of St. Andrews

Paola Marrati
The Johns Hopkins University

Robin Osborne
University of Cambridge

Wolfgang Rösler
Humboldt University, Berlin

Ralph Rosen
University of Pennsylvania

Haun Saussy
Yale University

Richard Seaford
University of Exeter

Marc Shell
Harvard University

Charles Stewart
University of London

Richard Thomas
Harvard University

Helen Vendler
Harvard University

Music and Cultural Politics
in Greek and Chinese Societies

Volume I:

Greek Antiquity

Edited by

DIMITRIOS YATROMANOLAKIS

Department of the Classics, Harvard University
Distributed by Harvard University Press
Cambridge, Massachusetts, and London
2011

COPYRIGHT © 2011
BY THE PRESIDENT AND FELLOWS OF HARVARD COLLEGE
ALL RIGHTS RESERVED

This book is printed on acid-free, recycled paper; its binding
materials have been chosen for strength and durability.
The typeface is Arno Pro (© Adobe).
Composed by Nancy Wolfe Kotary.
Manufactured in the United States of America by Sheridan Books,
Ann Arbor, MI.

LIBRARY OF CONGRESS CATALOGING-IN-PUBLICATION DATA

Music and cultural politics in Greek and Chinese societies : Greek antiquity / edited by
 Dimitrios Yatromanolakis. -- 1st ed.
 p. cm. -- (Cultural politics, socioaesthetics, beginnings ; 3)
 Includes bibliographical references and index.
 ISBN 978-0-9835322-0-0
1. Music--Political aspects--Greece--History--To 1500. 2. Music--Social aspects--
 Greece--History--To 1500. 3. Music--Political aspects--China--History--To 1500. 4.
 Music--Social aspects--China--History--To 1500. 5. Greece--Civilization--To 146
 B.C. I. Yatromanolakis, Dimitrios.
ML3917.G75M87 2012
780.938--dc23
 2012018991

For Elaine Scarry
and Gregory O. Hutchinson

CONTENTS

Preface

Music and Cultural Politics in Greek and Chinese Societies, Volume 1: Greek Antiquity,
is the first part of a three-volume set that focuses on the intriguing but often
underexplored interaction between music and song making, on the one hand,
and practices of cultural politics, on the other.

The scope of this three-volume set is comparative and transhistorical. Given
the abundance of relevant evidence with regard to Greek antiquity, the first
volume investigates major aspects of this complex sociocultural phenomenon
exclusively in ancient Greek societies, with special emphasis on classical Greek
song-making, Athenian drama, Platonic philosophy, and Hellenistic perfor-
mance culture. Accompanied by an extensive chapter advancing a new cross-
disciplinary approach to this sociocultural phenomenon, the second volume
explores parallel manifestations of the interplay between music and cultural
politics in ancient and medieval Greek and Chinese contexts. Albeit often wide-
ranging, current comparative research on China and Greece has paid little or
almost no attention to the significant complexities of this area. The third volume
focuses on comparative material from ancient, medieval, and modern Chinese
and Greek societies across a transhistorical scope of investigation, drawing on
a variety of musical and performative genres. The present volume constitutes
prolegomena to these wider investigations of music, song-making, and cultural
politics in noticeably different Chinese and Greek societies.

Dimitrios Yatromanolakis

Chapter One

The Politics of Metrical Variety in the Classical Athenian Theater

Edith Hall

1. Vocal performance and society[1]

> Greek poetry in the fifth century before Christ was a highly
> developed and complex art. Greek poets had begun to sing in
> the remote past. Their successors in the age of Aristophanes
> had inherited from many singers in many lands—the coast of
> Asia, the islands of the Aegean and the Continent—a great
> treasure of rhythmical phrases that had gradually been devel-
> oped and perfected during centuries of practice amid a song-
> loving people . . . The poets of the later age, guided by that intu-
> itive apprehension and appreciation of beauty of form which
> characterized their race in all ranges of creative art, combined
> these phrases into harmonious periods and symmetrical stro-
> phes with extraordinary skill, but they were only vaguely con-
> scious of historical relations.[2]

So John Williams White opened his study of the verse of ancient Greek comedy
two years before the First World War. This was at a moment in history when the

[1] In this chapter, the following abbreviations are employed: *PMG* (= D. L. Page, *Poetae Melici
Graeci*, Oxford 1962); Consbruch (= M. Consbruch, *Hephaestionis Enchiridion, cum commentariis
veteribus*, Leipzig 1906); Kassel-Austin (= R. Kassel and C. Austin, *Poetae Comici Graeci*, 8 vols.,
Berlin 1983–).
[2] J. W. White, *The Verse of Greek Comedy*, London 1912, vii.

performance of ancient Greek drama, on both the professional and the pedagogical stages, in both ancient Greek and modern language translations, had awakened scholars to the *aural* impact of ancient drama's metrical variety.[3] The appreciation of form through performance was a crucial complement to the more abstract science of ancient Greek dramatic metrics pioneered a century earlier in the seminal books published by Gottfried Hermann between 1796 and 1816.[4]

White's point was primarily aesthetic. He was at a loss to express his admiration for the diversity of verse forms that the fifth-century dramatists inherited, and the artistry with which they integrated them into their plays. But his final point—that the ancient Greeks were "only vaguely conscious of historical relations"—reveals that he was dimly aware that verse forms carried more than aesthetic weight. Another century later, an additional dimension of these verse forms has begun to attract scholarly attention, and that is the manner in which their formal aspects might relate to the Athenian *polis* society that produced them—that is, "politically."[5] This chapter is intended to be a "think piece," which explores, tentatively, some avenues of approach to the sociopolitical dynamics underlying the varied metrical and musical shape of Athenian drama. In the final section, I argue that an important factor, by the time of the Persian wars and

[3] See P. Easterling, "The Early Years of the Cambridge Greek Play," in C. Stray (ed.), *Classics in 19th and 20th Century Cambridge: Curriculum, Culture, and Community* (= *Proceedings of the Cambridge Philological Society* suppl. 24), Cambridge 1999, 27–47; E. Hall, "Aristophanic Laughter across the Centuries," in E. Hall and A. Wrigley (eds.), *Aristophanes in Performance, 421 BC–AD 2007: Peace, Birds, and Frogs*, London 2007, 14, 17–18; E. Hall, "The English-speaking Aristophanes, 1660–1914," in Hall and Wrigley 2007, 85–6; A. Wrigley, "Aristophanes Revitalized! Music and Spectacle on the Academic Stage," in Hall and Wrigley 2007, 136–54. It is in this context that T. Goodell ("Structural Variety in Attic Tragedy," *Transactions of the American Philological Association* 41 [1910], 71) wrote in passing that he could not explain why scholars had failed to notice the remarkable shifts both in meter and in mode of delivery from speech to song in tragedy, lending the genre its "really extraordinary variety of formal structure," although his main point is that each *play* differed metrically from every other one.
[4] G. Hermann, *De metris poetarum Graecorum et Romanorum libri III*, Leipzig 1796; G. Hermann, *Handbuch der Metrik*, Leipzig 1799; G. Hermann, *De usu antistrophicorum in Graecorum tragoediis dissertatio*, Leipzig 1810; G. Hermann, *De metrorum quorumdam mensura rhythmica dissertatio*, Leipzig 1815; G. Hermann, *Elementa Doctrinae Metricae*, Leipzig 1816.
[5] E. Hall, "Actor's Song in Tragedy," in S. Goldhill and R. Osborne (eds.), *Performance Culture and Athenian Democracy*, Cambridge 1999, 96–122; P. Wilson, "The Musicians among the Actors," in P. Easterling and E. Hall (eds.), *Greek and Roman Actors: Aspects of an Ancient Profession*, Cambridge 2002, 33–68; E. Csapo, "The Economics, Poetics, Politics, Metaphysics, and Ethics of the 'New Music,'" Chapter 3 here.

our first extant drama, is the Athenian use of the ideology of Panhellenism to underpin its imperial aspirations and activities.

Around the turn of the second century AD, Epiktetos thought about the disappearance of the actor's real "self" behind a costume and mask, and insightfully commented that the only part of his physical presence which was not disguised or erased was his voice (*Discourses* 1.29.6). Yet the material, empirical reality of real-life performance space, inhabited by real-life Athenians dressed in costumes, could only become fully *transformed* into the imaginative world conjured by the play at the moment when disembodied sound was produced from the actor's fleshly body; he expressed air physically through his torso, throat, and head, at which point it entered the communal space of the atmosphere and mutated into language, poetry, ideology, and culture. It was the actor's voice that turned matter into things of the mind, thus allowing the biological body to meet the metaphorical body politic.[6]

By Epiktetos' day, the sociopolitical roles played by theatrical performances, along with the relationship between actors and their audiences, were different from those that pertained in classical Athens when the original dramas were first produced. The varied verses that actors and choruses delivered at the Athenian festivals of Dionysos under the democracy had a political dimension if for no other reason than that the ears that heard them were largely those of fellow *politai*.[7] The simple act of attending the theater, or performing in a play either as an individual actor (*hypokritês*) or chorusman (*choreutês*), was to discharge one of the functions of a citizen and to define and reinforce identification with that social role. Many of the spectators had once performed in dramatic choruses themselves; a large proportion would have been watching the participation of their own sons, nephews, and grandsons—as well as neighbors and fellow demesmen.[8] Moreover, at least in the fifth century, the plays were written and performed by poets and actors who were almost exclusively all Athenian citizens (Ion of Chios is an exception). Athenian acting families, poets, and amateur chorusmen collaboratively created fictions in the communal space of

[6] E. Hall, *The Theatrical Cast of Athens: Interactions between Ancient Greek Drama and Society*, Oxford 2006, 288.

[7] See S. Goldhill, "The Great Dionysia and Civic Ideology," *Journal of Hellenic Studies* 107 (1987), 58–76; J. J. Winkler, "The Ephebes' Song," in J. J. Winkler et al. (eds.), *Nothing to do with Dionysos? Athenian Drama in its Social Context*, Princeton, NJ 1990, 20–62.

[8] See M. L. West, *Ancient Greek Music*, Oxford, 1992, 17; E. Hall, "The Singing Actors of Antiquity," in P. E. Easterling and E. Hall (eds.), *Greek and Roman Actors: Aspects of an Ancient Profession*, Cambridge 2002, 5–6 and Hall 2006 (see above, n. 6), 2.

the theater that affected their whole community—the real, social beings who gathered together to watch them in the theater. Moreover, that citizen audience had a chance to contribute its own vocal performance, since its *thorybos* (noisy performance of applause or denigration) was an element in the total experience at the drama competitions that could affect the judges' decisions determining the victor.[9]

Yet the sociopolitical ramifications of ancient Greek theatrical verse forms have been neglected, partly as a result of the activities undertaken historically by classical scholarship itself. During the twentieth century there was an estrangement between formal analysis of tragedy and anthropologically inflected studies promoting the erasure of the distinction between what used to be called "art" and "reality." The German-speaking philological tradition long produced important books about the formal and metrical elements of tragedy; the French, on the other hand, wrote about gender, *polis* group identity, democracy, myth, and the interpenetration of cultural artifacts such as plays and vase-paintings with the more overtly civic discourses. But recent scholarly work, especially in the area of the so-called New Music associated with Timotheos, has meant that ancient theater studies are beginning to benefit from a dialogue between the "formalist" school of literary analysis, of which the metrical tradition of criticism is an important constituent, and the society-oriented synthetic approach, at least in the case of the drama of the last two decades of the fifth century.[10] It is increasingly accepted that both form itself and the codes by which dramatists selected formal structures were conditioned by social and political factors.

When it comes specifically to the variety of meters in which the actors could communicate with their spectators, there are in fact several ways of looking at the question politically. One method is to examine the casts of plays—the personnel who inhabit the fictive worlds represented in the theater—from a perspective that combines sociological taxonomy with metrical analysis. That is, which social classes are given which meters to utter, either as individuals or chorally, and what might this imply? I have argued in detail elsewhere that in

[9] See Hall 2006 (see above, n. 6), 363–66.

[10] E. Csapo, "Later Euripidean Music," in M. Cropp et al. (eds.), *Euripides and the Tragic Theatre in the Late Fifth Century*, Champaign, IL, 2000, 399–436, P. Wilson, "Athenian Strings," in P. Murray and P. Wilson (eds.), *Music and the Muses: The Culture of "Mousikê" in the Classical Athenian City*, Oxford 2004, 269–306, E. Csapo, "The Dolphins of Dionysus," in E. Csapo and M. Miller (eds.), *Poetry, Theory, Praxis: The Social Life of Myth, Word and Image in Ancient Greece*, Oxford 2003, 69–98; Csapo, Chapter 3 here (see above, n. 5).

Athenian tragedy, at any rate, there are important ideological structures under-lying the choices that the playwrights made about meter: characters of certain social status are far more likely than others to be given lyrics to sing, as opposed to iambic trimeters to speak: tragic lyricists are predominantly either distraught females or male barbarians.[11]

In fifth-century tragedy, individual slaves from birth (as opposed to aristo-crats who have become enslaved) scarcely ever sing, with the exception of the quintessentially barbarian eunuch from Phrygia in Euripides' *Orestes*. Neither do gods or Athenian middle-aged men (again, with an interesting exception: Theseus in *Hippolytos*, who is given some rather half-hearted lyric lines).[12] But the rules change completely, of course, when the slaves or supernatural beings or Athenian men form a chorus (see, e.g., *Oidipous at Kolonos*). In the case of the distinction between individuals and choruses in drama, one ancient critic was quite clear that in "the old days" of theater, class hierarchies could certainly be signified by formal means—if not by particular meters, then certainly by specific musical modes. The Hypodorian and the Hypophrygian modes were the preserve of the individual characters on stage, because they were ruling class (*hêgemones*) and therefore socially superior to the collective populace being represented in the chorus (*hoi de laoi*, [Aristotle], *Problems* 19.48).[13]

A second way of looking at the question of the political connotations of verse form in classical Greek drama is to think about what specific meters might have signified, whether emotionally or in terms of generic and ritual asso-ciations. Here the problem identified by White becomes pressing: since the Athenians themselves may often only have been "vaguely conscious of historical relations" between metrical form and the contexts that had originated and devel-oped those forms, it becomes all too easy to indulge in speculation about how the audiences would have "heard" a particular rhythmic formation, especially in the almost complete absence of either the accompanying music or even basic information about the musical modes employed.[14] There is no way to achieve

[11] Hall 1999 (see above, n. 5), revised version in Hall 2006 (see above, n. 6), 288–320.

[12] Hall 2006 (see above, n. 6), 314–15.

[13] Hall 2006 (see above, n. 6), 289.

[14] For an edition of almost all the extant musical papyri, including those relating to the theater, see E. Pöhlmann and M. L. West, *Documents of Ancient Greek Music: The Extant Melodies and Fragments,* edited and transcribed with commentary, Oxford 2001. An exciting new papyrus frag-ment with music composed for Karkinos' fourth-century *Medea* has subsequently been published by A. Bélis, "Un papyrus musical inédit au Louvre: Identification, transcription et interprétation musicale," in *Comptes Rendus de l'Académie des Inscriptions et Belles-Lettres* fasc. 3, 1305–29 = C.Acad. 90 (2004): fasc. 3 (Jul–Oct), 2004.

an "archaeology of ears" and scrape away the barnacles of our culturally deter-mined emotional and aesthetic responses in order to replace them with those of an ancient audience.[15] One amusing example of entirely different scholarly reac-tions to both the prosody and the words of a song embedded within an ancient playscript is provided by the song at *Ekklesiazousai* 960–76, which has been identified by different scholars, according to their subjective responses to it, as both a charming "love duet" and as a thoroughly lewd *paraklausithyron*.[16]

Yet in a few cases the associations of a particular metrical form can be partially established, and can indeed illuminate the total experience of the play in performance. The evidence of comedy suggests that iambic songs, as opposed to spoken iambics, sounded somewhat primitive and demotic in tone, partly because the iambic itself was the meter least distanced from elevated, colloquial speech, as Aristotle twice insists (*Poetics* 4.1449a 19–28; *Rhetoric* 3.1408b24–6).[17] Generic associations may sometimes be detected: when the Underworld chorus introduces the great debate between the tragedians in *Frogs*, it sings a strophic prelude largely composed of dactylic hexameters (814–29), which "contribute to the portrayal of the contest as a heroic combat."[18] The dochmiac rhythm is intimately bound up with the history of tragedy itself as a genre—it never appears before tragedy and scarcely ever afterward. But its associations are fundamentally psychological rather than "political:" it appears at moments of extreme mental agitation, especially when highly resolved into strings of consec-utive short syllables, which created a twittering effect that seems to have invited comparison with birdsong.[19] But some meters obviously had at least broadly sociopolitical associations. The Ionic *a minore* meter, for example, which is such a conspicuous feature of both *Persians* and *Bacchai*, clearly had Asiatic connota-tions as well as ritual, Dionysiac ones, and helped to create what would now

[15] On the ease with which modern Western-centered aesthetic and artistic concepts and judg-ments can creep into the study of the music of other cultures see the ethnomusicologist A. Merriam, *The Anthropology of Music*, Chicago 1964, chap. xiii, 259–76.

[16] See S. D. Olson, "The 'Love Duet' in Aristophanes' *Ecclesiazusae*," *Classical Quarterly* n.s., 38 (1988), 238–39.

[17] See White 1912 (see above, n. 2), 26, on *Frogs* 416–38 and *Acharnians* 1008–17 = 1037–46.

[18] K. J. Dover, *Aristophanes' Frogs*, edited with an Introduction and Commentary, Oxford 1993, 291.

[19] Most famously, of course, in the Hoopoe scene in Aristophanes' *Birds*, on which see A. Barker, "Transforming the Nightingale: Aspects of Athenian Musical Discourse in the Late Fifth Century," in P. Murray and P. Wilson (eds.), *Music and the Muses*, Oxford 2004, 185–204. On tragic singing, the dochmiac, and birdsong, see Hall 2002 (see above, n. 8), 8.

be called an "Oriental" atmosphere that cannot have failed to mean something political in Athens ever after the Persian Wars.[20]

Thinking about the connotations of verse forms and their juxtaposition and arrangement within a particular playscript can help to develop a critical practice in which the choice of form is understood to contribute to the meaning created in performance. If art is to be understood as a product of a particular society at a particular time, criticism must involve "illuminating some of the ways in which various forms, genres, and styles . . . come to have value ascribed to them by certain groups in particular contexts."[21] In the case of comedy, particular verse forms and their generic connotations are sometimes marshaled in support of discrete political positions. In Aristophanes' *Peace*, as I have argued elsewhere, the battle for peace is formulated as a battle between poetic genres, and heroic epic is identified with the enemy (i.e., supporters of the foreign policies of the recently deceased Kleon). Even Ionian *iambos* and Aesopic fable are, within the opening sequence, enrolled at least by allusion in the service of Trygaios' mission, along with tragedy, satyr play, Stesichorean choral lyric, Alkaios' *symposion* poetry and above all Hesiod's agricultural verses.[22]

2. The poikilia *of theatrical form*

There is, however, a third way of looking at the question of classical Greek dramatic and metrical form "politically." This approach is more holistic, since it considers, from the visual perspective of the reader looking at the printed page, the *phenomenon* of the rhythmically variegated entity that was the total aural experience of ancient Greek drama and which is an obvious feature of the text, even today. The word "phenomenon" is particularly appropriate: to insist that the visible surface manifested by a text offers vital clues that must not be ignored in favor of the analysis of deep structures, is indeed, methodologically speaking, to take a "phenomenological" approach.

The heterogeneity of ancient Greek theatrical verse forms would instantly attract the attention of any phenomenological analyst of theater, for whom playscripts have a special claim to truth value. Such critics, who trace their approach to Edmund Husserl, the founder of phenomenology, stress the importance of visible manifestations or symptoms of underlying social structures, the forms

[20] E. Hall, *Aeschylus' Persians*, edited with Introduction, Translation and Commentary, Warminster 1996, 113.
[21] J. Wolff, *The Social Production of Art*, London 1981, 7.
[22] Hall 2006 (see above, n. 6), ch. 11.

taken by their instantiations on the *surface* of cultural life. To Bruce Wilshire, an influential phenomenological theorist of theater, theater is a "disciplined use" of the imagination that can "discover … aspects of actuality."[23] Theater is a privileged source for documenting psychosocial "reality" precisely because it is so obviously artificial, its poetic languages and media of communication (including, of course, musical accompaniment to speech) so estranged from everyday life, and its characters so unreal. This results in a potential to reveal the truth entirely unshackled from the mendacious tendency of discourses, genres, and media that stake false claims to veracity. Untrue, partial, or distorted historiography, oratory, funerary monuments, and medical textbooks can all "masquerade" as truth, but theater can never masquerade as the truth because it *is* masquerade.

The exceptional nature of ancient drama's formal heterogeneity was expressed by the Byzantine Greek scholar Michael Psellos, when he described ancient tragic poetry (*tragikê poiêsis*) as "adorned [*kosmoumenê*] with a variety of rhythms, and encompassing variegated [*poikila*] meters."[24] The term *poikila* here very likely reveals the connection that Psellos drew, perhaps consciously, between the patterned nature of Dionysiac clothing and animal skins and his figurative Tragic Poetry, semipersonified by being decked out with meters metaphorically construed as her theatrical costume and *skeuê*.[25] For words with this *poikil-* stem are used by the dramatists in reference to textiles or clothes of varied patterns (Aischylos *Choephoroi* 1013, Aristophanes *Wealth* 530) or animals with dappled or mottled hides (Euripides *Iphigeneia at Aulis* 226). In Isokrates, the poets in general are said to have more resources than some other writers, because they can "embroider" (*diapoikillein*) their poetry by using not only conventional expressions but exotic terms, neologisms, and all kinds of figures of speech (9.9). This sort of metaphor is used in Sokrates' denigration of democracy in the *Republic* (8.557b–c), where he characterizes it as a system made up of "all sorts" of people (*pantodapoi*), which may seem very lovely, especially to women and boys, "in the same way as a patterned [*poikilon*] mantle, variegated in its embroidery [*pepoikilmenon*] with all kinds of flowers," since it

[23] B. Wilshire, *Role Playing and Identity: The Limits of Theatre as Metaphor*, Bloomington, IN, 1982, 11; see further E. Hall, "Towards a Theory of Performance Reception," *Arion* 12 (2004), 67–68.

[24] A. R. Dyck, *Michael Psellos: The Essays on Euripides and George of Pisidia and on Heliodorus and Achilles Tatius*, Vienna 1986, 21–24.

[25] On the classical Greek and Roman precedents for the personification of Tragedy or Tragic Poetry, see E. Hall, "Tragedy Personified," in C. Kraus et al. (eds.), *Visualizing the Tragic*, Oxford 2007, 221–56.

is likewise "variegated" (*pepoikilmenê*) through the diversity of characters within it. One of the problems with democracy, at least radical democracy, is precisely the "unlikeness" of one citizen to another. In Plato's *Laws*, the Athenian uses the same stem to create words applied specifically to our chief interest here: the Athenian condemns the sort of elaborate music in which there is a "divergence" (*heterophônia*) and "variety" (*poikilia*) marking the relationship between the notes of the lyre on the one hand and the melody of the song on the other, leading to a combination of pitch, speed, tonality, "and all sorts of rhythmical variations" (*tôn rhythmôn pantodapa poikilmata*, 7.812d–e).[26]

Despite Plato and Psellos, there is of course no reason to imagine (with the exception of some passages in Aristophanes, above all the explicit discussions of meter in the debate between the tragedians in *Frogs*), that any ancient Greek dramatist composing in his *poikila* or *diapepoikilmena* rhythms ever himself had "principles of pure metric" uppermost in his mind, or was even conscious of them.[27] He certainly did not have at his disposal the classifications applied by the assiduous metrician Hephaistion in his *Encheiridion* (summary handbook) on meter (ca. 200 AD), which even today forms the basis of the terminology used by specialists in ancient Greek prosody, despite the assault Paul Maas launched against ancient metrical theory.[28] Yet it was indeed one of the most remarkable innovations of the ancient Greek dramatists, comic as well as tragic, that they produced forms of poetry that include several types of song, in the genres and meters that had for the most part been standardized and canonized in the archaic period.[29] With one signal exception—the *Margites*—no work with a claim to an earlier date than drama, in any genre, juxtaposes within its overarching structure even two blatantly contrasting metrical schemes, let alone several entirely different ones, delivered in such a variety of performance styles. Nor is there any evidence (again, besides the *Margites*) that dactylic hexameter episodes from

[26] On the precise meaning of the passage from the *Laws* on lyre accompaniment, see A. Barker, "*Heterophonia* and *Poikilia*: Accompaniments to Greek melody," in B. Gentili and F. Perusino (eds.), *Mousikê: Metrica, ritmica e musica greca*, Pisa 1995, 41–60. The stem does appear in Mycenaean, where it appears to refer to textiles, its primary meaning in classical Greek: see P. Chantraine, *Dictionnaire étymologique de la langue grecque*, new edition with a supplement by A. Blanc, C. de Lamberterie, and J.-L. Perpillou, Paris 1999, 923.
[27] A. M. Dale, *The Lyric Metres of Greek Drama*, 2nd ed., Oxford 1968, 1–2.
[28] P. Maas, *Griechische Metrik*, in A. Gercke and E. Nordern (eds.), *Einleitung in die Altertumswissenschaft*, 3rd ed., Leipzig and Berlin 1927, 2; see J. M. van Ophuijsen, *Hephaestion on Metre: A Translation and Commentary*, Leiden 1987, 3–4.
[29] J. Herington, *Poetry into Drama: Early Tragedy and the Greek Poetic Tradition*, Berkeley, CA 1985, 3–10.

epics were ever made to alternate with other types of musical performance, as is the case with some North African indigenous epic traditions.

The comic narrative poem *Margites* is a fascinating and important exception, since it interspersed iambics into its dactylic hexameters (Hephaistion *On Poems* 3.4 = *Encheiridion* p. 65, 10–11 Consbruch). But in a sense it may be the exception that proves the rule. Although it went in antiquity under the name of Homer, the actual poem to which Hephaistion refers, and which may well be constituted by the mixture of hexameters and iambics in P.Oxy. 2309, is of uncertain date.[30] It postdates Archilochos, despite a misleading reference,[31] and is very likely to be placed as late as the sixth century (in the second half of which drama was invented) or even the fifth or fourth. One author of a specialist study has argued that the author was the Presocratic philosopher Xenophanes; others have argued, rather more plausibly, that the conjunction of different meters stems from a *parody* of the original, "Homeric" *Margites* by a poet of Old Comedy, Kratinos.[32] In a study of the evolution of verse forms in ancient Greece, A. M. Dale remarked that she was "quite unable to take seriously the claim" that the *Margites* antedated Archilochos; she therefore approved the association with Kratinos, since "the perpetrator of that farrago was himself no metrical inventor—the whole joke assumes familiarity with the iambic line and its normal uses—and we should be given to postulate a considerable body of iambic poetry already in existence before the seventh century."[33]

In its article under "Pigres," the *Suda* attributes the poem to this fourth-century Halicarnassian poet, as well as claiming that he had produced a metrically variegated work that interpolated not iambics but elegiacs into the *Iliad*.[34] Needless to say, the confused ancient references to the *Margites* have always presented a challenge to theorists and classifiers of epic as a genre, whether Aristotle (*Poetics* 4.1448b30), Renaissance readers of Aristotle,[35] or modern

[30] When Edward Lobel published P.Oxy. 2309 in *The Oxyrhynchus Papyri* 12 (London 1954, 1–2), he regarded it as "a reasonable conclusion" that it contained the Margites (p. 1).

[31] M. L. West, "The Invention of Homer," *Classical Quarterly*, n.s., 49 (1999), 377.

[32] F. Bossi, *Studi sul Margite*, 1986. Cf. T. Bergk, *Poetae Lyrici Graeci Tertiis Curis* Pt. 2, *Poetas Elegiacos et Iambographos Continens*, Leipzig 1846, 153; S. D. Olson and A. Sens, *Matro of Pitane and the Tradition of Epic Parody in the Fourth Century BCE*, Atlanta, GA 1999, 5–6. On Kratinos' adaptation of preexisting verse forms, see, above all, E. Bakola, *Cratinus and the Art of Comedy*, Oxford and New York 2010.

[33] A. M. Dale, "Stichos and Stanza," *Classical Quarterly*, n.s., 13 (1963), 47.

[34] See J. A. Davison, "The Oxyrhynchus Papyri," review in *Classical Review*, n.s., 6 (1956), 13.

[35] R. C. Williams, "Metrical Form of the Epic, as Discussed by Sixteenth-Century Critics," *Modern Language Notes* 36.8 (December 1921), 451.

papyrologists.[36] It is conceivably possible that the metrical experimental *Margites* preceded the invention of drama, but it is far more plausible that parodying epic by interspersing iambics into hexameters only became possible as a result of the experience of comic parody.

Whether the formal metrical variety of theatrical performances was the result of an aesthetic decision taken consciously at the points that tragedy and comedy were respectively invented, or a teleological consummation of an organic process that by gradual increments assimilated additional genres to an ancient tradition of choral dancing, is a question as unanswerable as the origin of drama itself. The sociological dimension of the polymorphic form of Athenian drama is, however, surely better understood if approached *synchronically*, in an attempt to understand its effect and function during the decades from which we have extant examples, rather than diachronically in terms of etiology in an earlier period— Peisistratean Athens—about which we know desperately little.

Despite all the problems with the evidence, it is clear that a powerful difference was felt in antiquity between sung lyric and spoken iambic verse. An ancient grammarian named Diomedes even recommended that we should sing ancient Greek lyric poetry when we read it, regardless of whether or not we know or can remember the tune.[37] It is not clear how this should be done, beyond raising the pitch of our voice on accented syllables.[38] But Diomedes' recommendation suggests that the difference between sung and spoken verse was so powerfully perceived that even an invented melody would help the reader to recover the experience of a sung lyric poem. Taking into account the perceived difference in effect, it must be stressed that regardless of what happened in the half century preceding our earliest extant drama, Aischylos' *Persians* (472 BC), the difference between its metrical constituents and those of any earlier ancient Greek poem is astounding.

Besides the use of iambic trimeters and trochaic tetrameters, simply *staging* a story means that the marching anapaest comes into its own as a meter reflecting

[36] See H. Langerbeck, "*Margites*—Versuch einer Beschreibung und Rekonstruktion," *Harvard Studies in Classical Philology* 63 (1958), 33–63.

[37] *dei meta melous anagignôskein*, 21.19–21 Hilgard (*Grammatici Graeci*, Leipzig 1878–1910). Diomedes' advice appears in his commentary on a passage in Dionysios of Thrace's *Ars Grammatica*, where it is recommended that lyrics be read *emmelôs*, and laments in an abandoned and dirge-like manner: p. 6, par. 2.8–11 Uhlig (*Grammatici Graeci*, Leipzig 1878–1910).

[38] So suggests Lionel Pearson in his *Aristoxenus, "Elementa Rhythmica": The Fragment of Book II and the Additional Evidence for Aristoxenean Rhythmic Theory*, edited with Introduction, Translation and Commentary, Oxford 1990, xlix.

physical movement. Anapaests regularly kick off choral odes in *Persians*, including the parodos, which is itself a strophic structure more complicated than any surviving archaic poem or epinician, and includes passages that are dominantly Ionics *a minore* (see above), lyric iambics, and lecythia. Other choral passages incorporate further elements such as lyric dactyls and lyric anapaests. There is an *epirrhêma* in which the messenger's spoken iambic trimeters alternate with the chorus's lyric iambics, and a fifteen-stanza *kommos* concludes the play.

The point of the last paragraph is not to blind the reader with metrical science but simply to underline what White expressed so well in the quotation that began this chapter, and that is just what a different beast dramatic poetry was from anything that had gone before it. The audience was exposed, in *Persians* alone (itself only one in a group of four plays performed sequentially), to a large number of aural "gearshifts." I say "aural" rather than "metrical" because many of these gearshifts marked not only a shift from spoken verse unaccompanied by the *aulos* to accompanied verse, but a shift in the nature of the vocal delivery from speech to recitative or song. Even discounting the modulations within choral odes between dominantly dactylic and dominantly iambic or Ionic passages, and counting only the transitions between anapaest, lyric meters, iambic trimeters, and trochaics, there are no fewer than twenty-one shifts (counting conservatively) in basic verse form in the course of this tragedy, which consists of fewer than eleven hundred lines. That means approximately one gearshift every fifty lines.

A sole, precious piece of evidence suggests that tragic audiences did not simply appreciate the pleasure that comes from diversity but found emotive the precise moments of change, within a single performance, from one type of meter and delivery to another—the actual gearshifts. The pseudo-Aristotelian *Problem* 19.6 says that the form of delivery in tragic songs called *parakatalogê* (i.e., some kind of recitative) is effective "because of the contrast involved [*dia tên anômalian*] . . . Contrast is emotive in situations of great misfortune or grief; regularity [*to homales*] is less conducive to lamentation." The effect of contrast or sudden gearshift within an individual speaker or singer's delivery, described in this *Problem*, can perhaps be illuminated by the use of the cognate term *anômalos* in Aristotle's account of an adolescent male voice, when in the process of breaking (*hotan anômalos êi hê phônê*), swerving suddenly from the childhood register to the adult male's (*Generation of Animals* 5.7.788a1–2). Such striking transitions are not necessarily only appropriate to tragedy, by being conducive to lamentation: metrical and vocal *anômalia* is also a fundamental principle of comedy, as

can be seen from the earliest extant example, Aristophanes' *Acharnians*, as well as all the fragments of plays that were first performed before 425 BC.[39]

3. The politics of form

It is puzzling how reluctant scholars of Greco-Roman societies have been to enquire into the relationship between these societies and the formal, genre-based characteristics of the literature in ancient Greek and Latin that they produced. This reluctance contrasts sharply with the serious consideration that has been given to, for example, the relationship between the emergence of capitalism and the form of the English, French, or Russian novel, certainly ever since Lukács' seminal discussion of Lawrence Sterne in *Die Seele und die Formen* (1911). It is, admittedly, *easier* to see how subject matter and content can be involved in discussions of the social role of literature than issues of meter and form. This must be why there have been so very few attempts to explain, for example, why the dactylic hexameter dominated narrative poetry and indeed the educational canon in both Greek and Latin during the whole of the classical period, which was also polytheistic, slave-holding, patriarchal, and grounded in particular types of economic relationship and agricultural practice.[40] Although the ways that the form of the epinician and the trilogic form of tragic theater related to their social contexts have indeed been thoughtfully discussed by Peter Rose,[41] virtually no attention has ever been paid to sociopolitical ramifications of the centrality of aural "gearshifts" to the classical Athenian theatrical experience.

This is particularly surprising given the very widespread respect that has been accorded by classical scholars to the ideas of Michael Bakhtin. If we think about the consequences of his work for ancient Greek dramatic genres, as genres they look increasingly revolutionary: any genre, he wrote, "enters life and comes into contact with various aspects of its environment. It does so in the process of its actual realization as something performed, heard, read at a definite time, in a definite place, under definite conditions. . .*It takes a position between people organized in some way.*"[42]

[39] The term *anômalia* signifies not only "variety" or "diversity" in the more material application in which Aristotle regularly uses it (e.g., *Generation of Animals* 788a24), but of inconsistency of abstract entities such as character (Aischines 2.7) or political constitution (Plato, *Menex.* 238e).

[40] One outstanding exception is P. Rose, *Sons of the Gods, Children of Earth: Ideology and Literary Form in Ancient Greece*, Ithaca, NY 1992, 43–46.

[41] Rose 1992 (see above, n. 40), 27–29, 141–43, 159–65, 185–94.

[42] P. N. Medvedev and M. Bakhtin, *The Formal Method in Literary Scholarship: A Critical Introduction to Sociological Poetics*, trans. A. J. Ehrle, Baltimore, MD 1978, 131 (my emphasis).

The assembled citizens between whom ancient drama took its position when it was performed were certainly people organized in a very distinctive, and actually revolutionary way, at least after the reforms of Kleisthenes. But to Bakhtin, genre also has an internal aspect as a force that shapes consciousness: every significant genre "possesses definite principles of selection, definite forms of seeing and conceptualizing reality, and a definite scope and depth of penetration."[43] In other words, genres are viewpoints on the world, and, as Vernant and Vidal-Naquet dedicated much of their lives to arguing, Athenian tragedy constituted heroic myth inspected from the viewpoint of the fifth-century citizen. But they focused on content rather than form: Bakhtin would include the organization of verse forms in his definition of genre, which always "develops and generates in the process of ideological social discourse. Therefore, a genuine poetics of genre can only be a sociology of genre."[44] The "poetics" of genre involves looking at not only the development of individual genres but also their "inclusiveness"—ways they integrate, oppose, synthesize, or hierarchically organize material from other genres. The idea of an "included" intergeneric dialogue could scarcely be more suggestive for the analysis of the form of ancient Greek drama.

It is also an area in which Russian Formalism and Western Marxism have a good deal in common. In a famous assault on some previous Marxist definitions of the relationship between form and content, Terry Eagleton argued that they are existentially inseparable but methodologically distinct. Of course, in literary practice, when a text is being written or read, form and content are inevitably impossible to pry apart. But they have been *historically* distinguished, and are therefore distinguishable in the practice of critical and historical *theory*: "such a recognition must precede debate as to whether their theoretical relationship is harmoniously reciprocal, interactive but asymmetrical, or whatever."[45] Now, one of the fundamental ways in which the Marxist tradition Eagleton was criticizing had looked at form was as a dimension of a text that, by imposing shape and order on experience and its representation in language, can be seen as a phenomenon that attempts to *resolve* the social and psychological contradictions raised and exposed by content. According to this view, form is a repressive force that effectively beats material reality into shapes that are ideologically acceptable to

[43] Medvedev and Bakhtin 1978 (see above, n. 42), 131.
[44] Medvedev and Bakhtin 1978 (see above, n. 42), 135.
[45] T. Eagleton, "Marxism and Form," *Poetry Nation* 1 (1973), 59–60.

ruling-class interests.[46] But the problem with this somewhat reductive model, as Eagleton stresses, is that historical "content" does not come without itself being preformed by social and productive forces. When literary change happens, it is indeed, as Fredric Jameson argues in his landmark study *Marxism and Form*, essentially a function of content seeking "its *adequate expression* in form." Jameson of course goes on to insist that all "content" also has its "inner logic," of which adequate literary form is the articulation.[47] On this basis one could see the Athenian invention of theatrical presentations of myth as *partially* preformed content seeking a form of articulation adequate to the drastic social and epistemic changes that produced the Kleisthenic revolution.

Leon Trotsky is not an author often cited in classical philology, but since he asked questions about the relationship between meter and social experience, it is worth considering his dazzling *Literature and Revolution*, written in the early 1920s. When analyzing the relationship of literature to social change, he argued that rhythms are related to society in embodying the *parameters* of the forms taken by *consciousness* in a historical society.[48] Consciousness is framed by and instantiated in the very shape taken by the serial pulses in which language is organized in a rhythmic text, most demonstrably in poetry. These forms of historical consciousness are fragile and subterranean and emerge in the "pulse" because they are far too delicate and submerged to be explicitly articulated:

> The poet can find material for his art only in his social environment and transmits the new impulses of life through his own artistic consciousness. Language, changed and complicated . . . gives the poet a new verbal material, and suggests or facilitates new word combinations for the poetic formulation of new thoughts or of new feelings, which strive to break through the dark shell of the subconscious. If there were no changes in psychology produced by changes in the social environment, there would be no movement in art.[49]

[46] Eagleton's (1973; see above, n. 45) major targets here were two "classics" of Marxist criticism in English, both published in 1937 (both men died in the Spanish Civil War): Ralph Fox, *The Novel and The People* and Christopher Caudwell, *Illusion and Reality*.

[47] F. Jameson, *Marxism and Form*, Princeton, NJ 1971, 311.

[48] L. Trotsky, *Literatures and Revolution*, reissue of English translation by R. Strunsky, London 1991 [1925], 173–75, and 195–96; the passage begins thus: "Though individual shadings of poetic form correspond to individual make-up, they do go hand in hand with imitation and routine, in the feeling itself, as well as in the method of expression."

[49] Trotsky's concept was later reworked by R. Williams in his influential idea of "structures

This approach to form can be integrated with Vernant's insistence that scholars need to examine the processes whereby Athenian tragedy *transformed* reality while assimilating it into its own medium—what Raymond Williams would call the processes of artistic "mediation:" as Vernant influentially put it, "No reference to other domains of social life . . . can be pertinent unless we can also show how tragedy assimilates into its own perspective the elements it borrows, thereby quite transmuting them."[50] Vernant proposed that scholars need not only to be aware of the particular codes and conventions conditioning such processes of transformation, but also to ask what those codes reveal about the society operating them. The expression, in the theater, of Athenian civic consciousness in metrical art is one such process of transformation, and the codes informing that process of transformation or "mediation" need to be investigated since they can potentially illuminate far more than mere metrical habit.

It might be argued that classical Greek dramatic genres were remarkably "inclusive" genres in the Bakhtinian sense. Bakhtin's central examples were epic and the novel, "global" linguistic structures that not only included but thoroughly assimilated preexisting genres of speech and literary discourse: Homeric epic presents all its songs and speeches in the same overarching meter, and the nineteenth-century novel (although not Petronius' *Satyricon*) assimilated nearly every form of human expression to the same prose form. Tragedy and comedy were indeed inclusive in that they incorporated so many previously discrete poetic genres, from lament, wedding song, sacrificial ululation, partheneion, hymn, encomium, and the narrative lyrics of Stesichoros in tragedy to work songs, drinking songs, dithyrambs and vituperative lampoon in comedy. Sometimes, as in the delicate generic shifts *within* some choral odes, the preexisting genres have been fused into a new metrical entity embedded within the total structure of the play. Often they are used ironically: L. P. E. Parker has shown in her magisterial *The Songs of Aristophanes* how Euripides uses the hymeneal associations of the glyconic, an old Aeolic meter, when it appears inserted into Kassandra's perverted wedding song in *Trojan Women* (308–40).[51] On the other hand, in comparison with other ancient poetic media, tragedy and comedy leave the discrete genres, which in combination constitute them, accommodated

of feeling," which he first used in *Culture and Society: 1780–1950*, London 1959, and in which he included poetic rhythms as well as modes of sensibility and semantic figures (R. Williams, *Marxism and Literature*, Oxford and New York 1977, 133).

[50] Vernant in J.-P. Vernant and and P. Vidal-Naquet, *Myth and Tragedy in Ancient Greece*, trans. J. Lloyd, Cambridge, MA 1988, 31.

[51] L. P. E. Parker, *The Songs of Aristophanes*, Oxford 1997, 292–93.

but unassimilated, their traditional meters relatively unaltered, in a spectacularly uneven (i.e., *anômales*) overall display.

The question of metrical variety and performative gearshifts is impossible, of course, to separate from the issue of theater's apparently unique fusion of choral sections with those delivered by an individual or individuals—monologue, dialogue, solo recitative, monody, duet with another actor, or *kommos* or *epirrhêma* interacting with the chorus. In Aristophanic comedy, the chorus and the actors are two forces who interact in a dynamic ensemble, even though the balance between them differs from play to play.[52] Acting out narratives in intermissions between choral dancing may have been the way theater began, and when it comes to tragedy, of which we have much earlier examples than comedy, in Aischylos' plays the chorus remains predominant, although the actors assumed greater significance as the medium developed. Moreover, amongst the actors, with the exception of *Prometheus Bound* (the authorship and date of which are contested), the sense is more of an ensemble than of a star and his supporting actors.

In Aischylos' earlier works, the balance between the size and the significance of the roles remains fairly equal and no one figure, at least until Klytemnestra in *Agamemnon*, stakes a claim psychologically to dominate the action of a single play;[53] Klytemnestra, moreover, yields her central position over the course of the trilogy to Orestes. But as tragedy evolved, the individual actor challenged the dominance of the chorus;[54] what was expected of star actors then affected the way in which plays were composed. It is significant that a tragic actor's prize was not added to the Lenaia festival until the late 430s, and possibly not until 423 BC.[55] By the 420s, tragedies were more likely to revolve around a titanic personality who rarely leaves the stage, for example in Sophokles' *Oidipous* or Euripides' *Hekabe*.

[52] See the intelligent study of M. Treu, *Undici cori comici: Aggressività, derisione e tecniche drammatiche in Aristofane*, Genova 1999.

[53] See further Hall 2006 (see above, n. 6), 22–23, 24. Herington 1985 ([see above, n. 29], 143 and 271, n. 72) is to be commended when failing to be impressed by attempts to make Eteokles in *Septem* commensurate with the towering monolithic heroes of Sophokles or of *Prometheus Bound*.

[54] See Csapo, Chapter 3 here (see above, n. 5), Hall 2007 (above, n. 25), and E. Hall, "Greek Tragedy 430–380 BC," in R. Osborne (ed.), *Debating the Athenian Cultural Revolution*, Cambridge 2007, 264–87.

[55] The precise date depends on reconciling the evidence from several inscriptions, for a discussion of which see E. Csapo and W. J. Slater, *The Context of Ancient Drama*, Ann Arbor, MI 1995, 227–28.

What this means "politically" is that the fifth-century tragic theater was characterized by an intergeneric tension, even an ongoing confrontation, between the predominantly lyric forms of the poetry sung by choruses and the predominantly iambic forms of poetry spoken by the individual actors. This was manifested in two ways. First, in terms of the amount of airtime composed for the chorus relative to the individual characters, there was a struggle over proportional control of the process of the performance. This could perhaps be seen as an aesthetic mediation, transplanted to the remote and predemocratic mythical past and expressed more in form than in content, of the ongoing encounters between democratic mass and elite in the assembly and law courts; in Raymond Williams' terms, this mediation would constitute the crucial relationship between the cultural "formation" of tragedy and the social "institutions" of the democratic *polis*.[56] Second, the struggle for predominance within the genre can be seen in terms of tension between the emerging star actor and his supporting actors, since in time his presence overshadowed the deuteragonist and tritagonist. One way of understanding this tension is to see it as mediating, within the aesthetic realm, the increasing importance of the individual powerful statesman as public figure during and after the years of Perikles' leadership.

Yet whatever the balance of formal power (defined through type and extent of poetic self-expression) within individual plays, theatrical performances all remained examples of a fundamentally ensemble medium, in which the total effect was far greater than the sum of the parts, a fitting fictional world in which a democracy (where thousands of individuals shared power, and their contributions to the success of the *polis* were equally important if qualitatively different) could inspect itself. Homeric epic, originally the product of an age of monarchs and tyrants, was performed by the master-singer, the storyteller, the bard, who knew all things, however the god might impel him to sing (*Odyssey* 8.44–45), and in whose authoritative solo voice all the speaking characters of the epic were effectively ventriloquized. Drama was different. It put the people on the stage, each to be ventriloquized by an individual actor, or a group ventriloquized by a chorus. The physical presence of a group that dances also affects metrical practice: rhythms that are designed for dancing have, for example, an immanent tendency toward resolution into multiple short syllables, a tendency that is clear in Aristophanes' use of paeonics within trochaic verse systems.[57]

[56] Williams 1977 (see above, n. 49), 119–20.
[57] White 1912 (see above, n. 2), 84–85.

The fundamentally agonistic nature of the plots enacted in Aristophanic comedy (a feature that can scarcely be divorced from comedy's political role in the democracy) is metrically instantiated in this poet's widespread use of the catalectic anapaestic tetrameter in every part of his debate scenes—the distichs in which the chorus exhorts a debater to launch his case, in the debate itself, and occasionally in the rendering of the verdict.[58] This agonistic meter seemed to the metrician Hephaistion to be so typical of Aristophanic comedy that he gave it the name *to aristophaneion* (*On the Anapaest* 8.2 = *Encheiridion* p. 25, 1–9 Consbruch).[59] White points out that the *embatêria* which the Spartan infantry sang on the march and when joining battle were anapaestic, with a spondaic ending (a verse that was itself used by Aristophanes' rival Kratinos to open his *Odysseis*—see fragment 143.1 Kassel-Austin). Although the "recitative tetrameter" of Aristophanes' adversarial scenes was not itself a march verse, "its employment in the debate is in felicitous accord with its military use," and the distichs that kick off debates "may be a reminiscence of the exhortation with which the leader once incited his men to battle."[60]

One of the consequences of writing poetry for delivery by a socially diverse cast of characters, impersonated directly by actors in painted masks denoting age, ethnicity, gender, and status, was that the notion of *êthos* became more important for the dramatic poets than for those of preexisting genres. In tragedy, there were conventions governing the allocation of spoken and sung verses to characters of different ethnicity and status (see above); in comedy, it begins to be possible to see how even individual meters are handled to represent particular types of character in particular situations. In *Wasps*, for example, Aristophanes gives the elderly chorus trochaic rhythms for rapid delivery before and after their fight with Bdelykleon (403–29, 463–87), in order to convey their excitement and activity. But there is a further peculiarity: in their longer speeches, the number of reduced metra increases significantly toward the end, conveying the unmistakable impression that these old men who have exerted themselves are running out of breath (403–14, 463–70).[61] Such characterization may not represent an instance of the "politics" of metrical variety, but it certainly exemplifies its "sociology."

[58] White 1912 (see above, n. 2), 181–82.
[59] On the rather different meaning of the *metron* called "Aristophaneion" in modern metrics, see the qualifying remarks of van Ophuijsen 1987 (see above, n. 28), 86.
[60] White 1912 (see above, n. 2), 121–22.
[61] See D. M. MacDowell, *Aristophanes: Wasps*, edited with Introduction and Commentary, Oxford 1971, 28–29.

4. Poikilia *as sympotic and as Panhellenic: Two homologies*

Part of the reason for the variety of versification in all classical drama may, on a broad conceptual level, have something to do with Dionysos, a god whose very essence involves mutation, alternation, and *alterité*.[62] Indeed, the only surviving rival as shape-shifter of either Proteus or Kirke in archaic literature is the god Dionysos, one of whose own so-called *Homeric Hymns* (7.38–53) relates the myth of his escape from pirates who had abducted him in his true shape—that of a handsome youth. Dionysos first made the ship sprout vines and ivy, and then himself changed into a lion and a bear, before turning his adversaries into dolphins. It is no coincidence that this shape-shifting god, once theater was invented at Athens in the sixth century BC, became its tutelary deity and the patron of the acting profession.[63]

Dionysos wears patterned clothes made from textiles displaying complex combinations of colors, is attended by maenads in dappled fawnskins, and his ritual servants—masked actors—were themselves Protean shape-shifters, required to assume serial outward forms, identities, and voices during the plays performed in his worship. The music of the theatrical *aulos* is itself fluid and sinuous, with an inherent polytonality that incurred criticism and suspicion.[64] Following the example of the dramatists, at the height of the Athenian empire the composers of the Dionysiac genre of the dithyramb also began to include astrophic and irregular, polymorphic metrical schemes within their performances.[65]

One of the numerous types of song that appear in Old Comedy is the traditional drinking-song (the *skolion*, in the form *a a b c*). A *skolion* by Timokrates is parodied in our earliest extant comedy, Aristophanes' *Acharnians* (see 532), and another *skolion* appears in *Ekklesiazousai* (938–41). Of course, one place where Athenians had long encountered the juxtaposition, or at least serial performance, of different types of song had been a more ancient institution of which Dionysos was the presiding and attendant deity—the *symposion*. Variety (indeed, the Greek term *poikilia*) is one of three key terms of sympotic approba-

[62] Cf., among others, F. I. Zeitlin, "Staging Dionysus between Thebes and Athens," in T. H. Carpenter and C. A. Faraone (eds.), *Masks of Dionysus*, Ithaca, NY 1993, 152.

[63] See the remarks of C. Isler-Kerényi, *Dionysos in Archaic Greece: An Understanding through Images*, trans. W. G. E. Watson, Leiden 2007, 174–76, and E. Hall, *The Return of Ulysses: A Cultural History of Homer's* Odyssey, London 2008, ch. 3.

[64] P. Wilson, "The *Aulos* in Athens," in Goldhill and Osborne 1999 (see above, n. 5), 96–122.

[65] See Csapo, Chapter 3 here (see above, n. 5).

tion that a study has identified in Athenaios' *Deipnosophistai*; praise is bestowed for the display of *poikilia* both in foodstuffs and types of poetry and entertainment, both within quotations and within the "frame" narrative.[66]

The importance of poetry to the *symposion* had not been missed by the classical vase-painters, who included many images of singing.[67] It has been speculated that a prototypical form of acting out roles in a collective, celebratory ritual context was to be found in the sympotic songs composed by such poets as Alkaios.[68] By the sixth century, the musical entertainments on offer at *symposia* had changed, and were as likely to be performed by guests as by hired performers. New genres of poetry had arisen to be performed in these contexts: choral lyric narratives, monodic love songs, and elegiac poetry, as well as popular songs. As Rossi succinctly put it, "la storia della lirica è la storia del simposio."[69] By the later fifth to early fourth centuries, the entertainments on offer at *symposia* could also include iambic passages from drama, victory songs from the games, *aulos*-recitals, competitions in epideictic rhetoric, and sexy mythological mime (Xenophon *Symposion* 9.2–7).[70] The perceived affinity—what the critic Lucien Goldmann would have called a *homology*—between enjoying performances of *mousikê* in the presence of Dionysos at the *symposion* and in the theater is given its paramount expression, of course, in Plato's *Symposion*, where the host is the tragedian Agathon and the occasion for the party his victory in a dramatic competition at Athens.[71] *Symposia* celebrating theatrical victories must have had a very special status in fusing the two premiere civic haunts of the wine-giving god.

[66] See 1.35a, 3.107c, 4.132c, 4.139d, 5.187b, 15.665a and A. Lukinovich, "The Play of Reflections between Literary Form and the Sympotic Theme in the *Deipnosophistae* of Athenaeus," in O. Murray (ed.), *Sympotica: A Symposium on the* Symposion, Oxford 1990, 263–71.

[67] F. Lissarrague, *The Aesthetics of the Greek Banquet: Images of Wine and Ritual*, trans. A. Szegedy-Maszak, Princeton, NJ 1990, 124–39, and D. Yatromanolakis, *Sappho in the Making: The Early Reception*, Cambridge, MA 2007, ch. 2.

[68] E.g., G. Nagy, *Pindar's Homer*, Baltimore, MD 1990, 384–404.

[69] L. E. Rossi, "Il simposio Greco arcaico e classico come spettacolo a se stesso," in *Atti del VII Convegno di studio: Spettacoli conviviali dall'antichità classica alle corti italiane del '400*, Viterbo 1983, 49.

[70] See M. Vetta, "Introduzione: Poesia simposiale nella grecia arcaica e classica," in M. Vetta (ed.), *Poesia e simposio nella Grecia antica: Guida storica e critica*, Bari 1983, xxxi–xxxv; E. Pellizer, "Outlines of a Morphology of Sympotic Entertainment," in O. Murray (ed.), *Sympotica: A Symposium on the* Symposion, Oxford 1990, 177–84. On the complex nature and diverse ideologies of ancient Greek *symposia*, see D. Yatromanolakis, "*Symposia*, Noses, Πρόσωπα," in D. Yatromanolakis (ed.), *An Archaeology of Representations: Ancient Greek Vase-Painting and Contemporary Methodologies*, Athens 2009, 414–64.

[71] See M. D. Usher, "Satyr Play in Plato's *Symposium*," *American Journal of Philology* 123 (2002), 205–28.

There is no need to enter the almost completely undocumented area of the sixth-century origins of theater in Athens and make a speculative case for the important role played by the symposium in introducing men to the experience of the cumulative emotional and psychological effects of different kinds of musical and poetic performances in relatively concise chunks, although such a picture is indeed suggestive. It is much more important that the symposium in democratic Athens was by no means a preserve of the rich, aristocratic, and powerful elite but a social activity in which less distinguished citizens also participated. The formal *symposion* may have belonged primarily to the wealthier classes (perhaps suggested by *Peace* 839–41), but certainly not to those with antidemocratic persuasions alone (*Ath. Pol.* 34.3).[72] Although some scholars have argued that Philokleon's stance toward sympotic behavior suggests that it belongs to a world alien to him,[73] Angus Bowie points out that Bdelykleon behaves and speaks as though *symposia* are regular activities in that household (see 1252).[74] In any case, the widespread sympotic imagery in drama and on pottery suggests good understanding of its features among the citizen population, even if some were too poor or otherwise busy to spend a great deal of time at drinking parties.[75]

In a fascinating discussion of wine and drinking scenes in Old Comedy, moreover, Ewen Bowie stresses that the Athenian festivals for Dionysos at which drama was performed "were characterized themselves by both ceremonial and casual consumption of wine."[76] It was almost inevitable, therefore, that the two great forms of drinking party in the democratic period, which were also of course two Dionysiac institutional rituals—the public theatrical competitions and private *symposia*—mutually informed the evolution and aesthetic experience of one another. As Agathon the victorious tragedian says to Sokrates at the most famous symposium of them all, they can have a competition in wisdom, and, just as Dionysos presided over the drama competitions and was to preside over the competition between Aischylos and Euripides for the Chair of Tragedy

[72] A. M. Bowie, "Thinking with Drinking: Wine and the Symposium in Aristophanes," *Journal of Hellenic Studies* 117 (1997), 3.

[73] J. Vaio, "Aristophanes' Wasps: The Relevance of the Final Scenes," *Greek, Roman, and Byzantine Studies* 12 (1971), especially 337.

[74] Bowie 1997 (see above, n. 72), 3.

[75] Bowie 1997 (see above, n. 72), 2–3.

[76] E. Bowie, "Wine in Old Comedy," in O. Murray and M. Tecuşan (eds.), *In Vino Veritas*, Oxford 1995, 113. On the germination of civic commensality and drinking in archaic social formations, see P. Schmitt Pantel, *La cité au banquet: Histoire des repas publics dans les cités grecques*, Paris and Rome 1992, 107–13.

in Hades, at this sympotic *agôn* "Dionysos shall be our judge" (Plato *Symposion* 176a).

When the audiences gathered at the theater to enjoy variegated musical performances, they must therefore have felt as though they had been invited to a huge public party and could anticipate a program of entertainment that had structural affinities with the various forms of fun to be had at a *symposion*. The host was the city of Athens; Dionysos was president. But we need to think about the people who were on the list of invitees. At the smaller Lenaia, the Athenians explored their collective identity together, along with their metics, and without visitors from other ancient Greek states. At the Great Dionysia, when so many of our plays were first performed, the audience included visitors and guests from all over the Greek-speaking world where the Athenians had tributary states and allies.

The second "homology" that I would like to suggest is therefore geopolitical. It has to do with the macropolitical projection of Athenian identity rather than with Athenian social life. It is well known that part of the Athenians' own self-definition rested on their pride in openness to outside cultural influence and contacts. By the later part of the sixth century Hipparchos welcomed the foreigners Anakreon and Simonides to his court, while Thoukydides' Perikles, decades later, says to the bereaved families of Athens that their city is proud to throw itself open to the world and welcome outsiders (2.38.1). Social and cultural inclusiveness was therefore a central dimension of classical Athenian self-description and collective identity; so was innovativeness. The Athenians not only were involved in a period of intense novelty and creativity, but, as Armand D'Angour has rightly stressed, were well aware of it. They "might reasonably lay claim to having discovered innovation" since they wrote about innovation, and even produced the early known term for it, *kainotomia*, in Aristophanic comedy.[77]

It is possible to see the unprecedented metrical variety of Athenian drama, the generic inclusiveness of which had allowed it to absorb poetic forms associated with other ancient Greek *poleis*, as a formal manifestation of the ideological project of Panhellenism. Athens had no distinctive poetic genre of its own, despite the Peisistratean attempts to hegemonize Homeric epic. The Dorians were culturally identified with choral lyric, the Spartans with anapaestic

[77] A. D'Angour, "What's New? Some Answers from Greece," *OECD* Observer, September 14, 2000, summarizing the argument of A. D'Angour, *The Dynamics of Innovation: Newness and Novelty in the Athens of Aristophanes*, Ph.D. diss., London 1998.

marching songs, the eastern Aegeans with monody, and the Ionians had the strongest claim to dactylic hexameters and of course the *iambos*: in drama the Athenians elaborated inclusive new genres that embraced them all, as well as adding others of less specifically identifiable provenance, such as the trochaic, the dactylo-epitrite, and the dochmiac. A way of looking at theatrical versification could therefore be to see it as *aesthetically* "Panhellenizing" through form.

Yet whatever its archaic origins in joint festivals and cult centers, in the fifth century Panhellenism was not in any sense a neutral ideal. Along with its corollary, the idea of the collective barbarian enemy of the Greeks, it was a crucial element of the Athenian ideology that underpinned the Delian league and subsequently the Athenian empire. It "served as a tool of propaganda for the hegemonial or imperial rule of a *polis*; it served to justify the hegemony and mastery of one *polis* over other states by proposing a common aim, war against the barbarians."[78] The *polis* in question, from the moment of the destruction of Naxos in 468 BC, was of course Athens, a position consolidated when the Delian league's treasury was moved there in the next decade (Thoukydides 1.98). The officials appointed to collect tribute from the league were called the *Hellênotamiai*, the "treasurers of the *Greeks*" (Thoukydides 1.96).[79]

In this political context, the variegated form of classical Athenian drama can be seen from an ideological perspective as Panhellenism, and therefore Athenian imperialism, performed on the level of genre.[80] Indeed, it would be surprising if there were no perceptible sign of a "homology" between the Athenian idea of projecting the city as the leader of a Panhellenic community, and the cultural formations that the society effecting that project produced and maintained. The genres that the sponge-like media of Athenian tragedy and comedy took over were drawn from other parts of the Greek-speaking world, before being treated with considerable metrical assurance and often with cavalier *license*.[81] These self-confident acts of aesthetic and cultural appropriation and makeover of form were wholly consonant with the economic, political, and military activities on which the basis of the Athenian empire was founded.

Moreover, there are several examples of included song-types that raise the question whether the dramatists could use metrical means to make explicit

[78] S. Perlman, "Panhellenism, the *Polis*, and Imperialism," *Historia* 25 (1976), 5; see also E. Hall, *Inventing the Barbarian: Greek Self-Definition through Tragedy*, Oxford 1989, 17.

[79] Hall 1989 (see above, n. 78), 59–60, 162–65.

[80] A suggestion I made briefly in Hall 1999 (see above, n. 5), 122.

[81] Parker 1997 (see above, n. 51), 328.

comments on the Athenians' relationships with other communities, in a dazzling form of musical geopolitics. In tragedy, an outstanding example is the inclusion of the heroine's elegiacs in Euripides' *Andromache* (103–116). Long ago Denys Page implicitly argued that in this play, choice of metrical form and sung performance were inextricably bound up with Athenian politics and its imperial program. He suggests that *Andromache* was first produced at Argos at a time when Athens was seeking to secure Argive support against Sparta. He points out that there was a tradition of "Doric threnodic elegy" at Argos, of which the Argive poet Sakadas was the chief representative poet, and that this play was not first produced at Athens (so a scholion on line 445). The inference Page draws is therefore that the elegies sung by Andromache strongly suggest an Argive first production and constitute a sung compliment, by inclusion of a genre unusual in tragedy, to the Argive poetical tradition.[82]

In comedy, a good example is offered by the inclusion of specifically Spartan lyric material in *Lysistrate*. When the herald arrives from Sparta at 980, he launches the concluding sequence in which the two semichoruses are reconciled (1014–42), and act together in the scenes of international peace-making (1076–1188). But for the end of the play, Aristophanes introduces two "Spartan" monodic hymns, with an Athenian one in between. Despite the consistent attempts by scribes to "correct" non-Attic spellings and dialect forms, there are still signs of specifically Spartan diction.[83] Parker has pointed out that the first "Spartan" song (1247–72), which is predominantly trochaic, uses together dactylic, trochaic, aeolo-choriambic, and lecythia—a combination that also occurs in the so-called Louvre Partheneion of Alkman (fr. 1 *PMG*), our only author of surviving Spartan lyric poetry. There are also sequences of three or more longs in the comic monody. These contrast strongly with the high proportion of short syllables in the intervening Athenian song (1279–94), which suggests a much lighter, faster rhythm.[84]

The second "Spartan" song (1296–1321) is basically iambic rather than trochaic, but there are, again, more long syllables, and one sequence praising Artemis (1311–14) is in purely spondaic anapaests. Its content is very obviously connected with Sparta, "invoking a Spartan muse, evoking a Spartan locale (the

[82] D. L. Page, "The Elegiacs in Euripides' *Andromache*," in *Greek Poetry and Life: Essays Presented to Gilbert Murray on his Seventieth Birthday*, Oxford 1936, 223–28.

[83] See J. Henderson, *Aristophanes: Lysistrata*, edited with Introduction and Commentary, Oxford 1987, 212, note on *Lys*. 1252–53.

[84] Parker 1997 (see above, n. 51), 387, 390.

banks of the Eurotas), and listing . . . only Spartan deities: Apollo at Amyklai, Athena Chalkioikos, the Tyndaridai, Helen."[85] The matter is confused by the apparent instruction at the end of the *first* song to the chorus telling them to leave singing a song specifically to Athena Chalkioikos (1316–21), the cult title of an identifiably Spartan version of the goddess broadly equivalent to the Athenian Athena Polias. No such hymn follows in the manuscripts, but Henderson explains the apparent anomaly by saying that exit-hymns, which were traditional, were not composed by Aristophanes and therefore did not need to be preserved.[86] Yet in terms of my argument it scarcely matters whether the hymn has dropped out of the manuscript *paradosis* or was omitted because scribes saw it as un-Aristophanic, traditional and familiar. The point is, rather, that the performance seems to have included a hymn that celebrated the goddess closest to the Athenians' heart in the cult form she took in the center of the city of their historic foe.

The conscious contrast between the handling of the rhythms in the Spartan and Athenian mouths must have connoted more, in 411 BC, than mere ethnic characterization. It raises the question whether the Athenian comic poet is expropriating, welcoming, complimenting, or deriding the ancient Lacedaemonian rhythms of his countrymen's longstanding enemy. Wilamowitz was rightly struck by the inclusion of these examples of Spartan poetry, to which it is indeed plausible to see the Athenians as having had little recent exposure. But he felt that Aristophanes was soliciting a response of condescension from his audience by comparing what he felt was an uncultivated Spartan idiom and the more sophisticated Athenian monody.[87] Parker says that there "is little point in speculating on how far the songs are pastiche or parody, or on how the audience was intended to react," but at the same time suggests that the foregoing choral songs may offer "beneath the humor a sour hint that the revelry of comedy is illusory."[88]

Lysistrate was performed in 411 BC but we are not in a position to be certain at which festival of Dionysos. In the spring of 411, Athenians with oligarchic

[85] Henderson 1987 (see above, n. 83), 218.

[86] Henderson 1987 (see above, n. 83), 214.

[87] U. von Wilamowitz-Moellendorff, *Die Textgeschichte der griechischen Lyriker*, Berlin 1900, 94. His analysis of this Spartan song has been criticized in a detailed study by F. Perusino, "La seconda canzone nella *Lisistrata* di Aristofane (vv. 1296–1321)," in B. Gentili and F. Perusino (eds.), *La colometria antica dei testi poetici greci*, Pisa 1999, 207–12, who point outs that examples in the other plays of Aristophanes show that the Athenians were rather more familiar with, and able to appreciate, Spartan verse forms than Wilamowitz-Moellendorff suggested.

[88] Parker 1997 (see above, n. 51), 386, 382.

aspirations had already begun to silence the democratic opposition and to embark on a campaign of terror (Thoukydides 8.66). But we do not know for certain whether or not any Spartans attended the City Dionysia in 411 BC (even though it seems unlikely). If, however, the play was performed at the Lenaia, which was closed to outside visitors, we might expect that the Spartan songs were received rather differently.

Ancient Greek drama is far from the only theatrical tradition that we know, in its early stages, displayed a considerable variety of comparatively undigested meters and performance styles, reflecting a rich and diverse cultural experience of poetry and song. "In the matter of meter, the most striking feature common to English religious plays is the great variety exhibited by them," explains an influential early twentieth-century encyclopedia article on the subject of the Medieval Mystery plays.[89] The metrical variety in that tradition is thrown into relief by comparing it with the consistency to which the octosyllabic couplet (occasionally with a triolet interspersed) is adhered in the Miracle and Mystery-Plays written in French,[90] and indeed with the almost complete monopoly that blank verse was subsequently to gain in the field of English-language verse drama. Yet, over time, the diversity in the early English plays began to give way to what seems to have been an "internal logic," intuitively driving the genre toward greater uniformity. There is very marked diversity of versification in the early York Plays and in the Chester Plays, a phenomenon that speaks for their "early origin."[91]

These religious plays exhibit what has been called "a combined looseness and ingenuity of metrification," which was consonant with "the freedom of treatment which, notwithstanding the nature of its main source, and what may be termed the single-mindedness of its purpose, was characteristic of the English mystery- and miracle-drama."[92] These words are, to be sure, powerfully suggestive for the relationship between the "source" of ancient Greek tragedies (largely archaic poetry), the purposes to which that source material was being put in the fifth century in the new environment of the Athenian imperial democracy, and "the freedom of treatment" to which the great dramatists subjected their subject matter. The new medium of drama was required by the new social and

[89] A. W. Ward, "Variety in Dialect and Metre in the English Mysteries and Miracle-plays," "The Origins of English Drama," part I.1 sec. 13, in *The Cambridge History of English and American Literature*, vol. 5, Cambridge and New York 1907–1921, 21.

[90] G. Saintsbury, *A History of English Prosody*, 2nd ed., London 1923, vol. 1, 203–5.

[91] Ward 1907–1921 (see above, n. 89), 21.

[92] Ward 1907–1921 (see above, n. 89), 21.

political formations, and to appreciate the metrical diversity of the individual dramas to feel that new rhythmical pulse beating—is to begin to appreciate what Raymond Williams meant by a culture's "structure of feeling."

Metrical diversity within the same ancient Greek theatrical performance does not seem to have survived the cultural transformations of the fourth century much better than the original metrical diversity of the Mystery Plays survived the drive to uniformity at the end of the fifteenth century. When Aristotle created a novel theory of tragedy consonant with its new, international status in the second half of the fourth century, when it became divorced not only from Athens but from the ritual context of the Athenian festivals of Dionysos, he simultaneously ignored its political dimension and relegated "song-writing" to second-to-last place, ahead only of spectacle, in the list of the constituents of the genre (*Poetics* 6.1450b15–16).[93] The forms of Greek drama that survived as part of the cultural *koinê* of the Hellenistic age lost much of their metrical *poikilia*. In the case of tragedy, the lyric sections disappeared (see Dion Chrysostomos *Or.* 19.5) as the monodies became detached, to be sung separately in recitals by traveling star *tragôidoi*;[94] correspondingly, the polymetric flamboyance of Aristophanes and his rivals was replaced by the nearly homogeneous sub-tragic iambic dialogue of Menander and his contemporaries. The metrical, poetic, and musical *poikilia* of ancient Greek drama, which drew on genres from the entire Greek-speaking world, emerged and flourished at a very particular sociopolitical moment in the inclusive, open, but profoundly centripetal culture of the Athenian performance context. "A new artistic form, taken in a large historic way, is born in reply to new needs."[95]

[93] See E. Hall, "Is There a *Polis* in Aristotle's Poetics?," in M. Silk (ed.), *Tragedy and the Tragic: Greek Theatre and Beyond*, Oxford 1996, 295–309.

[94] See Hall 2002 (above, n. 8), 12–24.

[95] Trotsky 1991 [1925] (above, n. 48), 195. I would like to record my thanks to Armand D'Angour and Eric Csapo for many helpful comments. This chapter has also benefited from several responses when it was orally delivered, once at a conference in honor of Oliver Taplin held at Oxford in September 2008, and once at the conference "Moisa Epichorios: regional music and musical regions" held in Ravenna, October 1–3, 2009. I have particularly benefited from suggestions made on those occasions by Andrew Barker, Ewen Bowie, François Lissarrague, and Marcus Mota. I am very grateful to Dimitrios Yatromanolakis for offering me the opportunity to participate in this fascinating book.

Chapter Two

Aristophanes and the "New Music"

Acharnians, Knights, Clouds, Birds, Thesmophoriazousai, Frogs

Egert Pöhlmann

1. Old Music and New Music

MUSIC AND POETRY MAINTAIN an important place in Plato's political thought.[1] In the third book of the *Republic*, their adequacy for education is called into question, with the result that the mimetic arts (μιμητικαὶ τέχναι) are excluded from the education of the guardians of the ideal state. On this occasion, Plato discusses the expressive power (ἦθος) of different keys and rhythms (396c–400d). Because of the deep impact of music on the human soul, musical innovations are considered dangerous for morals and the individual, as well as for the laws and the political order of society as a whole. Therefore, every innovation in music was to be avoided (423d: τὸ μὴ νεωτερίζειν). This was the view of Damon of Oa[2]—personal advisor of Perikles—who is quoted in the

[1] For metrical terms and symbols used in this chapter, see section 10. The following abbreviations are frequently employed: *TrGF* (= B. Snell, R. Kannicht and S. Radt, *Tragicorum Graecorum Fragmenta*, 5 vols. [vol. 1, 2nd ed. 1986], Göttingen 1971–2004); Kassel-Austin (= R. Kassel and C. Austin, *Poetae Comici Graeci*, 8 vols., Berlin 1983–); *DAGM* (= E. Pöhlmann and M. L. West, *Documents of Ancient Greek Music: The Extant Melodies and Fragments*, edited and transcribed with commentary, Oxford 2001); *LIMC* (= *Lexicon Iconographicum Mythologiae Classicae*, Zurich 1981–2009); Maehler (= H. Maehler, *Pindari Carmina. Pars II: Fragmenta*, Leipzig 1989). Thanks are owed to copyeditor Martha Ramsey for correcting the English in this chapter.
[2] U. von Wilamowitz-Moellendorff, *Griechische Verskunst*, Berlin 1921, 58–66, for Damon's rhythmics and fragments; F. Lasserre, *Plutarque: De la musique. Texte traduction, commentaire précédés d'une étude sur l'éducation musicale dans la Grèce antique*, Olten/Lausanne 1954, 53–73 and 74–87, for Damon's theories and fragments. See R. W. Wallace, "Performing Damon's *harmoníai*,"

Republic 4.424c: οὐδαμοῦ γὰρ κινοῦνται μουσικῆς τρόποι ἄνευ πολιτικῶν νόμων τῶν μεγίστων, ὥς φησί τε Δάμων καὶ ἐγὼ πείθομαι ("styles of music are nowhere altered without change in the greatest laws of the city; so Damon says and I concur").[3] This argument is explained in the *Republic* in detail (424d–425b). In the tenth book, relevant discussion is instigated again alongside the theory of ideas, which had been developed earlier in the work.

In the *Laws*, Plato repeats Damon's view, providing an outline of the decay of poetry and music (3.700a–701b). In aristocratic times, there were specific genres of poetry and music, each connected with appropriate keys, rhythms, and instruments. Later, in democratic times, the poets began to mix up genres and musical elements, with the aim of pleasing the audiences in theaters. The result of this revolution is discussed in more detail in the second book of the *Laws* (669a–670a): men's words were performed with effeminate expression and melody, and melodies and movements of freeborn men were coupled with rhythms more appropriate for slaves. Moreover, the poets emphasized less the unity of word, melody, and rhythm, promoting instead unaccompanied instrumental music. Plato aims to save the poetry and music of old times through an appropriate educational program (2.670a–673b), though nevertheless allowing for musical virtuosity: he notes that there shall be separate contests and judges for the genre of choral lyric (which is not mimetic), on the one hand, and for the genres of monody, rhapsody, kitharody, and solo *aulos*-playing (which are mimetic and performed by *virtuosi*), on the other (6.764b–765a).

Plato's hostility toward the so-called "New Music" was shared by Aristoxenos, who also believed in a gradual decline of music caused by the contemporary musicians of the late fifth century BC. Following mainly Aristoxenos,[4] Pseudo-Plutarch's *On Music* praises the noble simplicity of "Old Music" from Homer to Lasos of Hermione, which was followed by gradual decay, culminating in the alleged monstrosities of "New Music" at the end of the fifth century BC. The following examples, as outlined in Pseudo-Plutarch's *On Music*, are exclusively related to composers of dithyrambs and kitharodic *nomoi*.

in S. Hagel and C. Harrauer (eds.), *Ancient Greek Music in Performance*, Vienna 2005, 147–56; A. Barker, *Psicomusicologia nella Grecia antica*, Naples 2005, 57–74 ("Damone e i sofisti").

[3] Translation A. Barker, *Greek Musical Writings. Vol. 1: The Musician and his Art*, Cambridge 1984. Plato also mentions Damon in *Laches* 180c–d, 197d, 200a–b, and in *Republic* 3.400b–c.

[4] See A. Meriani, *Sulla musica greca antica*, Naples 2003, 15–48 ("Festa, musica, identità culturale: Il caso di Poseidonia [Aristox. fr.124 Wehrli]"), and 49–81 ("Tracce aristosseniche nel *de musica* Pseudoplutarcheo").

Lasos of Hermione (born ca. 548–545 BC),[5] who introduced the dithyramb into the musical contests in Athens during the time of Hippias, the son of Peisistratos, was renowned as a composer of dithyrambs. The treatise *On Music* (29.41c) attributes both rhythmical and melodic innovations to Lasos. He is said to have changed the rhythms for the movement of the dithyramb. Moreover, he transferred the multiplicity of the sounds of *auloi* to the *kithara*, innovating the character of the music of his time.

Pseudo-Plutarch's *On Music*, which also refers to Krexos, Timotheos, and Philoxenos (12.35d), adds Melanippides to the catalogue of contemporary poets/musicians (30.41c), as well as Kinesias and Phrynis (see the fragment from the comedy *Cheiron* by Pherekrates that is quoted in the treatise *On Music* 30.41d–42a = Pherekrates fr. 155 Kassel-Austin). What follows is a concise introduction to each of those musicians.

Aristoxenos accuses Melanippides of Melos (ca. 450–400 BC) of having increased the number of strings of the seven-stringed lyre of Terpandros (*On Music* 30.41c). We know three titles of his dithyrambs (*Danaides, Marsyas,* and *Persephone*); some other fragments from Melanippides' work have also been preserved.[6] According to Aristotle, Melanippides used free rhythmic compositions in his dithyrambs instead of the strophic form.[7]

Philoxenos of Kythera (435/434–380/379 BC) was a pupil of Melanippides. We know two titles of his dithyrambs (*Kyklops, Mysoi*); some other fragments have also been preserved,[8] in addition to the parody of the *Kyklops* in Aristophanes' comedy *Ploutos* (290–321). Aristophanes (fr. 953 Kassel-Austin = *On Music* 30.42a) condemns Philoxenos for having introduced monodies into the dithyramb. Pseudo-Plutarch's *On Music* also mentions that Philoxenos used the Hypodorian scale at the beginning of his *Mysoi*, while in the middle of this dithyramb he used the Hypophrygian and Phrygian scales, and in the "final section" (ἔκβασις) the Mixolydian and Dorian scales (33.42f.): an apt example of melodic variety (ποικιλία), rather than the noble simplicity of old music.

Krexos is mentioned in the treatise *On Music* as a modernist, along with Philoxenos and Timotheos (12.35d). The transfer of παρακαταλογή (alternating spoken and sung trimeters with continuous accompaniment) from tragedy to the genre of dithyramb is attributed to him (28.41b).[9]

[5] G. A. Privitera, *Laso di Ermione nella cultura ateniese e nella tradizione storiografica*, Rome 1965.
[6] D. F. Sutton, *Dithyrambographi Graeci*, Hildesheim, Munich and Zurich 1989.
[7] Aristotle *Rhetoric* 3.9.1409b 24–29: ποιήσαντα ἀντὶ τῶν ἀντιστρόφων ἀναβολάς.
[8] Sutton 1989 (see above, n. 6), no. 34.
[9] Sutton 1989 (see above, n. 6), no. 32.

Kinesias of Athens,[10] the scapegoat of comedy, was a contemporary of Philoxenos, and mentioned mostly because of his problems with digestion and his emaciated body.[11] In Aristophanes' *Birds* (414 BC), we see him fluttering in the air, where he hopes to find new airy and snowy melodies in free rhythm.[12] It seems that Kinesias introduced astrophic melodies into the genre of dithyramb, following the example of Melanippides.

Melanippides, Philoxenos, Krexos, and Kinesias were known as composers of dithyrambs, whereas Phrynis of Mytilene and Timotheos of Miletos composed mainly kitharodic *nomoi*. Phrynis is said to have combined the traditional hexameter of the kitharodic *nomos* with free lyric meters;[13] to have embellished the melodies with καμπαί ("twistings");[14] and to have replaced the enharmonic with the chromatic genus in the dithyrambs.[15]

Timotheos (ca. 450–360 BC), a pupil of Phrynis, was, like his teacher, famous as a composer of kitharodic *nomoi*. He is also said to have composed eighteen dithyrambs and twenty-one hymns, of which titles and fragments have been preserved.[16] We also have the second half of the kitharodic *nomos Persians* preserved on a papyrus of the late fourth century BC—a work that provides a better understanding of the structure of the genre of *nomos*, as well as of the rhythmic peculiarities of Timotheos.[17]

The representatives of "New Music," from Melanippides to Timotheos, were contemporaries of Kratinos, Eupolis, and Aristophanes. It might be expected that the comic *fragments* reflect the overall current views about these contemporaries. An unpublished study by Andrew Barker demonstrates that music—in all of its aspects—was a rewarding subject for comedy.[18] There are twenty examples related to "music at *symposia*" and sixteen examples referring

[10] Sutton 1989 (see above, n. 6), no. 22.

[11] Aristophanes *Clouds* 333 with schol., *Lysistrate* 838–60, *Frogs* 153, 366f., 1437, *Ekklesiazousai* 330; Aristophanes fr. 156 Kassel-Austin, Plato Comicus fr. 200 Kassel-Austin, Strattis *Kinesias* fr. 14–22 Kassel-Austin.

[12] Aristophanes *Birds* 1385: καινὰς λαβεῖν / ἀεροδονήτους καὶ νιφοβόλους ἀναβολάς.

[13] Proklos *Chrestomatheia* 320b9: τὸ ἐξάμετρον τῷ λελυμένῳ συνῆψε.

[14] Aristophanes *Clouds* 968–69: ἣ κάμψειέν τινα καμπὴν/οἵας οἱ νῦν τὰς κατὰ Φρῦνιν ταύτας τὰς δυσκολοκάμπτους.

[15] Scholion on Aristophanes *Clouds* 971: πρῶτος τὴν ἁρμονίαν ἔκλασεν ἐπὶ τὸ μαλακώτερον.

[16] Sutton 1989 (see above, n. 6).

[17] U. von Wilamowitz-Moellendorff, *Timotheos: Die Perser*, Leipzig 1903.

[18] "Music in the Fragments of Ancient Greek Comedy," paper read on July 7, 2006 at the Seminar on Ancient Greek Music, Ionian University, Kerkyra [Corfu] July 1–7, 2006. I am most grateful to Andrew Barker for allowing me to consult his valuable work.

to musical instruments. New Comedy introduced a new topic, "music and cooking," which is represented by seven examples. However, the problems of "New Music" were deemed less spectacular. Not every musician was as notorious as poor Kinesias (see above). An elder colleague of Kinesias was the kitharode and chorus-trainer Gnesippos, who is mentioned by Chionides (*Beggars*, fr. 4 Kassel-Austin) for his nine-stringed lyre. Kratinos slandered him for being unable to train a chorus (*Herdsmen* fr. 17 Kassel-Austin; *Seasons* fr. 276 Kassel-Austin). But Gnesippos was quite popular: Eupolis reports that his erotic ditties ousted the old-fashioned songs of Stesichoros, Alkman, and Simonides (*Helots* fr. 148 Kassel-Austin) from the *symposia*.[19] Finally, other remarks on music in comedy are less informative.[20]

It is important to note that the subject of Old and New Music in the *symposion* recurs in Eupolis (unknown title, fr. 326 Kassel-Austin), where a musician asks the guests if they want to hear a modern song or an old-fashioned one (ἄγε δή, πότερα βούλεσθε τὴν νῦν διάθεσιν/ᾠδῆς ἀκούειν ἢ τὸν ἀρχαῖον τρόπον). He is eventually instructed to play an example of each. But in Middle Comedy, the case is different, as we see in Antiphanes (*Diplasioi* fr. 85 Kassel-Austin): at the beginning of a *symposion* the Paian or outmoded *skolia* such as *Telamon* or *Harmodios*[21] are out of the question (ἔπειτα μηδὲν τῶν ἀπηρχαιωμένων/τούτων περάνῃς, τὸν Τελαμῶνα, μηδὲ τὸν/Παιῶνα, μηδ᾽ Ἁρμόδιον). In *The Third Actor*, Antiphanes (fr. 207.6 Kassel-Austin) considers Philoxenos to be already a classical author (εἰδὼς τὴν ἀληθῶς μουσικήν), comparing his style and his music with the mannerisms of the contemporary composers (fr. 207.7: οἱ νῦν δὲ κισσόπλεκτα καὶ κρηναῖα καὶ/ἀνθεσιπότατα μέλεα μελέοις ὀνόμασι/ποιοῦσιν ἐμπλέκοντες ἀλλότρια μέλη). Furthermore, in *Hyakinthos*, Anaxilas (fr. 27 Kassel-Austin) resigns himself to a music that, like Libya, "gives birth to" a new creature each year (ἡ μουσικὴ δ᾽ ὥσπερ Λιβύη, πρὸς τῶν θεῶν,/ἀεί τι καινὸν κατ᾽ ἐνιαυτὸν θηρίον/τίκτει).[22]

Fragments from Pherekrates' famous comedy *Cheiron* are also important to consider (frs. 155–62 Kassel-Austin). The play was staged between 437 and 410

[19] On Gnesippos, see D. Yatromanolakis, *Sappho in the Making: The Early Reception*, Cambridge, MA 2007, 229–31 and 288–89.

[20] Aristophanes fr. 596 Kassel-Austin (on Kephisophon), fr. 682 Kassel-Austin (on Euripides), fr. 692 Kassel-Austin (on Eudoxos), Phrynichos fr. 74 Kassel-Austin (on Lampros), Pherekrates fr. 6 Kassel-Austin (on Meles and Chairis). For Aristophanes fr. 953 Kassel-Austin (on Philoxenos), see discussion above.

[21] On *skolia*, see R. Reitzenstein, *Epigramm und Skolion*, Giessen 1893, and D. Yatromanolakis, "Ancient Greek Popular Song," in F. Budelmann (ed.), *The Cambridge Companion to Greek Lyric*, Cambridge 2009, 263–76.

[22] See discussion in Yatromanolakis 2007 (above, n. 19), 237–38.

BC. The title seems to refer to the wise centaur Cheiron, who in the play was evidently the arbiter in a quarrel between personified Music and her torturers, namely, Melanippides, Kinesias, Phrynis, and Timotheos. Pseudo-Plutarch's *On Music* preserves twenty-eight lines referring to the trial of Music before the personification of Justice (30.41d–42a = Pherekrates fr.155 Kassel-Austin).

The offenses of the modern composers against personified Music—as described in Pherekrates' *Cheiron*—have already been thoroughly examined.[23] They are evidently connected with well-known facts in the history of ancient Greek music. On the other hand, they are equivocal, as a rule, since Old Comedy was characterized by the tendency to describe alleged flaws as a kind of sexual trespassing.

In Pherekrates' *Cheiron*, the first of the modernists, Melanippides, is described as having taken hold of Music, pulled her down to the ground, and "slackened" her (fr. 155.5: χαλαρωτέραν τ᾽ ἐποίησε) with his "twelve strings." The musical sense of Melanippides' "violations" seems to be that he introduced scales, which Plato (*Republic* 3.398e) denounced as soft and slackening, namely the "ἰαστί" and the "χαλαρὰ λυδιστί."

Allusions to obscene jokes lie behind the reference to "twelve strings," which are repeated for Phrynis (16, "five strings") and Timotheos (25, "twelve strings"). The first of these allusions—the number twelve—refers to the "duodecim figurae veneris."[24] A second obscene allusion is based on a pun on the sexual meaning of the word χορδή, which can denote "string," "sausage," and "phallus," at the same time.[25]

The second tormentor of Music is Kinesias, who is accused, with no obvious sexual undertones, of applying to the strophes modulations that abandon the original key of a dithyrambic composition (*Cheiron* fr. 155.9: ἐξαρμονίους καμπὰς ποιῶν ἐν ταῖς στροφαῖς), with the result of destroying the structure of the dithyramb.

The third tormentor of Music is Phrynis, who invented a special revolving tuning peg (*Cheiron* fr. 155.14: στρόβιλος), by means of which he was able to

[23] I. Düring, "Studies in Musical Terminology in Fifth-Century Literature," *Eranos* 43 (1945), 176–97; E. K. Borthwick, "Notes on Plutarch *De Musica* and the *Cheiron* of Pherecrates," *Hermes* 96 (1968), 60–73; D. Restani, "Il *Chirone* di Ferecrate e la 'nuova musica greca,'" *Rivista Italiana di Musicologia* 18 (1983), 139–92; W. D. Anderson, *Music and Musicians in Ancient Greece*, Ithaca, NY 1994, 127–34; M. de Simone, "Nota a Pherecr. (fr. 155, 25 K.A)," in S. M. Medaglia (ed.), *Miscellanea in ricordo di Angelo Raffaele Sodano*, Naples 2004, 119–37.

[24] See K. J. Dover, *Aristophanes: Frogs*, Oxford 1993, 357 (on lines 1327f.).

[25] See Dover 1993 (see above, n. 24), 237 (on lines 338f.).

play twelve harmonies (i.e., positions of sexual intercourse) on *only* five strings (i.e., phalluses). The catchword for musical "modulations" reappears here (fr. 155.15: κάμπτων).

The last tormentor of music, Timotheos, is accused of having introduced manifold melismatic figures, which are described with diverse images. One of them (*Cheiron* fr. 155.23: ἐκτραπέλους μυρμηκιάς, "perverted ant-crawlings") reappears in Aristophanes' *Thesmophoriazousai* 100, where the *solfèges* of Agathon are referred to as μύρμηκος ἀτραπούς (see discussion below). The catchwords for musical "modulations" used for Kinesias (*Cheiron* fr. 155.26, ἐξαρμονίους, 28 καμπῶν) reappear. Each time Timotheos would meet Music alone, he would rape her (25, ἀπέλυσε κἀνέλυσε) with the help of his "twelve strings." As Mariella de Simone has observed, the musical meaning of this description is the introduction of microtones; ἀπολύω leads to the ἀπολελυμένα, lyric pieces without strophic structure.[26]

2. Aristophanes

Like his contemporary Pherekrates, Aristophanes (445–386 BC) concerned himself with the "New Dithyramb," a genre that inspired him with an abundance of witty parodies of modern composers, thus revealing intimate knowledge of the new style. However, his main targets were the (plots of the) tragedies of Euripides, of which Aristophanes mentions forty-six titles in his eleven surviving comedies.[27] At the beginning of his career, in *Banqueters* (Δαιταλῆς, 427 BC), Aristophanes mocked not the music of Euripides but the plots and characters of his tragedies. This was keeping with the overall contemporary view, which was hostile toward the new trends in the thematic content of Euripides' tragedies. Of course, Aristophanes had noticed that elements of "New Music" encroached on the monodies of tragedy as early as Euripides' *Hekabe* (425 BC). But it was not until the *Thesmophoriazousai* (411 BC) that Euripides' music itself became the target of Aristophanes' comedies. The attitude of Aristophanes toward "New Music" and tragedy is complex and somewhat ambiguous, as I shall argue in this chapter.

[26] De Simone 2004 (see above, n. 23), 127–32.
[27] W. Schmid and O. Stählin, *Geschichte der Griechischen Literatur*, vol. 4, Munich 1946, 178.

3. *Aristophanes'* Acharnians

At the beginning of the *Acharnians* (425 BC), the peasant Dikaiopolis sings an iambic monody[28] in honor of Phales (263–79), which is clearly divided by meter and content into three sections. In lines 263–70, an invocation to Phales is framed by iambic dimeters and completed with a pun (μαχῶν . . . Λαμάχων). Lines 271–76 are divided into three iambic trimeters and an iambic tetrameter, framed by an iambic monometer, which describes the joyful raping of a Thracian girl slave. Lines 277–79 consist of three iambic trimeters, which summon Phales to a drinking party. It is important to observe that this *astrophic* song is the first example in Aristophanes of a pattern that will recur in *Birds* and *Thesmophoriazousai*. Moreover, the Phales hymn is free of references to "New Music." Later in the play, Aristophanes makes fun of Euripides' *Telephos* (438 BC): the peasant Dikaiopolis pays a visit to Euripides (395–479) in order to obtain the outfit of Telephos (mythical king of Mysia) which includes a ragged coat, a poor cap, a beggar's walking stick, a damaged mug, and a little bottle plugged with a sponge (for cleaning a festering wound). In this disguise, the tragic Telephos of Euripides intrudes into the assembly of the Achaeans in Argos, forcing Achilles to cure his wound by taking little Orestes as hostage. Aristophanes had already alluded to the Telephos theme through an absurd hostage scene (*Acharnians* 326–35), in which Dikaiopolis takes a basket of charcoals as hostage in order to impress the charcoal-burners from Acharnai. After Dikaiopolis' visit to Euripides (*Acharnians* 395–479), Aristophanes "wheels" Euripides, along with all his props, off the stage on the *ekkyklêma* (408: ἐκκυκλήθητ'/479: κλῇε πηκτὰ δωμάτων). The Telephos scene in *Acharnians* ridicules the unworthy appearance of a king in the shabby outfit of a beggar. Obviously, King Telephos was the most shocking of the new characters Euripides brought on stage in his plays. As we shall see, in *Thesmophoriazousai*, Aristophanes repeats the hostage scene and introduces the *ekkyklêma*-scene in the well-known monody of the tragic poet Agathon.

4. Knights

At the beginning of *Knights* (424 BC), Aristophanes invents an oracle according to which Kleon will be superseded as supreme commander by a sausage-seller, Agorakritos. Kleon's main qualifications for politics are his almost complete lack

[28] L. P. E. Parker, *The Songs of Aristophanes*, Oxford 1997, 126–29.

of musical education (121–210, 1232–52). Kleon himself had learned to play on the lyre nothing except for the Dorian tune (985–96), which Aristophanes uses as a gross pun on Kleon's corruptibility: instead of playing in the Dorian tune (δωριστί), Kleon is skilled at taking bribes (δωροδοκιστί). It should be observed that the plot of this play does not have much room for poetry and music. In any case, Aristophanes manages to mention the famous funeral tune of the *aulos*-player Olympos, which is imitated by Nikias and Demosthenes, two colleagues of Kleon, who appear in the comedy as slaves (8–10). Similarly, in this play Aristophanes exploits lines of Aischylos (835 = *Prometheus Bound* 613f.) and of Pindar (1264f. = fr. 89 Maehler) and mentions Polymnestos as an example of erotic lasciviousness in the kitharodic *nomos* (1287). In the end, the oracle is fulfilled: Kleon, uttering numerous quotations from tragedies by Euripides,[29] must give way to the sausage-seller, and Agorakritos welcomes the rejuvenated Demos with a quotation from a dithyramb by Pindar focusing on Athens (1329 = fr. 76 Maehler).

5. Clouds

Aristophanes' *Clouds*, performed in 423 BC, was awarded only the third prize. Kratinos won the first prize and Ameipsias the second. The transmitted text is an unfinished revision from 421–417 BC, which was never performed.[30] Hypothesis I (VI) claims that the *parabasis* (518–562), the contest of Right and Wrong (889–1104), and the end of the comedy, where the house of Sokrates is burned down (1321–1511), are new. Yet, the new idea of comedy that Aristophanes attempted to explore in this play of 423 BC is still evident in the revised *parabasis*: he renounces popular jokes about the male genitals (538f.) or about men who are bald (540); he renounces the *kordax*—an obscene dance—(540), the vulgar slapstick of old men beating passengers (541f.), and the "ἰοὺ ἰού" cries and actors rushing to the stage with torches (543). Some of these promises are abandoned later in *Clouds*, perhaps as a consequence of the revision (see 734, 1321, 1478–1511). Instead of all these popular techniques, Aristophanes promotes *Clouds* as a comedy for the upper ten thousand (520–27, 535, 575), which, by renouncing the repetition of worn-out plots, is distinguished by the novelty of witty inventions (544–48, 561f.).

[29] Lines 1203–4: unknown tragedy; line 1237: unknown tragedy; line 1240: Euripides *Telephos* fr. 700 *TrGF*; lines 1243–44: cf. Euripides *Helen* 1194, *Orestes* 68; lines 1248–49: Euripides *Bellerophon* fr. 311 *TrGF*; lines 1250–52: Euripides *Alkestis* 177, 181–82.

[30] K. J. Dover, *Aristophanes: Clouds*, Oxford 1968, LXXX–XCVIII.

The subject of "New Music" appears early in the play: according to Sokrates, the Clouds nourish the composers of dithyrambs because of the poems the latter compose about the former. The composers of dithyrambs are introduced with the usual catchword ἀσματοκάμπται ("twisters of melodies"):

κυκλίων τε χορῶν ἀσματοκάμπτας ἄνδρας μετεωροφένακας,
οὐδὲν δρῶντας βόσκουσ᾽ ἀργούς, ὅτι ταύτας μουσοποιοῦσιν.

they [the Clouds] feed the twisters of the melodies of the dithyramb,
 fabulists
of the heaven, idle people doing nothing, as they praise the Clouds in
 their songs. (333–34)

In Aristophanes' *Gerytades* (fr. 156 Kassel-Austin), the representative of cyclic choruses is Kinesias, the composer of dithyrambs. Along with Phrynis and Timotheos, Kinesias is also denounced by Pherekrates for "twisting the melodies" (*Cheiron* fr. 155, lines 9, 15, 28 Kassel-Austin). The catchword κάμπτειν ("twisting") reappears later in *Clouds* (see below). In *Birds*, we shall see the ἀσματοκάμπτης Kinesias flying in the air (see discussion below). In *Clouds* (335–39), Strepsiades remembers relevant modern dithyrambs concerning clouds, storm, and rain that he has heard, quoting examples, which we cannot identify, complaining about the lavish entertainment that the poets receive after their performances.

The next reference to Old and New Music occurs in the contest of the Advocates of Right and Wrong (889–1104), which is part of the revision of *Clouds*. We know that in the *Clouds* of 423 BC, according to a scholion, there was a wholly different contest, including two fighting cocks in wicker baskets (a scene that may perhaps be depicted on a vase housed at the J. Paul Getty Museum in California).[31] In comparing the contest of "Right" and "Wrong" in the revision of *Clouds* with the contest of Euripides and Aischylos in *Frogs*, Kenneth Dover has demonstrated remarkable structural similarities between the two contests,[32] with only one exception: in *Clouds*, the Right argument, bound to lose the contest, is invited by the chorus to speak first (959f.), whereas in *Frogs*, the loser, Euripides, begins the contest without invitation (907).

[31] See schol. VE 889; Dover 1968 (see above, n. 30), XC–XCII; O. Taplin, *Comic Angels*, Oxford 1993, 101–4, pl. 23, no. 28.

[32] Dover 1968 (see above, n. 30), 209f.

In *Clouds*, the Right argument delivers an austere picture of ancient education in which music was predominant (961–72). In the morning, boys had to process in good order to the *kithara*-teacher, who taught them old-fashioned songs and melodies (967: perhaps Stesichoros or Kydias?).[33] Boys who entertained themselves by singing "twists" (καμπήν) in the style of Phrynis were heavily thrashed:

... ἢ κάμψειέν τινα καμπὴν
οἵας οἱ νῦν τὰς κατὰ Φρῦνιν ταύτας τὰς δυσκολοκάμπτους,
ἐπετρίβετο τυπτόμενος πολλὰς ...

but if one of them [...] introduced some twist into the melodies,
those ugly twists familiar today to the followers of Phrynis,
he got plenty of slaps (969–71)

Again we can compare Pherekrates, who accuses Phrynis of κάμπτειν τὴν μουσικήν (*Cheiron* fr. 155.15 Kassel-Austin). The text of *Clouds* as we have it shares the familiar views of the Old Comedy of the second half of the fifth century BC with regard to "New Music."

The subject of Old and New Music reappears at the end of *Clouds* (1321–1511): old Strepsiades, crying aloud ἰοὺ ἰού, complains about his son Pheidippides, who has been successfully trained in modern rhetoric in the *phrontistêrion*. At the beginning of an off-stage *symposion*, which is reported by Strepsiades (1353–72), Strepsiades asks Pheidippides to sing to the lyre a song of old Simonides (1356f. = Simonides fr. 507 *PMG*). But Pheidippides, disliking Simonides' songs, rejects the old-fashioned manner of singing *skolia*. Invited instead to perform Aischylos—holding a myrtle branch, as was customary—Pheidippides refuses again, disqualifying Aischylos in an ironic manner:

ἐγὼ γὰρ Αἰσχύλον νομίζω πρῶτον ἐν ποιηταῖς
ψόφου πλέων ἀξύστατον στόμφακα κρημνοποιόν

I certainly consider Aischylos, the first of the poets,
to be a noisy, rude, and pompous braggart (1366–67)

Instead, he sings a monody from Euripides' *Aiolos* (4a *TrGF*), in which Makareus seduces his half-sister Kanake.[34] The tenor of Pheidippides' judgment

[33] Dover 1968 (see above, n. 30), 215.
[34] See L. Prauscello, *Singing Alexandria*, Leiden and Boston 2006, 86–104.

on Aischylos reappears in the mouth of Euripides in *Frogs* (830–991). Therefore, it is possible that the revision of the end of *Clouds* began already with line 1321, thus reopening the contest of Right and Wrong.

6. Birds

1. Kinesias

Birds, performed at the City Dionysia of 414 BC, won second prize after Ameipsias' *Revelers* (Κωμασταί). Except for three irrelevant allusions to the Sicilian expedition that began in the summer of 415 BC,[35] the play seems to be free of direct political references. The vicissitudes of daily life in democratic Athens, however, are mirrored in the visits of different unwelcome visitors from the earth.[36] In order to keep the newly-founded city of the birds (a city that is located between heaven and earth) free of all terrestrial evils, such intruders are driven out of Cloudcuckooland.

Among the intruders, the representatives of Old (904–58)[37] and New Music (Kinesias: 1373–1409)[38] are treated differently. The first of them, pretending to have composed dithyrambs and maidens' choruses in the style of Simonides for a long time, uses a *hyporchêma* by Pindar (fr. 105a/b Maehler), which refers to the foundation of Aitna, as material for a beggar's song, and thereby praises the foundation of Cloudcuckooland (926f., 941–43). In order to get rid of this pestering poet, Peisetairos gives him a jacket and a tunic without disguising his contempt for him (906: τουτὶ τὸ πρᾶγμα; 931, 956: τουτὶ. . .τὸ κακόν).

Kinesias, on the other hand, enters with the first line of a poem in the choriambic meter of Anakreon (fr. 52 Diehl), which he adapts in the following lines (1372f., 1376), changing the meter to ionics with syncopation and ionics without syncopation:

ἀναπέτομαι δὴ πρὸς Ὄλυμπον πτερύγεσσι κούφαις	cho trim ba
πέτομαι/δ' ὁδὸν ἄλ/λοτ' ἐπ' ἄλλαν/μελέων	ion sync ion sync ion ion sync
ἀφόβῳ/φρενὶ σώματί/τε νέαν/ἐφέπων.	ion sync ion ion sync ion sync

[35] *Clouds* 639: allusion to the hesitation of Nikias before the expedition; 145–47: allusion to the arrest of Alkibiades by the police ship Salaminia and the lawsuit against him; 363f.: an allusion to the clever plan of Nikias and Lamachos—the two remaining generals in Sicily—to fortify the hills in the north of Syracuse.

[36] *Clouds* 863–94: priest; 904–53: old-fashioned poet; 958–91: oracle-seller; 992–1020: Meton the geometer; 1021–34: Athenian inspector; 1035–54: seller of decrees in favor of Athens; 1271–1307: herald; 1337–71: father-beater; 1373–1409: modern poet (Kinesias); 1410–69: sycophant.

[37] Cf. Parker 1997 (see above, n. 28), 324–33.

[38] Cf. Parker 1997 (see above, n. 28), 340–51.

I am flying up unto Olympos with swift wings;
I follow one after another path of song,
striving after the newest with fearless mind and body.

In the next example of his poetry, he manifests his wish; he wants to be feathered by Peisetairos (1380):

ὄρνις γενέσθαι βούλομαι λιγύφθογγος ἀηδών ia dim pher

I want to become a bird, a nightingale with her sweet voice.

Transformed into a bird, Kinesias wishes to fly to the clouds, in order to bring back new airy and snowy songs (ἀναβολαί) for his dithyrambs, since the most fascinating parts of dithyrambs have their origin in the clouds (1383–90). This was a familiar joke: already in *Peace* (421), Trygaios meets some poets of dithyrambs, collecting songs in the air, between heaven and earth.[39] Ἀναβολαί were instrumental preludes for epic recitation. But in later times the term was used to denote the different sections of free astrophic lyric, the ἀπολελυμένα,[40] which are said to be an invention of Melanippides.[41]

In the third lyric example (1393–97; 1398–1400), Kinesias evokes the experiences he hopes to have as a bird:

εἴδωλα πετεινῶν	reiz
αἰθεροδρόμων	ia
οἰωνῶν ταναοδείρων—	an dim cat
Pis. ὤπ.	
ἀλίδρομον ἀ/λάμενος ἅμ᾽ ἀνέ—	ia dim
μων πνοαῖ/σι βαίην.	cr ba
τοτὲ μὲν νοτίαν στείχων πρὸς ὁδόν,	an dim
τοτὲ δ᾽ αὖ βορέᾳ σῶμα πελάζων	an dim
ἀλίμενον αἰθέρος αὔλακα τέμνων.	an dim

O ye visions of winged birds, which hasten through the air with stretched
 neck—
[Pis. : whoops !]

[39] Aristophanes *Peace* 829f.: ψυχὰς δύ᾽ ἢ τρεῖς διθυραμβοδιδασκάλων/ . . . ξυνελέγοντ᾽ ἀναβολὰς ποτώμεναι.

[40] Aristides Quintilianus *On Music* 1.29, p. 52 Winnington-Ingram; Hephaistion *On Poems* 3.3, 5.1–4 Consbruch. Cf. de Simone 2004 (see above, n. 23).

[41] Aristotle *Rhetoric* 1409b25: ποιήσαντα ἀντὶ τῶν ἀντιστρόφων ἀναβολάς; see above.

> May I take with a leap the road to the sea, traveling with the blowing of
> the wind;
> sometimes following the southern route,
> sometimes again approaching with my body the chilly north,
> traversing the harborless furrow of sky.

Despite this fascinating composition of a dithyramb, Kinesias unfortunately is not feathered or transformed into a bird by Peisetairos. Instead, Peisetairos offers him employment as chorus-master for the birds under the *chorêgos* Leotrophides, a historical Athenian—an offer indignantly refused by Kinesias (1405–9).

The lyrics Aristophanes attributes to Kinesias are good examples of the special style of the "New Dithyramb." Furthermore, the first example, with its syncopated ionics, gives clues as to the musical originality of the "New Style." While syncopation at verse-end, common since Anakreon and Aischylos,[42] may denote a pause, syncopation inside the ionic verse itself produces a change of the rhythm ($\smile\smile--/\smile\smile-/\smile\smile--$) or lengthening of the syllable preceding the syncopation ($\smile\smile--/\smile\smile\sqcup/\smile\smile--$). The comments of Peisetairos (τί δεῦρο πόδα σὺ κυλλὸν ἀνὰ κύκλον κυκλεῖς), which ridicule the "lame foot" in Kinesias' cyclic choruses immediately after Kinesias' repeated syncopations in ionics (1374, 1376), seem to point to this rhythmic difficulty, produced by the abnormal frequency of the syncopations (1379). This has been noticed by Nan Dunbar,[43] who adduces as parallel the fact that Aischylos in *Frogs* (1322f.) points to a metrical anomaly in Euripides (ὁρᾷς τὸν πόδα τοῦτον), a glyconic with anapaestic basis. Nevertheless, it should be noted that syncopated ionics inside the colon are attested already in Aischylos (*Persians* 70–72 = 78–80; 101f. = 109f.; 951 = 965).[44]

2. The Hoopoe's monody

As we have observed, Aristophanes' treatment of Kinesias is remarkably moderate. Except for the parody of dithyrambs, there are no other polemics against "New Music" in *Birds*. Instead, it is significant that Aristophanes uses the style of "New Music" in order to imitate the music of the birds. This can be easily demonstrated in an analysis of the monody of the Hoopoe (227–62).[45] At

[42] M. L. West, *Greek Metre*, Oxford 1981, 124–27.
[43] N. Dunbar, *Aristophanes: Birds*, Oxford 1995, 667f.
[44] Cf. Parker 1997 (see above, n. 28), 62f.
[45] Cf. Parker 1997 (see above, n. 28), 296–304; Dunbar 1995 (see above, n. 43), 202–24.

the beginning of the *parodos*, the Hoopoe, in an anapaestic sequence (209–22), calls the nightingale to sing, after which the manuscripts announce a solo of the *aulos*-player by αὐλεῖ, which imitates the nightingale's song. After listening to the music, Peisetairos and Euelpides see the Hoopoe on the roof of the *skênê*, where he is preparing to sing a solo (223–26), perhaps with the accompaniment of an aulete.

The monody of the Hoopoe, devoid of strophic structure, is nevertheless clearly articulated in different sections of varying length, which are marked off by differences in content and also occasionally by bird cries, by meter, and, presumably, by the original melody as well. After an introduction in anapaests and iambic trimeters (227–29), in which all the birds are summoned, there follows a long section (230–37) beginning with dochmiacs and ending with bird cries (τιὸ τιὸ τιὸ τιὸ τιὸ τιὸ τιὸ τιό), which are addressed to the birds living in the fields. The second, short section (238f.), beginning with ionics, addresses the birds that pasture in the gardens. The third section (240–42), beginning with a trochaic trimeter and ending with the cries of birds (τριοτὸ τριοτὸ τοτοβρίξ), addresses the birds that live on the mountains. The fourth section (243–49), in cretics, summons the birds living in marshy places and ends with the repetition of a bird's name (ἀτταγᾶς, ἀτταγᾶς). The fifth section (250–52), in dactylic tetrameters, addressed to the birds living at the seaside, is neatly marked off by δεῦρ' ἴτε. The closing section (253–59), rounded off by δεῦρο, repeated four times (259), is again addressed to all birds, summoning them for deliberation regarding the plans of Peisetairos for the foundation of Cloudcuckooland.

The structure of the Hoopoe's monody is again a good example of the free, *astrophic* form that was introduced early on in instrumental music, according to Martin West.[46] The famous Pythic *nomos* by Sakadas, illustrating with *aulos*-music the struggle of Apollo with the well-known dragon at Delphoi, had five distinct sections (πεῖρα, κατακελευσμός, ἰαμβικόν, σπονδεῖον, καταχόρευσις), while the kitharodic *nomos* ascribed to Terpandros had seven (ἀρχά, μεταρχά, κατατροπά, μετακατατροπά, ὄμφαλος, σφραγίς, ἐπίλογος). Following the example of the kitharodic *nomos*, Melanippides is said to have abolished the *strophic* form in the dithyramb, replacing it with the free form (ἀναβολαί) of the kitharodic *nomos* (see above). The style of the "New Dithyramb" affected the monodies of later tragedy, especially those of Euripides. In *Hekabe* (425 BC) the blinded

[46] M. L. West, *Ancient Greek Music*, Oxford 1992, 212–17.

Polymestor performs a great monody (1056–1106) in the modern *astrophic* style.[47]

It is important to observe that in *Birds*, Aristophanes, despite his harmless mockery of the airy dithyrambs of Kinesias uses the style of the "New Dithyramb" in the monody of the hoopoe, without any element of extravagance, aiming only at the most naturalistic *imitation* of the music of birds. The pattern of free, *astrophic* form (ἀναβολαί, ἀπολελυμένα) recurs in *Thesmophoriazousai* and in *Frogs* (plays that will be examined below), as well as in the monodies of the last tragedies of Euripides: see, for instance, the monody of the Phrygian slave (1369–1502) in *Orestes* (408 BC). Fragments of texts with ancient musical notation show that this pattern of astrophic compositions was familiar even in the Hellenistic and Roman periods.[48] The best examples are the Delphic Hymns by Athenaios (128 BC) and Limenios (106 BC).[49]

7. Thesmophoriazousai

1. Politics

Aristophanes' *Lysistrate*, staged at the Lenaia of 411 BC, and *Thesmophoriazousai*, staged at the City Dionysia of 411 BC, were conceived and performed in a period of extreme social insecurity. After the catastrophe of the Athenian expedition against Syracuse in the late summer of 413 BC, the oligarchic faction in Athens enforced the installation of a board of ten elder citizens, the πρόβουλοι, who were in charge of the preparation of the decisions of the Council and the Assembly. At the end of 412 BC, members of the oligarchic faction in Samos, under the leadership of Peisandros, were sent to Athens to negotiate an alliance with Tissaphernes and Persia that concerned the return of the exiled Alkibiades to Athens and the abolition of democracy. After the failure of this complicated plot, Peisandros was sent by the Samian oligarchs to Athens again to overthrow democracy—where the oligarchs were in the process of killing their democratic adversaries. At the beginning of June 411 BC, the Assembly was summoned to the hill of Kolonos and was obliged to abolish the pay for public office (τροφή), to limit the citizenship to only five thousand wealthy citizens, and to replace the Council with a board of four hundred Athenians with absolute power. As

[47] Wilamowitz-Moellendorff 1921 (see above, n. 2), 545.

[48] E. Pöhlmann and M. L. West, *Documents of Ancient Greek Music*, Oxford 2001 (= *DAGM*), nos. 6, 20–21, 38, 41.

[49] For the structure, see Pöhlmann and West 2001 (see above, n. 48), 72f.

a consequence of the democratic revolt of the fleet in Samos, the four hundred were removed in September of 411 BC and replaced by the five thousand but democracy was not restored again until the summer of 410 BC.[50]

In *Lysistrate*, Aristophanes, after having severely attacked the πρόβουλοι along with the politicians in charge (387–613), provides an imaginary counterpart to the Peisandros-Tissaphernes-Alkibiades plot by recommending compromise and reconciliation with Sparta (1161–75). *Thesmophoriazousai* is reticent about the political situation of April 411 BC, except for some allusions to tyranny (335, 338f., 1143f.) in the parody of the curse performed by the Assembly of women (331–51) and in a hymn to Athena (1136–59), obviously due to the fear of oligarchic terror. Instead, in this play Aristophanes returns to the harmless subject of the parody of tragedy already explored in *Acharnians*. We find again a parody of Euripides' *Telephos* (466–519, 689–764), followed by parodies of his plays *Palamedes* (768–84), *Helen* (846–928), *Andromeda* (1008–35)—including a parody of Andromeda's monody (1015–55)—, and *Kyklops* (*Thesmophoriazousai* 1200–26 = *Kyklops* 675–88). And, at the beginning of *Thesmophoriazousai*, Aristophanes, by reworking the beginning of the *Acharnians* (see above), places the tragic poet Agathon, rather than Euripides, on the *ekkyklêma*, where he delivers a specimen of his *astrophic* lyrics (101–29). The absurd hostage-scene of *Acharnians* (see above) is reused later (689–759).

2. Agathon

Agathon is known to us through several testimonies and fragments.[51] His first victory at the Lenaia of 416 BC is celebrated in Plato's *Symposion*.[52] For many years, he was involved in a homosexual relationship with the older Pausanias.[53] Before 405 BC, he went with Pausanias to the court of Archelaos of Makedonia.[54] Aristotle ascribes to Agathon the introduction of ἐμβόλιμα, interludes without reference to the actual action in a tragedy.[55] He is said to have invented tragic plots devoid of mythical background[56] and to have introduced the hypodorian

[50] C. Austin and S. D. Olson, *Aristophanes: Thesmophoriazusae*, Oxford 2004, XXXIII–XLIV.

[51] Agathon T 1–27, F 34: *TrGF* I 39.

[52] Agathon T 1 f. *TrGF*.

[53] Agathon T 3, 11, 15 *TrGF*.

[54] Aristophanes *Frogs* 83f., Agathon T 12, 22, 25 *TrGF*.

[55] Agathon T 18 *TrGF*.

[56] Agathon F 2a *TrGF*.

and hypophrygian modes[57] as well as the chromatic genus.[58] Agathon's musical style is described as effeminate,[59] and his fragments, as usual, are limited to trimeters.

In *Thesmophoriazousai*, Euripides and his Kinsman are received by a servant when they knock at Agathon's door. The servant asks for silence in a solemn anapaestic hymn, explaining that the Muses are dwelling in Agathon's house, and that he is beginning the composition of a new tragedy. Agathon's craft is described through metaphors related to the crafts of the joiner (53/54: τορνεύει, κολλομελεῖ) and founder (56/57: κηροχυτεῖ, γογγύλλει, χοανεύει), interspersed with musical and rhetorical terminology (53: κάμπτει; 55: γνωμοτυπεῖ, κἀντονομάζει). As it is too cold during wintertime to "bend strophes" inside the house (68: κατακάμπτειν τὰς στροφάς), we are told that before long Agathon is bound to come out into the sun in order to sing (67: μελοποιεῖν ἄρχεται). The catchword κάμπτειν reminds us of the καμπαί of Kinesias, Phrynis, and Timotheos.

Agathon, entering the stage on the *ekkyklêma* (95f.), is reclining on a couch (261), clad in a woman's chiton and a breast-band (138f.) and wearing a white, female mask, but no stage phallus (191, 142). The couch is covered with many props, mostly suited for women. Therefore, the Kinsman believes that he sees the famous whore Kyrene (98), who is mentioned again in *Frogs* in reference to her sexual versatility (*Frogs* 1327f.: δωδεκαμήχανος). Agathon seems to begin with some *solfèges* (99), which the Kinsman compares to ant-tracks (100: μύρμηκος ἀτραπούς, ἢ τί διαμινύρεται), a metaphor that recurs in Pherekrates (*Cheiron* fr. 155.23 Kassel-Austin).

After this, Agathon begins to sing an *astrophic* duet with a chorus of Trojan maidens (110: Σιμουντίδι γᾷ; 120: Ἀσιάδος; 121f.: Φρυγίων. . .Χαρίτων), whose part he undertakes himself. The whole section could be part of a Trojan tragedy, such as the *Mysoi* or the *Telephos* by Agathon (*TrGF* 39, fr. 3 a.4). Austin and Olson suppose that Agathon's own play takes place after the feigned retreat of the Achaeans before the Sack of Troy.[60] But it is an open question whether Aristophanes derived his song from an original play by Agathon or wrote this song himself, imitating only Agathon's style.

[57] Agathon T 20c *TrGF*.
[58] Agathon *Mysoi* fr. 3a *TrGF*.
[59] Agathon T 20a–b *TrGF*.
[60] Austin and Olson 2004 (see above, n. 50), 87, 97.

It is important to observe that there are no parodic extravagances in Agathon's song. The text is subdivided into sections of unequal length, alternating between coryphaeus (Agathon) and the chorus.[61] I argue that the meter is no "eccentric medley,"[62] but exhibits a steady pattern that underlines the structure of the text by repeating anacreontics and aeolic heptasyllables, as we shall see.

Lines 101–3: Agathon summons the chorus to celebrate Demeter and Persephone with torches and a song. At the beginning we have two syncopated ionics as in Kinesias' first specimen (see discussion above); afterward, we have a choriambic dimeter, a dodrans and again a choriambic dimeter.

104–6: The chorus wonder who is the god who is to be worshipped, declaring their good will. At the beginning, an anacreontic is used; afterward, a trochaic dimeter and, at the end, an aeolic heptasyllable.

107–10: Agathon calls for a song for Apollo, the builder of the Trojan walls near the river Simois. At the beginning, an anacreontic is used; afterward, an ionic dimeter, a choriamb and an adoneus and, at the end, an aeolic heptasyllable.

111–13: The chorus ask Apollo to take joy in their song. At the beginning, two trochaic dimeters are used; at the end, an aeolic heptasyllable.

114–16: Agathon calls for a song for Artemis, goddess of the mountains. Here we have a trochaic dimeter and a dactylo-epitritic colon (x e x D).

117–19: The chorus obey, praising the offspring of Leto, Artemis of the Wild. Here two anacreontics are used, followed by an aeolic heptasyllable.

120–22: Agathon calls for a song for Leto, and also for music in an irregular rhythm on the Asiatic *kithara*, which becomes rhythmical through dance (ποδὶ παράρυθμ' εὔρυθμα Φρυγίων, 121), with the help of the Phrygian Charites (διὰ νεύματα Χαρίτων, 122). At the beginning we have an aeolic enneasyllable; afterward, a choriamb, an adoneus, and two ionics, the second syncopated (122). With 121f., Aristophanes perhaps comments on the complicated meter of this section (cf. discussion above).

123–25: The chorus praise Leto and the masculine loud sound of the *kithara*, mother of hymns. At the beginning, two anacreontics are used; afterward, an aeolic heptasyllable. This is an exact metrical echo of lines 117–19.

[61] Cf. Austin and Olson 2004 (see above, n. 50), 86–97.
[62] Austin and Olson 2004 (see above, n. 50), 88f.

126–28: Agathon continues the praise of the *kithara*, assuming that the gods are pleased by the instrument and the song, and summoning the chorus to praise Apollo again. With Meineke's <θεοῦ> after δαιμονίοις (126) we have in 126–27 a series of ten dactyls, followed by a catalectic iambic dimeter.

129: With the traditional formula χαῖρε, the chorus bid farewell to Apollo. Here we have a telesilleion as clausula.

As soon as Agathon has finished his song, the Kinsman provides significant comments on it (130–33). He explains that its sweet and erotically enticing melody has roused sexual desires in his butt. The belief that poetry and music can have effects on emotions was commonplace in the fifth century BC, as we can see in Plato's well-known chapter on music in the *Republic*, where Sokrates dismisses keys (ἁρμονίαι) that are high-pitched and plaintive (Μειξολυδιστί, Συντονολυδιστί) or low-pitched and lascivious (Ἰαστί, Λυδιστί) and admits only "manly" keys, which are apt for war and peace (Δωριστί, Φρυγιστί). The same qualification applies, according to Damon of Oa, to meters and rhythms as well (*Republic* 3.398–400).

There follows a long discussion focusing on the possible relation between the clothing and appearance of a poet and the character of his music (134–73). With quotations from Aischylos' *Lykourgeia*, the Kinsman attacks the effeminate outfit of Agathon (134–45) who, in turn, develops the idea that a poet must adapt himself to the nature of the themes of his poetry (146–72),[63] adducing as proof the pederastic poets Ibykos, Anakreon, and Alkaios, who are said to have put some spice into music (162: ἁρμονίαν ἐχύμισαν) and did wear ionic garments.[64]

With these hints, Aristophanes gives us some idea of the music of Agathon. The meters of his song, with choriambic, ionic, and anacreontic cola predominating, point to Ionia, while the keys used may have been low-pitched, lascivious keys.

3. Euripides

Later in the play, Aristophanes resumes the Telephos parody of *Acharnians*: the Kinsman, having been shaved and depilated, is disguised as a woman with the props of Agathon, in order to partake in the celebration of the women's festival, the Thesmophoria, at which he is eventually detected by the women. Taking a

[63] Austin and Olson (see above, n. 50), 105f.

[64] On this passage and its relation to the so-called "Anakreontic" vases, see Yatromanolakis 2007 (see above, n. 19), 110–40 and 221, n. 256.

baby as hostage, he seeks refuge on an altar (a scene depicted on the Würzburg *Telephos* krater).[65] As soon as the "baby"—that is, a wine-skin wrapped in baby's clothes—is "slaughtered" by the Kinsman, he is arrested. This gives Aristophanes the opportunity to indulge in parodies of Euripidean tragedies dealing with captivity in a foreign country (*Palamedes, Helen, Andromeda, Kyklops*).

While the chorus sings several *astrophic* songs in *Thesmophoriazousai*,[66] the only astrophic monody occurs in lines 1016–55 and is performed by the Kinsman, in a parody of Euripides' *Andromeda*. Andromeda was chained to a rock at the shore by her father Kepheus as an offering to a sea-monster (κῆτος) and rescued by the winged Perseus. Aristophanes does not follow the exact structure of Euripides' *Andromeda*: the monody sung by the Kinsman is presented before the actual beginning of *Andromeda*, an anapaestic duet between the heroine and Echo, sung in *Thesmophoriazousai* by the Kinsman and Euripides (1065–72)[67] and followed by a parody in the meter of dialogue (1098–1135).[68]

Euripides' *Andromeda* is preserved only in fragments,[69] some of which can be paralleled with the Kinsman's monody: line 1015, φίλαι παρθένοι φίλαι, occurs in Euripides' *Andromeda*,[70] and lines 1018–21 provide a hint of the nymph Echo in her cave, who is also mentioned in *Andromeda* fr. 118.[71] But since this fragment is different in wording and in meter, it would fit better after line 1078. Lines 1022f. constitute an adaptation of *Andromeda* fr. 120,[72] in the meter of the original. In lines 1029–55, Aristophanes seems to follow his original,[73] interspersing it with some jokes.[74]

Despite these uncertainties, the Kinsman's monody exhibits once more the already familiar pattern of the monody of the Hoopoe in *Birds* and the astrophic duet of Agathon in *Thesmophoriazousai*. There are sections that are different in

[65] Taplin 1993 (see above, n. 31), 36–40, pl. 11, no. 4.

[66] Parker 1997 (see above, n. 28), 396–99.

[67] *Andromeda* fr. 114f *TrGF*.

[68] *Andromeda* fr. 124f., F 128f., F 139 *TrGF*.

[69] *Andromeda* fr. 114–56 *TrGF*.

[70] *Andromeda* fr. 117 *TrGF*: φίλαι παρθένοι, φίλαι μοι.

[71] *Andromeda* fr. 118 *TrGF*: προσαυδῶ σὲ τὰν ἐν ἄντροις,/ἀπόπαυσον, ἔασον, Ἀχοῖ, με σὺν φίλαις/γόου πόθον λαβεῖν.

[72] *Andromeda* fr. 120 *TrGF*: ἄνοικτος ὃς τεκών σε τὰν πολυπονωτάταν βροτῶν/μεθῆκεν Ἅιδᾳ πάτρας ὑπερθανεῖν.

[73] *Andromeda* fr. 122 *TrGF*; cf. *Thesmophoriazousai* line 1033 with *Andromeda* fr. 121 *TrGF*: ἐκθεῖναι κήτει φορβάν.

[74] For instance, line 1033, where the sea monster (κῆτος) is replaced by a notorious glutton, Glauketas (see *Peace* 1008).

length, content, meter, and probably in music as well. The end of every section is marked off metrically. In the case of the Kinsman's monody, ithyphallics mark off seven sections:

Lines 1015–17: Andromeda/the Kinsman addresses the maidens' chorus by asking for help against the Scythian archer. At the end of this section, we have an ithyphallic.

1018–21: Andromeda/the Kinsman listens to Echo/Euripides in the cave (i.e., the stage-building) and requests her consent to return to his wife (see 1205f.). At the end of this section, we have an ithyphallic.

1022–29: Andromeda/the Kinsman, incriminating the Scythian archer, condemns Kepheus, who chained her and suspended her/him as food for the ravens. At the end of this section, we have an ithyphallic.

1029–33: Andromeda addresses the chorus, pointing to the fact that she is not dwelling in the circle of young maidens but has been put in chains in order to become a meal for the glutton Glauketas. At the end of this section, we have an ithyphallic.

1034–41: Andromeda summons the chorus to sing for her not wedding songs, but laments about prison, complaining of her miseries and reminding the chorus of the cruelties of Kepheus. At the end of this section, we have an ithyphallic; afterward, extra-metrically, we hear the cries αἰαῖ αἰαῖ ἒ ἔ.

1042–47: The Kinsman/Andromeda reminds the chorus that Euripides, after having shaved him, dispatched him, clad in women's clothes, among the women in the temple of Thesmophoros. At the end of this section, we have an ithyphallic.

1048–55: Andromeda/the Kinsman places emphasis on her present misery. Andromeda's desire to be killed by lightning is "transformed" by the Kinsman into a wish that he may kill the Scythian archer (1050f.: εἴθε με πυρφόρος αἰθέρος ἀστὴρ / τὸν βάρβαρον ἐξολέσειεν). But Andromeda's desire to die is "revived." At the end of this section, we have an ithyphallic. Afterward, Euripides, clad as an old woman, enters in the guise of Echo (1057f.).

To conclude: the parodic effects of Andromeda's/the Kinsman's monody do not depend on metrical (or musical) eccentricities but are created by the fact that the Kinsman constantly forgets his role as Andromeda and her tragic environment.

8. Frogs

1. Politics

Aristophanes' *Frogs* was produced by Philonides at the Lenaia of 405 BC, between the splendid naval victory of Konon at Arginousai (summer 406 BC) and the decisive defeat of the Athenian navy by Lysandros at Aigospotamoi (August 405 BC). After the victory of 406 BC, six commanders who had not been able to rescue shipwrecked citizens, were sentenced to death by the *ekklêsia*. The opportunity for easier negotiations with Sparta after the victory at Arginousai was spoiled by the excessive claims of the demagogue Kleophon, who was condemned to death at the end of 405. Eventually, a peace treaty mediated by Theramenes on much worse terms was concluded with Sparta (March 404).

In this climate of collective hysteria, Aristophanes began *Frogs* with Dionysos' decision to bring back Euripides (who had died in winter 407/406), in order to save the Athenian theater. But after his arrival at the Underworld, Dionysos is compelled to be a judge and decide on the quarrel between Aischylos and Euripides over the "throne" of poetry (754–813). This marks a shift from poetry to politics, as the victor of the quarrel is bound to return to earth in order to save Athens by offering prudent political advice. This shift is announced already in the *parabasis*:[75] in the *ôidê*, Kleophon is disparaged (674–85). In the *epirrhêma* (687–705), Aristophanes recommends the restoration of citizenship to repentant citizens who had been members of the oligarchic coup of 411 BC. In the *antôidê* (706–17), an otherwise unknown Kleigenes, a bath-keeper, is denigrated, and in the *antepirrhêma* (718–37), Aristophanes recommends that Athens returns to well-tried politicians of the old school. The same advice is later given by Aischylos himself (1443–48). Besides, Aischylos recommends that Athens brings Alkibiades back from exile, despite his flaws (1431f.) The poets' quarrel comes to an end after an extensive *agôn* (885–1118) and some "supplementary" tests in poetry by both contestants (1119–1466): in the end, Dionysos decides in favor of Aischylos. According to Dikaiarchos (*Hypothesis* Ic) and the ancient *Vita* of Aristophanes, *Frogs* was produced for a second time— because of the political advice offered and explored in the *parabasis*—perhaps in the spring of 404 with some important modifications.[76]

[75] Dover 1993 (see above, n. 24), 69–76.
[76] Cf. Dover 1993 (see above, n. 24), 373–76. Lines 1461–66 belong to the version of 405 BC, since the existence is assumed of the navy of Athens, which was lost in the battle of Aigospotamoi (summer 405 BC). This advice was replaced by lines 1442–50 in the version of 404 BC.

It is obvious that this setting does not leave much room for dispute over "New Music." Of course, in the *Frogs* we find again the airy Kinesias (153, 366, 1437; cf. discussion above) and see wonderful examples of melismatic style (cf. discussion below) and ἀναβολαί (independent musical sections in dithyrambic style). But I argue that, on the whole, the discussion of political correctness in Aischylos' and Euripides' tragedies is carried through on the level of the *text*, not on the level of *music*. On the other hand, we may find in *Frogs*, as in *Birds* (see discussion above), playful imitation of features of "New Music," without political implications.

2. The frogs' lyric dialogue

Dionysos' cruise to the Underworld is accompanied by a song performed by a chorus of frogs, which is astrophic, like the Hoopoe's monody in *Birds* (see discussion above) and represents a lyric dialogue (ἀμοιβαῖον) of the frogs with Dionysos. The *amoibaion* is neatly structured into eight sections of varying content by means of the refrain βρεκεκεκὲξ κοὰξ κοάξ, which imitates the croaking of the frogs through the use of a lecythion.

Lines 209–20: The frogs begin by repeating the aforementioned refrain twice (209–10). They summon their relatives to join in the song for Nysaean Dionysos in the marshes (ἐν Λίμναις), which they are accustomed to sing at the last day of the Anthesteria, the Chytroi. At the beginning of this section (211–18), we have iambic meters alternating with cretics (211–12, 215, 217), a choriamb, and a bacchiac (213). Line 216 is a telesilleion. Lines 218–20 in dactylo-epitritic cola describe the procession of the Chytroi. Line 220 is the frogs' refrain.

221–25: Dionysos' buttocks are aching because of the hard rowing, but the frogs do not take notice of it. Here three iambic dimeters are followed by line 225, which is the frogs' refrain.

226–35: Dionysos, disliking the frogs' music, is enervated by the constant croaking. The frogs explain in an amusing way their importance to the gods associated with music: they are the favorites of the Muses, of Pan, and even of Apollo, as they cultivate stalks of reed in the marshes—material necessary for the construction of Pan's *syrinx* and Apollo's lyre. Here we have iambic and trochaic dimeters (226–28, 233), trochaic trimeters (229–32), and, at the end of the section, a lecythion (234) and the frogs' refrain (235).

236–39: Because of the demanding rowing Dionysos has gotten blisters. His perspiring buttocks are about to produce a funny noise, which is drowned out

by the frogs' βρεκεκεκὲξ κοὰξ κοάξ. Here we have three iambic dimeters and, in line 239, the frogs' refrain.

240–51: Dionysos now resorts to flattery ("you musical gang, please stop"), but the frogs announce still louder songs, reflecting their jumping during hot days among the plants of the marshes, or their singing underwater in the depths whenever it rains. Here we have iambic and trochaic meters, alternating with cretics (240–41) and, after a lecythion (242a), trochaic dimeters (242b–48) with an interspersed cretic (245). At the end of this section, we have a one-word-lecythion, a linguistic monster—a familiar technique in comedy (249: πομφολυγοπαφλάσμασιν, "bubbling splutters")—and the frogs' refrain (250), this time taken over by Dionysos (251).

252–56: The frogs are impressed by Dionysos' surprise attack, while Dionysos is afraid of bursting while rowing. Here we have two trochaic dimeters, a lecythion (255), and, at the end of the section, the frogs' refrain.

257–61: A contest in shouting follows, which Kenneth Dover aptly compares to Aristophanes' *Knights* (274–77, 285–87).[77] Dionysos begins with an iambic dimeter (257) and the frogs answer with two trochaic dimeters and a lecythion (258a–259). The frogs' refrain (260) is again taken over by Dionysos (261, an iambic dimeter, followed by *hiatus*).

262–63: Dionysos rejects the last utterance of the frogs (262), a trochaic dimeter, with a lecythion (263), followed by *hiatus*.

264–67: Now Dionysos has the last word in the contest, taking over the frogs' words (258: κεκραξόμεσθα; 259: δι' ἡμέρας): he exclaims "I shall be shouting the whole day" (264–67). After three trochaic dimeters, rounded off by a cretic, there follows—for the last time—the frogs' refrain, once more taken over by Dionysos (267).

The frogs' song is introduced in lines 215–18 as a hymn for Dionysos ἐν Λίμναις—a dithyramb to be sung at the "ceremony of the pots" (χύτροι). Again we observe the pattern of the "free forms" of the kitharodic and aulodic *nomos*, which were later taken over by the dithyramb and the monodies of tragedy (see discussion above), namely a sequence of sections separated by content, meter, and probably music. From a metrical perspective, the song of the frogs is free of all the eccentricities of the New Dithyramb and even simpler than the Hoopoe's monody in *Birds* (see discussion above), which evidently has much in common

[77] Dover 1993 (see above, n. 24), 222f.

with the frogs' ἀμοιβαῖον (lyric duet) with Dionysos. Of course, there are some allusions to particular melodic elements: on hot days the frogs sing πολυκόλυμβα μέλη (245, "busily-diving melodies"), while on rainy days they perform χορείαν αἰόλαν . . . πομφολυγοπαφλάσμασιν (247–49, "dance-songs vibrating with bubbling splutters") underwater in the depths. In the Delphic Hymns I mentioned above, αἰόλος is a keyword for the oscillating melodic movements of the *aulos* or the *kithara* in chromatic passages.[78] But this, I suggest, is not enough to trace in the frogs' chorus a direct polemics against musical features of the New Dithyramb or of the novel tragedies of Euripides and Agathon.[79] Rather, we have in the frogs' *amoibaion* (and in the Hoopoe's monody in *Birds*) an intriguing playful use of the astrophic pattern of the New Dithyramb, without a concrete target. Aristophanes would thus have been expelled from Plato's ideal state, where poets who imitate everything, even the cries of animals (*Republic* 397a, *Laws* 669c), would have no place.

3. Aims of poetry, prologues of tragedy

The first part of the poets' contest in *Frogs* is an extended *agôn* (885–1118), in which Euripides tries to demonstrate the superiority of his modern drama over the old-fashioned tragedy of Aischylos. It is noteworthy that both contestants agree on the fundamental aim of poetry. A poet is obliged to improve the morality of the citizens (1019f.: ὅτι βελτίους τε ποιοῦμεν/τοὺς ἀνθρώπους ἐν ταῖς πόλεσιν). But Aischylos contends that Euripides' tragedies have the contrary effect, that is, the moral depravation of society. This agonistic section, which focuses on the characters and plots of Euripides' tragedies, culminates in a long catalogue of flaws that Aischylos finds in them (1078–88). Music is touched upon only *marginally*: Euripides traces the merits of his new tragedies in the introduction of monodies (944; but cf. also 849).

Some additional tests in poetic merit and political insight for both contestants follow (1119–1466). Euripides begins by criticizing the prologue of Aischylos' *Choephoroi* for its lack of clarity (1119–76). But Aischylos gets his revenge by denigrating the prologue of Euripides' *Antigone* because of its superficiality (1177–96), as well as the Euripidean prologues, more generally, because of their metrical monotony (1197–1247). Aischylos achieves this by

[78] *DAGM* 20, 128 BC, line 14: *aulos, DAGM* 21, 106 BC, line 16: *kithara*.

[79] See J. Defradas, "Le chant des Grenouilles: Aristophane critique musical," *Revue des Études Anciennes* 71 (1969), 23–37 and G. Wills, "Why Are the Frogs in the *Frogs*?" *Hermes* 97 (1969), 306–17. Comparing the Hoopoe's song in *Birds*, Dover 1993 ([see above, n. 24], 56, n. 2) denies a polemical point in the frogs' chorus.

inserting the nonsensical colon ληκύθιον ἀπώλεσεν ("he lost his oil-flask") after the caesura of specific lines coming from his opponent's tragedies—a gag that is applied to seven different Euripidean prologues.[80]

4. Aischylos' lyrics

Later in the play, the parody turns against Aischylos' lyrics. After a stage remark (διαύλιον προσαυλεῖ τις, "someone plays an interlude on the *aulos*"), Euripides begins with two lines from Aischylos' *Myrmidons*, nonsensically adapting the second line of this example to four other quotations from Aischylean tragedies[81] and thus demonstrating that Aischylos constantly repeats himself (1248–80). As an example of Aischylean interludes on the *kithara* (1282), Euripides quotes five examples from Aischylean tragedies,[82] adding after each example the nonsensical iambic dimeter τοφλαττοθρατ τοφλαττοθρατ (1281–97), an imitation of strumming with a plectrum (*plêktron*).[83]

5. Euripides' choral lyrics

After stressing his own originality, Aischylos charges Euripides with plagiarizing mediocre sources, namely whore songs, *skolia* by Meletos,[84] Karian *aulos*-tunes, dirges, and dances. Aeschylos adds that the Muse of Euripides, a woman entering the stage with castanets instead of a lyre, will be able to demonstrate this idiosyncratic feature of Euripides' songs. Here, Dionysos doubts her affiliation with the legendary Lesbian musicians Arion and Terpandros, by making an ambiguous joke (1298–1308).[85]

At this point, Aischylos, accompanied by Euripides' Muse, performs an *astrophic* song that, despite the textual difficulties it presents,[86] displays the characteristics of the free form of the "New Dithyramb" that we have seen in *Clouds*, *Birds*, *Thesmophoriazousai*, and in the frogs' *amoibaion* in *Frogs*. The text, though partly nonsensical, is clearly structured in four sections through the repetition of

[80] Euripides *Archelaos* (?) fr. 846 *TrGF, Hypsipyle* fr. 752 *TrGF, Stheneboia* fr. 661 *TrGF, Phrixos* fr. 819 *TrGF, Iphigeneia en Taurois* 1, *Meleagros* fr. 516 *TrGF, Melanippe* fr. 481.1 *TrGF.*

[81] Aischylos *Myrmidons* fr. 132 *TrGF, Psychagogoi* fr. 273 *TrGF, Telephos* (?) *Iphigeneia* (?) fr. 238 *TrGF, Priestesses* fr. 87 *TrGF, Agamemnon* 104.

[82] Aischylos *Agamemnon* 108–9, *Sphinx* fr. 236 *TrGF, Agamemnon* 111, *Memnon* fr. 282 *TrGF, Thracian Women* fr. 84 *TrGF.*

[83] West 1992 (see above, n. 46), 67, n. 86.

[84] For Meletos, see Yatromanolakis 2007 (see above, n. 19), 289–91 and n. 20.

[85] For the sexual undertones of λεσβιάζειν, see Dover 1993 (see above, n. 24), 351–52, and Yatromanolakis 2007 (see above, n. 19), 183–89.

[86] For the textual and metrical problems, see Dover 1993 (see above, n. 24), 352–57, and Parker 1997 (see above, n. 28), 504–8.

a colon familiar in Euripides,[87] the "choriambic dimeter," which appears in lines 1312 and 1321 as ⌣ ⌣ ⌣ ⌣ ⌣ – ⌣ ⌣ –, in line 1316 as – ⌣ ⌣ ⌣ – – ⌣ ⌣ –, and in line 1325 as – – – – – ⌣ ⌣ –.

The first of the ἀναβολαί (lines 1309–12) addresses the halcyons, introducing with the characteristic relative clause αἳ[88] a description of their chattering at the seaside, where they moisten their wings in the humid waves. The respective cola are 1309: cretic, hipponactean; 1310: lecythion; 1311: glyconic; and 1312: choriambic dimeter. The second ἀναβολή (1313–16) adds—in a similar way—a description of spiders in the corners of the ceiling of a house, which, with the help of the singing shuttle of their loom, weave their nets with their fingers. The respective cola are 1313: aeolic dactyls; 1314: telesilleion, bacchiac; 1315: lecythion; and 1316: choriambic dimeter.

However, in line 1314 (εἱλίσσετε δακτύλοις φάλαγγες) the manuscripts (except for Aac and Θac) repeat the εἱ- four to six times (εἱει ειει ειει λίσσετε).[89] This suggests the splitting of the respective long syllable by means of singing more than one note (corresponding to a long syllable). Doubling of long syllables set to two notes, which suggests singing two quavers instead of a crotchet, is attested in the musical fragments of Ptolemaic and Hellenistic times.[90] It is noteworthy, however, that this modest melismatic style expands in the papyri of Imperial times: in *DAGM* 57, line 2 (III AD), there are nine notes corresponding to a long and a short syllable and grouped into three triplets. In *Frogs* 1314, the syllable εἱ- is repeated more than once for the sake of parody. Aristophanes reuses this joke on this kind of exuberant melismatic style in *Frogs* 1348 (see discussion below). If we adopted the manuscript reading of four εἱ-s (εἱειειειλίσσετε) in *Frogs* 1314, we would have four semi-quavers. Six εἱ-s would give six semi-quavers grouped into two triplets. Be that as it may, line 1314 must be analyzed metrically as – – ⌣ ⌣ – ⌣ – ⌣ – – (telesilleion, bacchiac).[91]

The third ἀναβολή, characteristically introduced with ἵνα,[92] addresses the *aulos*-loving dolphin jumping around ships. Line 1317–18 is a quotation from Euripides' *Electra* 435–37 (ἵν' ὁ φίλαυλος ἔπαλλε δελ/φὶς πρῴραις κυανεμβόλοι-/

[87] See K. Itsumi, "The 'Choriambic Dimeter' of Euripides," *Classical Quarterly* 32 (1982), 59–74 and Wilamowitz-Moellendorff 1921 (see above, n. 2), 210–44.

[88] Cf. Dover 1993 (see above, n. 24): 352f.

[89] Cf. Dover 1993 (see above, n. 24): 353.

[90] See *DAGM* 3 (III/II BC) line 6 (ὡως), *DAGM* 6 (III/II BC) line 3 (-ελειει) and line 6 (ιωώ), *DAGM* 10 (III/II BC) line 12 (π]εριχαρειεῖ), *DAGM* 20 (128–127 BC) passim, *DAGM* 21 (106–105 BC) passim.

[91] Parker 1997 (see above, n. 28), 504.

[92] Dover 1993 (see above, n. 24), 352.

σιν εἱλισσόμενος), where we find in line 437 εἱλισσόμενος (cf. *Frogs* 1314, 1348) describing the dolphin, this time. In *Frogs* 1317, ἔπαλλε is associated nonsensically with the internal objects[93] μαντεῖα καὶ σταδίους (1319, "oracles and racetracks"), οἰνάνθας γάνος ἀμπέλου (1320, "delight of grape-bloom of the vine"), and βότρυος ἕλικα παυσίπονον (1321, "curling of trouble-ending grape-cluster"). The respective cola are 1317–18: glyconics; 1319: aeolic heptasyllable; 1320: glyconic; and 1321: choriambic dimeter.

The fourth ἀναβολή addresses the Muse of Euripides, who is asked to embrace the singer (1322). The public is waiting for an erotic scene, but after this opening, Aischylos, forgetting his role, comments (in the context of his dialogue with Euripides and then with Dionysos) on the metrical faults of line 1322, which is a glyconic with anapaestic beginning,[94] and on the faults of line 1323 (aeolic dactyls). Line 1324 is a glyconic, while line 1325 is a choriambic dimeter. The ἀναβολή is rounded off by two glyconics and a pherecratean (1326–28). Here Aischylos summarizes his reproaches: Euripides is not entitled to criticize Aischylos, since he composes πορνῳδίαι (cf. 1301), lyrics in the style of the famous *hetaira* Kyrene (1328),[95] which is also mentioned in *Thesmophoriazousai* 98 (see above).

To sum up: in this part of the play there are few metrical eccentricities, the most important being the splendid example of exuberant melisms (καμπαί), balanced by a stable structure of four ἀναβολαί, which are marked off by the repetition of the aforementioned special metrical colon, the choriambic dimeter. The parodic humor in this part of the comedy is generated by the text, in particular by the nonsensical joining of the four ἀναβολαί and the emphatic use of the stylistic peculiarities of Euripides, which are illustrated fully in the next part of the play.

6. Euripides' monodies

After the parody of Euripides' choral lyrics, Aischylos announces his parody of a Euripidean monody (1331–63), which is again neatly structured. As there is no repeated colon, like the choriambic dimeter employed in *Frogs* 1310–28, my analysis must focus on the content of the lines of this section of the play. In lines 1331–37, a woman relates a terrifying dream in high tragic diction,[96] the beginning of which is reminiscent of the well-known dream in Euripides'

[93] Cf. Dover 1993 (see above, n. 24), 355–56.
[94] Cf. Parker 1997 (see above, n. 28), 508, an exceptional colon, not attested in Euripides.
[95] Cf. Dover 1993 (see above, n. 24), 357.
[96] Cf. Dover 1993 (see above, n. 24), 358 and notes on lines 1331, 1334, and 1336a.

Hekabe 68–72. The triple compound μελανο-νεκυ-είμονα (1336, "shrouded in cadaverous black") is reminiscent of coinages of the "New Dithyramb" parodied by comedy (cf. line 249 and discussion above). The section begins with - - - ◡ - ◡ ◡ - (choriambic dimeter), followed by anapaests with two interspersed cretics (1336a) and ending in line 1337 with *brevis in longo* and *hiatus*.

The next section (1338–40) creates a new beginning in dactylic meter with ἀλλά (see ἀλλ᾽ in line 1356) and ends with a *hiatus* after ἀποκλύσω. The woman summons her servants to light a lamp, to fetch water from the river and to heat it, as she wishes to bathe after the dreadful dream she had. This was a usual practice in antiquity,[97] but Dover suspects a coarser meaning, adducing *Frogs* 479–90.[98]

After an invocation to Poseidon (1341, a pherecratean: ἰὼ πόντιε δαῖμον), still in high poetic diction (cf. Euripides᾽ *Andromache* 1010), the next section (1341–45) shifts to the sphere of an Athenian household. The woman tells the audience that her neighbor, Glyke, has stolen her cock and summons the nymphs and her servant, Mania, to pursue Glyke, in a series of cretic and trochaic cola, rounded off by a hemiepes with *hiatus* (1344), an iambic colon and a cretic clausula with *brevis in longo* and *hiatus* (1345: ὦ Μανία ξύλλαβε, "oh Mania, arrest her").

The next section (1346–51) displays, mostly in aeolic cola, the motif of the lonely woman[99] at the loom, which we also find in the scene in Euripides᾽ *Orestes* where Helen is spinning and twisting flax with a spindle (1431–32: ἃ δὲ λίνον ἠλακάτᾳ δακτύλοις ἕλισσεν)—wording that is very close to Aristophanes᾽ *Frogs* 1314–15 (see above). The "twisting" (εἰλίσσω) reappears in line 1348, where some manuscripts repeat the syllable εἰ- four or six times. Aristophanes uses again his splendid joke of line 1314 that focuses on exuberant melisms. Of course, εἰλίσσουσα χεροῖν (1348) can be scanned as a dodrans. But according to the manuscripts, Aristophanes might have given to the syllable εἰ- four semi-quavers or six semi-quavers with triplets.

The next section (1352–55) is crowded with tragic repetitions typical of late Euripides.[100] The cock, in a long run of anapaests (1352a–b), has risen with his nimble wings to heaven (1352f., ὁ δ᾽ ἀνέπτατ᾽ ἀνέπτατ᾽ ἐς αἰθέρα/κουφοτάταις πτερύγων ἀκμαῖς), leaving the woman in distress (1353, ἐμοὶ δ᾽ ἄχε᾽ ἄχεα κατέλιπε) and in tears (1354f., δάκρυα δάκρυά τ᾽ ἀπ᾽ ὀμμάτων/ἔβαλον ἔβαλον ἁ τλάμων).

[97] See Aischylos *Persians* 201f. and *Tragica Adespota* 626.37–39 *TrGF*.

[98] Dover 1993 (see above, n. 24), 363f. on line 1340.

[99] See Sappho fr. 221 Lobel-Page, Alkaios 108 Lobel-Page (Horace *Carm.* 3.12), *Anthologia Palatina* 5.297.

[100] Dover 1993 (see above, n. 24), 358.

The woman's grief about her lost fellow—which is, of course, ironically exaggerated, given the relative importance of a cock—is displayed by a chain of iambic cola with many resolutions and ending with *catalexis* (1355).

The closing section (1356–63) is again marked off by ἀλλ' (cf. line 1338). At the beginning (1356–60), cretic cola occur with an interspersed lecythion (1358), aptly fitting the context. There follow dactylo-epitritic cola, a trochaic dimeter and two cretics with *catalexis*. The lonely woman summons Cretan archers from Mount Ida, Diktynna with her hounds, and Hekate with torches in hand in order to surround the neighbor's house: she is bound to make a house inspection for her cock in Glyke's home (1362–63: ὅπως ἂν εἰσελθοῦσα φωράσω).

Despite some allusions to extant tragedies (see above), there seems to be no specific target in this parody. Laetitia Parker has demonstrated that this monody "is not a consistent parody of any type of Euripidean monody, but rather a medley of specimens of almost every type,"[101] which is true metrically, but this does not exclude the possibility of a concrete target in Aristophanes' parody. Therefore, I should like to suggest that it is Euripides' *Stheneboia*.

Stheneboia was staged before 423 BC, and it is important to note that it was parodied frequently by Aristophanes.[102] Besides the ancient hypothesis[103] and a lacunose prologue,[104] ten further fragments exist,[105] as well as several vase-paintings, which are later than 420 BC.[106] Since the relevant myth was exploited by Homer, it was known to everyone.[107] The plot of the tragedy can be recovered:[108]

[101] Parker 1997 (see above, n. 28), 515.

[102] *Stheneboia* fr. 664 *TrGF*, parodied by Kratinos fr. 299 Kassel-Austin (423 BC) and Aristophanes' *Thesmophoriazousai* 401–4. For Aristophanes' *Wasps* 111f. and 1074, see *Stheneboia* frs. 665 and 663 *TrGF*; for *Peace* 124–26, see *Stheneboia* fr. 669 *TrGF*. *Frogs* 1217–19 = *Stheneboia* fr. 661, 1–3 *TrGF*.

[103] *Stheneboia* T IIa *TrGF*.

[104] *Stheneboia* fr. 661 *TrGF*.

[105] *Stheneboia* fr. 663–71 *TrGF*.

[106] *LIMC* VII 1994 "Proitos," 525, nos. 1–6.

[107] *Iliad* 6.152–211. There are some deviations from the *Iliad* in Euripides' tragedy: the father-in-law of Proitos, Iobates, is nameless in the *Iliad* (6.170, 173). He is king of Lykia (*Iliad* 6.168, 171–73), not of Karia (T IIa *TrGF*, lines 14 and 23). His elder daughter, the wife of Proitos, is named Anteia (*Iliad* 6.160), not Stheneboia. The *Iliad* does not refer to the winged horse Pegasos. Bellerophon has to defeat in Lykia the Chimaira, as well as the Solymoi, the Amazons, and an army of Lykian warriors (*Iliad* 6.179–90). After that, he marries the younger daughter of Iobates and remains founder of the dynasty of the Glaukides in Lykia (*Iliad* 6.179–99), whereas in Euripides' tragedy Bellerophon, after having defeated only the Chimaira with the help of Pegasos, returns with his winged horse to Tiryns.

[108] See U. von Wilamowitz-Moellendorff, *Kleine Schriften*, vol. 1, Berlin 1935, 274–81 ("De Euripidis Stheneboia"); U. von Wilamowitz-Moellendorff, *Kleine Schriften*, vol. 4, Berlin 1962,

Bellerophon, who had caught and tamed the winged horse Pegasos in Korinth, arrives in Tiryns, where he is purified of a blood guilt by King Proitos. The wife of Proitos, Stheneboia, the daughter of Iobates, the king of Karia, falls in love with Bellerophon, who refuses her advances. Having been accused of sexual harassment by Stheneboia, Bellerophon is sent by Proitos to Iobates, along with a sealed tablet (δέλτος) asking Iobates to bring about Bellerophon's death (*Stheneboia* T IIa. 13–17 *TrGF*). There are some vases dated after 420 BC that depict Bellerophon's farewell to Tiryns, with old king Proitos handing over a sealed scroll to him, who is accompanied by his winged horse, while in the background Stheneboia appears in deep distress.[109] Fragment 665 *TrGF* shows that Stheneboia's love is still alive. In fragment 664 *TrGF*, Stheneboia is afraid that Bellerophon has already died. After Bellerophon's happy flight to Karia, King Iobates, according to the fatal letter, gives him orders to defeat the Chimaira. Having killed her with the help of Pegasos, Bellerophon returns safe to Tiryns, where he narrates his adventures, accusing Proitos and Stheneboia of calumny and attempted murder. Fragment 665a *TrGF*—a fragment from this scene— proves that Pegasos was on stage in Tiryns. After a renewed ambush by Proitos, Stheneboia informs Bellerophon, who, feigning love, persuades her to flee with him back to Karia. In fragment 669 *TrGF*, Stheneboia warns Bellerophon against the dangerous traveling in mountainous Karia, but he informs her that they will fly on Pegasos. This is actually what they do, but near the island of Melos, Bellerophon throws Stheneboia down into the sea. Her corpse is eventually found by fishermen (fr. 670 *TrGF*) and delivered to Tiryns. Bellerophon, returning to Tiryns on the back of Pegasos, informs Proitos about Stheneboia's death, claiming for himself the justification of revenge. Proitos' last words recommend mistrust of all women (fr. 671 *TrGF*).

If Euripides' *Stheneboia* was the target in the parody of the relevant monody in *Frogs* 1331–63, we have to identify the cock (which has risen with its nimble wings to heaven) with Bellerophon on Pegasos on his flight to Karia, and the lonely woman (deploring the loss of her fellow) with Stheneboia. There is only one fitting place in Euripides' fragmentary tragedy for a monody by Stheneboia, her menacing dream, and her distress about the departure of Bellerophon on Pegasos. This is the night after Bellerophon's farewell, who was sent to Karia carrying the fatal letter by Proitos. Perhaps it is not by chance that this scene

528–41 ("Zum Lexikon des Photios"); W. Schmid and O. Stählin, *Geschichte der Griechischen Literatur*, vol. 3, Munich 1940, 390–92.
[109] *LIMC* VII 1994 "Proitos," no. 1, 2–6.

became a favorite motif of vase-painters after 420 BC. A monody by Stheneboia at this point of the play may have helped to cover the lapse of time between Bellerophon's departure to Karia and his return to Tiryns.

But who is Glyke, the neighbor of the lonely woman, who has stolen her winged companion and is threatened with a house inspection by an enormous mythological battalion? In the *Iliad* (6.192), we hear that Bellerophon, after his adventures, was married to a daughter of King Iobates. Did Stheneboia in Euripides' tragedy attack her younger sister, who was going to take Bellerophon away from her? But how could Stheneboia foresee the future? There remains the possibility that Proitos, in order to get rid of Bellerophon, promised him the younger daughter of his father-in-law, pretending that this was the basic content of the sealed letter to Iobates, and informing Stheneboia accordingly.

If the target of Aristophanes' parody in *Frogs* 1331–63 was a monody by Stheneboia from Euripides' *Stheneboia*, it appears that the comic effects of the parody are the result of the clash between tragic myth and high tragic diction on the one hand and elements of low social status on the other.[110] The tragic heroine Stheneboia has a dreadful dream. She then realizes (see the colloquial τοῦτ' ἐκεῖν') the theft of her cock, which humbly represents the tragic hero Bellerophon and his winged horse. The cock has been stolen by her neighbor Glyke. There is a Glyke who is a waitress in a brothel in Pherekrates' *Korianno*.[111] In *Thesmophoriazousai* 43, Aristophanes calls an Athenian housewife Glyke. Stheneboia's servant Mania bears a name common for slaves from western Asia Minor,[112] but also for *hetairai*.[113] Stheneboia herself is bound to sell woven flax in the morning at the market (1350–51), which is not the expected, proper behavior of a tragic heroine. The hounds of mythical Diktynna are addressed by the colloquial diminutive κυνίσκα.[114] And in the end, Cretan archers, Diktynna and Hekate are brought into the plot prosaically for a house inspection, as Attic law would prescribe.[115]

[110] Cf. Dover 1993 (see above, n. 24), 358, 363–65 (on lines 1340–45, 1341, 1363).

[111] Pherekrates *Korianno* fr. 76 Kassel-Austin (quoted in Athenaios 430e).

[112] Cf. Dover 1993 (see above, n. 24), 313 (on line 965).

[113] Machon at Athenaios 578–79.

[114] Dover 1993 (see above, n. 24), 358 (on line 1342 and 1359).

[115] Φωρᾶν is a term of Attic law: Dover 1993 (see above, n. 24), 365.

9. Conclusions

As I have shown in this chapter, Aristophanes did not adopt and exploit the controversy between "Old" and "New Music" as a subject for comedy before the *Clouds* (423 BC). In *Clouds*, the Clouds nourish the airy composers of dithyrambs. In the same play, the Right and Wrong arguments and, later, Strepsiades and Pheidippides quarrel about the Old and the New. In *Birds*, an old-fashioned poet and the modernist Kinesias are juxtaposed in an intriguing manner. The catchwords in this contest are καμπαί ("twisting of melodies") and ἀναβολαί (astrophic sections). Note that astrophic compositions were familiar to Aristophanes even earlier: the Phales hymn in *Acharnians* is a parody of an unknown cult song (see discussion above). As I have argued, in *Birds* the Hoopoe's monody explores the metrical liberty of "New Music," aiming only at the most naturalistic *imitation* of the music of birds. Agathon's duet in *Thesmophoriazousai* is an imitation of luxuriant "Ionic" rhythm and lascivious melody, and the comic effects of Andromeda's monody in the same play are based on the parodic use of the *text* of a Euripidean play. All these monodies share the familiar pattern of the "free form," insofar as they are articulated into sections of unequal length, marked off by content and meter. This holds true also for the frogs' lyric concert in *Frogs*, a dithyramb sung by animals, like the Hoopoe's monody. Furthermore, in the same play, the parody of Euripides' choral lyrics is again neatly structured into four sections, which lump together alcyons, spiders, dolphins, and erotic advances to a nonsensical entity. The comic effects of the parody of a monody from Euripides' *Stheneboia* are the result of the clash between high tragic style and elements of lower social status (see discussion above). In both cases, we have examples of the florid melodies of "New Music," which are characterized by melismatic style.

The systematic analysis of all these cases suggests that Aristophanes' polemics against Euripides is directed mainly against the content and thematic tendencies of his tragedies. As far as music is concerned, Aristophanes does not subscribe to one-sided crude attacks against "New Music" (as, for instance, Pherekrates does) but enjoys experimenting with the rhythmic and melodic achievements of "New Music" for the purposes of his own genre: comedy. If Aristophanes had been a poet and composer of *tragedies*, he might have written in the popular musical style of his lifetime, the style of the late Euripides and of Agathon, with which he was so profoundly acquainted.[116]

[116] Sections 7 and 8 of this chapter develop arguments advanced in a paper ("Aristophanes, Free

10. Metrical terminology

On metrical terminology in general, cf. L. P. E. Parker, *The Songs of Aristophanes*, Oxford 1997, XII–XVII.

Symbols

⌣	short syllable or position
–	long syllable; diseme, a position with the time value of two shorts
x	anceps position
o o	aeolic basis, where at least one position must be long
⌐	triseme, equivalent of – ⌣
⌐	triseme, equivalent of ⌣ –
⌐	tetraseme, equivalent of – –

Abbreviations

monom	monometer
dim	dimeter
trim	trimeter
cat	catalectic
sync	syncopated

Types of metron

an	anapaest: ⌣ ⌣ – ⌣ ⌣ –
ba	bacchiac: ⌣ – –
cr	cretic: – ⌣ –
cho	choriambic: – ⌣ ⌣ –
da	dactylic: – ⌣ ⌣
do	dochmiac: x – – x –
ia	iambic: x – ⌣ –
ion	ionic: ⌣ ⌣ – –
ion sync	syncopated ionic: ⌣ ⌣ ⌐

Form, and the Monody") I gave at the International Conference of the Ionian University in Kerkyra [Corfu], June 26–29, 2008.

| sp | spondee: – – |
| tro | trochaic: – ⏑ – x |

Dactylo-epitritic code

| D | – ⏑ ⏑ – ⏑ ⏑ – |
| e | – ⏑ – |

Aeolo-choriambic cola

adon	adonean: – ⏑ ⏑ – –
aeol da	aeolic dactyls: o o – ⏑ ⏑ – ⏑ ⏑ – ⏑ ⏑ – ⏑ ⏑ –
dod	dodrans: – ⏑ ⏑ – ⏑ – or – – – ⏑ ⏑ –
glyc	glyconic: o o – ⏑ ⏑ – ⏑ –
heptasyll	heptasyllable: x – ⏑ – ⏑ ⏑ –
hipp	hipponactean: o o – ⏑ ⏑ – ⏑ – –
pher	pherecratean: o o – ⏑ ⏑ – –
reiz	reizianum: x – ⏑ ⏑ – –
tel	telesillean: x – ⏑ ⏑ – ⏑ –

Other metrical cola

anac	anacreontic: ⏑ ⏑ – ⏑ – ⏑ – –
hem	hemiepes: – ⏑ ⏑ – ⏑ ⏑ –
ith	ithyphallic: – ⏑ – ⏑ – –
lec	lecythion: – ⏑ – x – ⏑ –

Chapter Three

The Economics, Poetics, Politics, Metaphysics, and Ethics of the "New Music"

Eric Csapo

THE CRITICS CRIED "INSURRECTION" AND "BUGGERY" with a vehe-
mence that dumbfounds the modern reader. The extant poetry associated
with the New Music contains no overt discussion of politics or ethics. Even the
music, so far as we can reconstruct it, is tame by modern standards. The furor
had less to do with what was performed than where, how, and by whom. In this
chapter, I examine three closely integrated aspects of the New Musical "revolu-
tion": its historical context (section 1), its style (section 2), and its reception
(sections 3–5). For us, the story of New Music is mainly the story of its recep-
tion by predominantly hostile contemporaries who attacked it on every ground
trodden by ancient cultural criticism: political (section 3), theological (section
4), and ethical (section 5).[1]

1. "Theater music," or the economics of New Music

The term "New Music," written as a proper noun, is useful but misleading. The
name Νέα Μουσική, or the like, never appears in antiquity as a genre concept

[1] In this chapter, I employ the following abbreviations for standard critical editions: *PMG*
(= D. L. Page, *Poetae Melici Graeci*, Oxford 1962); *TrGF* (= B. Snell, R. Kannicht and S. Radt,
Tragicorum Graecorum Fragmenta, 5 vols. [vol. 1, 2nd ed., 1986], Göttingen 1971–2004); *PCG*
(= R. Kassel and C. Austin, *Poetae Comici Graeci*, 8 vols., Berlin 1983–); *DAGM* (= E. Pöhlmann
and M. L. West, *Documents of Ancient Greek Music: The Extant Melodies and Fragments,* edited and
transcribed with commentary, Oxford 2001); Delattre (= D. Delattre, *Philodème de Gadara: Sur
la Musique, Livre IV*, 2 vols., Paris 2007); W[2] (= M. L. West, *Iambi et Elegi Graeci ante Alexandrum
cantati*, 2 vols., 2nd rev. ed., Oxford 1989–92).

or even an epoch style. Our term "New Music" is right insofar as the practitioners of the new style described their songs as "novel," or "modern" and opposed them to songs and styles that were "ancient," "old-fashioned," or "traditional."[2] The critics were even more insistent on the music's newness and difference. There was indeed a lot that was new, and there was a fetishization of novelty that was unprecedented, even if many of the innovations had precedents and even if claims of newness were in fact traditional in ancient Greek song.[3] But all these claims to novelty, justified or not, had a common feature that was undoubtedly new. What was really new about New Music was its performance venue. When they spoke generically of music in the "recent" or "modern" style, the ancient critics identified it as "theater music" or "stage music."[4]

It might be helpful to follow the ancient critics in thinking about this music as more "theater" than "new." New Music most affected the theatrical genres of drama and men's or boys' circular choruses (often "dithyramb" in popular speech and in the language of New Music's critics), which were performed in theaters at theatrical festivals.[5] The acknowledged champions of the new style were tragedians (Euripides and Agathon), or lyric poets (Phrynis, Melanippides, Kinesias, Timotheos, Philoxenos, Krexos, and Telestes) who were chiefly famous for dithyrambs and nomes. Nomes are instrumental pieces with or without solo

[2] See, especially, Timotheos *PMG* 791.202–3, 211–13, *PMG* 796; Euripides *Tr.* 512–15.

[3] A. D'Angour, "The 'New Music': So What's New?," in S. D. Goldhill and R. Osborne (eds.), *Rethinking Revolutions*, Cambridge 2006, 264–83; E. Csapo and P. Wilson, "Timotheus the New Musician," in F. Budelmann (ed.), *The Cambridge Companion to Greek Lyric*, Cambridge 2009, 282–83.

[4] Plato *Leg.* 700a–701d (discussed below); Aristotle *Pol.* 1342a.18; Aristoxenos frs. 26, 29 da Rios; Philodemos *De Mus.* 4, p. 67 Kemke and 13 Kemke (with H. Koller, *Die Mimesis in der Antike*, Bern 1954, 177–78); Ps.-Plutarch *De Mus.* 1140d–f, 1142d; Maximos of Tyre *Diss.* 37.4.80–89; Boethius *De Inst. Mus.* 1.1.

[5] Circular choruses probably did derive from dithyramb, historically, but official terminology was careful to distinguish the former theatrical entertainment from the cultic ritual. In popular speech, however, men's and boys' circular choruses might be called dithyrambs, and were more regularly called so by the critics of New Music, possibly because the term "dithyramb" epitomized New Music's Dionysian character (one of the primary targets of the critics' attacks). In this chapter, I generally conform to the practice of the ancient (and most modern) critics by referring to the Athenian "men's," "boys'," or "circular" choruses as "dithyrambs." The distinction, if sometimes tricky, is nonetheless significant: see E. Csapo and M. C. Miller, "General Introduction," in E. Csapo and M. Miller (eds.), *The Origins of Theater in Greece and Elsewhere: From Ritual to Drama*, New York 2007, 8–12; P. Wilson, "Performance in the *Pythion*: the Athenian Thargelia," in P. Wilson (ed.), *The Greek Theater and Festivals: Documentary Studies*, Oxford 2007, 168–69; D. Fearn, *Bacchylides: Politics, Performance, Poetic Tradition*, Oxford 2007, 161–224. A study of this problem by Atticus Cox is forthcoming.

song accompaniment, which, though strictly speaking not a theater genre, were generally composed by the same musicians who composed dithyrambs; they also came to be performed in theaters at large festival competitions. As we will see, the general influence of drama on the dithyramb and nome, indeed the "theatricality" of New Music in the broadest sense, was enough to justify the epithet "theater."

The rise of the theater in fifth-century Athens had a deep impact on the economics and sociology of musical patronage, performance, and spectatorship. With the building of massive theaters and the creation of annual theatrical festivals, certain kinds of musical performance increased in frequency and magnificence. In most democratic states public entertainment outgrew aristocratic patronage. At Athens, theatrical performance depended on a complex combination of public money, private patronage, admission charges (previously unknown at public entertainments), and the capital investment of publicly licensed entrepreneurs.[6] At the Great Dionysia alone, roughly 29 talents changed hands over the course of five days, more than Hipponikos, the richest man in Greece, could earn in as many years.[7] Only large states and powerful tyrants were in a position to finance theater.

Theater spread quickly.[8] By the end of the fifth century Attica had at least six annual theatrical festivals, at least fifteen or sixteen by the mid-fourth, and a minimum of eighteen or nineteen in the late fourth century.[9] By the last decades

[6] P. Wilson, "Costing the Dionysia," in M. Revermann and P. Wilson (eds.), *Performance, Iconography, Reception: Studies in Honour of Oliver Taplin*, Oxford 2008, 88–127; E. Csapo, "The Men Who Built the Theaters: Theatropolai, Theatronai, and Arkhitektones," in P. Wilson (eds.), *The Greek Theatre and Festivals: Documentary Studies*, Oxford 2007, 87–115.
[7] Cost of Dionysia: Wilson 2008 (see above, n. 6). Hipponikos: J. Davies, *Athenian Propertied Families 600-300 BC*, Oxford 1971, 260.
[8] Main discussions: R. Frederiksen, "The Greek Theater: A Typical Building in the Urban Centre of the Polis?," in T. E. Nielsen (ed.), *Even More Studies in the Ancient Greek Polis*, Stuttgart 2002, 65–124; E. Csapo, "Some Social and Economic Conditions Behind the Rise of the Acting Profession in the Fifth and Fourth Centuries BC," in C. Hugoniot et al. (eds.), *Le Statut de l'acteur dans l'antiquité grecque et romaine*, Tours 2004, 53–76.
[9] Inscriptions or reliable literary evidence guarantee the following latest dates for the inclusion of drama and/or dithyramb: Great Dionysia (ca. 508 BC); Lenaia (ca. 440 BC); Anthesteria (ca. 330 BC); Rural Dionysia at Anagyrous (ca. 440 BC), Ikarion (440-415 BC), Eleusis (late fifth century BC), Thorikos (ca. 400 BC), Akharnai (early fourth century BC), Salamis (early fourth century BC), Aixone (early fourth century BC), Kollytos (ca. 370 BC), Peiraieus (well before 346 BC), Aigilia (before mid-fourth century BC), Paiania (mid-fourth century BC), Halai Araphenides (341 BC), Myrrhinous (ca. 340 BC), Rhamnous (by late fourth century BC), Halai Aixonides (? by late fourth century BC).

of the fifth century theatrical festivals are attested in Makedonia and are prob-
able for Syracuse, Tarentum, Metapontum, Argos, Eretria, and Isthmia. They
were widespread in Greece by the mid-fourth century and ubiquitous by the late
fourth. We are less well informed about the spread of competitions for dithy-
ramb, but the little evidence we have shows a comparable pattern. "Men's" and
"boys'" circular choruses seem first to have begun when the Athenian democ-
racy converted dithyramb into a mass spectacle performed in the theater, around
508 BC.[10] Twenty of these new theater "dithyrambs" were included in the demo-
cratic reorganization of the Great Dionysia. In Attica, dithyrambic contests
spread quickly: to the Greater and Lesser Panathenaia, Thargelia, Hephaistia,
and Prometheia by the end of the fifth century; to three or four of the Rural
Dionysia by the fourth.[11] Outside Athens contests in the circular chorus are
attested in the fifth century at Delos and Delphoi, and by the end of the fourth
century at Thebes, Keos, Euboia, Iasos, and probably Thasos.[12]

All this suggests that from the last decades of the fifth century Athens was in
serious competition for top theatrical talent. For one, the tyrants of Makedonia
attracted many artists (allegedly Archelaos could afford to pay the epic poet
Choirilos a retainer of 400 drachmas a day), and made permanent residents of
New Music's best poets (Melanippides, Euripides, Agathon, and Timotheos).[13]
The received opinion that smaller festivals in Attica and Greece were content
to watch reperformances by wandering, second-rate artists is based only on a
passage of Plato, which exaggerates to make a rhetorical point, and is in any case
demonstrably refutable in several instances: even the Rural Dionysia secured
top talent and possibly new works.[14] It was perhaps the rising demand for good
performers that induced the Athenian state to assume directly the cost of poets,
actors and, possibly, pipers for its theater festivals.[15]

[10] Csapo and Miller 2007 (see above, n. 5), 8–12, with further literature.

[11] Old Oligarch, *Ath.Pol.* 3.4; G. Ieranò, *Il ditirambo di Dioniso*, Rome 1997, 49–73; P. Wilson, *The
Athenian Institution of the Khoregia: The Chorus, the City and the Stage*, Cambridge 2000, 32–40;
Wilson 2007 (see above, n. 5).

[12] Ieranò 1997 (see above, n. 11), 74–86; Wilson 2000 (see above, n. 11), 283–301.

[13] Plato *Rep.* 568a–b, *Symp.* 172c; Aristotle *Pol.* 1311b.33; Schol. on Aristophanes *Ra.* 83; Aelian
Var. Hist. 13.4; Suda *s.v.* "Melanippides." For Archelaos and the theater, see J. M. Bremer, "Poets
and their Patrons," in H. Hoffmann and A. Harder (eds.), *Fragmenta Dramatica: Beiträge zur
Interpretation der griechischen Tragikerfragmente und ihre Wirkungsgeschichte*, Göttingen 1991,
42–44. Choirilos' pay: Istros *ap.* Athenaios 345d. Makedonia and theater: E. Csapo, *Actors and
Icons of the Ancient Theater*, Malden, MA 2010, 99–100, 172–82.

[14] Csapo 2004b (see above, n. 8), 62–64, 70–73.

[15] Wilson 2008 (see above, n. 6), 106–8; A. W. Pickard-Cambridge, *The Dramatic Festivals of*

Leisure-class Athenians dominated dramatic poetry and were even promi-
nent among actors until the early fourth century. But by 440-430 BC theater
music was performed almost entirely by working-class foreign professionals.[16]
Pipers were the first to live entirely from the proceeds of the new mass enter-
tainment industry that would one day number 151 specialized trades.[17] Aristotle
maintains that gentlemen amateurs did cultivate pipe music in the pre- and
post-Persian War generations, and is even able to cite the case of a choregic-class
Athenian who piped in the comedy he himself sponsored in or after 457/454 BC;
but his statement that the following generation "rejected the pipes as unworthy
of free men" is a sufficient index of the growing importance of wage-earning
professionals.[18] The increased frequency, scale, and distribution of theatrical
entertainments now afforded musicians a comfortable living, while the theater's
very public and competitive arena conferred unprecedented opportunities for

Athens, 2nd rev. ed. J. Gould and D. M. Lewis, Oxford 1988, 75–76, 90, 93–95. For the payment
of poets, see further Bremer 1991 (above, n. 13), 54–56. Ps.-Plutarch *De Mus.* 1141c explicitly
connects the rise of New Music to the fact that pipers ceased to be paid directly by the poets.
Afterward, pipers were chosen and possibly paid by the state, since they, like the actors, were
assigned to the *chorêgoi* by lot (Demosthenes 21.13-14).

[16] There is great need for a sociological study of ancient actors. Sutton (D. F. Sutton, "The
Theatrical Families of Athens," *American Journal of Philology* 108 [1987], 9–26) is a step in the
right direction, but avoids the sociological questions and expresses pessimism about the pros-
pects of such a study. For actors and poets, see M. Kaimio, "The Citizenship of the Theater-Makers
in Athens," *Würzburger Jahrbücher für die Altertumswissenschaft* 23 (1999), 43–61; O. Taplin,
"Spreading the Word through Performance," in S. D. Goldhill and R. Osborne (eds.), *Performance
Culture and Athenian Democracy*, Cambridge 1999, 35. For pipers, see J. Kemp, "Professional
Musicians in Ancient Greece," *Greece and Rome* 13 (1966), 213–22; G. Nordquist, "Some Notes
on Musicians in Greek Cult," in R. Hägg (ed.), *Ancient Greek Cult Practice from the Epigraphical
Evidence: Proceedings of the Second International Seminar of Ancient Greek Cult, organized by the
Swedish Institute at Athens, 22-24 Nov. 1991*, Stockholm 1994, 81–93; A. Scheithauer, "Musik,
musikalische Bildung und soziales Ansehen im frühen Griechentum," *Archiv für Musikwissenschaft*
53 (1996), 1–20; A. Scheithauer, "Les aulètes dans le theater grec de l'époque hellénistique," *Pallas*
47 (1997), 107–27; P. Wilson, "The *Aulos* in Athens," in S. D. Goldhill and R. Osborne (eds.),
Performance Culture and Athenian Democracy, Cambridge 1999, 74–75.

[17] R. Wallace, "Speech, Song and Text, Public and Private: Evolutions in Communications Media
in Fourth-Century Athens," in W. Eder (ed.), *Die athenische Demokratie im 4. Jahrhundert v. Chr.:
Vollendung oder Verfall einer Verfassungsform?*, Stuttgart 1995, 209–11; A. Chaniotis, "Zur Frage der
Spezialisierung im griechischen Theater des Hellenismus und der Kaiserzeit auf der Grundlage
der neuen Prosopographie der dionysischen Techniten," *Ktema* 15 (1990 [1994]), 89–109. Note
that when Aristophanes (*PCG* 696) has Aischylos say "I devised the dance figures for the chorus
myself" this is implicit evidence for a class of professional *chorodidaskaloi* in Aristophanes', not in
Aischylos', day (as Anderson [W. D. Anderson, *Music and Musicians in Ancient Greece*, Ithaca, NY
1994, 119] supposed).

[18] Aristotle *Pol.* 1341a 26–39; Wilson 1999 (see above, n. 16), 93–95.

musicians to acquire a level of celebrity and social status that an entrenched birth-elite might well envy. By the last quarter of the fifth century, theater pipers were competing for professional distinction internationally.[19] The appearance of pipers' names, even before the poets', on choregic inscriptions, is testimony to the growth of the piper's status and independence in the early fourth century.[20] The famous piper Pronomos sits just below the couch of Dionysos at the very center of a vase-painting of about 400 that presents a cast portrait in the style of a votive painting commemorating a dramatic victory (fig. 1).[21] The fact that the name of Pronomos' son, Oiniades, is inscribed, uniquely for a piper, with patronymic on two Athenian monuments shows just how much clout the new professional dynasts could wield.[22]

Figure 1: The "Pronomos Vase," an Attic red-figure volute-krater, Pronomos Painter, ca. 400 BC.

Pipers are the unsung heroes of the New Music. They most felt the economic pressures for virtuosity and innovation that characterized New Music, and it was doubtless these (for the most part anonymous) professionals who introduced many of the technical innovations in music and instruments that ancient tradition ascribes to the better-known poets: at any rate, of the very few pipers whose names are preserved, Pronomos and Antigeneidas were credited with the most significant technical innovations to the pipes.[23] Because pipers never specialized

[19] Kemp 1966 (see above, n. 16), 218; M. L. West, *Ancient Greek Music*, Oxford 1992, 366–68.

[20] Wilson 2000 (see above, n. 11), 214.

[21] Naples, NM H 3240; *ARV2* 1336 (Pronomos Painter); see O. Taplin and R. Wyles (eds.), *The Pronomos Vase and Its Context*, Oxford 2010 and in particular the essays by E. Csapo, "The Context of Choregic Dedication," and P. Wilson, "The Man and the Music (and the Choregos?)," in Taplin and Wyles 2010 (see above, n. 21).

[22] Wilson 2000 (see above, n. 11), 215.

[23] J. Landels, *Music in Ancient Greece and Rome*, London 1999, 29–30, 36, and further bibliog-

in any single theatrical genre, as did almost all other theater professionals—poets, actors, and chorus-trainers, they were ideally placed to transmit musical ideas between genres, and in particular between nome, drama and dithyramb.[24]

Theater changed music as it changed the piping profession. Aristocratic patronage was tradition bound and more "sponsor directed."[25] It was now replaced by a complex consortium of interests that paid the piper, but lacked sufficient coherence to call his tune. It was rather the dictates of the "star system" that demanded novelty and virtuosity in conspicuous display. "New Music" was chiefly characterized by innovation, variety, versatility and a highly "theatrical" performance style. The piper was no longer content to serve the chorus or even soloists as an invisible backdrop or to limit music's contribution to a mere accompaniment.

The new focus on the pipes, rather than the traditional lyre, facilitated a large number of formal innovations that increased music's variety and subtlety of expression.[26] The rage for innovation resulted in technical improvements to increase the range and versatility of the pipes, *kithara*, and lyre. Musicians added new notes and intervals to the traditional scales, introduced new modes, and created new octave species or genera. At the same time, they broke free of traditional rules of consistency and formal symmetry. They dissolved the unity of the vocal and instrumental lines, allowing themselves some room to experiment

raphy, below n. 64.

[24] There is no certainly attested case in antiquity of the same poet writing in both tragedy and comedy: see B. Seidensticker, *Palintonos Harmonia*, Göttingen 1982, 14 (no sure counterexample arises from K. Rothwell, "Was Carcinus I a Tragic Playwright?," *Classical Philology* 89 [1994], 241–45; see the reply by S. D. Olson, "Was Carcinus I a Tragic Playwright? A Response," *Classical Philology* 92 [1997], 258–60). We hear of some poets who produced both tragedy and circular choruses: Ion of Chios (*TrGF* 19, T 2a–b, 3); Hippias of Elis, a famous Jack-of-All-Trades (Plato *Hipp. Min.* 368c–d); Anaxandrides (Chamaileon fr. 43 Wehrli); Dikaiogenes (Harpokration *s.v.* Dikaiogenes; Suda δ 1064; Philodemos *De Poem.* 4 col. 10). It is not until 100 BC that we find actors performing in both tragedy and comedy (Seidensticker 1982 [see above, n. 24], 15–16; P. Ghiron-Bistagne, *Recherches sur les acteurs dans la Grèce antique*, Paris 1976, 135). Even whole theatrical families seem never or almost never to have mixed genres (Sutton 1987 [see above, n. 16], 10). Pipers by contrast specialized late and far less: see Scheithauer 1997 (above, n. 16), 113–14.

[25] Bremer 1991 (see above, n. 13), 59.

[26] The best general survey is West 1992 (see above, n. 19), 356–72. The essays in S. Hagel and C. Harrauer (eds.), *Ancient Greek Music in Performance*, Vienna 2005, are helpful on technical points: see the essays by J. C. Franklin, "Hearing Greek Microtones," 9–49, and S. Hagel, "'Twenty-four in Auloi:' Arist. *Met.* 1093b, the Harmony of the Spheres, Another Formation of the Perfect System," 51–91.

with harmonic effects, counterpoint, and ornament.[27] They moved freely from one mode to another, and from one rhythm to another, within a single composition.[28] Versatility was enhanced by discarding the structure of strophic responsion in favor of an astrophic "free" verse. An ancient theorist speaks of liberating the music for the greater mimetic powers of professional actors and musicians.[29]

Dithyramb hosted the most radical innovations. It stood between the nome and drama and borrowed musical ideas from each. The nome allowed greater scope for musical virtuosity since it was either purely instrumental (auletic and kitharistic nomes) or, if it involved solo song by the musician (kitharodic nome) or an accompanist (aulodic nome), nonetheless came to include large segments of purely instrumental music. The nome first developed an astrophic and polymetric "free" form at a time when other genres had strophic responsion. Melanippides, who composed in both genres, is said to have been the first to abandon strophic response in dithyramb and vary the choral performance with instrumental and vocal solos, including solos accompanied by the lyre in place of the traditional pipes.[30] But for its narrative and performance style, New Music borrowed directly from drama. Boardman argues that Melanippides first incorporated solos in *Marsyas*, a dithyramb narrating the contest for musical supremacy between Apollo and Marsyas, in turn displaying the god's virtuosity on the lyre and the satyr's skill on the newly invented pipes.[31] If so, the mythical contest was not merely narrated by the chorus but acted by the musicians in the style of a dramatic *agôn*. This would be the first known occurrence

[27] A. Barker, "*Heterophonia* and *Poikilia*: Accompaniments to Greek Melody," in B. Gentili and F. Perusino (ed.), *Mousikê: Metrica, ritmica e musica greca in memoria di Giovanni Comotti*, Pisa and Rome 1995, 41–60.

[28] Modulation: S. Hagel, *Modulation in altgriechischer Musik: Antike Melodien im Licht antiker Musiktheorie*, Frankfurt 2000; J. C. Franklin, "Diatonic Music in Greece: A Reassessment of its Antiquity," *Mnemosyne* 56 (2002), 693–98; J. C. Franklin, "'Songbenders of Circular Choruses:' Dithyramb and the 'Demise of Music,'" in B. Kowalzig and P. Wilson (eds.), *Dithyramb in Context*, Oxford, forthcoming. Rhythm: Aristophanes *Thesm.* 121; Dionysios of Halikarnassos *Comp.* 19; C. Kugelmeier, *Reflexe früher und zeitgenössischer Lyrik in der alten attischen Komödie*, Stuttgart and Leipzig 1996, 228–29 (with further literature); M. L. West, "Metrical Analyses: Timotheus and Others," *Zeitschrift für Papyrologie und Epigraphik* 45 (1982), 1–13.

[29] Ps.-Aristotle *Pr.* 918b.

[30] Aristotle *Rh.* 1409b; A. Barker, *Greek Musical Writings. Vol. 1: The Musician and his Art*, Cambridge 1984, 93; West 1992 (see above, n. 19), 205–6.

[31] J. Boardman, "Some Attic Fragments: Pot, Plaque and Dithyramb," *Journal of Hellenic Studies* 76 (1956), 19. See also Wilson 1999 (see above, n. 16), 66–68; cf. T. Power, "*Kyklops Kitharoidos*," in Kowalzig and Wilson, forthcoming (see above, n. 28).

of a general trend toward dramatic mimesis in choral and musical performance. Dramatization offered musicians an opportunity to display their virtuosity *conspicuously,* emerging from the background to stand virtually as actors, at the focal point of the narrative as well as the performance.

Musicians were eager for a larger presence in the theater and a larger share of the audience's attention. Theophrastos names the pipers Andron of Katane and Kleolas of Thebes as the "first inventors" of the rhythmic gyrations of the body that were commonplace by his day.[32] Pronomos is said to have "delighted his audience somewhat excessively both with his facial expressions and with the movements of his entire body."[33] Some pipers used dramatic effects to insert themselves more fully into a choral narrative. Timotheos' piper imitated a storm at the climax of *Nauplios,* the screams of a woman in labor in *The Birth Pangs of Semele,* and made a mime of dragging off the *koryphaios* in *Skylla,* doubtless while reproducing the monster's wild hisses and roars through his instrument.[34] Aristotle complains of "vulgar" pipers who wheeled about in imitation of a discus, and elsewhere blames such showmanship on the tastes of "a vulgar audience [that] tends to debase music, so that it makes even musicians performing for it take on a certain character and transforms their bodies through movement."[35] Even the piper's costume could play a mimetic role: Antigeneides is said to have worn appropriately effeminate shoes and a *krokotos* while piping for Philoxenos' *Komast.*[36]

The poets encouraged this kind of role-playing by musicians. It offered them an opportunity to incorporate musical ideas that were beyond the range of the average large volunteer chorus (as all choruses were at Athenian festivals, at least until 317 BC). The Pratinas fragment, which should probably be

[32] Theophrastos fr. 92 Wimmer; I. Stephanis, Διονυσιακοὶ Τεχνῖται, Herakleion 1988, 50, 262.

[33] Pausanias 9.12.5-6.

[34] Athenaios 338a, 352a; Dion Chrysostomos 78.32; Aristotle *Poet.* 1461b.30. Cf. the νίγλαροι with which Timotheos is said (by Pherekrates *PCG* 155) to have filled Music. On νίγλαροι, see D. Restani, "Il *Chirone* di Ferecrate e la 'nuova' musica greca," *Rivista italiana di musicologia* 18 (1983), 186–90; West 1992 (see above, n. 19), 362 and n. 26; M. Telò, *Eupolidis Demi,* Florence 2007, 285–90. The nome had already developed some trivial forms of performative mimesis. As early as 586 BC, Sakadas displayed his virtuosity in performing the *Pythikos Nomos* by imitating the sounds of gnashing teeth and hissing serpents on the pipes when narrating Apollo's battle with the snake Pytho: see West 1992 (see above, n. 19), 213–14.

[35] Aristotle *Poet.* 1461b.30, *Pol.* 1341b.15–18.

[36] Suda *s.v.* "Antigeneides." Cf. West 1992 (see above, n. 19), 367. For komastic transvestism, see M. C. Miller, "Reexamining Transvestism in Archaic and Classical Athens: The Zewadski Stamos," *American Journal of Archaeology* 103 (1999), 223–53.

dated to the late fifth century, presents a self-referentially musicological *agôn* in which the piper contends with a chorus of satyrs for the hegemony of music over words.[37] In Aristophanes' *Birds* the piper took on the role of the nightingale in an explicit parody of the New Musical style.[38] Late fifth- and early fourth-century comedy shows a clear trend toward "metatheatrical" inclusion of the piper in the performance.[39]

The poets of dithyramb experimented with other means of enhancing the musical and dramatic quality of their compositions—generally at the cost of the chorus's traditional unity. In the dithyramboid hymn by pseudo-Arion, an "Arion," possibly the *koryphaios*, seems to interact with the rest of the chorus who play the part of dolphins.[40] Role differentiation is also apparent in the lyric duet sung by "Agathon" and his chorus in Aristophanes' parody of Agathonian New Music in *Thesmophoriazousai*.[41] In his *Kyklops* Philoxenos went a stage

[37] *TrGF* 4, fr. 3. For a late fifth-century date, see, among others, H. Lloyd-Jones, "Problems of Early Greek Tragedy," *Cuadernos de la Fundación Pastor* 13 (1966), 11–33; Webster in A. W. Pickard-Cambridge, *Dithyramb, Tragedy and Comedy*, second revised ed. T. B. L. Webster, Oxford 1962, 17–20; B. Zimmermann, "Überlegungen zum sogenannten Pratinasfragment," *Museum Helveticum* 43 (1986), 145–54; R. Hamilton, "The Pindaric Dithyramb," *Harvard Studies in Classical Philology* 93 (1990), 211–22. An early date is supported by R. Seaford, "The 'Hyporchema' of Pratinas," *Maia* 29-30 (1977–78), 81–94; R. Seaford, *Euripides: Cyclops*, Oxford 1984, 13–14; R. Seaford, *Reciprocity and Ritual: Homer and Tragedy in the Developing City-State*, Oxford 1994, 268 n. 349; M. J. H. van der Weiden, *The Dithyrambs of Pindar*, Amsterdam 1991, 5–7; West 1992 (see above, n. 19), 343; Ieranò 1997 (see above, n. 11), 219–26; M. Napolitano, "Note all' iporchema di Pratina (*PMG* 708 = *TrGF* I 4 F 3)," in A. Cassio et al. (eds.), *Synaulia: Cultura musicale in Grecia e contatti mediterranei (AION filol.-lett.* 5), Naples 2000, 111–55; A. Barker, *Euterpe: Ricerche sulla musica greca e romana*, Pisa 2002, 56; P. Cipolla, *Poeti minori del drama satiresco*, Amsterdam 2003; L. Prauscello, "'Epinician Sounds' and their Reception: Pindar and Musical Innovation," in P. Agocs et al. (eds.), *Reading the Victory Odes*, Cambridge (forthcoming 2012). The piece is described as a "hyporcheme" by Athenaios who quotes it (617b–f). In Plato's *Ion* 534c, where the term is first attested, this is not a genre, but a mode of composition found in dithyramb, *enkomion*, epic, and iambic poetry.

[38] A. Barker, "Transforming the Nighingale: Aspects of Athenian Musical Discourse in the Late Fifth Century," in P. Murray and P. Wilson (eds.), *Music and the Muses: The Culture of "Mousikê" in the Classical Athenian City*, Oxford 2004, 185–204.

[39] O. Taplin, *Comic Angels and Other Approaches to Greek Drama through Vase-Paintings*, Oxford 1993, 70–78.

[40] *PMG* 939; see E. Csapo, "The Dolphins of Dionysus," in E. Csapo and M. C. Miller (eds.), *Poetry, Theory, Praxis: The Social Life of Myth, Word and Image in Ancient Greece*, Oxford 2003, 69–98 with further literature. C. M. Bowra, "Arion and the Dolphin," *Museum Helveticum* 20 (1963), 128–29 supposes that the part of Arion is played by an actor.

[41] Aristophanes *Thesm.* 101-29. Cf. P. Mureddu, "Il poeta dramatico da didaskalos a mimetes: alcuni aspetti della critica letteraria in Aristofane," *Annali dell'Istituto universitario orientale di Napoli* sez. filol.-lett. 4/5 (1982–83), 84.

further in introducing an actor to play the part of the Kyklops and to sing a monody to the *kithara*, a duet with the chorus, and possibly a duet with a second actor playing Odysseus.[42] Aristophanes' parody of the Philoxenos has the actor switching from the role of Polyphemos to that of Kirke, while the chorus switch from the role of Polyphemos' sheep and goats to that of Odysseus' companions turned into pigs.[43] The dithyramb had become fast-clip operatic drama.

Krexos mixed genres still further by introducing the recitative verse of drama into the dithyramb.[44] Even the kitharodic nome became more dramatic, and certainly more dithyrambic.[45] Timotheos famously used a *kithara* with many more strings than the traditional, expanding its range to rival the pipes;[46] he altered the kitharodic nome's stately language to give it the pathos and volubility of the dithyramb;[47] he is even said to have given it a chorus.[48] Plato, in his complaint about genre-mixing in *Laws* (700d), specifically mentions "poets who imitated pipe-music on the *kithara*." The influence of drama is also apparent in the preference in New Musical nome and dithyramb for dramatic narrative in direct speech, developing a feature that goes back at least to Bacchylides.[49]

[42] *PMG* 819, 820; Ps.-Plutarch *De Mus.* 1142a = Aristophanes *PCG* 953; D. F. Sutton, "Dithyramb as Δρᾶμα: Philoxenus of Cythera's *Cyclops or Galatea*," *Quaderni Urbinati di Cultura Classica* 13 (1983), 37–43.

[43] Aristophanes *Pl.* 290–321; Mureddu 1982–83 (see above, n. 40), 79; G. Dobrov and E. Urios-Aparisi, "The Maculate Muse: Gender, Genre, and the *Chiron* of Pherecrates," in G. Dobrov (ed.), *Beyond Aristophanes: Transition and Diversity in Greek Comedy*, Atlanta 1995, 168–70.

[44] Ps.-Plutarch *De Mus.* 1141a–b; Philodemos *De Mus.* 4.6 (Neubecker, = X 1 ff. Kemke); Pickard-Cambridge 1962 (see above, n. 37), 54; for a different view of the Philodemos passage, see Neubecker *ad loc.*

[45] T. Power, *The Culture of Kitharoidia*, Washington, DC 2011, 57.

[46] Pherekrates *PCG* 155; Pausanias 3.12.9-10; Athenaios 636e; Proklos *Chrest.* in Photios *Bibl.* 320a 33ff.; Nikomachos *Harm.* 274.5. The sources sometimes exaggerate Timotheos' role in ascribing the addition of strings as a technical innovation to the *kithara*, but eleven strings were used as early as Ion of Chios and Phrynis had also experimented with a larger than normal range: see Ion fr. 32 W², Plutarch *Prof. virt.* 84a, *Agis* 10; Csapo and Wilson 2009 (see above, n. 3), 283–85; T. Power, "Ion of Chios and the Politics of Polychordia," in V. Jennings and A. Katsaros (eds.), *The World of Ion of Chios*, Leiden 2007, 179–205. For artistic representations of multi-stringed kitharas: see the kalyx-krater by the Peleus Painter, Ferrara T 617, *ARV2* 1038.1 (ca. 440–430 BC) and the oinochoe by the Meidias Painter, Ruvo, Jatta 1538, *ARV2* 1314.16 (420–410 BC).

[47] Ps.-Plutarch *De Mus.* 1132d. Phrynis had already made significant moves in this direction: H. Schönewolf, *Der jungattische Dithyrambos: Wesen, Wirkung, Gegenwirkung*, Diss. Giesen 1938, 28.

[48] Clement of Alexandria *Strom.* 1.79.1, reasonably doubted by Power forthcoming (see above, n. 31).

[49] Direct quotation in New Music: S. Bassett, "The Place and Date of the First Performance of the *Persians* of Timotheus," *Classical Philology* 26 (1931), 161; W. Kranz, *Stasimon: Untersuchungen zu Form und Gehalt der griechischen Tragödie*, Berlin 1933, 259; G. Brussich, "La lingua di Timoteo,"

Small wonder then that Aristotle lumps the nome and dithyramb together with tragedy and comedy in classifying mimetic arts that use all the modes of musical mimesis, or that he freely cites examples from dithyramb in his discussions of dramatic mimesis.[50]

Even dramatic music became more mimetic and more histrionic. The late plays of Euripides contain frequent astrophic and polymetric monodies. As the Aristotelian *Problems* (918b) observes, the greater complexity of astrophic and polymetric music favors trained actors over amateur citizen choruses. The extant Sophokles has no or little actor's monody; in all but six tragedies Euripides has one or two, mostly from plays datable to the late 420s onward.[51] There is also an increase in duets between actor and chorus, and particularly an increase in astrophic and freely structured lyric exchanges: Popp finds the later forms of Euripidean exchanges "strongly influenced by monody," and characterized by "mimetic elements and musical effects."[52] Doubtless the actors were as keen as the musicians to display their musical talents. These developments go a long way toward explaining the dwindling importance of the dramatic chorus to late fifth-century drama. But even the choral odes came under the spell of New Music. Astrophic choral song appears in later Euripides and is ascribed to Agathon by Aristophanes' parody in *Thesmophoriazousai*, while strophic stasima have increasingly lengthy astrophic epodes.[53] The poetry of many later Euripidean odes reproduces the New Musical style as we know it from the fragments of dithyramb and nome, from information given by the critics, and from comic parodies. I will argue that this New Musical style, to which we now turn our

Quaderni triestini per il lessico della lirica corale greca 1 (1970), 76–77; O. Panagl, "Zur Funktion der direkten Reden in den dithyrambischen Stasima des Euripides," *Wiener Studien* 6 (1972), 5–18; J. Herington, *Poetry into Drama: Early Tragedy and the Greek Poetic Tradition*, Berkeley, CA 1985, 154 and 156–57; B. Zimmermann, "Gattungsmischung, Manierismus, Archaismus, Tendenzen des griechischen Dramas und Dithyrambos am Ende des 5. Jahrhunderts v. Chr.," *Lexis* 3 (1989), 39–54; J. Porter, *Studies in Euripides' "Orestes,"* Leiden 1994, 203.

[50] Aristotle *Poet.* 1447b.24-7, 1454a.30–31. Cf. G. Kirkwood, *Early Greek Monody: The History of a Poetic Type*, Ithaca, NY 1974, 87; Csapo and Wilson 2009 (see above, n. 3), 289.

[51] E. Csapo, "Later Euripidean Music," *Illinois Classical Studies* 24–25 (1999–2000), 407; M. Pintacuda, *La musica nella tragedia greca*, Cefalù 1978, 165–66; G. A. Privitera, " Aspetti musicali nella storia del ditirambo arcaico e tardo-arcaico," *Annali dell'Istituto universitario orientale di Napoli* sez. filol.-lett. 13 (1991), 153.

[52] H. Popp, "Das Amoibaion," in W. Jens (ed.), *Bauformen der griechischen Tragödie*, Munich 1971, 229, 264–73 (quotation p. 273). Sophokles has only two astrophic exchanges (*Tr.* 871–95, *TrGF* 210.29–56 (*Eurypylos*) and two astrophic epodes following strophic exchanges, both from his latest plays (*Ph.* 1169–1217, *OC* 208–53).

[53] Csapo 1999–2000 (see above, n. 51), 407.

attention, is conditioned, even in its more minute idiosyncrasies, by the material and economic conditions of theater-performance in the later fifth and fourth centuries.

2. Pipe music, or the poetics of New Music

Economic forces encouraged theater pipers to develop their showmanship, originality and virtuosity in performance. This meant an enormous expansion in dithyramb and drama of the range and intensity of those effects that only music, and especially pipe music, could produce. New Musical poets attempted to maximize the musical element in song, both by giving the musician free rein to strut his expertise and by writing in a style calculated to complement and often to highlight the music, encouraging mimetic play between voice and pipes, words and sounds, verse and musical form.

The double-*aulos* ("pipes") might be called the "material cause" of the new style. Peter Wilson has shown how stark a contrast Athens drew between the pipes and stringed instruments, especially the lyre.[54] Though heavily over-determined by ideological divisions within Athens, the opposition was not without some foundation in the real or perceived nature of the pipes. They were contrasted with strings both for their limitations and their versatility.

The most bruited limitation of the pipes is that they, unlike strings, stop the mouth. This could be interpreted as robbing a performer of his *logos* (speech and reason) and hence of the instrumentality of the free citizen. Aristotle is explicit on both counts: the pipes are not to be used in education because pipe music is "orgiastic" and because "it hinders the use of one's *logos.*"[55] Indeed the voice of another, of the pipes themselves, is said to emanate from the player's mouth, speaking with a tongue that is not the player's tongue (the reed, called *glôtta,* "tongue," is inserted into the player's mouth). At the same time the pipes also disfigure the face: the lips are puckered, the cheeks puffed out, so that the face becomes bloated like a mask or *gorgoneion* and unrecognizable (this is why both Athena and Alkibiades rejected them).[56] The pipes thus at once obliterate voice, reason, identity and individuality. For this reason pipers are often represented frontally in ancient Greek vase-painting, normally an index of an extraor-

[54] Wilson 1999 (see above, n. 16); "Euripides' 'Tragic Muse,'" *Illinois Classical Studies* 24–25 (1999–2000), 427–50; "Athenian Strings," in Murray and Wilson 2004 (see above, n. 38), 269–306.

[55] Aristotle *Pol.* 1341a; Wilson 1999 (see above, n. 16), 85–95.

[56] Wilson 1999 (see above, n. 16), 59–64, 87–91.

dinary state of mind, and especially possession, and normally possession by Dionysos.[57] In addition to the mind and face, they destroy the symmetry of the body, protruding awkwardly, and setting it in motion, like a tail wagging a dog or, rather, like the Dionysiac phallus, invading and controlling its possessor.[58] Stringed instruments by contrast embellish the voice of the player, sit with Apollonian grace on the body, decorously respect its contours, and extend, rather than diminish its control.

The critics of New Music developed these oppositions. They treated it as a reversal of the traditional hierarchy of *logos* (= word/logic/argument) over sound. "A song is *logos*," Plato insists, "and mode and rhythm are to follow the words" (*Rep.* 398d). Music was, and should be, nothing more than a "sweetener" added to language (Ar. *Poet.* 1449b.28-29). The opposition of song and music appears already in the "hyporcheme" ascribed to Pratinas: "The Muse made song queen. Let the pipes dance in her train. It is a servant."[59]

Most often, however, it is the greater versatility of the pipes that emerges from any contrast between them and stringed instruments. Stringed instruments have only a limited number of notes (in performance, musicians normally did not change the length or tension of their strings, which they played open). Even a standard concert-*kithara* had only seven strings (which New Musicians increased to eleven or twelve). By contrast, a piper could produce many times that number of notes, while his lips and breath worked together to produce a far greater range in volume and tone color.[60] Plato knew the pipes as the "most many-

[57] See, especially, Plato *Symp.* 215c; Aristotle *Pol.* 1342b; Wilson 1999 (see above, n. 16); E. Csapo, "Riding the Phallus for Dionysus: Iconology, Ritual and Gender-Role De/construction," *Phoenix* 51 (1997), 257.

[58] For the phallic conception of the pipes, see Wilson 1999 (see above, n. 16), 69–70, 72, 83; for the Dionysiac conception of the phallus, see Csapo 1997 (see above, n. 57). Note that some ancient theorists thought erections caused by an influx of air: T. Hopfner, *Das Sexualleben der Griechen und Römer*, Prague 1930, sec. 2.2.

[59] We should be cautious about thinking that Pratinas concurs with this vindication of the sovereignty of the verbal over the musical line. The piece is written in a New Musical style, and is probably a dithyramb. The words are spoken by a chorus of satyrs who are better suited to parody elite critics than to serve as bona fide champions of Apollonian *logos*; moreover, the claim that the Dorian mode (or style?) is most appropriate for Dionysos has troubled many scholars who are inclined to take the satyrs' criticisms at face value. The fragment preserves only the chorus's side of a debate with the piper, who may well have clinched the argument by responding with a virtuoso performance.

[60] Landels 1999 (see above, n. 23), 34–36; A. Barker, "Text and Sense at *Philebus* 56a," *Classical Quarterly* 37 (1987), 106–7 (referring especially to Aristoxenos *Harm.* 43.1-6; Theophrastos *HP* 4.11.1–7).

noted" of instruments.[61] Indeed, their range might be perceived as not merely great but absolute: the pipes were described as capable of emitting all sounds and voices, and as a result were deemed the most mimetic of instruments.[62] The New Musicians made a virtue of the pipes' natural versatility: Euripides is said to have "first used a large range of notes" and "many more genera and more variety than his predecessors."[63] Pronomos further enhanced the versatility of the pipes by a device that permitted quick shifts, possibly a rotating collar that blocked and opened holes, so that the same pair of pipes could play in all modes.[64]

Closely related is a third distinctive feature of the *aulos,* its volubility. Once the lyre or *kithara* was tuned, each string produced a clear, distinct and invariable sound. But the advance tuning of the *aulos* through the adjustment of the reed was just one of several factors contributing to the pitch and quality of its notes. Unlike the sound of strings, the sound produced by pipes—notoriously—depended on factors present only at the moment of performance: not just the lingering but the pressure of the performer's breath, and the tension and position of the lips on the reed.[65] These factors were variable from moment to moment and so too were the actual sounds produced when one attempted to "capture" or "hit" a note. Aristoxenos finds the pipes useless for the theoretical study of harmonics since pipers "for the most part fail to attain the proper tones," and indeed "every sound produced by the pipes alters in accordance with the agencies through which it is produced."[66] To Plato, this volubility in performance made the "whole art of pipe-playing" a matter of practiced guesswork involving "a great deal that is uncertain/indistinct (τὸ μὴ σαφές) mixed into it and little that is sure/stable (τὸ βέβαιον)."[67] The pipes' reputation for indistinctness and instability was only made worse by the remarkable fact that, by contrast to the distinct and clearly articulated tones of stringed instruments, the pipes can glide from one note to another, giving the impression of a constant and confused flux of sound. Plato likened pipe music to a beast in flight: "the whole art of

[61] Plato *Rep.* 399d. Cf. Pindar *Ol.* 7.11–12, *Pyth.* 12.19-21, *Isth.* 5.27; *PMG* 947 (Simonides?); Ps.-Plutarch *De Mus.* 1141c.

[62] Pindar *Pyth.* 12.19 (πάμφωνον); Plato *Rep.* 399d 4; Wilson 1999 (see above, n. 16), 92–93.

[63] Anon. *On Tragedy* 5.39 Browning.

[64] Pausanias 9.12.3; Athenaios 631c; West 1992 (see above, n. 19), 87; Landels 1999 (see above, n. 23), 29–30, 36; Hagel 2005 (see above, n. 26), 88–89; D'Angour 2006 (see above, n. 3).

[65] Barker 1987 (see above, n. 60), 106–7.

[66] Aristoxenos *Harm.* 54.2–4 da Rios (adapting the translation of A. Barker, *Greek Musical Writings. Vol. 2: Harmonic and Acoustic Theory,* Cambridge 1989, 158). For Aristoxenos on pipes, see Franklin 2005 (see above, n. 26), 16–19.

[67] Plato *Phlb.* 56a7, with the crucial discussion by Barker 1987 (see above, n. 60).

pipe-playing hunts the proper pitch of each note [i.e., of each and every note during actual performance] by shooting at it as the note moves."[68] The sentiment was strongly endorsed by Aristoxenos: "pipes are in flux and never stay the same"; "more than any other instrument they wander, because of the craft of pipe-making, because of manual techniques, and because of their own peculiar nature."[69] There are thus two types of perpetual movement that characterize the pipes: one arising from an inability to control the production of notes to reproduce exact tones; the other arising from the constant flux of sound as it glides from one note to the other. By nature Dionysiac, the pipes are like satyrs, the auletes of myth, whom Lissarrague describes as being in "perpetual movement, as though they were incapable of controlling their bodies."[70] In contrast to the notes of the pipes, the notes of strings were thought stable and precise: the Aristotelian *Problems* recommends pipe-accompaniment to the voice, especially for bad singers, since the dissimilarity and precision of the lyre would make the singers' errors more conspicuous, as if measuring them against a "yardstick."[71]

The fourth distinctive feature of pipe music is its manyvoicedness, its polyphony, or more strictly speaking, its diphony, since it is the double-pipes that were the standard instrument for theatrical performance. There is controversy about the relationship of the sounds produced by the two pipes, but vase-paintings "of auletes…almost always seem to show the fingers of both hands equally busy, as though both were playing quite complex patterns of notes," and Pseudo-Plutarch's *On Music* speaks of the interplay of the pipes and the "conversations" (διάλεκτοι) they hold with one another.[72] The pipes were thus literally and fundamentally "many-voiced."[73] It is true that ancient music did not

[68] Plato *Phlb.* 56a 5–6 (trans. Barker 1987 [see above, n. 60], 109 with minor adjustment).

[69] Aristoxenos *Harm.* 54.2–3, 54.9-10 da Rios. Franklin 2005 (see above, n. 26), 18 notes that "there is … an interesting resonance between [Aristoxenos' "wander"] πλανᾶται and the mosaic in the house of Aion in Paphos, showing the contest of Apollo and Marsyas, above whose head πλάνη is written."

[70] F. Lissarrague, "On the Wildness of Satyrs," in T. Carpenter and C. Faraone (eds.), *Masks of Dionysus*, Ithaca, NY 1993, 212.

[71] Ps.-Aristotle *Pr.* 922a. The Greek saying cited by Cicero, "those who cannot become citharodes become aulodes," possibly echoes this notion (Cicero *Mur.* 29; Quintilian *Inst.* 8.3.79).

[72] Barker 1995 (see above, n. 27), 43–46; Barker 1984 (see above, n. 30), 227, n. 140, 243; Ps.-Plutarch *De Mus.* 1144c, 1138b.

[73] It was also, of course, possible to strike several strings at once on the lyre or *kithara*. Indeed, the pipes were even more restricted by nature since the *auloi* produced only two sounds simultaneously. But the number of chords available to the player of seven to eleven open strings was very limited and chords seem not to have been used with great frequency. For chords on the *kithara* accompanying song, see Barker 1995 (see above, n. 27), 49.

make extensive use of harmonics or polyphony, but the common impression that they were totally absent, or at best marginal, is wrong and largely due to the silence or hostility of our sources, since this was another realm of New Musical experimentation.[74]

A fifth distinctive feature was the *aulos*'s capacity for uninterrupted play, that is, a capacity to sustain a single tone, or to move without pause from one tone to another. In the fifth century, professional pipers developed this capacity of their instrument. Ancient sources usually explain the use of the halter or *phorbeia* by professional pipers as an aid to breath control, designed to help regularize the flow of breath into the pipes.[75] This has long been received as evidence that the *phorbeia* helped produce softer and longer (continuous) tones (or series of notes) by preventing loss of breath around the sides of the mouth-piece and/or by helping the musician to maintain even pressure.[76] Comparative evidence suggests that the *phorbeia* did more than permit the lengthening of notes: it facilitated the technique of circular breathing by which breath stored in the cheeks is pushed through the mouthpiece while the piper inhales through the nostrils, with the result that a piper can play indefinitely without pausing for air.[77] Vase-painting frequently shows the piper's cheeks—even without the *phorbeia*—puffed up like a chipmunk's. So long as instrumental music merely followed song, pipe music's potentiality for sustained tones or phrases remained underdeveloped.

New Musical verse expressed New Music's essential musicality—indeed its essentially auletic form of musicality—at all levels of language: the phonic, the syntactic, and the semantic.

[74] Barker 1995 (see above, n. 27), especially p. 50.
[75] Schol. on Aristophanes *V.* 582; Suda *s.v.* φόρβιον; Plutarch *De Cohib. Ira* 456b–c; Simonides (cited by Plutarch *loc. cit.*) fr. 177; Sophokles *TrGF* 768.
[76] L. Purser, "Capistrum," in W. Smith, et al. (eds.), *A Dictionary of Greek and Roman Antiquities*, vol. 1, London 1890, 357; W. How, *Cicero: Select Letters*, vol. 2, Oxford 1926 104; D. MacDowell, *Aristophanes: Wasps*, Oxford 1971, 211 (on Aristophanes *V.* 582). A. Howard, "The Αὐλός or Tibia," *Harvard Studies in Classical Philology* 4 (1893), 29–30, reasonably points to the *phorbeia*'s additional benefit in aiding to support the pipes leaving the hands freer for play.
[77] C. Sachs, *A Short History of World Music*, London 1956, 36; F. Romer, "When is a Bird not a Bird," *Transactions of the American Philological Association* 113 (1983), 141; D. Paquette, *L'Instrument de musique dans la céramique de la Grèce antique: Études d'organologie*, Paris 1984, 33; West 1992 (see above, n. 19), 106–7. Cf. Kantharos [Cantharus] *PCG* 1.

Phonemes

Play with the sound of words or syllables for rhythmic or harmonic effects is found in all ancient Greek lyric, but the purely phonic aspects of language gain unprecedented importance in New Musical verse. In part this may simply be explained through the centrality of dithyramb, since the repetition of words or syllables, for example, is typical of hymn and cultic song, especially Dionysiac song.[78] New Dithyramb and New Music conspicuously revived this feature of old cultic dithryramb.[79] Repetition is both relatively rare in Sophokles and especially characteristic of Euripides' late style (most notably in corresponding parts of strophe and antistrophe).[80] The style also cultivated the sound echoes of homoioteleuton, assonance, and alliteration.[81]

"Sound figures" generally form part of the emotive and mimetic program of New Music. Repetition can imitate and intensify the emotional hue of the verse: in late Euripidean lyrics repetition is typical with words of high passion or urgency.[82] Mimetic intentions are often evident in the sound-play of the verse: in

[78] E. Norden, *P. Vergilius Maro: Aeneis Buch VI*, 3rd ed., Leipzig, 1927 (reprint. 1957), 136–37; E. R. Dodds, *Euripides: Bacchae*, 2nd ed., Oxford 1960, 80; W. S. Barrett, *Euripides: Hippolytus*, Oxford 1964, 169; A. Henrichs, "Changing Dionysiac Identities," in B. Meyer and E. Sanders (eds.), *Jewish and Christian Self-Definition. Vol. 3. Self-Definition in the Greco-Roman World*, London 1982, 156; F. Bornmann, "Simmetria verbale e concettuale nelle responsioni dei canti strofici in Euripide," in R. Pretagostini, *Tradizione e innovazione nella cultura greca da Omero all'età ellenistica: Scritti in onore di Bruno Gentili*, Rome 1993, 565–66, 574–76; A. Bierl, *Der Chor in der alten Komödie*, Munich 2001, 357.

[79] Anadiplosis in New Dithyramb: Timotheos *PMG* 791.129; Pratinas *TrGF* 4, fr. 1.3; Diagoras *PMG* 738.1 (Diagoras is called a διθυραμβοποιός by Sextos Empeirikos *Math.* 9.53). Repetition was also characteristic of nome: see Proklos *Chr.* in Photios *Bibl.* 320b.12; T. Fleming, "The Musical Nomos in Aeschylus' Oresteia," *Classical Journal* 72 (1977), 224. Anaphora, often together with anadiplosis: e.g., Timotheos *PMG* 791.76; Pratinas *TrGF* 4, fr. 1.3; Euripides *El.* 169, *Ph.* 679–80, 686, *Or.* 323, *IA* 785, *Ba.* 143–44.

[80] Sophokles: R. W. B. Burton, *The Chorus in Sophocles' Tragedies*, Oxford 1980, 24 (and index *s.v.* repetition); Bornmann 1993 (see above, n. 78), 566–68. Euripides: Kranz 1933 (see above, n. 49), 231; W. Breitenbach, *Untersuchungen der euripideischen Lyrik*, Stuttgart 1934, 234ff.; Dodds 1960 (see above, n. 78), 80; Bornmann 1993 (see above, n. 78), 569; Porter 1994 (see above, n. 49), 179.

[81] Brussich 1970 (see above, n. 49), 66; B. Zimmermann, *Dithyrambos: Geschichte einer Gattung*, Göttingen 1992, 121; for Euripides, see Breitenbach 1934 (see above, n. 80), 214 ff. This feature of New Music is parodied in Aristophanes *Av.* 1374, 1376, 1384–85, 1396–97, 1400.

[82] E.g., Euripides *Hipp.* 525; *El.* 585; *Ion* 1066, 1231; *Tr.* 804, 806, 840, 1066, 1077, 1090; *IT* 402; *Hel.* 118, 1118, 1163, 1462, cf. 1341; *Ph.* 679, 681, 819, 1091, 1030, 1054, 1286; *Or.* 324, 339; *IA* 183, 587; *Ba.* 68, 83, 107, 116, 152, 163, 986; and the parodies at Aristophanes *Ra.* 1336, 1352–55, on which see B. Zimmermann, "Parodia metrica nelle *Rane* di Aristofane," *Studi Italiani di Filologia Classica* 81 (1988), 42. The style is not always appreciated by modern textual critics, who,

Phoinissai's ἐκάλεσ᾽ ἐκάλεσα βαρβάρῳ βοᾷ ἰώ, βαρβάροις λιταῖς, βᾶθι βᾶθι (678–81, "I called I called with a barbarian shout, oh, with barbarian prayers, come, come") the anadiplosis, anaphora, and alliteration combine in imitation of the barbarian barking of which they speak.[83]

The prioritizing of sound over sense can be found in another feature of New Music. Traditional music is said to have respected the verse in fixing the quantity of notes, one per syllable. New Musicians notoriously assigned two or more notes to a syllable of verse ("melism") or two or more syllables to a note. The Rainer Papyrus of Euripides' *Orestes*, which probably preserves something of Euripides' original score, freely stretches single syllables over two notes, as do a group of probably fourth-century musical fragments of tragedy, citharodic nome, or dithyramb, in a papyrus in the Ashmolean Museum.[84] The effect is parodied in the "Euripidean" monody of *Frogs* (1314, 1248) where a line from *Electra* has its first syllable repeated anywhere from five to seven times. There can be little doubt that the melism appeared in Euripides' original, and still less doubt that Aristophanes exaggerates the number of repetitions.[85]

The prioritization of sound over sense can also be exemplified by the treatment of pitch accent. Dionysios cites the *parodos* of *Orestes* to illustrate violation of the principle that "music thinks it proper to subordinate the words to the tune and not the tune to the words."[86] He describes a number of instances where accented syllables are sung to the same note or a lower note than adjacent syllables. The musical papyri of *Orestes*, *Iphigeneia at Aulis*, and the Oxford "C fragments" also show multiple violations of speech tones.[87]

like their ancient counterparts, find the New Musical style weak in sense and syntactic economy, and are, for that reason, too ready to suspect diplography or intrusive glosses. D. Mastronarde, *Euripides: Phoenissae*, Cambridge 1994 (see ad *Ph.* 697) is an exception.

[83] Paronomasia is very common in jingling puns, especially where sound mimics sense: see, e.g., Melanippides *PMG* 759, 761; Likymnios *PMG* 770a–b; Euripides *Hel.* 1344, *Ph.* 808–11; and the parodies at Aristophanes *Av.* 1401, *Ra.* 1334.

[84] *DAGM* nos. 3 and 5, especially p. 39. The fidelity of the musical papyri to original scores is open to question. See L. Prauscello, *Singing Alexandria: Music between Practice and Textual Transmission*, Leiden 2006, which includes a detailed discussion of the Euripidean musical papyri.

[85] See, especially, E. Pöhlmann, *Griechische Musikfragmente: Ein Weg zur altgriechischen Musik*, Nürnberg 1960, 29–48; E. K. Borthwick, "New Interpretations of Aristophanes' *Frogs* 1249–1328," *Phoenix* 48 (1994), 31–32. Five notes to a syllable is extravagant and not paralleled until much later in ancient music. *DAGM* no. 57 has a six-note melism, *DAGM* no. 41 has a nine-note melism (see W. Johnson, "Musical Evenings in the Early Empire: New Evidence from a Greek Papyrus with Musical Notation," *Journal of Hellenic Studies* 120 [2000], 75).

[86] Dionysios of Halikarnassos *Comp.* 11 = *DAGM* no. 2.

[87] *DAGM* nos. 3, 4, 6.

A musical papyrus in Berlin has been ascribed to the *Mad Ajax* of Timotheos, the most notorious of New Musicians, partly on the grounds of the music's violation of the natural quantities of the verse through melism and silences, and its complete indifference to natural pitch, which it violates nine out of ten times![88] Paradoxically, it is for this reason that West and Pöhlmann deny the possibility of it being a New Dithyramb.[89] Their premise is that such violations are an index of strophic composition. It is generally assumed that strophic songs do not normally correspond in accent as well as in meter, because of the difficulty that the task of writing two stanzas containing words of precisely the same metrical and melodic shape would impose on poets (and the fact that melodic accents do not precisely correspond between the words of a tragic strophe and antistrophe). There are, however, a number of studies that challenge this view. Walström's study of early lyric (select odes of Sappho, Alkaios, Alkman, and Pindar) argues that these earlier composers did tend to place words with the same accent in corresponding parts of a strophic composition.[90] More recently a study of three tragic odes by Comotti shows a tendency to preserve accent-pitch between strophe and antistrophe in Aischylos and Sophokles and a relative but measurable tendency to ignore it in Euripidean drama.[91] Landels demonstrates an essential correspondence between strophe and antistrophe in the "Ode to Man" of Sophokles' *Antigone* and concludes that in early strophic lyric generally "some compromise was made, by delaying or advancing rises and falls of pitch in the *antistrophe*, so that essentially the same melodic outline was adapted to the different words."[92] The question of the tonal correspondence between words and music in strophic composition remains open. The lack of correspondence between pitch accent and musical tone in the *Orestes* papyrus may not therefore

[88] *DAGM* nos. 17–18; 2 *TrGF* 683. Ascribed to *Mad Ajax* by A. Bélis, "Un Ajax et deux Timothée (*P. Berol.* no. 6870)," *Revue des Études Grecques* 111 (1998), 74–100, and C. Del Grande, *Ditirambografi: Testimonianze e frammenti*, Naples 1946, 89–90. Surviving scores appear to respect pitch accent about 85 percent of the time (L. Gamberini, *La parola e la musica nell'antichità*, Florence 1962, 23–66). For pitch accent in general, consult W. S. Allen, *Accent and Rhythm: Prosodic Features of Latin and Greek*, Cambridge 1973, 231–34.

[89] *DAGM* p. 58.

[90] E. Wahlström, "Accentual Response in Greek Strophic Poetry," *Commentationes Humanarum Litterarum (Soc. Scient. Fenn. Helsinki)* 47 (1970), 1–23. But Anderson 1994 (see above, n. 17), 95 analyzes P. *Ol.* 2 and finds no pattern. For background to the question, see Pintacuda 1978 (see above, n. 51), 67–72.

[91] G. Comotti, "Melodia e accento di parola nelle testimonianze degli antichi e nei testi con notazione musicale," *Quaderni Urbinati di Cultura Classica* 32 (1989), 91–108.

[92] Landels 1999 (see above, n. 23), 124–28.

be significant, since it preserves music from the antistrophe of the play's first stasimon. But the controversy does not affect the *Iphigeneia at Aulis* papyrus, since it belongs to an epode (and is hence not strophic). In all three cases where the melodic line for an entire word survives the melody does not respect the spoken accent.[93]

The musical papyri reveal yet another way in which the music differed from the verbal line. The *Orestes* papyrus includes notation for both instrument and voice and they are different.[94] The polyphonic character of the pipes was thus further extended in the relationship between the voices of the pipes and the voice of the singer, which offers a further example of a violation to the (alleged) tradition of unison between voice and instrument.[95]

Syntax

The syntax of New Musical verse expresses the new priority of music over verse in other ways. The new style shows a clear preference for long periods (very often the length of the entire verse stanza), with few strong sense-pauses. Aristotle draws an explicit analogy between the "continuous style" in prose composition (λέξις εἰρομένη) and New Dithyramb.[96] Demetrios calls it "the loosened-up style," λέξις λελυμένη.[97] The critics regularly describe the New Music, apparently both verse and music, as loose and wandering. They compare it to the unending, formless, and circuitous movements of ants.[98] A general lack of correspondence

[93] A reassuring contrast to the freedom of late Euripidean and post-Euripidean drama is a musical papyrus, recently published by Bélis, that can be ascribed to the *Medea* of Karkinos the Younger, who shows every indication of being reactionary in both poetic and musical style: there is no violation of natural pitch and, to anticipate a few topics of discussion, no exuberant language, no modulation, no chromatism, and only the mildest extension of natural syllable length (A. Bélis, "Un papyrus musical inédit au Louvre," *Comptes Rendus des Séances de l'Académie des Inscriptions et Belles-Lettres* 2004, 1317, 1320, 1321, 1326). Assuming the papyrus reflects the style of the original musical setting, it is little wonder that Philodemos chooses him as a foil to the brilliance of Euripides (*P.Herc.* 994, *De Poem.*, col. 25.10 Sbordone = 1 *TrGF* 70, T 7) or that the famous New Musician, Stratonikos (Wilson 2004 [see above, n. 54], 290–92), should have honed his wit at the expense of Karkinos' music (Athenaios 351f = 1 *TrGF* 70, T 8).

[94] West 1992 (see above, n. 19), 277–78, 284–85; Barker 1995 (see above, n. 27), 47.

[95] Pratinas *TrGF* 4, fr. 3.12 (with Barker 1995 [see above, n. 27], 46–47, 55–56); Plato *Leg.* 812d-e.

[96] Aristotle *Rh.* 1409a, cf. 1409b.24–30; R. Fowler, "Aristotle on the Period (*Rhet.* 3.9)," *Classical Quarterly* 32 (1982), 91. For the use of musical terminology in rhetoric, see J. Chailley, "Le mythe des modes grecs," *Acta Musicologica* 28 (1956), 151 n. 4; Restani 1983 (see above, n. 34), especially pp. 152–54.

[97] Fowler 1982 (see above, n. 96), 93–94.

[98] Aristophanes *Thesm.* 99–100; Suda *s.v.* "Philoxenos."

between musical rhythm and word- or phrase-ending heightened the effect.[99] New Musical syntax might best be described as agglutinative. The verse was infamous for its extravagant compounds,[100] concatenations of adjectives, nouns, or participial phrases, and the stringing of subclauses, usually paratactically, often asyndetically.[101] Rejecting the logical organization and syntactic variation of hypotaxis, the poets of New Music preferred paratactic strings of parallel syntagms, as they preferred concatenating strings of different rhythmic *metra*, to achieve an incantatory effect, accelerating or adding to the impetus of the music. By amassing short phrases and postponing the marked pause of the period, the poet abandoned natural speech rhythms in imitation of the rapid short cola and longer periods of pipe music. In this way New Music exploited the potentiality of the pipes for indefinitely sustained tones and phrases, echoing and amplifying the new auletic virtuosity in the winding and agglutinative style of its verse.

Semantics

The priority of music over logic is also apparent at the semantic level. Aristotle found the agglutinative style ugly and formless because not goal-oriented and not permitting the normal anticipations that facilitate comprehension.[102] To be sure, the style is not well-adapted to the efficient transfer of information, but this was never the objective. New Music's verse style aimed at a more musical or poetic form of communication.[103] The longer syntactic units added to the impetus of the music; they compelled the intellect to press onward, with the

[99] T. B. L. Webster, *The Tragedies of Euripides*, London 1967, 20; Porter 1994 (see above, n. 49), 203.

[100] Antiphanes *PCG* 205; Plato *Crat.* 409c; Aristotle *Poet.* 1459a.8, *Rh.* 1406b.1–2; Demetrios *De Eloc.* 91; Schol. on Philostratos *Vit. Apoll.* 1.17. Parodied: Aristophanes *Nu.* 332 ff.; *Pax* 831, *Av.* 1380, 1384–85, 1389–90, 1393 ff., *Ra.* 1336 (with K. J. Dover, *Aristophanes: Frogs*, Oxford 1993, *ad loc.*). See U. von Wilamowitz, *Timotheos: Die Perser*, Leipzig 1903, 45–46; Bowra 1963 (see above, n. 40), 125–26; Brussich 1970 (see above, n. 49), 71–76; C. Collard, *Euripides: Hecuba*, Warminster 1991, 187 (ad Euripides *Hekabe* 1056–1106); H. G. Nesselrath, *Die attische Mittlere Komödie: Ihre Stellung in der antiken Literaturkritik und Literaturgeschichte*, Berlin 1990, 243–44; Zimmermann 1992 (see above, n. 81), 121. Unlike the heavy, powerful and carefully managed compounds of poets like Aischylos or Pindar, these compounds are said by Schönewolf 1938 (see above, n. 47), 25, to be "Mittel, ein intellektuell Geschaffenes in die Höhe des mitreissenden, Dichterpathos hinaufzusteigern."

[101] Aristotle *Rh.* 1409a.24; Kranz 1933 (see above, n. 49), 239–40; Brussich 1970 (see above, n. 49), 65; and in comic parody: R. Hunter, *Eubulus: The Fragments*, Cambridge 1983, 167; Zimmermann 1988 (see above, n. 82), 39; Nesselrath 1990 (see above, n. 100), 244. This feature New Music may have acquired from nome: Fleming 1977 (see above, n. 79), 225.

[102] Aristotle *Rh.* 1409a–b; Fowler 1982 (see above, n. 96); cf. Restani 1983 (see above, n. 34), 152.

[103] To use Jakobson's precise formulations, the new style is set toward "emotive" and "poetic"

surge of the music, in search of elusive grammatical closure. Unsuited to the development of clear logical progressions, the new verse cultivated a (more musical) logic of association, bypassing the intellect and appealing to the senses, the subconscious and the emotions. As the Stagyrite himself puts it, the professional music composed for competition was geared more to pleasure than self-improvement, just as pipe music aimed at a "flushing of emotions [*katharsis*] rather than instruction [*mathêsis*]."[104]

New Music placed a higher premium on the connotative values of words. Its vocabulary was far-flung, its expressions riddling and circumlocutory.[105] It cultivated an agglutinative semantics to match its syntax, amassing images, rather than naming concepts. For "arrow" Timotheos says "slender-winged, bronze-headed, string-tautened things."[106] The pseudo Arion does not say "dolphins" but "floating, lightly leaping, snub-nosed, ruffle-necked, swift-running, whelps, beats, music-loving nurslings of Nereids."[107] The preference for images to concepts is typically combined with an appeal to the senses, especially to the ear and eye of the mind.[108] The imagery is sumptuous, seductive, luxurious, and

rather than "referential" communication (R. Jakobson, *Roman Jakobson: Selected Writings*, vol. 3, edited by S. Rudy, The Hague 1981, 21–29).

[104] Aristotle *Pol.* 1341b.11–12, 1331a.23–24.

[105] Especially rich in archaism, glosses and neologisms: Antiphanes *PCG* 205; Schol. on Aristophanes *Nu.* 335; Brussich 1970 (see above, n. 49), 70–76; Nesselrath 1990 (see above, n. 100), 250–51; Zimmermann 1992 (see above, n. 81), 145–46. For its riddling language: I. Waern, *ΓΗΣ ΟΣΤΕΑ: The Kenning in Pre-Christian Poetry,* Uppsala 1951, 92–104, 132–38; Brussich 1970 (see above, n. 49), 67–69; Hunter 1983 (see above, n. 101), 155; Nesselrath 1990 (see above, n. 100), 259–64; Kugelmeier 1996 (see above, n. 28), 262–64; E. Csapo, "New Music's Gallery of Images: The 'Dithyrambic' First Stasimon of Euripides' *Electra*," in J. R. C. Cousland and J. R. Hume (eds.), *The Play of Text and Fragments: Essays in Honour of Martin Cropp*, Leiden 2009, 104–8. The enigmatic style may be a development from traditional dithyramb and Dionysian art, cult, and mysteries generally (though not exclusively, since it can also be found in lyric poets like Pindar and Simonides), see R. Seaford, "On the Origins of Satyric Drama," *Maia* 28 (1976), 209–21; Seaford 1977-1978 (see above, n. 37); R. Seaford, "Dionysiac Drama and the Dionysiac Mysteries," *Classical Quarterly* 31 (1981), 254–55; R. Seaford, "Immortality, Salvation and the Elements," *Harvard Studies in Classical Philology* 90 (1986), 19–20; G. Casadio, *Storia del culto di Dioniso in Argolide,* Rome 1994, 96–99; and K. Tsantsanoglou, "The First Columns of the Derveni Papyrus and their Religious Significance," in A. Laks and G. Most (eds.), *Studies on the Derveni Papyrus*, Oxford 1997, 95, 120–23.

[106] Timotheos *PMG* 791.30–1.

[107] West 1982 (see above, n. 28), 8–9.

[108] Images: V. di Benedetto, "Il rinnovamento stilistico della lirica dell'ultimo Euripide e la contemporanea arte figurativa," *Dioniso* 43 (1971-1974), 326–33; Csapo 2003 (see above, n. 40); Csapo 2009 (see above, n. 105). Ornamental epithets: Brussich 1970 (see above, n. 49), 66. Sounds:

contributes to the aesthetic effect referred to since ancient times as *poikilia*.[109] The poetic ornamentation of the new style was conceived of as patterning and "colors."[110] The terms reveal a further homology between poetic and musical styles. *Poikilia* is a term often used for musical complexity, while "color" came to refer both to the addition to traditional tunings of microtones to enhance resonance and to a new system of tuning, developed in the mid- to late fifth century, called the "chromatic genus."[111] Both are closely associated with New Music. Aristotle approved of "colors" for the gratification of the inferior audience of mechanics and laborers who could only respond to music at an emotive level.[112] Both "colors" and *poikilia* served to produce a sensuous and emotional intoxication appropriate to Dionysian art.

Above all it was the volubility of the verse that defied ready intelligibility. Its structural freedom permitted all manner of lurches and leaps. Sentence structure not only meandered but was susceptible to grammatical derailment: the subjects of potential main clauses were sometimes left hanging and verbless, forgotten as the verse ambled into a series of dependent relative or participial clauses.[113] A much more common and serious obstacle to intelligibility was rapid changes in both music and verse, which produced an effect of *heteroglossia*, analogous to the many-voicedness of the pipes. Because of its frequent shifts in mode, meter, and manner of delivery, the musical style came to be described as "broken," or "fragmented" (*melos keklasmenon* or *epikeklasmenon*).[114] The epithet might just as well have been applied to the verse, with its penchant for sudden changes of

Kranz 1933 (see above, n. 49), 243; Zimmermann 1986 (see above, n. 37), 150; Csapo 1999–2000 (see above, n. 51), 419–23.

[109] Kranz 1933 (see above, n. 49), 242–43; Zimmermann 1992 (see above, n. 81), 123–24.

[110] Plato *Rep.* 601a–b, *Gorg.* 465b and *Phdr.* 239d (where the terms seem to be used with an eye to rhetoric); Hermogenes *Stat.* 5, 278 Rabe; Cicero *Brut.* 87, 298, *De Orat.* 3.25.100, *ad Quint.* fr. 2.14; J. C. G. Ernesti, *Lexicon Technologiae Graecorum Rhetoricae*, Leipzig 1795, 384–85; H. Lausberg, *Handbuch der literarischen Rhetorik*, Munich 1960, 511, sec. 1061; Restani 1983 (see above, n. 34), 180–83; Kugelmeier 1996 (see above, n. 28), 235–39. Cf. χρωννύειν and the Latin rhetorical terms *pingere* and *ornare*.

[111] For musical *poikilia*, see Edith Hall, "The Politics of Metrical Variety in the Classical Athenian Theater," Chapter 1 here; Franklin forthcoming (see above, n. 28). For "colors," see E. Rocconi, "Colors in Music: Metaphoric Musical Language in Greek Antiquity," in E. Hickmann and R. Eichmann (eds.), *Studien zur Musikarchäologie IV*, Rahden 2004, 29–34; Franklin 2005 (see above, n. 26), 24–38.

[112] Aristotle *Pol.* 1342a.25.

[113] Csapo 2003 (see above, n. 40), 72, 77.

[114] Ps.-Plutarch *De Mus.* 1138c; Philodemos *De Mus.* 4, col. 128.25 (Delattre, p. 244); Plutarch *Pyth. Orac.* 397b 1; Loukianos *Demonax* 12.6; Schol. on Aristophanes *Nu.* 971a.

speaker through the use of direct quotation, which also entailed sudden shifts in vocabulary and diction, because of the New Music's greater interest in *êthopoieia*.[⊠] Plato was particularly upset by the use of direct speech in poetic narrative, alleging that it required "all modes and all rhythms if it is to be delivered properly, since it involves all manner of shifts."[115] Indeed, the plurality of instrumental and human voices mixed freely together: instrumental solos followed or even disrupted song.[116] The new style also cultivated abrupt shifts in narrative place, time, and mood.[117] Taken altogether, the voluble rhythm and melody, the strange vocabulary, the chaotic syntax, the vague but emotionally nuanced and colored language, the sudden ruptures in the music, song, and narrative, and the displacement of linear argument with often rapid and baffling concatenations of images—all could conspire to create a dizzying effect of giddiness, if not outright hysteria.

The critics especially attacked New Dithyramb for volubility, volatility, lack of substance, and aimlessness. Plutarch speaks of dithyramb as "full of shifts that contain wandering and wrenching displacement."[118] Aristotle warns speechwriters away from the style of dithyrambic prologues because "the undefined wanders aimlessly."[119] The comic poets especially ridiculed the songs for lightness, airiness, and mistiness.[120] Aristotle remarks that dithyrambic poets are "full of noise"; Dionysios that dithyramb is "full of sound and high sentence, but signifies little."[121] It told tales like an idiot: the expression "you make even less sense than a dithyramb" was apparently proverbial.[122]

3. The "people's music," or the politics of New Music

It would be difficult to argue that politics motivated New Music in any fundamental way. The poets and musicians were mainly interested in exploring the potentialities of musical form. But politics was very much a part of New Music's

[115] Plato *Rep.* 397b.
[116] Above, p. 72; Bélis 1998 (see above, n. 88), 78–85.
[117] Panagl 1972 (see above, n. 49), 235–36.
[118] Plutarch *De E apud Delphos* 389a.9–10.
[119] Aristotle *Rh.* 1415a.
[120] Aristophanes *Pax* 827, *Nu.* 332 ff., *Av.* 1388–90 (with scholia); Schol. on Aristophanes *Thesm.* 100; Athenaios 551d. Cf. Zimmermann 1992 (see above, n. 81), 119–21; Kugelmeier 1996 (see above, n. 28), 231–35.
[121] Aristotle *Rh.* 1406b 1–2; Dionysios of Halikarnassos *Dem.* 7.17–19, cf. 23, *Ep. ad Pomp.* 2; Plato *Phdr.* 241e; *P.Berol.* 9571, col. 2 (πλήρε[ις κ]αὶ ψόφους).
[122] *PCG adesp.* 843.

reception. Growing up, as it did, in the polarized atmosphere of the "radical democracy" of Athens, New Music's program of "liberating" music from traditional constraints was more than a little suggestive.

A political interpretation of New Music was encouraged, above all, by the language used to describe its innovations. The boldest of these were marked by terms like *polychordia, polytrêtia, polymetria, polyharmonia, polychrômia, polykampteia,* and *polyphônia,* which stressed the pluriformity and broad inclusiveness of New Music.[123] Nearly as common are words like *metaballein, kamptein, aiolein, poikillein,* which stress the music's heterogeneity, variability, and adaptability.[124] The character of the New Music was typically described by words like *apolelumenos* or *eklelumenos,* which signified the "liberation" of the verse from formal structures such as strophic responsion, or by words like *aneimenos* and *chalaros,* which are used of loosening of the strings of the *kithara,* and hence of the tunings and modes based on these shorter intervals, but which also imply a release from constraints or a loosening of bonds.[125] If the terminology does not go back to the innovators themselves, there can be little doubt that they embraced it, since pluralism, change, and liberation had positive value for the broader public in late fifth-century Athens (and other parts of Greece touched

[123] *Polychordia*: Plato *Rep.* 399c–d, *Leg.* 812d; Artemon *ap.* Athenaios 636c; Plutarch *Quaest. Conv.* 661d.6, 662a.7, 674e.10, 713a.10; "Spartan decree" *ap.* Boethius *De Inst. Mus.* 1.1; Psellos *De Trag.* 5 Browning (cf. *PMG adesp.* 29b; Euripides *Med.* 196, *Rhes.* 548; Ps.-Plutarch *De Mus.* 1137a–b; Theokritos 16.45. *Polytrêtia*: Pollux 4.80; Nonnos *Dion.* 3.236, 15.56; Manetho 2.334; Anon. *De Phil. Plat.* 14.11 Westerink; *Anthologia Graeca* 7.214.3, 9.266.1, 9.505.5. *Polymetria*: Athenaios 608c; cf. Aristotle *Poet.* 1447b.21, 1460a.2. *Polyharmonia*: Plato *Rep.* 399c–d. *Polychrômia*: Psellos *De Trag.* 5 Browning. *Polykampteia*: Pollux 4.66–67, 73. *Polyeideia*: Ps.-Aristotle *Pr.* 918b.16; Philodemos *Mus.* col. 1 B 40 (= p. 64 Kemke); Psellos *De Trag.* 5 Browning. *Polyphônia*: Pollux 4.67, 4.70; Plutarch *Quaest. Conv.* 674e.10; Ps.-Plutarch *De Mus.* 1141c; "Spartan Decree" *ap.* Boethius *De Inst. Mus.* 1.1; Dion Chrysostomos *Or.* 2.56.7; cf. Plato *Leg.* 812d (*heterophônia*).
[124] Timotheos *PMG* 802; Aristophanes *Nu.* 869–70; Pherekrates *PCG* 155.14–5; Plato *Leg.* 812d; Aristotle *Metaph.* 993b.15; Ps.-Plutarch *De Mus.* 1141c, 1142d; H. Abert, *Die Lehre vom Ethos in der griechischen Musik,* Leipzig 1899, 81–82; R. Winnington-Ingram, *Mode in Ancient Greek Music,* Cambridge 1936, 19–21; I. Düring, "Studies in Musical Terminology in Fifth-Century Literature," *Eranos* 43 (1945), 184; Restani 1983 (see above, n. 34), 157–77; Zimmermann 1992 (see above, n. 81), 140-41; B. Zimmermann, "Das Lied der *Polis*: Zur Geschichte des Dithyrambos," in A. Sommerstein et al. (eds.), *Tragedy, Comedy and the Polis,* Bari 1993, 52; Kugelmeier 1996 (see above, n. 28), 212–16, 249–53. For the meaning and use of *aiolos*: R. Dyer, "On Describing Some Homeric Glosses," *Glotta* 42 (1964), 127–29; Anderson 1994 (see above, n. 17), 90–92; Franklin forthcoming (see above, n. 28).
[125] Düring 1945 (see above, n. 124), 180; LSJ *s.v.* ἀνίημι II 6, 7 (LSJ = H. G. Liddell, R. Scott, and H. S. Jones, *A Greek-English Lexicon,* 9th ed. with a revised supplement, Oxford 1996); Pherekrates *PCG* 155.4; Aristotle *Pol.* 1340b.3–7, 1342b.22; Ps.-Plutarch *De Mus.* 1126e, 1136e; Hephaistion *Poem.* 3.3; Plutarch *De Unius in Rep.* 827b; Suda *s.v.* Ἀγαθώνιος αὔλησις.

by democratic ideology). New Musicians employed the terms to flag the abundance, variety, and variability in their verse.[126]

It was the critics who politicized the music. Though their attacks on all aspects of New Musical performance are as multifarious and inventive as the New Music itself, there are three strategies of defamation that seem to dominate the written record of this particular struggle. One is play with language. The critics contested the technical musical terminology, imbued it with negative ethical and political meanings, and twisted "liberation" words in the direction of "indiscipline" and "anarchy," "variability" words in the direction of "lack of control" and "revolution," and "plurality" words in the direction of "excess" and "mob-rule."[127] The second strategy is theoretical speculation on the political, ethical, and eschatological effects of music. The elite theorists characterized New Music and its practitioners as effeminate, barbarous, vulgar, and likely to infect their audiences with the same qualities. The third strategy is historical fiction. The critics invented a timeless musical tradition to which they gave an ethical stamp that was opposed to New Music in every way: very manly, very Greek, and very noble.

Male versus female

Around 440 BC, Damon claimed that music affects the movements of the soul and thereby affects character, for good or ill.[128] Aristides Quintilianus reports that Damon labeled specific notes male or female according to their ethical effects, and specific scales male or female according to the proportion of male or female notes. If not Damon himself, then Damon's followers—the music professors (*harmonikoi*), Plato, Aristotle, Herakleides, Aristoxenos, and Diogenes of

[126] E.g., Timotheos *PMG* 791.221, 232; Telestes *PMG* 805c (with Wilson 1999 [see above, n. 16], 68), 806.3, 808.4; *P.Berol.* 13270, l. 8, with B. Bravo, *Pannychis e simposio: Feste private notturne di donne e uomini nei testi letterari e nel culto*, Pisa 1997, 72–99. Pratinas *PMG* 712 (doubtless the New Musical Pratinas) puns on αἰολίζειν and the Aeolian mode. Cf. comic parody: e.g., Aristophanes *Ra.* 245, 247–48.

[127] In the lost third book of *De Musica* Philodemos apparently criticized the role homonymy played in the ethical tradition of musical criticism inherited by the Stoics: see Philodemos *De Mus.* 4, cols. 60–61 (Delattre, p. 121).

[128] On Damon, see R. Wallace, "Damone di Oa ed i suoi successori: Un' analisi delle fonti," in R. Wallace and B. Maclachlan (eds.), *Harmonia Mundi: Musica e filosofia nell'antichità*, Rome, 1991, 30–54; R. Wallace, "Damon of Oa: A Music Theorist Ostracized?," in Murray and Wilson 2004 (see above, n. 38), 249–68; E. Moutsopoulos, "Beauté et moralité musicales: Une initiative damonienne, un idéal athénien," in F. Malhomme and A. G. Wersinger (eds.), *Mousikè et Aretè: La musique et l'éthique, de l'antiquité à l'âge moderne*, Paris 2007, 39–44.

Babylon—all accepted a gendered classification of modes or genera.[129] To this Damonion chorus we may justly add, with Philodemos, "the comic poets."[130]

We are fortunate to have remnants of both sides of the debate on the ethical effects of music. A papyrus preserves a protest, by a theoretician, probably of the fourth century, who attacks the *harmonikoi* for claiming that "some melodies make people disciplined, others make them sensible, others just, others manly and others cowardly."[131] The view that music has no ethical, only an aesthetic, function was probably picked up by the Epicureans, but the tradition does not resurface in extant literature before Philodemos.[132]

Both modes and genera remain at issue throughout the long history of the debate. Though earlier theorists seem to have located the chief expression of music's ethical quality in the modes, later theorists, particularly after Aristoxenos, placed it in the genera.[133] The Hibeh sophist also names the genera as specifically at issue: "[The *harmonikoi*] are hardly conscious of the fact that the chromatic genus could not produce cowards any more than the enharmonic could make its users manly" (15-17).

It is fairly clear that much of the elaboration of Damonian theory was directed against New Music's experimentation with the "colors" that made music "softer," "sweeter," more sensual and more emotional through the introduction of new microintervals and the mixing of scales. "Colors" were particularly associated with women and with the New Musicians Euripides, Philoxenos, and especially Agathon.[134] Plato complains of mixing men's speech with "women's colors and songs."[135] Plutarch identifies Agathon's introduction of the chromatic genus into tragedy as the chief reason for the general censure of Agathon's music as effeminate.[136] Philodemos would later protest against the views of Diogenes

[129] See Wallace 1991 (see above, n. 128), 48–49.

[130] Philodemos *De Mus.* 4, col. 128.38 (Delattre, p. 245).

[131] P.*Hibeh* 13. See Barker 1984 (see above, n. 30), 183–85; M. L. West, "Analecta Musica," *Zeitschrift für Papyrologie und Epigraphik* 92 (1992), 16–23. The *harmonikoi* are probably to be equated with "the followers of Damon:" Wallace 1991 (see above, n. 128), 44 and n. 42; Wallace 2004 (see above, n. 128), 256.

[132] G. Rispoli, "Elementi di fisica e di etica epicurea nella teoria musicale di Filodemo di Gadara," in Wallace and Maclachlan 1991 (see above, n. 128), 69–103; D. Delattre, "La musique, pour quoi faire? La polémique du Jardin contre le Portique chez Philodème de Gadara," in Malhomme and Wersinger 2007 (see above, n. 128), 99–117.

[133] J. Thorp, "Aristoxenus and the Ethnoethical Modes," in Wallace and Maclachlan 1991 (see above, n. 128), 54–68.

[134] Franklin 2005 (see above, n. 26), 28.

[135] Plato *Laws* 669c.

[136] Plutarch *Quaest. Conv.* 645e. Psellos (*De Trag.* 5 Browning) says that no one used "color" in

of Babylon, and (through him) against Herakleides and the whole Damonian tradition, that

> Music in itself does not produce the effects that he asserts as if an absolute certainty, and it does not tempt men or women to disgraceful forms of intercourse, nor tempt adolescent youths to adopt the female role. Neither he nor the comic poets have shown anything of the sort in the music of Agathon or Demokritos; they merely allege it.[137]

Indeed the comic poets leave no doubt that Agathon was part of the debate by the late fifth century. They ridiculed him "for softness and effeminacy" (εἰς μαλακίαν... εἰς θηλύτητα).[138] The portrait of Agathon as drag queen that we find in Aristophanes' *Thesmophoriazousai* may owe something to the fact that Agathon was a famous *pais kalos* in his day, but it most certainly also owes a lot to contemporary music criticism. In *Gerytades* Aristophanes appears to have called effeminate pipe music "Agathonian," an expression that later became proverbial for music that was "soft and loose" (μαλακὴ καὶ ἐκλελυμένη).[139] In *Thesmophoriazousai* it is not just Agathon but his song that is "womanish" (131). The response of the Inlaw to the sound of Agathon's song makes it likely that Aristophanes is also poking fun at Damonian theory: while listening to its erotic and effeminate tones, the Inlaw declares, "a sexual itch crept into my very fundament" (133).[140]

Instruments too—not just poets, musicians, and audiences—could be given a gendered classification, at least in later antiquity, according to fifth-century categories of tradition and innovation: Aristides Quintilianus classi-

tragedy before the time of Euripides. Franklin 2005 (see above, n. 26), 28 speculates that Euripides and Agathon actually used a chromaticized enharmonic.

[137] Philodemos *De Mus.* 4, col. 128, 31–42 (Delattre, p. 245); cf. col. 43 (Delattre, pp. 69–70).

[138] *TrGF* 39, T 11, 12.

[139] Aristophanes *PCG* 178 where several sources specify Agathon's pipe music as the object of criticism, while others abbreviate to Agathon himself. Note that Aristides Quintilianus (*De Mus.* 2.18) would later maintain that all pipe music partakes of a feminine nature "even when played with much knowledge and self-control." On Aristophanes' Agathon and the so-called "Anakreontic" vases, see D. Yatromanolakis, *Sappho in the Making: The Early Reception*, Cambridge, MA 2007, 110–40.

[140] Aristophanes *Nu.* 648–51 also makes comic use of Damonian theory: Wallace 1991 (see above, n. 128), 46.

fies the seven-stringed lyre and *kithara* as "male" and the polychord *kithara* and Phrygian pipes as "female."[141]

Greek versus barbarian

The names of the musical modes are ethnic. These ethnic labels implied ethical values and ethical values in turn attracted gendered expression. The modes with Greek names (Dorian, Aeolian, Ionian) were, in general, more manly. Those with Eastern names (Lydian, Phrygian) were effeminate. But a rigorous ethical posturing might cast doubt on modes named after the more Asiatic Greek races. Plato declared the Dorian mode "the only true Greek mode," an expression of manliness, nobility, and self-control; the Mixolydian, Tense Lydian, and Ionian were, by contrast, effeminate, vulgar, and self-indulgent— "useless even to respectable women, let alone men."[142] For Aristotle this was not schematic enough. He protested that Plato was willing to allow the Phrygian mode into his republic although "among modes the Phrygian has the same effect as the pipe among instruments: both are orgiastic and emotional," in explicit contrast, of course, to the Dorian, which is "most steadfast and has an especially manly spirit."[143]

Critics eventually forced a stark opposition between the Dorian and Phrygian modes. The two ethnic labels, placed in opposition, had, through the Trojan and Persian wars, enough mythical and historical resonance to give critics a convincing symbolic template for shaping broad ethical distinctions between New Music and "tradition." Plato was not too subtle to accept the division between Greek and Asiatic modes, or to reduce the only "really Greek" mode to the Dorian, but he knew too much about musical practice to allow the Phrygian to stand as the Asiatic mode *par excellence.*[144] But earlier

[141] Aristides Quintilianus *De Mus.* 2.16.23–40.

[142] Plato *Lach.* 188d (first quotation), 193d, *Rep.* 398d (second quotation), 398e–9c, *Ep.* 7336c. Pindar is said to have called Dorian song "most dignified" (fr. 67 Maehler). Damon, or in some versions Pythagoras, is said to have quelled a riot by ordering music to be played in the Dorian mode (the drunken youths had been excited by listening to music in the Phrygian mode): see A. Pagliara, "Musica e politica nella speculazione platonica: Considerazioni intorno all'*ethos* del modo frigio (*Resp.* III 10, 399a–c)," in Cassio et al. 2000 (see above, n. 37), 193–201. On musical modes and instruments, regional and ethnic identities, and politics of music and gender, see Yatromanolakis 2007 (see above, n. 139), 227–38.

[143] Aristotle *Pol.* 1342a.32–b.3, 1342b.13.

[144] On the "contradiction" in Plato, see, more recently, A. Gostoli, "L'armonia frigia nei progetti politico-pedagogici di Platone e Aristotele," in Gentili and Perusino 1995 (above, n. 27), 133–44, and Pagliara 2000 (see above, n. 142). Scholars tend to assume too readily that Aristotle and

critics had already laid the foundation for the final reduction of musical modes to this overarching opposition, and it was, in any case, well-prepared by the dithyrambic poets themselves: Melanippides' contest between Apollo on the lyre and the Phrygian Marsyas on pipes; Pratinas' opposition of New Music to "Dorian dance-song;" and Telestes' praise of the "Phrygian," who (somewhat confusingly) "first composed the Lydian song as a rival to the Dorian Muse."[145] A reductive binarism in the theory of modes was in any case commonplace by the time of Aristotle, when "some thinkers," to Aristotle's evident approval, opposed the Dorian and Phrygian as the only "pure" modes and regarded all others as mere variations on one or the other.[146] The schematism had advanced so far that Aristotle could claim that the dithyramb, like the pipes,[147] was "a Phrygian thing by general consensus."[148] He cites unnamed experts who illustrate this proposition by asserting that no one could possibly compose a dithyramb in the Dorian mode: of this, says Aristotle, Philoxenos is proof because he attempted to do just this with *Mysians*, "but failed and fell naturally back into the Phrygian mode as that suited to his composition."[149] Apparently, for Aristotle and his sources, Dorian and Phrygian were so mutually exclusive that to prove the dithyramb un-Dorian was tantamount to proving it very Phrygian. Aristotle's student Herakleides of Pontos attained the ultimate seamless perfection in his ordering of ethno-ethical oppositions. He assigns pristine virtue to the Dorian, Aeolian, and Ionian modes and claims that the Phrygian and Lydian were brought to Greece by barbarian immigrants: ethically best, of course, was the Dorian, most

others are accurately describing, not actively creating, the character and meaning of the Phrygian mode.

[145] On Melanippides, see above, p. 72. Pratinas *TrGF* 4, fr. 3.17 and above, pp. 73–74; Telestes *PMG* 806.

[146] Aristotle *Pol.* 1290a 19–29.

[147] The sources insist on a Phrygian origin for the pipes: H. Huchzermeyer, *Aulos und Kithara in der griechischen Musik bis zum Ausgang der klassischen Zeit*, Emsdetten 1931, 14, n. 57. Cf. West 1992 (see above, n. 19), 330–31. Athenaios exercises a well-trained scholarly reflex in citing *Iliad* 18.495 to show that "Homer ascribes the pipes to the barbarians" (i.e. "Phrygian" Trojans). The actual origin of the pipes is not all that clear: see West 1992 (see above, n. 19), 81–82. There were competing, but less attractive, traditions that localized the origin of the pipes in Greece: e.g., Troizen (Pausanias 2.31.3) or Thebes (Wilson 1999 [see above, n. 16], 61).

[148] Aristotle *Pol.* 1342b.7. Cf. *Vit. Soph.* 23 (citing Aristoxenos) and Psellos *De Trag.* 5 Browning where Sophokles is said to have used the Phrygian mode in a "more dithyrambic style" (but this treatise is considerably less schematic than Aristotle, since it identifies the Hypophrygian and Hypodorian as most suited to dithyramb, and claims Agathon first introduced them to tragedy; cf. Ps.-Aristotle *Pr.* 922b).

[149] Aristotle *Pol.* 1342b.8–12.

"manly and grandiose, not diffuse or giddy, but somber and severe, not embellished [*poikilon*] and variegated [*polytropon*]"—not, one need hardly say, like the New Music.[150] And yet, the Dorian mode differed from the Phrygian only in that the last note of the scale was higher by a single tone.[151]

The critics pursued this cultural work with little regard for musical reality. It is, incidentally, not true that dithyrambs were not written in the Dorian mode and also not true that Philoxenos failed in the attempt.[152] Aristoxenos, who was generally more inclined to technical than ideological argument, protested against the critics' claims that it was only late degenerate tragedians who introduced the Asiatic modes, or that the Dorian mode was always controlled, unemotional, and manly. He pointed out, on the one hand, that early tragedy used Mixolydian, Ionian, and Slack Lydian modes, and, on the other, that the Dorian mode was used for maiden choruses, tragic laments, and love songs.[153] It is not that Aristoxenos rejected the theory of music's ethical effects. In the spirit of Hellenism he shifted the burden from race to class, and from mode to genus. The threat of cultural barbarization was entirely internalized: in his *Sympotic Miscellanies* Aristoxenos' cultivated "few" share happy fantasies of what music was like in the good old days, so very different from the degeneracy of the present, "now that the theaters have been thoroughly barbarized and this People's Music [πάνδημος μουσική] has led to massive corruption."[154]

Old oligarchs versus new democrats

Plato's political discourse is filled with metaphors from music. We need a close study of his application to democracy of the standard terms used to characterize New Music—like ποικίλος and πολυειδής.[155] Or should we call it metonymy rather than metaphor, since Plato, like Damon, ascribed to music and dance the primary responsibility for instilling ethical qualities into people and classes?

[150] Herakleides of Pontos fr. 163. Cf. Athenaios 624b.

[151] Barker 1984 (see above, n. 30), 165–66.

[152] West 1992 (see above, n. 19), 181, 364–65. A choregic epigram from the early fifth century, before such things were problematized, commemorates a dithyramb accompanied by "pure Dorian pipes" (*Anthologia Graeca* 13.28.7–8).

[153] Aristoxenos fr. 82 Wehrli. Cf. Psellos *De Trag.* 5 Browning; Ps.-Plutarch *De Mus.* 1137a; West 1992 (see above, n. 19), 179; and note 148 above (Sophokles' use of the Phrygian mode).

[154] Aristoxenos fr. 28 da Rios.

[155] E.g., Plato *Rep.* 557b–c. For Plato's use of musical vocabulary in general: Anderson 1994 (see above, n. 17), 142–69; A. G. Wersinger, *Platon et la dysharmonie: Recherches sur la forme musicale*, Paris 2001; P. Murray, "The Muses and their Arts," in Murray and Wilson 2004 (see above, n. 38), 375–78.

In the ninth book of his *Republic,* Plato describes his ideal state as a concord between the three divisions of the citizen body. This depends on the concord between the three parts of the soul in the individual constitution of the members of each class. This in turn depends on training, especially musical education. Here and elsewhere, Plato repeatedly employs musical terms for "harmony" and "disharmony" both in the individual soul and in the hierarchy of the state.[156] The homology between music, the soul, and the state has most to do with the hierarchy of control: the words of the song must rule the music, the logical part of the soul must rule the emotional, and the philosophically educated elite must rule the masses. In each case *logos* or its deputies must keep in check the forces of disorder: the purely aural parts of music, the appetitive part of the soul, and the disorderly masses.[157] It does so by enlisting the aid of the middle term in each of these hierarchies: that part of music, the individual and the state that belongs to the higher emotions and is responsible for action. In this way dance, the part of the soul responsible for valor, and the military classes are all linked by Plato's relentlessly schematic logic. Not all these associations are original with Plato; to some extent he elaborates the equation between musical and political revolution that he ascribes to Damon:

> One must beware of changing to a new form of music, since this puts at risk the entire social structure. For the forms of music are never disturbed without unsettling the very constitution of the state. So says Damon and I believe him.[158]

Plato makes no secret of his musical tastes. If there is one thing that characterizes them all, it is violent antipathy to every feature of New Musical style. In his ideal state he would ban pipe music;[159] musical innovation;[160] Dionysian

[156] For συμφωνεῖν and cognates meaning to be self-consistent: e.g., Plato *Lach.* 188c–d, 193d–e; *Cra.* 433b; *Ep.* 7.322d-e; *Leg.* 689d. For συμφωνεῖν and cognates used to refer to the concord of the bodily passions with the reason: e.g., Plato *Rep.* 430e, 591d; *Leg.* 653b; cf. Aristotle *Pol.* 1334b.10. συμφωνεῖν used of concord of the state or confederacies: e.g., Plato *Leg.* 691a, 693. διαφωνεῖν or ἀσυμφωνεῖν and compounds: e.g., Plato *Gorg.* 482b–c, *Leg.* 689a, 691a. πλημμέλεια and its cognates used of social discord and discord within the individual: e.g., Plato *Leg.* 689c, 691a.
[157] Plato *Rep.* 424c–444c, 543a-592b; *Leg.* 669–670a, 689a-e; *Plt.* 291a–b.
[158] Plato *Rep.* 424c.
[159] Plato *Rep.* 399d; cf. *Gorg.* 501e.
[160] Plato *Leg.* 816c.

music and dance;[161] music unaccompanied by words;[162] mode and rhythm that do not follow the verbal line;[163] the use of more than one note per syllable;[164] direct speech or vocal mimesis;[165] modulations in music or violent changes in the motion of dance;[166] or any sort of embellishment (ποικιλία) in melody or rhythm, and particularly polyphony, *polychordia, polyharmonia,* polymetry, and "colors."[167]

New Music had become a symbol of all that was ill in democracy. It is easy to see why. In an age where elite wealth and leadership were increasingly under democratic control, the maintenance of class distinction depended increasingly on claims of ethical and cultural superiority. But elite cultural superiority, at least, was openly threatened by the rise of professionalism in many branches of the arts, and especially the music of the theater. By the later fifth century a gentleman's musical accomplishments looked slim beside those of musicians from plebeian backgrounds who acquired both wealth and fame by performing to the assembled *dêmos* in the theater. The elite could only maintain their claim to cultural superiority in this domain by separating "good" from "bad" music, which they did, not only by questioning the musical and ethical values of every innovation but also by demonizing the instrument, the performers, and the audiences of New Music.

For the demonization of the *aulos* I need only refer to the excellent essays by Peter Wilson.[168] The best known myth about the *aulos* told how it was thrown aside as indecorous by the goddess Athena, but taken up, much to her disgruntlement, by the grotesque satyr Marsyas (who would later pay with his skin for his presumption in offering a musical rival to Apollo's lyre). The anecdote is curiously mirrored by a similar refusal by the conspicuously aristocratic Alkibiades, who refused to continue with his pipe lessons as "unbecoming to the appearance and comportment of a gentleman" and "because it took away a man's voice and speech"—"Let the sons of Thebes play the pipes," he reportedly said, "since they do not know how to converse."[169] Aristotle evidently felt it necessary to offer

[161] Plato *Leg.* 815c–d. Note that, nonetheless, some provision is made for Dionysian choruses, but of old men only, to help renew the fire of youth (*Leg.* 665a–6c).
[162] Plato *Leg.* 669d–70a. Cf. Philodemos *De Mus.* 4, col. 51 (Delattre, pp. 83–84).
[163] Plato *Rep.* 400d, *Leg.* 669e.
[164] Plato *Leg.* 812d.
[165] Plato *Rep.* 392c–96e.
[166] Plato *Leg.* 814e–16c.
[167] Plato *Leg.* 655a, 812d–e, *Rep.* 397c–9e.
[168] Wilson 1999 (see above, n. 16); Wilson 2004 (see above, n. 54).
[169] Plutarch *Alc.* 2.5–6; cf. Plato *Alc.* 1.106e; Pamphila *FHG* 3.521.9.

proofs (against the incredulity of his readers) that in the new leisure society after the Persian Wars when gentlemen dabbled in all the arts indiscriminately, "they even introduced pipe playing into the education" of elite citizens.[170] By the late fifth century it is clear that the pipes were not considered a fit instrument for a gentleman or even an Athenian. As Wilson puts it: "the *aulos* was a danger: it threatened self-control; it marred the aesthetics of the body; it introduced the allure of the alien."[171]

As for pipers, our ancient sources accuse them of effeminacy, luxuriance, corruption, incontinence, uncontrolled irrational behaviour, and even brain damage from blowing too much.[172] The pipers' vulgarity (*amousia*) became proverbial.[173] Those who sponged off others were said "to lead the life of a piper."[174] Professionalism itself was the object of most particular contempt; it was a touchstone of vulgarity to play an instrument "too well," or for money, or for theater audiences.[175]

Ultimately, however, it was the masses themselves who, in the Old Oligarch's words, "destroyed respect for those practicing music."[176] Plato firmly blamed the "theater mob," coining the phrase "theatrocracy," for cultural democracy.[177] Aristotle assigned the degeneration of music to the tastes and needs of the audience of "handworkers."[178] New Music "played to the gallery": "Krexos,

[170] Aristotle *Pol.* 1341a.30–36.

[171] Wilson 1999 (see above, n. 16), 58.

[172] Phrynichos Com. *PCG* 67; Ps.-Aristotle *Pr.* 956b.11; Athenaios 337e–f.

[173] Loukianos *Astr.* 2.

[174] Apostolios 4.33.1.

[175] Pratinas *TrGF* 4, fr. 3 (with Hartung's emendation *thês*, worker for a daily wage, used of the pipe—Athenaios 617b claims that Pratinas composed the piece through indignation at the way "wage-earning" pipers and choreuts invaded the dancing places); Aristotle *Pol.* 1341b 8–18 (cf. 1337b.1–21, 1339b.5–10, and Plato *Leg.* 809e–10a); Ps.-Aristotle *Pr.* 956b; Ath. 631f; Plutarch *Per.* 1.4–5; Suda *s.v.* "Arabios angelos"; Apostolios 3.71.1. By Diogenes of Babylon's day even a gentleman singing to the accompaniment of strings was considered "ridiculous and professional" (Philodemos *De Mus.* 4, col. 85.32–41, Delattre, pp. 162–63). A. Bélis, "Mauvaise musique, mauvaises moeurs," in Malhomme and Wersinger 2007 (see above, n. 128), 77–86, explores elite hostility to auletic virtuosity.

[176] Old Oligarch *Ath.Pol.* 13. For the translation, cf. J. Henderson, "The *Dêmos* and Comic Competition," in J. Winkler et al. (eds.), *Nothing to do with Dionysos?*, Princeton, NJ 1990, 278 and n. 16.

[177] See below, pp. 102–3. Cf. Plato *Gorg.* 501e–2c where pipe music, dithyramb, kitharistic, Kinesias, and tragedy are all specifically condemned for "gratifying the mob" and the Platonic *Minos* 320f where tragedy is described as "most delicious to the *dêmos*."

[178] Aristotle *Pol.* 1341b.7–18.

Timotheos and Philoxenos and the poets of that generation became more vulgar and innovative, pursuing what is now called the 'popular cash-prize' style."[179]

The protestations of these touchy aristocrats reflect more on their own ideological makeup than on musical realities. Scholars would do well to be more skeptical of what they say, not only about New Music, but about musical tradition. The elite critics invented a musical past in which all was simplicity and order: the catchwords "simplicity" (haplotês) and "good order" (eutaxia or eukosmia) stand in diametric opposition to New Music's language of plurality, complexity, and change. Traditional music was spare: the critics even invented a new "oligo- compound" to contrast with New Music's "poly- compounds": traditional music's noble oligochordia ("few-notedness") was wrecked, they said, by New Music.[180]

Few doubted the general scheme of this myth-history: even pipe music "changed from a more simple to a more complex form" (ἀφ᾽ ἁπλουστέρας εἰς ποικιλωτέραν); "even the dithyramb was orderly [tetagmenos]" before Philoxenos, Timotheos, and Telestes.[181] The Greater Argument of Clouds characterized the music of the previous generation as "orderliness" [eutaxia] consisting in the singing of songs and modes handed down by "our fathers," who rewarded with a sound thrashing any attempt at modulation à la Phrynis.[182] In Pherekrates' Cheiron the change in Music is pictured as a loss of innocence after a series of violent rapes by Melanippides, Kinesias, Phrynis, and Timotheos.[183]

The words for "order" used by the Greater Argument, taxis, kosmos, and other forms from the same roots appear with great frequency in discussions of music and its ethical effects from the time of Aristophanes until late antiquity. In music taxis is a technical term referring to the tuning of one or more strings.[184] But, from the time of Aristophanes onward it is the word's moral, military, and political connotations that dominate the critical discourse. In these domains the

[179] Ps.-Plutarch 1135c. The word θεματικόν here translated as "cash-prize," literally refers to musical and dramatic competitions that offered straight cash prizes rather than crowns. Though "thematic" contests might be disprized as contests for money rather than honor, the difference was more ideological than real, since even winners of crown contests would normally melt down the (gold or silver) crowns to recover their cash value.

[180] Ps.-Plutarch De Mus. 1135d.5, 1137a.8. Cf. oligometria in Eustathios 353.39.

[181] Ps.-Plutarch De Mus. 1141c; Dionysios of Halikarnassos Comp. 19.

[182] Aristophanes Nu. 963–72.

[183] Pherekrates PCG 155; see Egert Pöhlmann, "Aristophanes and the 'New Music': Acharnians, Knights, Clouds, Birds, Thesmophoriazousai, Frogs," Chapter 2 here.

[184] Ion PMG 32; Aristoxenos Harm. 53.12–13; Franklin forthcoming (see above, n. 28). Cf. σύνταγμα used of a "tuning": Aristotle Pol. 1290a.22; IStrat 1044.

word normally refers to the subordination of the individual and his emotional impulses to a preordained or ideal "order," for which the archetype was the order of the hoplite battle line. *Eutaxia* and *eukosmia* therefore implied knowing one's place and keeping to it through the proper exercise of self-control and self-denial.

Eutaxia and *eukosmia* were central to the self-conception of ancient elites. By contrast, elites represented the *dêmos* as completely lacking in the qualities evoked by these terms, through deficiency of both nature and education. The Old Oligarch chooses "wickedness," "lack of education," and "lack of order" (*ataxia*) as the qualities that most succinctly characterize the Athenian *dêmos*. "Lack of order" is also characteristic of the depraved and the young.[185] Plato especially regarded dance and song as the primary vehicles for teaching the young "good order."[186] His musical reforms were expressly designed to put *taxis* back into music.[187] *Taxis* was deemed crucial to hoplite warfare, indeed its necessary condition,[188] and so an elaborate analogy was developed between choral formation and hoplite formation, freely trading vocabulary and tactics from one sphere to another.[189]

"Order" was the outward, public manifestation of self-discipline (*sophrosynê),* which is the aristocratic virtue *par excellence*—the word *sophrosynê* is used

[185] Plato *Leg.* 664c–5a, 840e, 897d.

[186] See, especially, Plato *Rep.* 401e–3a, 413e, 425a, *Leg.* 659d–60a, 664e–5a. Cf. "Cheiron" *ap.* Ps.-Plutarch *De Mus.* 1146b. At some point grammarians adopted the belief that in Dorian lands schools were called "dancing places" (*choros*) and schoolmasters "dance-masters" (*chorêgoi*): see Pollux 9.41. The ideas possibly go back to Damon or the *harmonikoi* (see the language of Athenaios 628d, who may still be citing "the students of Damon").

[187] See, especially, Plato *Leg.* 802c.

[188] Xenophon *Mem.* 3.1.7; Aristotle *Pol.* 1297b.18–22.

[189] See J. Winkler, "The Ephebe's Song: *Tragoidia* and *Polis*," in Winkler et al. 1990 (see above, n. 176), 50–53; F. D'Alfonso, *Stesicoro e la performance*, Rome 1994, 27. The degree to which *taxis* was necessary to naval warfare was hotly contested. Xenophon (*Mem.* 3.5.6), who was a military man, recognized the importance of *taxis* in naval maneuvers and describes sailors as attentively waiting for commands "like choreuts," but elite voices from the last quarter of the fifth century onward regularly characterize the navy, the military arm of the lower classes, as an undisciplined mob: see Thoukydides 8.72.2, 48.3, 86.5; Euripides *Hek.* 607 (Hekabe speaks), *Tr.* 686–93 (Hekabe again); Plato *Leg.* 706c–7b; Aristotle *Pol.* 1291b.20–4, 1304a.22, 1327b.7–8; B. Strauss, "The Athenian Trireme, School of Democracy," in J. Ober and C. Hedrick (eds.), *Dêmokratia*, Princeton, NJ 1996, especially pp. 316–17. Note that Aristophanes' "Aischylos" specifically blames Euripides for the indiscipline of contemporary sailors (*Ra.* 1069–73; cf. E. Csapo, "Kallippides on the Floor-Sweepings: The Limits of Realism in Classical Acting and Performance Styles," in P. Easterling and E. Hall [eds.], *Greek and Roman Actors: Aspects of an Ancient Profession*, Cambridge 2002, 132). J. Rancière, *On the Shores of Politics*, London 1995, 1, is of the opinion that "the whole political project of Platonism can be conceived as an anti-maritime polemic." On naval music, cf. Power 2007 (see above, n. 46), 185.

tout court to denote oligarchy—and little wonder, since no repressive social hierarchy could survive without it: *sophrosynê* meant knowing your place and acting accordingly.[190] *Sophrosynê* also distinguished men from women and Greeks from barbarians. The lack of this quality among the democratic plebs made them dangerous even to themselves, morally obliging their betters to impose discipline for everyone's good. And just as discipline meant submission to the laws of tradition, music too had its *nomoi* (both "laws" and "traditional melodic patterns," namely "nomes").[191] The critics claimed that the same word meant both "nome" and "law": either because the first laws were sung for mnemonic reasons (allegedly still a practice in Crete); or because the melodic patterns were protected by law against innovation; or because traditional nomes helped establish the rule of law.[192] The pun, if not the theoretical baggage, has been traced as far back as Aischylos; it is a little more surprising to find it in the Phrygian eunuch's song in *Orestes,* and the reference to *eunomia* that ends Timotheos' *Persai*—signs that Euripides and Timotheos, in these flagship New Musical performances, were willing to contest, if not to mock, the historical and ethical claims of their critics.[193]

These explanations of the homonymy of "law" and "nome" were only part of an elaborate musical prehistory that placed the nome at the very heart of a socially and ethically perfect music that New Music obliterated.[194] Plato's *Laws* describes how the New Music's transformation of the nome was a transgres-

[190] H. North, *Sophrosynê: Self-Knowledge and Self-Restraint in Greek Literature,* Ithaca, NY 1966, 44, 102, 111–12. Plato's timarchic man prides himself on being "exceedingly obedient to his commanders, but eager to command" (*Rep.* 549a). For the link between *eutaxia, eukosmia* and *sophrosynê,* see, especially, Thoukydides 1.84.3, Xenophon *Mem.* 3.5.21, Aischines 1.22. At Plato *Prt.* 326a it is the function of the music teacher to teach *sophrosynê.* Cf. Aristophanes *Nu.* 962–64.

[191] West 1992 (see above, n. 19), 215–17; Anderson 1994 (see above, n. 17), 119.

[192] Ps.-Aristotle *Pr.* 19.28; Aelian *Var. Hist.* 2.39; Ps.-Plutarch *De Mus.* 1133c, 1146b; Plato *Rep.* 424d, *Leg.* 700b, 799e; Philodemos *De Mus.* 18.31.5, 85.49–86.19 Kemke; Plutarch *Lyk.* 4.21; Suda *s.v.* μετὰ Λέσβιον ᾠδόν; *Etymologicum Magnum s.v.* νόμος.

[193] For Aischylos, see Fleming 1977 (see above, n. 79); Euripides *Or.* 1426, 1430 (cf. G. Comotti, "La musica nella tragedia greca," in L. de Finis [ed.], *Scena e spettacolo nell'antichità,* Florence 1989, 57–58). On the pun in Timotheos *PMG* 791.240, see discussions by Bassett 1931 (see above, n. 49), D. Korzeniewski, "Die Binnenresponsion in den Persern des Timotheus," *Philologus* 118 (1974), 22–39, T. Janssen, *Timotheus: Persae,* Amsterdam 1989, 20, 148 (against any political connotation), and Wilson 2004 (see above, n. 54), 306. Purely innocent punning on *nomos* at Athenaios 352b and Euboulos *PCG* 106.3 (though in a dithyrambizing context: see Nesselrath 1990 [above, n. 100], 264).

[194] For this purpose, nome was even placed in opposition, it seems, to dithyramb. We have a very garbled echo preserved in Proklos *ap.* Photios *Bibl.* 5.320a–b, 161, 12-30 Henry. Cf. Ieranò 1997 (see above, n. 11), 155–59.

sion against natural law as embodied both in traditional music and in traditional society.[195] Earlier Athenians had been "willing slaves to the *nomoi*" at a time when Athens had a moderate constitution and when the genres and forms of music were fixed and nontransferable.[196] Audiences had once been governed by internal as well as external discipline: in the old days "the majority of the citizens wished to be governed in an orderly fashion."[197] But then, buoyed by success in the Persian Wars, Athens "pushed the majority toward every form of liberty."[198] Traditional music and dance changed because of a search for new and "disorderly" pleasures.[199] The poets themselves were "the originators of this musical lawlessness," because they were "excessively given to the pursuit of pleasure."[200] The poets mixed genres, imitated one instrument with another, and mixed everything together. They claimed that music had no standard of correctness beyond the listener's pleasure. As a result, the plebs in the theaters turned from a silent congregation into a shouting mob as if they knew what was *kalon* ("good," "noble," "right"). "Instead of an aristocracy, a corrupt theatrocracy came into existence."[201] And from this, thinking they knew something, the plebs became fearless and audacious and ceased to be governed by their betters. Musical self-indulgence was thus not only endemic to democracy, it actually created democracy: theatrocracy and democracy are necessarily linked, the former is but the cultural side of the latter, and the latter nothing but the political face of the indiscipline that arises when the masses (the analogue of the appetitive portion of the soul)[202] are permitted to run amuck.

Democratic culture was responsible for the degeneration of music everywhere in Greece except in Sparta and Crete.[203] Nostalgic and embittered elites throughout Greece, encouraged doubtless by Sparta's extreme cultural conservatism, its rigidly hierarchic social and political structure, and its support for oligarchy abroad, singled Sparta out to serve as an antidemocratic utopia and a remnant of bygone order and simplicity in politics, ethics, and music—indeed the paradigmatic proof that good politics, good ethics, and good music were

[195] Plato *Leg.* 700a–1d; cf. Ps.-Plutarch *De Mus.* 1132e.

[196] Plato *Leg.* 698b.

[197] Plato *Leg.* 700d.

[198] Plato *Leg.* 699e.

[199] Plato *Leg.* 657b.

[200] Plato *Leg.* 700d.

[201] Plato *Leg.* 701a.

[202] Plato *Rep.* 559d–63e; *Leg.* 689b. See, further, my sections 4–5.

[203] Plato *Leg.* 657b, 660b. The Spartan constitution was thought to be very closely modeled on the Cretan: Aristotle *Pol.* 1271b.22.

mutually implicative.[204] Political order and moral discipline presupposed an orderly and disciplined music: for the ancient critics "the very constitution of society, as visualized in the traditions of ... Sparta, is choral performance."[205]

There may well be a core of abused historical truth underlying these idealizations of Sparta and Crete, but it is much easier to spot the abuse than the truths. Relatively few outsiders had direct contact with these remote and closed societies and little of the real knowledge that would have been needed to constrain the creative fantasy of elite ideologues. The latter were canny enough to enhance the credibility of their theories by narrowing their focus on the one form of Spartan music that *was* widely known, because it was the one form of music that Sparta exported: ancient discussions of Spartan music deal exhaustively with its military music and little else.[206] Some claimed that Lykourgos permitted music no function except military; others believed that Sparta and Crete conscripted dancers as they conscripted soldiers, or that they disciplined choreuts like soldiers, penalizing deserters from the choral ranks with the death penalty as if they had deserted from battle.[207] All Sparta's and Crete's putative military and political orderliness (*eunomia*) were thanks to mulish adherence to their still more putative musical traditions.[208]

The critics enshrined the marching song, or *embatêrion,* as the archetype of all Spartan music.[209] It offered a brilliant antithesis to New Music and all that it symbolized. The marching song, which might, it seems, be called a *nomos,*[210] stood for old-fashioned simplicity and good order, precisely because Spartans

[204] Athenaios 628b, 632f–33a.

[205] G. Nagy, *Pindar's Homer,* Baltimore, MD 1990, 367.

[206] A. Gostoli, "Terpandro e la funzione etico-politica della musica nella cultura spartana del VII sec. a.C," in B. Gentili and R. Pretagostini (eds.), *La musica in Grecia,* Rome 1988, 321.

[207] Plutarch *Inst. Lac.* 238b; Libanios 64.17.

[208] Ps.-Plutarch *De Mus.* 1146b-c; Philodemos *De Mus.* 4, col. 32 (Delattre, pp. 46–48); Libanios 64.17.

[209] Gostoli 1988 (see above, n. 206), 231, with references; cf. West 1992 (see above, n. 19), 34. The "ancient Cretans" are said to have preserved the same custom, and Polybios ascribes the high reputation for virtue of the Arcadians in his own day in part to the continued custom "nobly conceived by their ancestors" of "practicing *embatêria* to pipe music" (4.20.1–6, 21.12). Athenian hoplites probably did not march to the pipes, but the evidence precludes certainty: Wilson 1999 (see above, n. 16), 81, n. 88.

[210] Thoukydides 5.69. See A. Gomme, A. Andrewes, and K. Dover, *A Historical Commentary on Thucydides,* vol. 4, Oxford 1970, 118, who take "nomos" to refer to custom/law. Gostoli 1988 (see above, n. 206), 235–36, n. 12, and the scholiast take it in the musical sense. Both meanings produced somewhat strained Greek, but perhaps Thoukydides is straining to allow both meanings. Cf. the *nomos polemikos* mentioned by Philodemos (*De Mus.* 4, col. 39, Delattre, p. 63).

knew, as the Athenian *dêmos* did not, how to keep their place and receive direction from their betters. Discipline, in its rawest and most coercive military form, was presented as the original and highest function of music and choral dance.[211] Here all motion, music, and words were ideally yoked to the single purpose of instilling a manly resolve, setting a steady and controlled pace, and maintaining the order of the hoplite line.[212] For this reason some supposed that pristine music concentrated on rhythm, as opposed to "modern" music's concentration on melody.[213] Rhythm could make music "rough and stimulating" (τραχὺ καὶ κινητικόν), while melody was "soft and pacifying" (μαλακὸν ... καὶ ἠρεμαῖον).[214] Aristides Quintilianus reports that "some of the ancients called rhythm male, and melody female."[215]

Many myths were created to reinforce this image of Sparta as a paragon of musical discipline. Certainly, the subordination of music to military ritual allowed little room for innovation. Plutarch even claims that Spartan law proscribed innovation in music or dance.[216] By contrast, Timotheos' songs were

[211] Cf. Chamaileon *ap.* Athenaios 628e "for the style of dancing used in choruses was elegant and stately and just like an imitation of the movements of men in arms"; 628f "dancing was almost like a military exercise." Cf. Phillis *ap.* Athenaios 21f–22a.

[212] Plutarch *Lyk.* 21.1; Gostoli 1988 (see above, n. 206), 232.

[213] Aristoxenos in Ps.-Plutarch *De Mus.* 1138b–c.

[214] Ps.-Aristotle *Pr.* 19.49, 922b.30–32. This level of schematization risked tying the theoreticians up in serious contradictions, as can be seen from their counterfactual claim that when the pipes and lyres are played together, it is the pipes' lower tones that establish the melody and lyres' higher ones that establish the rhythm. The belief seems inexplicable except on the ideological assumption that pipe music must belong to the side of the soft, and the lyre, associated with "noble" music, belongs on the side of the "rough and stimulating." See the discussion in Barker 1995 (see above, n. 27), 56.

[215] Aristides Quntilianus *De Mus.* 1.19.

[216] Plutarch *Inst. Lac.* 238c. Cf. Athenaios 633b, Philodemos *De Mus.* 4, col. 31 Delattre. The myth of the Spartan law seems to presuppose Damon's insistence on the dependence of political on musical stability. At a guess, the claim that musical tradition was safeguarded by the Spartan constitution originates with Plato's uncle, the arch-conservative, oligarchic, and Laconizing Kritias. The guess is based not only on the idealization of Sparta, but on the close link between Damon and Plato's family, the shadowy presence of Egypt in the background as the ultimate model for Sparta's musical conservatism, and the fact that Kritias wrote a *Constitution of the Lacedaemonians* in verse as well as in prose in which Sparta contrasts favorably with Athens in matters of culture as well as law and government. In one fragment of this work praise for Spartan moderation in drinking is sharply contrasted with criticism of the debilitating effects of unrestrained drinking at Athenian *symposia* (Kritias 88, B 6 Diels-Kranz). The moral contrast probably also extended to musical practice (cf. B 1). *Laws* (656d–e, 799a–b) presents Egypt as a society, based on immutable god-given laws of art and music, very much "in tune" with the Egypt of *Timaios* as presented by Kritias, who claimed to have learned it from his grandfather Kritias, who learned it from Solon, who visited

characterized by "innovation," Timotheos' and Philoxenos' by "the greatest possible innovation," and Timotheos, Philoxenos, and Krexos were themselves characterized as "very vulgar and innovative."[217] The mysterious "Spartan Decree" against Timotheos testifies to Sparta's later connivance in this reputation for musical conservatism.[218] The description of how Timotheos "dishonored the ancient Muse" and "polluted the hearing of youth" makes liberal use of the language of classical criticism with complaints about the *polyphônia* and *polychordia*; his use of "ignoble and intricate" instead of "simple and orderly" music; his "colors," modulations and avoidance of the enharmonic genus and strophic responsion. Nothing offered so fine a contrast to Spartan simplicity as the notoriously intricate works of Timotheos.[219]

Ideology transferred all the virtues of Spartan discipline to the Dorian mode. As early as Pratinas (probably a later fifth-century lyric poet) the Doric mode in general is characterized as "tense" (σύντονος) in opposition to the Ionian mode which is characterized as "slack" (ἀνειμένος).[220] The words refer in the first instance to the tautness or looseness of a string on the lyre, but transferred to moral or military contexts they came to connote the strictness or laxness of discipline.[221] When Aristotle compares two binarist tendencies, on

Egypt. Kritias may also be the source of Herodotos' claim that "the Lacedaemonians are like the Egyptians" in only permitting pipers who inherit their craft from their ancestors (5.60). On Kritias' active intervention in musicological debates in the late fifth century, see P. Wilson, "The Sound of Cultural Conflict: Kritias and the Culture of *Mousike* in Athens," in L. Kurke and C. Dougherty (eds.), *The Cultures within Greek Culture*, Cambridge 2003, 181–206.

[217] "Spartan Decree" *ap.* Boethius *De Inst. Mus.* 1.1 (best text by B. M. Palumbo Stracca, "Il decreto degli Spartani contro Timotea [Boeth. *De inst. mus.* I 1]," in A. C. Cassio [ed.], KATA ΔΙΑΛΕΚΤΟΝ: *Atti del III Colloquio Internazionale di Dialettologia Greca, Napoli-Fiaiano d'Ischia, 25-28 settembre 1996. AION [filol.]* 19, Naples 1999, 141); also L. Prauscello, "Wandering Poetry, 'Travelling' Music: Timotheus' Muse and Some Case Studies of Shifting Cultural Identities," in R. Hunter and I. C. Rutherford (eds.), *Wandering Poets in Ancient Greek Culture: Travel, Locality and Panhellenism*, Cambridge 2009, 168–94; Aristoxenos fr. 26 da Rios; Ps.-Plutarch *De Mus.* 1135c.

[218] The decree belongs to the second century AD. It is fully contextualized by Prauscello 2009 (see above, n. 217). For Spartan involvement in the myth of Spartan music, cf. Athenaios 628b; Pausanias 3.12.10 (with Csapo and Wilson 2009 [see above, n. 3], 280).

[219] Aristoxenos fr. 26 da Rios.

[220] *PMG* 712. Herakleides interpreted σύντονος as referring to the Dorian mode. Page deletes the reference to the Ionian mode ('Ιαστί) in the text preserved by Athenaios (cf. Pratinas *TrGF* 4, fr. 5), partly no doubt because of its ascription to the early fifth-century Pratinas, who is early for adverbs of this sort. If it is a gloss, it is certainly on the right lines. For the general interpretation, cf. Anderson 1994 (see above, n. 17), 88–93.

[221] "Dissolution" most commonly in the form of the participle ἀνειμένος: see, e.g., Thoukydides 1.6.3, 5.9.6; Plato *Rep.* 410e, 412a, 549d.7, 573a; Aristotle *Pol.* 1270b.32, 1290a.28; Theophrastos *CP* 5.4.4, 5.7.1. In the form of the finite verb, ἀνίημι, see, e.g., Thoukydides 4.22.1 (relaxing one's

the one hand to classify all political constitutions as varieties of "oligarchy" or "democracy," on the other to view all musical modes as variations on the Dorian and the Phrygian, his only slightly less reductive trinary solution involves a comparison of oligarchic constitutions to the "tenser and more masterful modes" (συντονωτέρας καὶ δεσποτικωτέρας), namely the Doric "varieties," and a comparison of all the democratic constitutions to the "slacker and softer" varieties (τὰς δ᾽ ἀνειμένας καὶ μαλακάς), namely the Phrygian.[222] To make a constitution συντονωτέραν meant to key it up from democracy toward oligarchy.[223] To gauge the trajectory of these mad fantasies, it is helpful, once again, to keep in mind that a lyre player could change from the Phrygian to the Dorian mode by tightening his top string by a single note.

Figure 2: Paestan red-figure bell-krater, Asteas, ca. 350 BC.

Conservatives fantasized about stretching New Musicians on the rack of penal and military discipline. Later historians claimed that Spartan ephors cut the excess strings of the kitharas of Timotheos and Phrynis.[224] A bell-krater by Asteas (fig. 2) preserves a scene from Eupolis' *Demoi*, in which a reluctant Phrynis, still holding his lyre, is being dragged off by the old-fashioned Athenian

guard); Xenophon *Cyr.* 7.5.70 (neglecting military exercise); Euripides *Or.* 941 (laws becoming impotent). In the form of the noun, ἄνεσις, see, e.g., Athenaios 633c (contrasted with *sophrosynê*, both musically and ethically). For σύντονος, see, e.g., Plato *Rep.* 619b. For τείνω and compounds used of discipline, see, e.g., Plato *Rep.* 410d, 412a.

[222] Aristotle *Pol.* 1290a.

[223] Aristotle *Pol.* 1304a.21.

[224] Csapo and Wilson 2009 (see above, n. 3), 284-86.

general "Pyronides" (possibly a nickname for the historical Myronides) in an apparent *apagôgê* (a legal procedure by which ordinary citizens could haul a malefactor before a magistrate).[225] Plato yearns for the "disciplining rod" that once checked the "museless shouts" of the theater audience.[226] But when the dream of disciplining the mob seemed hopeless, the critic turned his lust for law and order inward on his students and on himself. Aristoxenos, alienated by the "effeminized music" of the mob and the theater, encouraged his students to pursue the traditional "manly" forms, and he himself, "indifferent to the contempt of the *dêmos* and the mob, preferred Art to popularity, since it was not possible to obey the laws of Art and also sing what pleases the many."[227] But, unlike Plato, Aristoxenos did not find discipline and manhood in the "simple and noble" diatonic genus but in the enharmonic, a genus (represented as being) of such complexity that it could only be mastered with hard work and perseverance, while the other genera apparently served as a default style for the lazy and self-indulgent.[228] So much moral training was required that Aristoxenos feels it necessary to warn that sudden exposure to the enharmonic genus could cause the unmanly and dissolute to vomit bile.[229] Not surprisingly, Aristoxenos found the enharmonic genus ideally suited to the Dorian mode, while the diatonic was ideally suited to the Phrygian.[230]

4. God's music, or the metaphysics of the "Old" Music

"Nothing," says Plato, "is more dangerous than change of any sort...whether change of seasons, winds, or the disposition of the *psychê*;" but the changes

[225] Paestan red-figure bell-krater by Asteas, ca. 350 BC, Salerno, Museo Provinciale Pc 1812, *PhV2* 58. For its place in Eupolis' comedy, see, most recently, I. C. Storey, *Eupolis: Poet of Old Comedy*, Oxford 2003, 169–70; Telò 2007 (see above, n. 34), 28–36; Csapo 2010 (see above, n. 13), 61–63. Telò makes the important observation that Phrynis must be among the dead brought back to Athens from the Underworld in the play. I am, however, disinclined to his conclusion that the vase shows a forcible abduction to the upper world. A literal *apagôgê* for punishment before a magistrate for musical offenses by (the perhaps, on acquaintance, disillusioned) Pyronides better suits the disciplinary fantasies of anti-New Musical discourse.
[226] Plato *Leg.* 700c.
[227] Aristoxenos fr. 29 da Rios. Cf. Krexos, Timotheos and Philoxenos pursuing the "φιλάνθρωπον and mercenary style" in preference to the noble simplicity of ancient music (Ps.-Plutarch *De Mus.* 1135d). The word φιλάνθρωπον implies "publikumswirksam" (L. Richter, "Der Stilwandel in der griechischen Musik zur Zeit der Poliskrise," in E. Welskopf [ed.], *Hellenische Poleis* III, Berlin 1974, 1456).
[228] Aristoxenos frs. 29, 102 da Rios.
[229] Aristoxenos fr. 100 da Rios.
[230] Aristoxenos fr. 103 da Rios.

affecting the *psychê*, particularly the *psychê* of a nation, are far the worst, because "every soul dreads and fears to change in any way the established laws with which one has been brought up and which, by the grace of the gods, have remained unchanged for so very long a time that no one remembers or has even heard of a time when they were different."[231]

Music is the leitmotif in the discourse about change. The critics never reserved such irony nor afforded such significance to any word in the New Musician's vocabulary as the technical term for "modulation," *metabolê*, which happily for them, also meant "change."[232] The pursuit of changelessness drove conservative ideologues ever deeper into the fantasy worlds of myth and metaphysics as the real world of the contemporary *polis* grew increasingly voluble. If the complex New Music of the theaters symbolized democracy and all its ills, the simple Old Music of traditional cult came to symbolize its antidote.

Long before Plato and Damon there was a tradition that systematically linked the tuning of the lyre, the movements of the heavenly bodies, and the health of the human soul. John Franklin has recently redrawn our attention to how deeply these homologies were rooted in ancient Near Eastern and Greek religion and science.[233] In ancient Greece the connection between music, cosmology, and psychology found its fullest articulation in Pythagorean thought.[234] From the Pythagoreans the theory of a musical concord between the cosmos and the human soul spread to mystery cult and to Plato, and through them became broadly diffuse in popular thought, philosophy and music theory.[235] For the sociology of music, the main effect of the doctrine of cosmic harmony was to give

[231] *Leg.* 797d–98b.

[232] Koller 1954 (see above, n. 4), 183–85, 229–30, n. 109; A. D'Angour, "The Sound of *Mousikê*: Reflections on Aural Change in Ancient Greece," in R. Osborne (ed.), *Debating the Athenian Cultural Revolution: Art, Literature, Philosophy, and Politics, 430-380 BC*, Cambridge 2007, 297, n. 29.

[233] J. C. Franklin, "The Wisdom of the Lyre: Soundings in Ancient Greece, Cyprus and the Near East," in E. Hickmann et al. (eds.), *Musikarchäologie im Kontext*, Rahden 2006, 379–97; J. C. Franklin, "Lyre Gods of the Bronze Age Musical Koine," *Journal of Ancient Near Eastern Religions* 6.2 (2006), 39–70.

[234] Koller 1954 (see above, n. 4), 178–79; W. Burkert, *Lore and Science in Ancient Pythagoreanism*, Cambridge, MA 1972, 350–68; L. Richter, "Struktur und Rezeption antiker Planetenskalen," *Die Musikforschung* 52 (1999), 289–306; Hagel 2005 (see above, n. 26); Franklin in Hickmann et al. 2006 (see above, n. 233), 380; Franklin 2006 (see above, n. 233), 53–57.

[235] Mystery cult: M. L. West, *The Orphic Poems*, Oxford 1983, 29–33; A. Hardie, "Muses and Mysteries," in Murray and Wilson 2004 (see above, n. 38), 26–29; E. Csapo, "Star Choruses: Eleusis, Orphism, and New Musical Imagery and Dance," in Revermann and Wilson (see above, n. 6). For Plato, see below.

music, Old Music, the divine sanction required to secure it as a foundation for ethical and political science.

The fullest expression of the importance of music to metaphysics and ethics is to be found in Plato's late dialogues. Here the universe is portrayed as a layered hierarchy of changelessness. Absolute or near absolute changelessness character-izes everything up top: gods are "to the utmost degree perpetually unchanging and unaltered";[236] "to the most divine of all entities alone belong immobility, immutability, and self-identity";[237] even truth and reality are "by nature eternally changeless."[238] Change, by contrast, increases as one descends. It is the fate of all that partakes of a bodily nature. Even the heavenly bodies are subject to change. But within the material universe there is, of course, distinction.

It is motion that causes change and Plato discerns several different kinds of motions graded according to the change each generates and according to the degree each partakes of reason.[239] At the top end of the corporeal hierarchy are the motions of heavenly bodies: they are minimal, confined "as much as possible to a locomotion that is single and in the same place and of the same kind."[240] Far below them and subject to more complex (and less rationally governed) motions are earthly beings. Humanity and human affairs are subject to constant flux.[241] But even human activities can be ranked by the degree to which they participate in reason.[242] The hierarchy of being thus descends from a realm of incorporeal mind and reason, where all is simplicity, changelessness, and order, to the realm of the corporeal drives, characterized by multiple impulses, constant motion, and disorder: for the corporeal element "partook of great disorder [*ataxia*] even before entering the world order."[243] The trick, then, for both individuals and entire polities, is to reduce the changefulness of self and society, by reducing the extent, number, and complexity of the motions responsible for change. In order to do this, the gods gave humanity music. Music is mankind's principle link to stability, permanence, and order. The right kind of music, at least, could bring the human soul in tune with the divine symphony.[244]

[236] Plato *Rep.* 381c.9–10.
[237] Plato *Pol.* 269d.
[238] Plato *Phlb.* 58a.
[239] Plato *Leg.* 897d–8b, cf. *Tim.* 34a–b and 90c–d.
[240] Plato *Pol.* 269d–e; *Leg.* 894c.; *Epinom.* 982a–3c.
[241] Plato *Pol.* 294a–b.
[242] Plato *Leg.* 904c.
[243] Plato *Pol.* 273b.6–7.
[244] Aristotle basically agrees with Plato's general hierarchy of the cosmos based on movement, identifying happiness as that attained by the most perfect being without any activity, with

Plato's *Timaios* explains the essentially musical beginnings and ends of divine and human life. Attunement (*harmonia*) is the very essence of the soul. The proportions that correspond to the intervals of an octave were converted by the Creator God into the substance from which all souls are formed. Out of this soul-substance the Creator formed the other gods who are the stars and planets. Being less perfect than the Creator they are not entirely changeless, but they are nearly perfect because their motion is simple and regular. Their daily and annual movements through the sky are the simplest and most noble form of change and imitate the motions of the material portions of soul-substance. The movement of the heavenly bodies thus provide a visual analogue of the harmony that is soul-substance.[245]

Less perfectly created soul-substance was used to create humans. But their bodies were cruder, with more complex motions (six in all: up and down, forward and backward, left and right). Because of cruder workmanship and all the jolts and jostling caused by complex movement, the soul, like a stringed instrument, is regularly stretched and twisted. Motion puts the soul out of joint, and causes it to lose its original attunement to divine proportion. All human souls go bad this way, but, naturally, some get a lot worse than others (so bad in fact that they can be reborn in the form of women or lower animals!). But god provided two safeguards against universal degeneration. He gave men eyes so that they could contemplate the harmony of the heavenly bodies: "God invented and gave us the gift of sight so that we might benefit from contemplation of the revolutions of intelligence in heaven, and so that, by understanding the movements within ourselves, which, though disturbed, are akin to them which are unperturbed, and by studying and partaking of the natural precision of their calculations, we might adjust our own wandering movements by imitating the completely unerring movements of the god."[246] God also gave men hearing so that they could hear harmonies and rhythms and thereby recalibrate the harmony and rhythm of the soul's proportions and movements.[247] Finally, to facilitate the deployment of these gifts, the Muses gave men dance and music for no other purpose than to permit them to imitate the god-given harmonies and rhythms that they saw and

happiness and perfection both decreasing as activity increases until one reaches the condition of humanity (*De Caelo* 292a19–b25). But humans, unlike beasts or plants, at least can attain happiness through activity. Happiness is harder to attain with complex movements than with simple and few (*De Caelo* 292a28–31).

[245] Cf. Plato *Phdr.* 259d, *Rep.* 521–534e.

[246] Plato *Tim.* 47b6–c4.

[247] Plato *Tim.* 47c4–d2.

heard, because imitation of the original movements of the world-soul through the practice of music and dance was the easiest way to restore proper movement to the human soul.[248] The best souls are thus, like lyres, precisely attuned to the "noble and simple" diatonic genus, for this is the genus of Plato's cosmic scale, as Stefan Hagel demonstrates.[249] Music and dance are thus the greatest gifts of the gods, bringing us goodness, happiness, and health. The main problem for ethics and indeed politics is that not all music was content to imitate the simple and restrained movements established by the Creator and handed down by tradition. By linking his distaste for contemporary music with Pythagorean cosmogony Plato gave his musical dislikes an absolute ethical, metaphysical, and theological foundation. Music was the common man's last link to the divine order but the New Music and the democratic culture that enabled it, through receptiveness to innovation and change, had severed that link.

5. The people's sophrosynê, or the ethics of the "Old" Music

Among Plato's many contradictions the revolutionary zeal with which he promoted "changelessness" must count as the oddest. He made changelessness the essential characteristic of god and the world-soul. Music in turn was change-lessness' physical expression. But music's theological and metaphysical impor-tance was, as we saw, already fixed in Plato's cultural inheritance and it served Plato mainly as a foundation for his ethical and political thought. Plato's most original contribution to musical theory was not the discovery of "God's music" but the exposure of the Devil's.

The characteristics shared by God, nature, and traditional music are precisely those of the good man and the good polity: above all, changelessness, simplicity, and homogeneity. But even here Plato draws on a fund of traditional elite values that made a virtue of invariability. Accolades to invariability begin at the time of democracy's first glimmer and (we will see) are frequently given an antidemo-cratic form of expression. A basic hostility to change is, after all, the one thing all conservatives everywhere, by definition, share. But, in this, Greek conservatives pretty clearly went over the top. Invariability became a touchstone of truth and nobility in the eyes of men who themselves took pride in their own inability to adapt: most notably Plato's immediate predecessors, the religious-philosophical

[248] Plato *Tim.* 47d2–e1. Cf. Plato *Rep.* 410a–c; *Laws* 659e, 664b, 666c, 670e; *Protag.* 312b.
[249] Hagel 2005 (see above, n. 26), 74–77.

sects who set themselves in opposition to sophistic thought and the values of the democratic *polis*.[250]

The politics of intransigence

William Slater has argued that elite self-definition only became a matter of serious pursuit in the late sixth century: "What is an aristocrat is a question that only, so far as I can see, has an answer after about 520 BC. An aristocrat is someone who knows *ta kala* and is capable of realizing *ta kala*."[251] Whether this knowledge of the good is bred in the bone, as traditional elites maintained, or could be ingrained through teaching as a second nature, as the sophists and Sokrates maintained,[252] the position permits only the simplest relationship between disposition, thought, word, and action. Because virtue consisted in following a certain code of behavior and because adherence to the code lay in the grain, right and virtuous action sprang naturally and spontaneously from the right character. In Herodotos' fictional debate on government, Megabyxes, who argues for oligarchy and against democracy, reasons that "a tyrant when he acts at least recognizes what he is doing, but the *dêmos* is incapable of this recognition. How could it recognize it when it has never been taught *to kalon* and knows none within itself?"[253]

As a matter of instinct for (or categorical knowledge of) the good, noble character belongs to the realm of the eternal and inalterable. It is regularly described in terms of stability and unreflective spontaneity. The supremely class-conscious Theognis declares that "a nobleman always has a fixed resolve."[254] Euripides' Hekabe, a die-hard aristocrat, defines "the noble man" as one who "does not corrupt his nature under the influence of (mis)fortune but is continuously good/noble," while Euripides' Menelaos chides Agamemnon: "a nobleman must not change his ways when he does well."[255] Even Aristotle makes a positive virtue of mental fixity: in the *Eudemian Ethics* he contrasts "the good/noble

[250] M. Detienne, *The Masters of Truth in Archaic Greece*, trans. J. Lloyd (French original 1967), New York 1996, 119–34.

[251] W. J. Slater, "Aristo-Talk," in D. Papenfuss and V. M. Strocka (eds.), *Gab es das Griechische Wunder? Griechenland zwischen dem Ende des 6. und der Mitte des 5. Jahrhunderts v. Chr.*, Mainz 2001, 46.

[252] There remained, even in the late fifth century, "those who think they are noble by nature and despise learning," and who believed they could "speak and act as statesmen spontaneously and off-the-cuff" (Xenophon *Mem.* 4.1.3–2.7).

[253] Herodotos 3.81.2.

[254] Theognis 319, cf. 1083–84.

[255] Euripides *Hek.* 597–98, *IA* 345–46.

man," who "is always of the same mind and never changes his character," with the *phaulos* and the fool, "who do not resemble themselves from morning to evening"; "the bad man is not one, but many, and becomes another in the course of a single day and is capricious"; in the *Nicomachean Ethics* "good men's counsels are steadfast and do not ebb and flow with the tide"; and a virtuous action is not a sign of a virtuous agent unless, among other things, "he acts from a fixed and unchangeable disposition."[256]

The implied contrast with nonelite dispositions might have remained tacit (and the reference to the *phaulos* or the *kakos* might have been confined to the moral, not sociological, meanings of the "common" and "vulgar" man). But it did not. Volubility is one of the chief criticisms Athenian elites leveled at the *dêmos*, and particularly the *dêmos* in its political role as the constitutive decision-making body of the Athenian state. The Athenian Assembly's readiness to reverse decisions was as much a cliché of historical or rhetorical portraiture as of comic caricature.[257] The Athenians were notoriously ταχύβουλοι and μετάβουλοι, "quick to take counsel" and "quick to change it."[258] They not only changed their minds, but never came to a final decision, always reopening the question, never taking anything as settled, and proved in the end incapable of action, because incapable of decision. For this reason their *dysboulia* became proverbial (while the undeniable successes of Athenian policy could be dismissed as "good luck").[259] Even Kleon is portrayed by Thoukydides as admitting that a city with unchanging laws, even bad ones, was better than a city with good ones that were ineffectual, because constantly in flux.[260] The critics of Athenian volubility did not hesitate to name this mythically changeless state Sparta, where the law forbade any attempt to reopen a decision once made.[261] Thoukydides regularly lays the blame for the crippling volubility of Athens at the feet of the democracy, the *dêmos*, or, simply, "the mob" itself.[262]

[256] Aristotle *EE* 1239b.12, 1240b.17; *EN* 1167b.6; 1105a.32-33. Cf. Antiphon 80, B 44a.26–29 Diels-Kranz; Plato *Rep.* 381a–b, *Lys.* 214c–d, *Minos* 320a–b. Cf. in Stoic philosophy Julian *Or.* 2.50c; Seneca *De Benefic.* 4.34.4; von Arnim, *Stoicorum Veterum Fragmenta* vol. 3, nos. 548, 563 (pp. 147, 149).

[257] See, especially, Thoukydides 2.65, 3.36.5, 3.38.2, 3.42; Aischines 3.3–4 (with J. Ober, *Mass and Elite in Democratic Athens*, Princeton, NJ 1989, 301–3); Isokrates 15.19; Demosthenes *Proem.* 33, 34.1 Clavaud; Aristophanes *Ekkles.* 797–98, 823–29.

[258] Aristophanes *Ach.* 630, 632.

[259] Aristophanes *Nu.* 587, *Ekkles.* 473–75; Eupolis *PCG* 219; Demosthenes 18.253–55, 19.256; Suda *s.v. Athenaiôn dysboulia.*

[260] Thoukydides 3.37.3.

[261] Demosthenes *Proem.* 34 Clavaud.

[262] E.g., Thoukydides 2.65.4, 3.37.1.

The earliest personifications of Democracy and the Demos were caricatures of volubility: Parrhasios painted Demos "with different characters: irritable, unfair, fickle, and—albeit the selfsame person—approachable, kindly, sympathetic, boastful, lofty, humble, fierce, timid—all at the same time."[263] Plato described the "truly democratic man" as being, like his city, "both all-natured [*pantodapos*] and filled with the greatest number of characteristics, both attractive and variable [*poikilos*]," democracy itself as variable [*poikilos*], and the democratic constitution as "like a variegated garment decorated with every flower [ἱμάτιον ποικίλον πᾶσιν ἄνθεσι πεποικιλμένον] and embroidered with every possible character [πᾶσιν ἤθεσιν πεποικιλμένη]."[264] For Plato, the chaos of transitory passions characterized Democracy like no other political order, save only tyranny, in which the human soul is "filled with confusion and changes of mind."[265]

Volubility was the leitmotif of antidemocratic criticism because it was the negative view of the democrat's own self-professed versatility and adaptability. In place of knowledge of the good, voices sympathetic to democracy urged that there was no absolute, natural, or god-given "good," but that values were a matter of collective agreement through social dialogue (*logos*) and the enlightened calculation (*logismos*) of advantage.[266] In this way, the good was not only open to negotiation, but in principle always the product of ongoing renegotiation based on circumstances and need. There are moments when even our most hostile sources preserve the democratic voices they oppose. No other race, says Thoukydides' Perikles, "is equal to so many emergencies, and graced by so happy a versatility, as the Athenian"; Athenians were superior in judging the better course because they "did not suppose deliberations an obstacle to action, but, on the contrary, thought it a hindrance not to consider first in debate, before undertaking a necessary action"; Athenians were unique in showing daring after calculating risks, "among other nations daring is a form of ignorance and calculation begets hesitation" (a thought that directly anticipates Epikouros' "bravery is not a matter of nature, but comes through the calculation of advantage").[267] It is

[263] Pliny *NH* 35.69: *pinxit (Parrhasius) Demon Atheniensium argumento quoque ingenioso: ostendebat namque varium: iracundum, iniustum, inconstantem, eundum exorabilem, clementem, misericordem, gloriosum, excelsum, humilem, ferocem fugacemque et omnia pariter.*

[264] Plato *Rep.* 561e, 558c, 557c.

[265] Plato *Rep.* 577e.

[266] This is not the place to give a full demonstration of this proposition. For the exploration of the democratic strand of sophistic thought (especially Demokritos), see T. Cole, *Democritus and the Sources of Greek Anthropology*, Cleveland 1967 and C. Farrar, *The Origins of Democratic Thinking: The Invention of Politics in Classical Athens*, Cambridge 1988.

[267] Thoukydides 2.41.1–2 (following Crawley's translation), 40.2–3; Epikouros fr. 517 (cf. fr. 540)

rather men who "feel their inferiority in matters of deliberation" who "rush reck-
lessly into action."[268] The moral superiority of the stubbornly inadaptable was at
least contested in the democratic forum. In the Athenian law courts, Andokides
felt comfortable claiming that "the most prudent men are the quickest to change
their minds"[269] and Lysias that "the best and wisest are most inclined to change
their minds."[270] Above all, aristocratic stubbornness became a subject of spec-
tacle in the Athenian theater, particularly in the plays of Sophokles, whose
noble heroes notoriously stick to their decisions—or rather, stick to their
codes, because decision-making, however momentous the consequence, is in
Sophokles rarely a process. Bernard Knox memorably defined the "Sophoklean
hero" as:

> one who, unsupported by the gods and in the face of human
> opposition makes a decision which springs from the deepest
> layer of his individual nature, his *physis*, and then blindly, fero-
> ciously, heroically maintains that decision even to the point of
> self destruction.[271]

But we must not suppose that Sophokles admired such heroes or intended
his audiences to accept them, somehow, as role models: there is after all a direct
correlation between their stubbornness and the misery they generate for them-
selves and others. If Knox' description fits Aias, Antigone, and Oidipous better
than Kreon or Neoptolemos, who conspicuously do change their minds, the
point is that mental flexibility and inflexibility are thematized, problematized,
and directly correlated with moral identity. In Sophokles *Philoktetes* 51 the adjec-
tive *gennaios* (basically "of noble birth") effectively means "true to," "unwavering
from"—but it is spoken by the most volubly adaptable and manipulative of all
speakers, "many-counseled" Odysseus to seduce Neoptolemos into a flagrant
betrayal of heroic principles: "stick by [be noble to] the purpose that you came
with … even if something new comes up."

Usener.

[268] Thoukydides 3.83.

[269] Andokides 2.6: σωφρονέστατοι δὲ οἳ ἂν τάχιστα μεταγιγνώσκωσι.

[270] Lysias 19.53: φασὶ δὲ καὶ τοὺς ἀρίστους καὶ σοφωτάτους μάλιστα ἐθέλειν μεταγιγνώσκειν.

[271] B. Knox, *The Heroic Temper*, Berkeley, CA 1964, 213. For mind-change in tragedy, see J. Gilbert, *Change of Mind in Greek Tragedy*, Göttingen 1995.

New Music incorporated: Treason, strategems, and spoils

Democratic variability for men like Plato and Parrhasios could be classified in two ways: the first I have described as *volubility*, the capacity of a person, class, or state to change its resolve, character, or appearance from one moment to the next; the second I can describe as *variegation*, the capacity of a person, class, or state to contain at any single moment different elements that seem to compete with one another. Both types of variability might be called *poikilia*. *Haplotês* (simplicity) is in this discourse the normal opposite of both meanings of *poikilia,* embracing both "uniformity" and "consistency."

For Plato the two forms of variability are causally connected. It is only because of internal diversity, namely the "mixture" of soul-substance with body, that humanity is susceptible to change at all. Only its association with body makes the soul appear "full of great diversity [ποικιλία] or unlikeness [ἀνομοιότης] or contradiction [διαφορά] in and with itself."[272] When mixed with body, soul-substance breaks down into three unequal parts depending on the measure of corporality present in each. Not coincidentally, these three parts correspond to the three classes of the ideal Platonic state, and also to the three varieties of constitution in Plato's classification. Each constitution has two parts: monarchy, whose perverse variety is tyranny; aristocracy, whose perverse variety is oligarchy; and democracy, which has no alternate name, presumably because always perverse, "whether it observes the laws or not and whether or not the multitude rules over the property owners by force or with their consent."[273] Democracy corresponds to the part of the soul that is most heavily burdened with body, most materialistic, and most attached to the body's needs and pleasures. Because of its bodily nature, democracy is also constantly in motion and constantly changing.

Democracy corresponds to the appetitive part of the soul (*epithymêtikon*), but this is a metonymic, not a metaphoric, connection since Plato believes that the constitutions of states correspond to the internal constitution of their citizens). Giving way to the appetites is likely to cause democracy; democracy in turn causes hypertrophy of the *epithymêtikon*. Because it impacts on his theory of music, it is worth examining some of the details of Plato's equation between *epithymêtikon* and democracy.

[272] Plato *Rep.* 611b.

[273] Plato *Plt.* 291. The correspondences are expressed somewhat differently in the *Republic*. Later at *Plt.* 301c–303b the ideal state is added to the list to make a seventh variety. Aristotle *Pol.* 3.7 basically follows *The Stateman*'s tripartite classification.

1. The *epithymêtikon* is "the largest and strongest" part of the soul, just as the *dêmos* is the majority of any state.[274] In *Laws,* Plato actually calls the *epithymê tikon* "the majority" (τὸ πλῆθος): "just as the part of the state that feels pain and pleasure is the *dêmos* and the majority."[275]

2. Both the *epithymêtikon* and the *dêmos* are devoted to the body and its appetites. They are materialistic. The social analogue of the *epithymêtikon* is called the *chrêmatistikon* because it is motivated only by "a most insatiable desire for *chrêmata* ["money," "material objects," or "consumer goods"]."[276] Although soul is the cause of all motion and change, motion and change increase in volume and complexity the greater the corporeal element in the mix. In the same way the more bodily nature of both *epithymêtikon* and democracy increases the overall quantity of their motion, both in violence and irregularity.

3. Democracy and the *epithymêtikon* are characterized, therefore, by sensuality. Plato uses the word *kinêsis* (usually "motion") of appetites themselves, of feelings of pleasure and pain, of emotions, and of the process involved in sensory perception (*aisthêsis* is derived from *aissô*, "move quickly"). Hence all sensory and sensual pleasures belong to the body and, when indulged, are at variance with soul as violent motion is to relative stability.[277] The movements involved in the production of corporeal pleasures are far greater than the motions proper to soul because they are principally movements between extreme opposites, normally involving repletion from a state of want, and evacuation from a state of plenitude.

4. Democracy, like the *epithymêtikon*, is volatile. In the political sphere *kinêsis* means "upheaval" and "revolution" and this connotation is everywhere implied in Plato's treatment of democracy. Indulgence of material, sensory, and sensual pleasure is the cause both of democratic revolutions, when other regimes are overthrown, and of democracy's own internal instability. It is in fact the proper task of the other parts of the soul (the *logistikon*, the seat of reason, and the *thymoeides*, the seat of the higher, more spiritual, passions) to keep the activity of the *epithymêtikon* in check, and to "keep

[274] Plato *Rep.*580e, cf. 442a.
[275] Plato *Leg.* 689a–b.
[276] Plato *Rep.* 442a.
[277] Appetites: *Tim.* 88b; Pleasure and pain: *Rep.* 583e; Emotion: *Leg.* 790e–91a; Sensation: *Tim.* 43c, 45d, 67b, cf. *Definitiones* 414c. The pleasures of soul and body are generally at variance: cf. *Phlb.* 41c.

watch over it lest by being filled with what we call the pleasures of the body it should grow large and strong and not keep to its own work, but try to enslave and rule over what it should not."[278] The process of individual degeneration and political decline is the same: control passes from the *logistikon* and "aristocracy" to the *thymoeides* and "timarchy" (states like Crete and Sparta, dominated by the nobler passions), to oligarchy, and finally, when the *epithymêtikon* takes over, to democracy and tyranny. The hierarchy of psychic and political states is correlated to the degree of stability within the constitutions themselves, with "reason" and "aristocracy" being "difficult to budge," whereas oligarchy, like a diseased man "requires only a tiny impulse" to topple it into democracy, while democracy and the democratic character titubate constantly between oligarchy and tyranny.[279] This is partly because degeneration, in states as in individuals, lays internal divisions ever barer and thereby increases their mutual antagonism. In Plato's musical language degeneration moves from "harmony" to "discord," and from "simplicity" to *poikilia.*

5. The *epithymêtikon,* like democracy, is variegated. So great is its multiformity (*polyeidia*) that Sokrates claims to be unable to encompass the desiring part of the soul with a single name (though he does nonetheless).[280] It is multiform and mob-like (πολυειδὲς θρέμμα…ὀχλῶδες), an all-in-one kind of creature (παντοδαπὸν θηρίον), an animal that is just too "busy" to be functional, containing, notably, far too many heads (θηρίον ποικίλον καὶ πολυκέφαλον).[281] In the *Republic* a series of similes liken the tripartite soul to a mythical monster, something like a Chimaira, Skylla, or Kerberos, in which the smallest part is human, the middle part a lion, and the largest part of all "combines the heads of tame and wild beasts that it can change and generate at will."[282] This image of multiple forms or multiple heads betrays a critical focus on the *dêmos* gathered in the assembly or the theater, precisely the contexts in which critics of the *dêmos* most readily portrayed its variety and volubility.[283]

[278] Plato *Rep.* 442a–b.

[279] Plato *Rep.* 546a, 556e, 559e–570e.

[280] Plato *Rep.* 580d.

[281] Plato *Rep.* 590a–b, 588e, 588c. Cf. the Old Oligarch (*Ath. Pol.* 2.7–8) who complained that through its naval empire the Athenian democracy learned to mix indiscriminately the language, lifestyle and dress of all Greeks and barbarians.

[282] Plato *Rep.* 588c.

[283] The audience of the theater is described as *pantoioi* (Plato *Laws* 665e) and *pantodapoi* (Plato

6. Democracy and the *epithymêtikon* are also more inclusive than their conge-
ners. The *epithymêtikon* notably contains not only rival desires but also
contradictory desires. Democracy, through its commitment to liberty, also
coexists with its enemies, and includes people and institutional structures
that adhere to other constitutional types. Democracy does not so much
replace other constitutions as include every variety in a confused jumble:
it is a "constitution market" (παντοπώλιον πολιτειῶν).[284] Indeed the demo-
cratic man, like democracy, is not the slave of his appetites so much as his
impulses: "one day he's drunk and listening to pipe music, the next he's on
a diet of bread and water, the next he's training in the gym, and then lazing
about and indolent, and then he studies philosophy."[285] For Plato, at least,
democracy can share the characteristics of lion as well as the snake, but a
lion that is out of control.

What is true of democracy is true of every manifestation of democratic
culture. Sophistry is every bit as varied and voluble as the *dêmos*. Sophists are
a "motley mob," a "genus of every variety," a mixture of "men resembling lions,
centaurs, and other such creatures, but mostly satyrs and other animals that are
weak and versatile" whose chief characteristic is "that they each quickly exchange
their shapes and their capacity for action with each other."[286] And like the *dêmos*
itself, to which he panders, the sophist is "many-headed."[287] The reversibility of
sophistic logic is, according to an ancient commentator, alluded to by the choice
of clouds as patron goddesses for sophists in Aristophanes' *Clouds*.[288] Sophists
appear mainly as teachers of rhetoric in this discourse and rhetoric is character-
ized as the art of producing rapid and arbitrary changes in the mind—the art
of persuasion "makes highly voluble the conviction in one's beliefs."[289] Sophists
use rhetoric to effect changes in the mind, just as doctors use drugs to effect
changes in the body.[290] But sophists are not entirely to blame for democracy's
volubility: it is rather the volubility of the *dêmos* that begets the volubility of

Rep. 604e).

[284] Plato *Rep.* 557d.

[285] Plato *Rep.* 561c–d.

[286] Plato *Plt.* 291a–b with C. J. Rowe, *Plato: Statesman*, edited with introduction and commentary,
Warminster 1995, 218–19.

[287] Plato *Soph.* 240c.

[288] Scholiast V *ad Nu.* 298.

[289] Gorgias 82, B11.13 Diels-Kranz, cf. 11.10; Plato *Theaet.* 166d-67d; *Rep.* 412e–13d; Detienne
1996 (see above, n. 250), 181–82, n. 111.

[290] Plato *Theaet.* 167a.5–6.

sophists. In the *Gorgias*, Sokrates, a lover of philosophy, compares and contrasts himself with Kallikles, who, he says, is in love with the Athenian *dêmos*. Each lover says whatever his beloved wants to hear, but, as a result, Kallikles is subject to complete turn-abouts (ἄνω καὶ κάτω μεταβαλλομένου) to please his listeners, while Sokrates, by contrast, always holds the same views.[291]

Rhetoric appears as a kind of disease that spreads the contagion of disharmony throughout democratic culture. Though it might seem odd that whenever Plato portrays democracy at its worst, he does not, like Thoukydides, turn to the assembly, or like Aristophanes, to the lawcourts. The kinetic center of democratic volubility is for Plato always the theater, as if it were the very *epithymêtikon* of democratic culture. Nothing distinguishes poets, especially tragedians, from sophists and demagogues, if not the fact that, while the latter unsettle the mind, the poets add a substantial agitation of the emotions and the appetites.[292] By far the worst aspect of drama is not the speech but the music, because it bypasses the head entirely, taking direct aim at the most voluble of volubles, the *epithymêtikon* of the *dêmos*, who are themselves the *epithymêtikon* of the state. For this reason theater music shares most of the features the *epithymêtikon* shares with democracy: it is material, sensual, voluble, variegated, multiform, and inclusive.

Noble imbecility

Plato is at the deep end of an elite tradition that disparaged the ethical qualities the Athenian *dêmos* most prized as national virtues, namely adaptability, subtlety, and quickness. By the late fifth and early fourth century elite writers had advanced so far in their reactionary ethics that they took the improbable step of advancing intractable simplemindedness as a positive virtue. From the time of Thoukydides we can detect a nostalgia for the "noble simplicity" that once characterized good men, but was vanishing in a world where faith and trust were no longer possible because the absolute standard of the good that once governed morality had given way to relativism and the individual calculation of advantage. This nostalgia particularly attached itself to the term *euêtheia*, in part because of its etymology ("good natured"), though the term had long acquired "stupidity," "gullibility," or "mental and verbal ineptitude" as its primary meanings. Thoukydides notoriously rues the fact that "as a result of factional struggle

[291] Plato *Gorg.* 481d–2c.

[292] Plato *Gorg.* 502d, *Laws* 817c, *Phdr.* 258b. It is evidently for this reason that Plato feels that tragedians will be most honored by tyrants, and second by democracy, but will find success progressively harder as they move "up" the constitutional scale: Plato *Rep.* 568c–d. Cf. Plato *Minos* 321a, where tragedy is described as "most *dêmos*-delighting" (*dêmoterpestaton*).

[between those who called for "political equality" and those who supported "orderly aristocracy"] every form of moral degeneracy arose in the ancient Greek world, and especially the fact that the quality of being *euêthes*, of which nobility has the greatest share, became an object of ridicule and vanished."²⁹³ It is as if to prove Thoukydides' point, that Plato portrays the sophist Thrasymachos dismissing "justice" as "truly noble simplicity" (πάνυ γενναίαν εὐήθειαν) or declares that the "braggart discourses," when making common cause with the appetites to seize control of the democratic man's soul, rage against the forces of thrift (hangovers from the previous oligarchic regime) and denounce shame as "simplemindedness," discipline as "cowardice" and moderation as "boorishness."²⁹⁴ Elsewhere Plato praises mental "simplicity" as a bygone aristocratic virtue, as for instance when his Hippias makes a favorable contrast between Achilleus, characterized as "most simple" (ἁπλούστατος), and "most many-faceted" (πολυτροπώτατος) Odysseus, adapting a pattern that becomes a topos in fifth-century literature, in which Odysseus, symbolizing the multifaceted and voluble character of democratic man takes advantage of a noble hero's naïve simplicity: in *Phaidros* Odysseus is the archetype of the sophist.²⁹⁵

Noble simplicity indeed plays an important role in Plato's theory of political evolution, and one diametrically opposed to the qualities fostered by democracy. In *Politikos* we learn something more about the movement of the cosmos. It is subject to change because it is corporeal, though minimally so, and hence the

²⁹³ Thoukydides 3.83.1. Translators often incorrectly render the word here translated as "nobility," τὸ γενναῖον (cf. γενναιότης at 3.82.7) as "honesty." The ambiguity of the term is very much to the point, but to overlook the sociological meaning, as the scholiast (*ad* 3.83.1 τὸ γενναῖον οἱ εὐγενείας μετέχοντες) saw, is to miss it entirely. Cf. M. Nussbaum, *The Fragility of Goodness: Luck and Ethics in Greek Tragedy and Philosophy*, Cambridge 1986, 404–5; G. Crane, *Thucydides and the Ancient Simplicity: The Limits of Political Realism*, Berkeley, CA 1998, 7. Note that in this passage, Thoukydides accesses the schema that pits the simple-minded against those who relied on the versatility (τὸ πολύτροπον) of their intellects (3.83.3).
²⁹⁴ Plato *Rep.* 348c, 560c–d.
²⁹⁵ Plato *Hipp. Min.* 364d–e; *Phdr.* 261b–c. Odysseus preys on the *euêtheia* of noble princes and warriors, especially: on Aias in Pindar's *Nemean* 7 and 8, *Isthmian* 4, and Sophokles' *Aias*, on Priamos and Hekabe in Euripides' *Hekabe* (see Nussbaum 1986 [see above, n. 293], 397–421, for discussion of their embodiment of *euêtheia*); on Neoptolemos in Sophokles' *Philoktetes*; and on Rhesos in *Rhesos*. Antisthenes presents Odysseus as a sophist and demagogue easily overcoming the blunt Aias in the contest for Achilleus' arms (fr. 14–15 Caizzi). Aristophon's famous painting of ca. 450 BC, described by Pliny (35.138), shows the encounter between Odysseus and Priamos, when Odysseus was discovered after entering Troy disguised as a beggar and convinced Priamos to release him. Beside Priamos was the figure "Credulitas," almost certainly "Euêtheia" in the original, and behind Odysseus "Dolus."

movement is circular, as we saw in *Timaios*. But in *Politikos* the Eleatic Stranger points out that the cosmos undergoes a periodic reversal (this being excused as the smallest variation possible). Under the guidance of the Creator God the universe moves in one direction only, because this is as simple as motion gets. But the Creator God periodically allows the universe to govern its own motion, and when it does so, it slips down a notch toward complexity, reversing and moving in the other direction in accordance with the "innate desire" of the corporeal element.[296] While God is "at the helm" men enjoy a Saturnian Golden Age. When, however, the universe sets its own course there is initially "the greatest and most complete change" that could ever occur in the celestial sphere and this results in the destruction of most living things.[297] After the initial upheaval, however, the universe "remembers the teaching of its father, the Demiurge," and adopts a more regular motion. Gradually, however, the universe forgets the paternal style, "its original disharmony takes control," and this disharmony increases until it triggers another period of destruction, after which the god takes control once again.[298]

It is in the period when the corporeal element is following its own path from relative harmony and simplicity to complete disharmony and multiformity that we are to imagine the degeneration of constitutional forms that leads us from monarchy to democracy and tyranny. Details of this world history are supplied by the third book of *Laws*, where Sokrates describes the early history of humankind after the periodic destructions. At the earliest (patriarchal) stage, humans had the noblest characters (γενναιότατα ἤθη). Above all they shared a predisposition to virtue that Plato identified with *euêtheia*. *Euêtheia* was a product of the relative harmony of the universe as it was mirrored in the harmonious social relations of the primitive patriarchal communities, and in the harmonious relations of the parts of each individual's soul. In this world there was no hybris, no injustice, no envy, and no jealousy. People trusted what they heard. If something was called beautiful or disgraceful they believed it to be so. They believed what they heard about gods and humans and it shaped their way of life. No one had the smarts (*sophia*) either to tell or suspect a lie; these are arts that characterize the present.[299] Because of this trust and goodwill they were "most easily

[296] Plato *Plt.* 272e.
[297] Plato *Plt.* 270b–d.
[298] Plato *Plt.* 273b–d.
[299] Plato *Leg.* 679a–c.

persuaded to follow virtue" (εὐπειθεστάτους πρὸς ἀρετήν).[300] These noble primitives were "simpler (euêthesteroi), braver, more self-controlled and altogether more just" than the men of the present because they were ignorant of the arts of disharmony, and especially "the arts of war which are now practiced on land and on sea, as well as those practiced in the *polis*, namely those called lawsuits and revolutions which are contrived through every contrivance of word and deed for people to inflict mutual injury and wrong."[301] But this kind of good-natured simplicity dwindled as life became more varied, complex, and disharmonious. In Plato's "present day," *euêtheia* was ridiculed as both stupid and old-fashioned: simplemindedness acquired a bad name.[302]

"Music oft hath such a charm... "

Plato's remedy is to reverse, as much as possible, the social and psychological consequences of cosmic degeneration. The cure for restoring harmony is to recreate *euêtheia* "because good harmony [*euarmosteia*] and good rhythm [*eurhythmia*] follow *euêtheia*" (as do indeed good words [*eulogia*] and graceful movement [*euschêmosynê*]).[303] The way to recreate the source of these overtly musical and choreutic virtues is, unsurprisingly, through music and dance, which, as we saw, the Muses had given men for the purpose of imitating the harmonious movements of the heavenly bodies.[304] Music and dance had performed this vital ethical and political function, slowing the growth of disharmony in the individual and disharmony in the state, until just after the Persian Wars, when poets "ignorant of the justice of the Muse and of tradition" redirected the function of music toward pleasing the mob.[305]

New Music, it seems, simply accelerates moral and political degeneration. It is possible because of the general cosmic drift away from harmony. We are evidently to infer that the natural internal harmony of the men of the past would simply not have responded to New Music any more than they could have followed the verbal acrobatics of the sophist. The enabling condition for the triumph of the Museless and inharmonious music of the theater was that it

[300] Plato *Leg.* 718c.
[301] Plato *Leg.* 679d–e.
[302] Plato *Leg.* 797c–d.
[303] Plato *Rep.* 400d–e, 401a.
[304] A. G. Wersinger, "'Socrate, fais de la musique!' Le destin de la musique entre *paideia* et philosophie," in F. Malhomme and A. G. Wersinger 2007 (see above, n. 128), 57: "La musique infléchit l'*èthos* et produit l'*euètheia*."
[305] Plato *Laws* 700d; see above, p. 103.

should give pleasure to audiences and the enabling condition for such pleasure was the loosening of the bond between the lower and upper portions of the soul. Plato seems to picture the cosmos in its present "corporeal" phase as a lyre slowly going out of tune. Within it, each state and each individual soul seems also to be going out of tune. Plato's use of musical terms expressing concord (συμφωνέω, ἁρμόζω etc.) and discord (ἀσυμφωνέω, διαφωνέω, πλημμελέω, ἀναρμοστέω etc.) in psychology or social relations are never mere metaphors. The laws that govern music also govern both the *psychê* and the *polis*. But this simple fact also offers a hope of salvation to the contemporary ills of Greece. The restoration of God's music is the first step to restoring harmony in both the soul and the *polis*.

"The just man," says Plato, "attunes the three parts of his soul exactly as one attunes the fixed intervals of a scale [*nêtê, mesê, hypatê*]"; the immediate result is the restoration of discipline [*sophrosynê*], itself defined as a "harmony and attunement," by which the worse part of the soul is made to respond to the leadership of the better.[306] Retuning the state is strictly analogous. In language so filled with musical metaphor as to strain intelligibility, Plato describes the process of discipline as "simply keying up the whole scale of the state throughout, making the weak, the strong, and those in the middle sing the same tune together."[307] In this scale of the state, the fixed intervals are, of course, the analogues of the fixed intervals of the scale of the soul: the lowest (weak) part, where one finds "many and all manner of desires, pleasures, and pains" because it is composed of children, women, slaves, "and the worthless majority of so-called free men," and the upper (middle and strong) classes, in which pleasures are "simple and moderate" (ἁπλᾶς τε καὶ μετρίας), where one finds the "few, who are best by nature and best by upbringing." The result of discipline is therefore "the concord between the naturally inferior and the naturally superior about who must govern in the state and in every other matter."[308]

The account of the physiology of hearing in Plato's *Timaios* has a number of oddities that can only be explained as by-products of his attempt to make a theory of perception conform to the requirements of his musical metaphysics. Particularly odd is the notion that the gods gave men ears only to absorb celestial harmony through (Old) music. One problem is that the theory seems unable to take any nonmusical sound (not even words) into account. Another is the path

[306] Plato *Rep.* 443d, 430e–31b.

[307] Plato *Rep.* 432a; for the musical terminology, see Wersinger 2001 (above, n. 155), 180–81; Wersinger 2007 (above, n. 304), 49.

[308] Plato *Rep.* 431b–32a.

sound has to travel. Sound is triggered by an impact on the head that is then transmitted through the brain and blood to the liver in which it is experienced as sound. The appeal for Plato of this particular route is, pretty clearly, his need to have the impulse travel through the regions associated with all three parts of the soul, and the liver—not normally associated with sound—is the chosen destination because of its location in the lower body and proximity to the *epithymê-tikon*.[309] A third problem with Plato's physiology is his insistence that different sounds reach the liver at different speeds relative to their pitch and (still more oddly) at a rate conversely proportionate to their initial speed so that they all end up arriving at the same time nonetheless. The theoretical gain in this complex process of differential acceleration and deceleration is that it allows musical notes to impact the liver simultaneously before any other part of the body and to be perceived there first as harmonies.[310] The sensation of harmony is then resent to the brain (possibly via the *thymoeides*). Each part receives the "harmony" and interprets it in its own way: the lower soul receives it as pleasure, the middle soul perhaps as inspiration, the upper soul as the mathematical proportion that preexisted bodily form when God designed the universe.[311]

The actual perception of sound, however, is governed by that part of the soul that dominates each individual's character.[312] For this reason, therefore, concordant sounds are said to produce "pleasure (*hêdonê*) in fools and a sense of well-being (*euphrosynê*) in the wise through their imitation of divine harmony in mortal movements."[313] For most of mankind, musical sensation thus remains a bodily titillation, but one that can do good to the tuning of the soul. For a superior few in the species musical sensation gives rise to intellectual rather than bodily pleasures.

This notion is the basis for the presentation of philosophy as "the greatest music."[314] For philosophy is defined, in *Philebos*, as the science of the permanent and unchanging (in contrast to rhetoric which is the science of the transitory and voluble),[315] and it is the duty of every philosopher to emulate the changeless

[309] Plato *Tim.* 71a–b; A. D. Barker, "Timaeus on Music and the Liver," in M. R. Wright (ed.), *Reason and Necessity: Essays on Plato's* Timaeus, London and Swansea 2000, 87.

[310] Plato *Tim.* 67c, 80b; Barker 2000 (see above, n. 309), 88–91.

[311] Barker 2000 (see above, n. 309), 91–98; cf. above, p. 111.

[312] Plato even implies a direct link between specific modes and specific parts of the soul, a link made explicit by the later Stoics: Philodemos *De Mus.* 4, col. 76–77 (Delattre, pp. 142–143).

[313] Plato *Tim.* 80b.

[314] Plato *Phaedo* 61a; cf. *Rep.* 591d; *Phdr.* 248d. For philosophy as a form of music, see Murray 2004 (above, n. 155), 374–83; Wersinger 2007 (above, n. 304), 45–62.

[315] Plato *Phlb.* 58a.

as far as the mortal condition permits.[316] Nothing but God himself could be as changeless as the proportions of which the material universe is a mere imitation. Philosophy, the greatest music, therefore stands to the people's music as form does to matter.

By the same argument, the people's music is reduced to a transitory and corporeal pleasure, like food and drink. Pleasure, "the greatest incitement to evil," is for Plato always the object of every aspect of democratic culture: rhetoric, sophistry, festivals, drama, and of course New Music. But "pleasure" also offered a lever with which to turn back the clock. Only the minority, as we saw, were capable of appreciating music intellectually. Divine providence, however, had also made music the source of bodily pleasure—indeed, had made it speak first and loudest to the most corporeal part of the soul through the lower reaches of the body. Through traditional music, which in its simplicity, constancy, and proportion imitated divine and minimally corporeal movement, one could nourish the higher parts of the soul through the lower not only without pain and effort, but through pleasurable, leisure activity. With music and dance one could create a predisposition to virtue that did not require the level of psychic and intellectual superiority needed for the study of philosophy. Just as philosophy was a higher music, so music was a lower philosophy. It could create that harmony of the soul called discipline: "The old simple music begets *sophrosynê*."[317]

The idea that music creates discipline is, if we can trust Plato's portrait of Protagoras, a good deal older than Plato himself.[318] But unlike Plato, Protagoras regarded all music as suited to that end, even tragic music, and all modes or tunings—Protagoras even gave a special role to the *aulos* in education, precisely because of its ability to play in all modes. For Protagoras the essence of *sophrosynê* appears to have been respect (*aidôs*) for others, and its transmission through music placed it within everyman's reach.[319] Plato adapted this theory to antidemocratic ends. No real *sophrosynê* is possible without philosophy. However, a kind of mindless disposition to virtue, "a people's discipline and justice " (δημοτικὴ σωφροσύνη τε καὶ δικαιοσύνη), a "simpleminded discipline" (εὐήθη σωφροσύνη), can be created "without philosophy or intelligence, through training and habit."[320] The mob can be given the same naïve disposition to virtue as the men

[316] Plato *Plt.* 303b.
[317] Plato *Rep.* 410a, cf. 404e.
[318] Plato *Prot.* 326a; Wersinger 2007 (see above, n. 304), 58.
[319] Wersinger 2007 (see above, n. 304), 58–59.
[320] Plato *Phaedo* 82a–b and 68e with Wersinger 2007 (see above, n. 304), 58.

of old, if conditioned through music and dance. But in this case it must be the right kind of music and dance: "the volubility and variegation [ἡ ποικιλία, sc. of the New Music] produces indiscipline, but simplicity in music creates discipline in the soul."[321]

6. Conclusion

Economic and social conditions in the second half of the fifth century brought a class of independent and competitive professional musicians together with mass audiences eager for virtuosity and novelty. A desire to develop and promote music's contribution to the performance of nome, dithyramb, and drama lies behind the great variety of features that characterize the new style. The result was a music of unprecedented power and complexity, which took musical accomplishment well beyond the range of amateur talents.

The music criticism of the day gives us a much-distorted picture of these developments. The critics characterized New Music's "liberation" of music as a rejection of traditional forms of control, whether the laws of genre, the words of the song, or the requirements of dance. The critical assault took a pattern familiar to fifth-century ideological debate, tainting the New Music as effeminate, barbarous, and self-indulgent. The diatribe expressed the hostility of a class that felt the loss of its ascendancy in matters of culture as in so much else. Similar reactions by elite thinkers could be described for a great many arts and crafts that flourished under the Athenian democracy especially those connected with the theater industry.[322] But from the violence of the reaction, the tendency of the arguments, and the structure of the debate, it is apparent that New Music came to symbolize the most threatening and unpleasant features of democracy itself. This is confirmed by explicitly political commentary on various features connected with the New Music and most impressively, by Plato's musicocentric theory of moral and political degeneration. Plato's most original contribution to music theory is indeed the elaboration of the concept of "bad music." In his eyes "bad" meant like contemporary Athenian democracy in every conceivable way. By no coincidence, the heyday of New Music coincides with the time of the

[321] Plato *Rep.* 404e.

[322] See Rouveret's excellent discussion (A. Rouveret, *Histoire et imaginaire de la peinture ancienne* [*Ve siècle av. J.-C.–Ier siècle ap. J.-C.*], Rome 1989, 115–27) of the violence of elite reaction to new painterly techniques and *skênographia* in particular, and Csapo 2002 (see above, n. 189) and Csapo 2010 (see above, n. 13), 117–39, on elite reactions to the development of acting.

greatest political polarization in Athens, during the radical democracy and on through the years of revolution and counterrevolution.

The form of the hostile criticism had much to do with Damon's theory that music was directly, perhaps primarily, responsible for the psychological formation of the citizen and the political formation of the state. But it had far more to do with the conditions of New Musical performance: the theatrical setting of dithyramb and drama, before the assembled *dêmos*, enjoying the license of a Dionysiac festival, and indulging in rapid succession the most violent emotions of pity, fear, scorn, and ridicule. In contrast to the New Music the critics invented musical utopias: in the past, in Sparta, and indeed in heaven—all based on the implausible assumption that ancient music, Spartan music, elite music, and God's music all sought nothing but the health of the (individual and collective) soul, and New Music nothing but the titillation of the masses. Just how much of the alleged musical tradition really was tradition will escape us without a serious attempt to outline the systematic distortion encouraged by the ideological debate. It is worth remembering that the New Musicians were also driven to invent a tradition of their own, in which ritual Dionysiac music is particularly prominent, as are appeals to founding figures like Orpheus, Olympos, or the Korybants.[323]

It remains to ask just what effect this diatribe had on the practitioners of New Music. Evidence of frustration might be found in Telestes' attempt to debunk the myth about Athena's rejection of the pipes, or in Timotheos' complaints about Sparta, the anecdotes about his attempted suicide, or the removal of many of the greatest musical innovators to Makedonia—but in this last move at least there was doubtless more pull than push.[324] If the poetic remains are any indication, the critics' influence, though great on musical theory or political and ethical philosophy, was slight on practice. Their claims probably even enhanced New Music's allure for the masses by articulating its democratic values.

Some response to the elite diatribe can at least be found among the theorists. Against those who pretended that good music was a part of ordained nature, or claimed that the meaning and value of its tunings and harmonies were established and guaranteed by god, or insisted that music originated simultaneously

[323] Timotheos *PMG* 791.221–22; Telestes *PMG* 806, 810 (with Power 2007 [see above, n. 46], 195); L. Battezzato, "The New Music of the Trojan Women," *Lexis* 23 (2005), 94.

[324] Telestes *PMG* 805 (cf. Zimmermann 1986 [see above, n. 37], 152–53 and, especially, Wilson 1999 [see above, n. 16], 66–67); *P.Oxy.* 1176, fr. 39, col. 22; and on Timotheos' complaints, cf. Wilson 2004 (see above, n. 54), 303–6; Csapo and Wilson 2009 (see above, n. 3), 284–86.

with the cosmos, could be heard the voices of men like Demokritos, the most important democratic ideologue of the fifth century, and after him Ephoros, who maintained that music was a human invention, of purely arbitrary and conventional significance, and rather recent in the order of inventions.[325] There is also the extended criticism of Damonian ethics by the Hibeh Sophist, the School of Epikouros, and ultimately Philodemos.[326] Philodemos preserves the voice of a sympathetic unnamed critic, probably contemporary with the New Music, when he notes that "although some declare that [the enharmonic] is majestic, noble, simple and pure, while [the chromatic] is unmanly, tedious, and vulgar, others call [the enharmonic] severe and despotic [αὐστηρὰν καὶ δεσποτικήν] and the [chromatic] mild and persuasive [ἥμερον καὶ πιθανήν]."[327] The contrast between "despotic" and "persuasive" might recall the contrast familiar to this critical discourse of Old Music's Spartan coercion and New Music's more democratic persuasion.

Far from contesting all the critics' charges about the ethos of music, however, New Music cultivated its womanly and barbarian associations, its reputation for high emotion and Dionysian hysteria.[328] The lyrics are filled with feminine, orientalizing, and Dionysian imagery. Most striking are the *personae* chosen for the choruses and soloists of New Musical odes. With the probable exception of *Archelaos,* every known Euripidean play after *Herakles* (ca. 418 BC) has a female chorus. And from the late 420s onwards the choruses tend not only to be women, but frequently Asiatic women, or if not Asiatic, then Greek women captive in Eastern lands. The Greatest New Musical monodies of the era, in Timotheos' *Persians* and Euripides' *Orestes,* used delirious, panic-stricken Persians and Phrygian eunuchs, and, in *Hekabe,* a blinded bestial Thracian, crawling on all fours and howling with grief and rage.[329] Such characters and situations maximized music's potential for expressing powerful and raw emotion. These scenes might even have been inspired by a desire to taunt and infuriate the Damonian eccentrics. They could not, in any case, have been staged in front of a democratic

[325] Koller 1954 (see above, n. 4), 145–52.
[326] Above, pp. 92–93.
[327] Philodemos *De Mus.* 4, col. 116.26–28. D. Delattre (*Philodème de Gadara: Sur la Musique, Livre IV*, Paris 2007, 212, n. 6) thinks "cette option est celle des partisans de la musique "nouvelle."
[328] Csapo 1999–2000 (see above, n. 51), 415–26; and Battezzato 2005 (see above, n. 323), who perceives an ambivalence on the part of the New Musicians toward these characteristics.
[329] For the Orientalizing and effeminizing tendencies of New Musical monody, see, especially, E. Hall, *The Theatrical Cast of Athens: Interactions Between Ancient Greek Drama and Society*, Oxford 2006, 255-320.

audience with serious concerns about musical emasculation. Indeed, for most Athenians, even for the average even-tempered, non-theoretical elites, the political furor inspired by the New Music was forgotten by the late fourth century,[330] when even Timotheos' dithyrambs acquired the institutional stature of musical classics.[331]

[330] Wilson 2000 (see above, n. 11), 227; West 1992 (see above, n. 19), 371–72, 381–82.

[331] The first three sections of this chapter are a revised and updated version of E. Csapo, "The Politics of the New Music," in Murray and Wilson 2004 (see above, n. 38), 207–48, but sections 4 and 5 are entirely new. I thank the editors of *Music and the Muses*, P. Murray and P. Wilson, and Oxford University Press for permission to reprint much of the material in sections 1–3 and 6. This research was made possible by an Australian Research Council Discovery Grant.

Chapter Four

Patterns of Chorality in Plato's *Laws*

Lucia Prauscello

Aᴅ FUNDAMENTAL CONDITION FOR THE SUCCESS of Plato's "second
best city" is the unity and "self-likeness" of its social body. The very
possibility of a well-ordered, functional *polis* is predicated on a mutual relation-
ship of care (φιλία) and communality (κοινωνία: 739c2–5) among its members:
they must willingly embrace not only shared thoughts and feelings but even
shared perceptions (739c7–d1).[1] The ideal city on which Magnesia will be
modeled is, quite literally, a living organism in which those elements that are
"by nature proper of the individual" (τὰ φύσει ἴδια) like eyes, ears, and hands,
will become "common to all" (κοινά): its citizens will "seem then to see, hear,
and act collectively," approving and disapproving "unanimously" on the basis
of their capacity of "rejoicing and feeling pain at the same things."[2] The main
aim of the laws is to create a community that may be as much as possible "one
polis" (μίαν ὅτι μάλιστα πόλιν 739d3–4), reflecting in its oneness the unity of

[1] On the "homogenization of citizenship" envisaged by Plato in the *Laws*, see recently M. M.
Sassi, "The Self, the Soul, and the Individual in the City of the *Laws*," *Oxford Studies in Ancient
Philosophy* 35 (2008), 141–43. In *Republic* 432a–b, the "natural attunement" (κατὰ φύσιν
συμφωνίαν) of a society is based on "shared opinion" (ὁμόνοια) between rulers and ruled: see M.
Schofield, *Plato: Political Philosophy*, Oxford 2006, 82–83. In this chapter, the following abbre-
viations are employed: *PMGF* (= M. Davies, *Poetarum Melicorum Graecorum Fragmenta*, vol. 1,
Oxford 1991); *TrGF* (= B. Snell, R. Kannicht and S. Radt, *Tragicorum Graecorum Fragmenta*, 5
vols. [vol. 1, 2nd ed. 1986], Göttingen 1971–2004); Rutherford (= I. Rutherford, *Pindar's Paeans:
A Reading of the Fragments with a Survey of the Genre*, Oxford 2001); Maehler (= H. Maehler,
Pindari Carmina. Pars II: Fragmenta, Leipzig 1989).
[2] 739c8–d3 οἷον ὄμματα καὶ ὦτα καὶ χεῖρας κοινὰ μὲν ὁρᾶν δοκεῖν καὶ ἀκούειν καὶ πράττειν, ἐπαινεῖν
τ' αὖ καὶ ψέγειν καθ' ἓν ὅτι μάλιστα σύμπαντας ἐπὶ τοῖς αὐτοῖς χαίροντας καὶ λυπουμένους. Cf. also
664a5–6, 829a1 (καθάπερ ἕνα ἄνθρωπον), 942c1–4.

the νοῦς.[3] To provide Magnesia with a communal ideology based on the willing acceptance, on the part of its citizens, to live out this belief,[4] the divinely inspired lawgiver must be able to display a whole set of communicative strategies that are deeply indebted to the social and religious fabric of the ancient Greek *polis*.[5] To bring this experiment in "mass persuasion" to a successful conclusion, Plato appropriates the entire spectrum of discursive strategies offered by the ritual frame of the *polis* system, from legislative speech and contemporary rhetorical theory to the language of public choral performances, poetry, and above all religion.[6] My intention is to focus on one particular form of ritualized public discourse: Magnesia's choral performances and the ways in which they become an essential tool for *constructing, experiencing,* and *projecting* a strong sense of civic identity and unity.[7] The self-presentation of the new colony through the

[3] On the importance of ὁμοίωσις θεῷ in the *Laws*, see J. M. Armstrong, "After the Ascent: Plato on Becoming Like God," *Oxford Studies in Ancient Philosophy* 26 (2004), 171–83, and S. Lavecchia, *Una via che conduce al divino: La "homoiôsis theôi" nella filosofia di Platone*, Milan 2006, 160–66.

[4] On the free submission of the citizens of Magnesia to the city's rules, see recently Schofield 2006 (see above, n. 1), 77–88. Cf. also H. Yunis, "Laws: Rhetoric, Preambles, and Mass Political Instruction," in *id., Taming Democracy: Models of Political Rhetoric in Classical Athens*, Ithaca, NY and London 1996, 215–18.

[5] Divine inspiration of the laws: see, especially, Lavecchia 2006 (see above, n. 3), 158–62, W. A. Welton, "Divine Inspiration and the Origins of the Laws in Plato's *Laws*," *Polis* 14 (1995), 53–83, and A. W. Nightingale, "Writing/Reading a Sacred Text: A Literary Interpretation of Plato's *Laws*," *Classical Philology* 88 (1993), 279–300 (esp. 298–99).

[6] Rhetoric and law: A. Laks, "The *Laws*," in C. Rowe and M. Schofield (eds.), *Cambridge History of Greek and Roman Political Thought*, Cambridge 2000, 258–92 (esp. 260–67, 285–90), J.-M. Bertrand, "Formes du discours politique dans la cite de Magnétes platonicienne," *Dike* 1 (1998), 115–49, H. Yunis, "Rhetoric as Instruction: A Response to Vickers on Rhetoric in the *Laws*," *Philosophy and Rhetoric* 23 (1990), 125–35, and Yunis 1996 (see above, n. 4); poetry (both choral and dramatic) and music: G. B. D'Alessio, "The Persuasion of Songs," forthcoming, G. Panno, *Dionisiaco e alterità nelle "Leggi" di Platone: Ordine del corpo e automovimento dell'anima nella città-tragedia*, Milan 2007 (chs. 3 and 4), L. Mouze, *Le législateur et le poète: Une interpretation des* Lois *de Platon*, Villeneuve D'Ascq 2005 (esp. 273–354 on the lawgiver as poet), B. Kowalzig, "Changing Choral Worlds: Song-Dance and Society in Athens and Beyond," in P. Murray and P. Wilson (eds.), *Music and the Muses: The Culture of "Mousikê" in the Classical Athenian City*, Oxford 2004, 39–65 (on the politics of chorality as a tool for social cohesion), P. Murray, "Plato's Muses: The Goddesses that Endure," in E. Spentzou and D. Fowler (eds.), *Cultivating the Muse: Struggles for Power and Inspiration in Classical Literature*, Oxford 2002, 29–46 (esp. 43–44), S. Halliwell, *The Aesthetics of Mimesis: Ancient Texts and Modern Problems*, Princeton, NJ 2002, 65–71, J.-M. Bertrand, *De l'écriture à l'oralité: Lectures des* Lois *de Platon*, Paris 1999, 400–5, S. H. Lonsdale, *Dance and Ritual Play in Greek Religion*, Baltimore, MD 1993, 21–43; religion: Welton 1995 (see above, n. 5), M. Schofield, "Religion and Philosophy in the *Laws*," in S. Scolnicov and L. Brisson (eds.), *Plato's Laws: From Theory into Practice. Proceedings of the VI Symposium Platonicum. Selected Papers*, Sankt Augustin 2003, 1–13, and Schofield 2006 (see above, n. 1), 282–331.

[7] Kowalzig 2004 (see above, n. 6) provides an excellent treatment of how "choral diversity"

choral voice of its citizens is envisaged by the Athenian Stranger as one of the most effective means of persuasively communicating, and at the same time enacting, "the best life" (664b).

I shall try to show how in constructing the voice of his ideal choruses, Plato draws profusely, though in a highly selective way,[8] on the representations of the communal voice instantiated in the Panhellenic lyric tradition. As we shall see, the claim of the Athenian Stranger that the whole *politeia* of Magnesia enacts "the best," "most beautiful," and "truest tragedy" (817b2–3 τραγῳδίας . . . καλλίστης ἅμα καὶ ἀρίστης; 817b5 τραγῳδίαν τὴν ἀληθεστάτην) since it "reproduces the most beautiful and virtuous life" (817b4 μίμησις τοῦ καλλίστου καὶ ἀρίστου βίου)[9] is made possible only by Plato's careful negotiation of the mimetic status of Magnesia's choruses. This negotiation entails a constant process of mediation between what we would call here for convenience's sake a strictly dramatic (tragic mimesis) and nondramatic (lyric mimesis) mode of performance.[10] The

within Plato's second-best city must be read against the background of ancient Greek polytheism and *polis* religion (49), yet, as D'Alessio (forthcoming [see above, n. 6]) observes, in Plato's time "real life" Athenian choruses were not the exclusive monopoly of Dionysos (cf. Kowalzig 2004 [see above, n. 6], 60): for non-Dionysiac *kyklioi choroi* at the Panathenaia, Thargelia, Prometheia, and Hephaesteia, see G. B. D'Alessio, "The Name of the Dithyramb," in B. Kowalzig and P. Wilson (eds.), *Dithyramb and its Context in Ancient Greek Society*, Oxford forthcoming.

8 One notable absence in Magnesia's festive calendar is epinician *choreia*. Though an intensively agonistic society (822e–23a) with its own athletic and musical contests where the rhetoric of public praise and blame plays an important part (cf., e.g., 829c on the μάχαι τινὲς ἑορταστικαί), Magnesia does not have any celebratory κῶμοι like in Pindar and Bacchylides' epinician odes. I cannot treat this issue here but certainly the notorious dearth of epinician performances in historical fourth-century Athens, together with Plato's anxiety about the containing of social envy (φθόνος), is part of the reason.

9 On the self-referential character of 817b1–5 as "text," see M. Adomėnas, "Self-reference, Textuality, and the Status of the Political Project in Plato's Laws," *Oxford Studies in Ancient Philosophy* 21 (2001), 55. Cf. also Panno 2007 (see above, n. 6), 41–47.

10 I use here the term "lyric mimesis" as a somehow inadequate but recognizable term to designate the kind of ritualized performances in which the members of the chorus perform a song for the community to which they belong as a body representative of that very community: that is, the performers are citizens who perform *in propria persona*. This, of course, does not mean, as Ferrari (G. Ferrari, *Alcman and the Cosmos of Sparta*, Chicago, IL 2008, 11–12) seems to imply, to deny that lyric choruses may play parts of mythical characters (see *apropos* G. Nagy, *Pindar's Homer*, Baltimore, MD 1990, 369). What is more relevant is, instead, the fact that the mythical characters performed by the lyric chorus are part and parcel of the ritual and identity of the *polis*: the citizens as performers enact their *own* mythical past. On the question of the relationship between dramatic and lyric chorus, see Kowalzig 2004 (see above, n. 6), 41–42 (from a political and social perspective), C. Calame, "From Choral Poetry to Tragic *Stasimon*: The Enactment of Women's Songs," *Arion* 3 (1994–95), 136–54, G. Nagy, "Transformation of Choral Lyric Traditions in the Context of Athenian State Theater," *Arion* 3 (1994–95), 41–55; C. Calame, "Performative

rescue of a choral dimension more genuinely cognate to the tradition of some strands of choral lyric in its civic and cultic context will also contribute to the shedding of some light on the reintegration of Dionysos into the social and musical cosmos of the *Laws*.

1. *The origin of* χορεία

It has often been remarked that the festival calendar of Magnesia is saturated with choral performances.[11] Plato's "second best city" is a community perpetually reenacting through dance and song what we might legitimately call one of the colony's "foundational myths" (653c7–654a7): the divine origin of χορεία, or, better, the bestowal of song and dance by the gods as a collective time of celebration for the whole community (653d2–3 τὰς τῶν ἑορτῶν ἀμοιβάς),[12] in which mortals find "respite from labors" (653d2 ἀναπαύλας τε αὐτοῖς τῶν πόνων ἐτάξαντο).[13] Significantly, this "quasi-mythical account"[14] of the birth of song as a powerful tool of socialization coincides with the origin of "correct education" (ὀρθὴ παιδεία),[15] which is at the same time represented as a process of "reeducation" made necessary by the unavoidable "corruption" and "slackening" that

Aspects of the Choral Voice in Greek Tragedy: Civic Identity in Performance," in S. Goldhill and R. Osborne (eds.), *Performance Culture and Athenian Democracy*, Cambridge 1999, 125–53, and C. Calame, "Giochi di generi e performance musicale nel coro della tragedia classica: Spazio drammatico, spazio cultuale, spazio civico," in F. Perusino and M. Colantonio (eds.), *Dalla lirica corale alla poesia drammatica: Forme e funzioni del canto corale nella tragedia e commedia greca*, Pisa 2007, 49–74 (on the "hermeneutical," "explanatory," and "self-reflexive" function of the tragic chorus which compensates for the loss of the lyric chorus's cultic voice).

[11] See, already, G. R. Morrow, *Plato's Cretan City: A Historical Interpretation of the* Laws, Princeton, NJ 1960, 352–55. A most perceptive discussion of the educative role of ἑορταί in the *Laws* is Panno 2007 (see above, n. 6), 135–78. For the importance of the *mousikê* in the *paideia* of Magnesia, see recently Mouze 2005 (see above, n. 6), 212–27, and J. J. Cleary, "Paideia in Plato's *Laws*," in S. Scolnicov and L. Brisson (eds.), *Plato's Laws: From Theory into Practice. Proceedings of the VI Symposium Platonicum. Selected Papers*, Sankt Augustin 2003, 165–73.

[12] For the social dimension implied by the term ἑορτή, see J. D. Mikalson, "The *Heortê* of Heortology," *Greek, Roman, and Byzantine Studies* 23 (1982), 213–21.

[13] As observed by J. S. Rusten, *Thucydides: The Peloponnesian War. Book II*, Cambridge 1989, 148, Plato's text at 653d is reminiscent of Thoukydides 2.38, where Perikles proudly claims that Athens provides its citizens with the most numerous occasions of respite from toil (καὶ μὴν καὶ τῶν πόνων πλείστας ἀναπαύλας τῇ γνώμῃ ἐπορισάμεθα) by celebrating games and sacrifices all year round (ἀγῶσι μέν γε καὶ θυσίαις διετησίοις νομίζοντες). Significantly, though, the emphasis in Thoukydides is more on the social than the religious value of the *heortai*.

[14] The expression is in Murray 2002 (see above, n. 6), 47.

[15] Cf. 653a1 τὴν ὀρθὴν παιδείαν, 653b7 τεθραμμένον . . . ὀρθῶς, 653c3 παιδείαν . . . ὀρθῶς ἂν προσαγορεύοις, 653c5–6 ὀρθῶς . . . παιδείας πέρι, 653c7–8 τῶν ὀρθῶς τεθραμμένων ἡδονῶν καὶ

intervene in the course of human life (653c8–9 χαλᾶται . . . καὶ διαφθείρεται κατὰ πολλὰ ἐν τῷ βίῳ).[16] The ὀρθὴ παιδεία consists first of all in infusing into individuals the experience of a "correct" physiology of pleasure and pain (653c7–8).[17] A "correct" way of perceiving pleasure and pain must be already activated before the full development of rational faculties (653c3–6) and the resulting συμφωνία between emotions and reason requires a form of control that must be situated beyond the strictly subjective sphere. It can be accomplished only within a "network of intersubjective relationships,"[18] and it is here that the socializing and educative role of choral performances, a divine gift, becomes an essential tool. The text of 653c9–d5 is worth quoting in full:

> [. . .] the gods, taking pity [οἰκτίραντες] on the suffering which is the natural lot of human race [τὸ τῶν ἀνθρώπων ἐπίπονον πεφυκὸς γένος], assigned [ἐτάξαντο] to the mortals the recompense of *heortai* [τὰς τῶν ἑορτῶν ἀμοιβάς][19] as relief from their toils [ἀναπαύλας . . . τῶν πόνων].[20] They gave to men the Muses, Apollo Musagetes, and Dionysos as fellow-participants in the *heortai* [συνεορταστὰς ἔδοσαν] so that they may be set right [ἵν' ἐπανορθῶνται]. They also gave mortals the nourishments that *heortai* afford [τάς τε τροφὰς γενομένας ἐν ταῖς ἑορταῖς][21] with the helping presence of the gods [μετὰ θεῶν].[22]

λυπῶν. The relationship between the definition of the *heortê* and that of *paideia* is subtly analyzed by Mouze 2005 (see above, n. 5), 212–20.

[16] On the noncontradictory roles of the *heortai* as a means to found and at the same time reestablish the *paideia*, see Mouze 2005 (see above, n. 6), 216–18.

[17] τούτων γὰρ δὴ τῶν ὀρθῶς τεθραμμένων ἡδονῶν καὶ λυπῶν παιδειῶν οὐσῶν; cf. also 653a5–c4.

[18] I owe the expression to Sassi 2008 (see above, n. 1), 129.

[19] The exact meaning of the expression τὰς τῶν ἑορτῶν ἀμοιβάς is debated: I follow K. Schöpsdau, *Platon: "Nomoi" (Gesetze) Buch I–III*, Göttingen 1994, 259, in understanding ἀμοιβάς to mean "recompenses," τῶν ἑορτῶν being the defining genitive attached to it ("die 'Entschädigung' für die Mühen besteht in den Festen"); see also Mikalson 1982 (see above, n. 12), 215, n. 12 for the text. E. B. England, *The "Laws" of Plato*, vol. 1, Manchester 1921, 275 *ad loc.* takes τὰς τῶν ἑορτῶν ἀμοιβάς to mean "changes consisting of festivals." Yet the use of ἀμοιβή ("benefit in return") to denote the reciprocity of the χάρις relationship between gods and humans since Homer (cf. R. Parker, "Pleasing Thighs: Reciprocity in Greek Religion" in C. Gill et al. [eds.], *Reciprocity in Ancient Greece*, Oxford 1998, 107–9) seems to me to favor strongly Schöpsdau's interpretation: the context of Plato's passage clearly suggests a mutual relationship of care between gods and men.

[20] The use of the verb τάσσω in this context is quite remarkable: the comfort and relaxation of the *choreia* is defined as a sort of τάξις, that is, an orderly regulated activity.

[21] For the ὀρθὴ τροφή, cf. also 643e4–6.

[22] This passage is textually very tormented. I do not follow Schöpsdau's interpretation ([see

Communal choral songs and dances (ἑορταί) are the medium through which the gap between the divine and human worlds can be reduced. The gods offer themselves as exemplary fellow-celebrants in dance and song (συνεορταστάς 653d4; cf. συγχορευτάς 654a1 and 665a4), guiding the mortals in their singing and dancing (χορηγεῖν 654a3; cf. χορηγούς 665a4) while enforcing community bonds and bringing joy (χαρά) through choral performance.[23] What the *heortai* do is establish a reciprocal network of χάρις, articulated through the persuasion of songs, with the gods: singing and dancing are presented as a response to divine authority but at the same time also enact a call for a divine response. The gods have given to men "the pleasant perception of rhythm and harmony" (654a2–3 τὴν ἔνρυθμόν τε καὶ ἐναρμόνιον αἴσθησιν μεθ᾽ ἡδονῆς) so that they may find pleasure and order in the *heortai*, but at the same time the *heortai* are also pleasing to the gods inasmuch as they celebrate their honor (809d2–7).[24] Magnesia's choruses must enchant with songs (ἐπᾴδειν) the souls of the children, to persuade them that the most virtuous life is the most pleasurable (663b3–5). The whole city (665c3–4 ὅλην τὴν πόλιν αὐτήν) must never cease to enchant itself (665c3–5 ὅλη τῇ πόλει . . . αὐτῇ ἐπᾴδουσαν μὴ παύεσθαί ποτε) with an incessant variety of songs (665c5–6 ἀεὶ μεταβαλλόμενα καὶ πάντως παρεχόμενα ποικιλίαν), so that they can infuse in the singers (τοῖς ᾁδουσιν) an "insatiable eagerness and pleasure for singing" (665c6–7 ὥστε ἀπληστίαν εἶναί τινα τῶν ὕμνων . . . καὶ ἡδονήν).[25] The vehicle of persuasion of both mortals and gods is the pleasure generated by song.[26] As brilliantly formulated by Bertrand, Magnesia's choruses contribute to

above, n. 19]), 260 in taking the gods as subject of ἐπανορθῶνται, with *heortai* as implied object. For other possible interpretations, see England 1921 (see above, n. 19), vol. 1, 275 and Morrow 1960 (see above, n. 11), 353, n. 193. For μετὰ θεῶν referring to the help of the gods and not only to their presence in cult, cf. Schöpsdau 1994 (see above, n. 19), 261.

[23] Enforcing human solidarity by intertwining each other with songs and dances: 654a4 ᾠδαῖς τε καὶ ὀρχήσεσιν ἀλλήλοις συνείροντας ("intertwining each other with songs and dances"); chorus and joy: 654a4–5 χορούς τε ὠνομακέναι παρὰ τὸ τῆς χαρᾶς ἔμφυτον ὄνομα ("[and the gods] called these activities 'choruses' from the noun 'joy' that is inborn to it").

[24] For a detailed analysis of the reciprocity of χάρις through song between men and gods, see S. H. Lonsdale, "*Homeric Hymn to Apollo*: Prototype and Paradigm of Choral Performance," *Arion* 3 (1994–1995), 25–40, on the *Homeric Hymn to Apollo*.

[25] Variation and diversity (ποικιλία) in songs have been explained by Kowalzig 2004 (see above, n. 6), 47, as mainly referring to the necessity of distinguishing, through dance and song, different types of worship within a polytheistic society, and this may well be part of what is going on. Yet the necessity to generate an "inexhaustible eagerness and pleasure for songs" in the performers (who are also the recipients of the songs themselves) seems more directly linked to the "correct" physiology of pleasure and pain exposed at 653a5–c4.

[26] D'Alessio forthcoming (see above, n. 6) is a fundamental contribution to the issue. The copious debate on the nature of persuasion (rational v. irrational) in the *Laws* has not yet sufficiently

Plato's "behavioral policy" by means of their own performativity: the performers and recipients of songs are the same.[27] However, it is worth noticing that the link established by Plato between choral performance and its behavioral meaning exploits a fundamental experience frequently thematized in ancient Greek cult poetry: the "joy" the choral performance causes in both gods and mortals. For the paraetymology χορός/χαρά at 654c4–5, commentators of the *Laws* refer only to *Etymologicum Magnum* (*s.v.* χορός, 813, 46–48 Gaisford).[28] But the association of χορός and χάρις-related words,[29] debated as it may be from a modern philological perspective,[30] should not only be regarded as one of the fanciful wordplays and associations of which Plato is so fond. The motif of the "joy" connatural to choral performances has very deep roots in the cultic language of choral lyric[31] (cf., e.g., Alkman 27. 2–3 *PMGF* ἐπὶ δ᾽ ἵμερον/ὕμνωι καὶ χαρίεντα τίθη χορόν,[32] Pindar fr. 75.1–2 Maehler [dithyramb] δεῦτ᾽ ἐν χορόν, Ὀλύμπιοι,/ἐπί τε κλυτὰν πέμπετε χάριν, θεοί,[33]

taken into account the extent to which Plato's persuasive strategy of communication is indebted to choral lyric. For the *status quaestionis*, cf. E. Buccioni, "Revisiting the Controversial Nature of Persuasion in Plato's *Laws*," *Polis* 24 (2007), 262–83, with previous literature. I personally agree with Welton 1995 (see above, n. 5) that Plato's language of divine inspiration and poetry integrates both irrational and rational components.

[27] J.-M. Bertrand, "L'utopie magnète: Réflections sur *Les Lois* de Platon," in M. H. Hansen (ed.), *The Imaginary Polis. Symposium: January 7–10, 2004*, Copenhagen 2005, 158: "La performance chorale participe, en effet, d'une politique comportementaliste à laquelle elle contribue par sa performativité même."

[28] See, e.g., the recent instances of Schöpsdau 1994 (see above, n. 19), 264 (according to whom the *Et. Magn.* is dependent on the Platonic passage) and Lonsdale 1993 (see above, n. 6), 285, n. 6. For a more productive approach, see D. Sedley, *Plato's Cratylus*, Cambridge 2003, 33, n. 14, who considers Plato's association of χορός/χαρά one of the cosmic etymologies of divine origin betraying a deeply rooted (and shared) conviction that our ancestors had "divine sources of information."

[29] Cf. also 657c3–6 (χορεία/χαίρειν).

[30] Cf. M. Meier-Brügger, "Zu griechisch χορός," in M. Fritz and S. Zeilfelder (eds.), *Novalis Indogermanica: Festschrift für Günther Neumann zum 80. Geburtstag*, Graz 2002, 300–2; more skeptical is P. Chantraine, *Dictionnaire étymologique de la langue grecque: Histoire des mots*, vol. 2, Paris 1968, 1270, *s.v.* χορός.

[31] On Plato's engagement with literary sources in his discussion of etymology and eponymy, see S. B. Levin, "Greek Conceptions of Naming: Three Forms of Appropriateness in Plato and the Literary Tradition," *Classical Philology* 92 (1997), 46–57. D. Tarrant, "Colloquialisms, Semi-Proverbs, and Word-Play in Plato," *Classical Quarterly* 40 (1946), 109–17, is silent on this passage of the *Laws*.

[32] For the meaning of the adjective χαρίεις applied to song, see J. Latacz, *Zum Wortfeld "Freude" in der Sprache Homers*, Heidelberg 1966, 101, "lust bereitend, erfreuend" (cf. also C. Calame, *Alcman*, Rome 1983, 464).

[33] On this para-etymology, see S. Lavecchia, *Pindari dithyramborum fragmenta*, Rome 2000, 256 with n. 17.

fr. 52m(a).10–11 Maehler [= Paean G2 Rutherford] χορὸν ὑπερτατ[/] χάριν).
A constant tension regarding the exact nature of the relationship between gods
and men is a distinctive feature of the *Laws*: yet, as pointed out by Laks, "the
gulf between the two orders is not insuperable after all, under certain exceptional
circumstances, or perhaps better in another period of what could still be described
as *human* history."[34] We could add that it is by reliving and reenacting the myth of
χορεία that Magnesia's choral performances manage, at least in part, to bridge this
gap: myth is reworked into human history on condition that the *polis* becomes
the living myth itself, constantly retelling its own story.[35]

 That Plato's account of the divine origin of χορεία in the *Laws* shares in a
larger pattern of ancient Greek thought is certainly part of the reason why his
myth becomes at least partly political theology. Affinities with the *Homeric
Hymn to Apollo*, the "prototype of all choral performance," have often been
noticed.[36] There, the gathering of gods on Olympos (187 μεθ' ὁμήγυριν) rejoices
at the songs of the Muses led by Apollo κιθαριστής: the Muses sing of "the gods'
immortal privileges" (190 θεῶν δῶρ' ἄμβροτα) and of "the sufferings of men"
(190–91 ἀνθρώπων/τλημοσύνας) under the gods (191 ὑπ' ἀθανάτοισι θεοῖσι),
powerfully symbolized by death and old age (191–92).[37] Men, in the *Hymn to
Apollo*, are apparently excluded from direct contact with gods, and it is only in
the temporary space of the feast, through their choral performances imitating
those of the gods, that they become for the time being "immortals and ageless"
(151 ἀθανάτους καὶ ἀγήρως) to the eye of the spectator. According to Lonsdale,
"this pathetic state of things [. . .] is taken up and transformed by Plato in the
origins of *paideia* in the *Laws*. The gods, in pity for the human race born to misery,
ordained feasts as a respite from toil and suffering, etc."[38] Yet Plato's "transforma-

[34] A. Laks, "In What Sense is the City of the *Laws* a Second Best One?," in F. L. Lisi (ed.), *Plato's
Laws and Its Historical Significance: Selected Papers of the I International Congress on Ancient Thought,
Salamanca 1998*, Sankt Augustin 2001, 108 (author's emphasis).

[35] If in the *Laws* there are passages where the gods and the children of gods (παῖδες θεῶν) seem
widely apart from humans (e.g., 732e), in the *Timaios* ancient Athens was founded by "divine" men
who are the offspring of gods and have been educated by them (24d5–6 γεννήματα καὶ παιδεύματα
θεῶν).

[36] See, in particular, Lonsdale 1994–95 (see above, n. 24), 33–35 and 1993 (see above, n. 6),
71–73; H. H. Bacon, "The Chorus in Greek Life and Drama," *Arion* 3 (1994-95), 14–16 (with a
good discussion also of the affinities of our passage with Pinda's *Pythian* 1; I hope to come back to
this topic in another venue).

[37] For the contextual meaning of θεῶν δῶρα and ἀνθρώπων τλημοσύνας, see F. Cassola, *Inni
omerici*, Milan 1975, 498–99 *ad loc.*

[38] Lonsdale 1994–95 (see above, n. 24), 33.

tion" itself, I suggest, is heavily indebted to the previous poetic tradition, and in particular to Pindar's *First Hymn* (frs. 29–35c Maehler). Already in Hesiod (*Theogony* 98–103) the soothing power of song is, of course, a gift of Zeus to mortals: thanks to the gifts of the Muses men may "forget [their] sorrows and do not remember [their] cares" (102–3 αἶψ' ὅ γε δυσφροσυνέων ἐπιλήθεται οὐδέ τι κηδέων/μέμνηται· ταχέως δὲ παρέτραπε δῶρα θεάων). But it is in Pindar's *First Hymn*, which refers to the wedding of Kadmos and Harmonia, that we find the closest parallel to Plato's myth of the divine origin of χορεία. Unfortunately, we possess only scanty remnants of this once celebrated poem,[39] yet the little we have is highly suggestive.[40] Aelius Aristides (= Pindar fr. 32 Maehler) tells us that "in his hymns Pindar, going through the vicissitudes and change of fortune befalling men in the whole span of time, says that Kadmos heard Apollo giving a display of correct music (μουσικὰν ὀρθὰν ἐπιδεικνυμένου)."[41] D'Alessio has most interestingly pointed out that this is "the first and only attested occurrence of the idea of 'correct music' before Plato,"[42] and we have already seen how Plato's concern for the ὀρθὴ παιδεία is indissolubly linked to that of the "correctness of music" (ὀρθότης τῆς μουσικῆς: 642a4, 655c8–d1, 657c2–3). Significantly, in *Pyth. orac.* 397b, Plutarch, quoting this same Pindaric passage, glosses the adjective ὀρθάν as "not sweet nor voluptuous nor winding in its melodies" (οὐχ ἡδεῖαν οὐδὲ τρυφερὰν οὐδ' ἐπικεκλασμένην τοῖς μέλεσιν). Hardie has suggested that the adjective ὀρθάν may allude "to some revelatory truth about the cosmos from which it has come, and which it seeks to describe."[43] This may be the case; but it is a remarkable coincidence that at 655c8–d3 the Athenian Stranger, while discussing the ὀρθότης τῆς μουσικῆς, strongly denies that the "correct music" may ever be designed for pleasure alone (τὴν ἡδονὴν . . . πορίζουσαν δύναμιν). Another interesting point of contact between Plato and Pindar is the cosmic frame surrounding the origin of

[39] On the wide renown enjoyed by Pindar's *First Hymn* in antiquity, see G. B. D'Alessio, "Il primo *Inno* di Pindaro," in S. Grandolini (ed.), *Lirica e teatro in Grecia: Il testo e la sua ricezione. Atti del II Incontro di Studi, Perugia, 23–24 gennaio 2003*, Naples 2005, 113–23.

[40] For this section I heavily rely on the new reconstruction of Pindar's *First Hymn* (most probably a hymn to Apollo and not Zeus) by D'Alessio 2005 (see above, n. 39), and G. B. D'Alessio, "Per una ricostruzione del *Primo Inno* di Pindaro: La 'Teogonia' tebana e la nascità di Apollo," *Seminari Romani di Cultura Greca* 10 (2007), 101–17.

[41] Aelius Aristides 3.620 (= I. 498 Behr-Lenz) κἂν τοῖς ὕμνοις διεξιὼν περὶ τῶν ἐν ἅπαντι τῷ χρόνῳ συμβαινόντων παθημάτων τοῖς ἀνθρώποις καὶ τῆς μεταβολῆς τὸν Κάδμον φησὶν ἀκοῦσαι τοῦ Ἀπόλλωνος μουσικὰν ὀρθὰν ἐπιδεικνυμένου.

[42] D'Alessio forthcoming (see above, n. 6).

[43] A. Hardie, "Pindar's 'Theban' Cosmogony (The First Hymn)," *Bulletin of the Institute of Classical Studies* 44 (2000), 33.

song in Pindar's hymn.[44] Once again, Aelius Aristides (= Pindar fr. 31 Maehler) informs us that in the section of the hymn relating to Zeus' wedding (to Themis: fr. 30 Maehler) and sung by the Muses themselves "when Zeus [after the creation of the *kosmos*] asked the gods if anything was lacking, they asked him to create for himself some divinities [that is, the Muses] who would adorn and order with words and music this great work of his and the whole of his arrangement."[45] The ordering power of music is something of which the gods themselves feel the necessity for the completion of the *kosmos*. The version of Pindar's hymn offered by Chorikios of Gaza (13.1) tells us a somewhat similar tale, with the interesting further detail that Zeus' creation was "an act of benevolence toward humankind" (τὰς τοῦ Διὸς ἐς ἀνθρώπους φιλοτιμίας: cf. θεοὶ . . . οἰκτίραντες at 653d1 and θεοὺς . . . ἐλεοῦντας at 665a4).[46] In Pindar's *First Hymn*, then, the Muses sing the origin of music that coincides with the completion of the *kosmos*, and their song at the wedding of Kadmos and Harmonia is described as "the god-built sound of *nomoi*" (Pindar fr. 35c Maehler νόμων ἀκούοντες θεόδματον κέλαδον).[47] The overall cosmic frame, the close proximity of gods and men through song, the music bestowed by Zeus on both gods and men as the proper completion of the *kosmos,* and the emphasis on the "correctness" of that music (Pindar fr. 32 Maehler) are all elements that we find resonating also in Plato's mythical account of the origin of χορεία.

In Plato's Magnesia, choral performances are the ritual space where mortals learn how to be "divine" by sharing with the gods the joy of χορεία, since, as we have seen, "it is necessary that one who takes delight [τὸν χαίροντα] in things *become similar* [ὁμοιοῦσθαι] to the things he rejoices in" (656b4–5). The "correct" use of the playful dimension related to song and dance (657c3–4 τὴν τῇ μουσικῇ καὶ τῇ παιδιᾷ μετὰ χορείας χρείαν ὀρθήν) brings about an identity between experiencing delight (χαίρειν) and the self-consciousness of "doing well" (οἴεσθαι εὖ πράττειν).[48] The vehicle through which a whole community

[44] This aspect has already been recognized by Lonsdale 1993 (see above, n. 6), 48 quoting Pindar fr. 31 Maehler. Cf. also Murray 2002 (see above, n. 6), 38–39.

[45] Aelius Aristides 2.470 (= I.277 Behr-Lenz) . . . καὶ τοὺς θεοὺς αὐτούς φησιν ἐρομένου τοῦ Διὸς εἴ του δέοιντο αἰτῆσαι ποιήσασθαί τινας αὑτῷ θεούς, οἵτινες τὰ μεγάλα ταῦτ' ἔργα καὶ πᾶσάν γε δὴ τὴν ἐκείνου κατασκευὴν κατακοσμήσουσι (codd.: κοσμήσουσι Wilamowitz) λόγοις καὶ μουσικῇ.

[46] A further version is in Philo *De Plant.* 127–29, introducing Mnemosyne as the mother of the Muses: see Hardie 2000 (see above, n. 43), 33, and D'Alessio 2005 (see above, n. 39), 120–21.

[47] On fr. 35c Maehler as preceding fr. 30 and probably signaling the introduction of the song by the Muses, see D'Alessio 2005 (see above, n. 39), 126–27.

[48] 657c5–6 χαίρομεν ὅταν οἰώμεθα εὖ πράττειν, καὶ ὁπόταν χαίρωμεν, οἰόμεθα εὖ πράττειν αὖ; "do we feel delight when we think that we are well and we think that we are well when we feel delight?"

(συνοικία) can be brought about to express its shared identity in "songs, myths, and logoi" (664a5–6 ἓν καὶ ταὐτὸν ὅτι μάλιστα φθέγγοιτ᾽ ἀεὶ διὰ βίου παντὸς ἔν τε ᾠδαῖς καὶ μύθοις καὶ λόγοις) is the persuasion enacted by continuous choral performances (663e–664d). As observed by D'Alessio, "Plato really does see choral performance as a crossroads of persuasion: the choruses have to persuade the community, and are, in their turn, to be persuaded by the gods."[49] It is to the *forms* of expression of such persuasion as voiced by Magnesia's choruses that we shall now pay closer attention.

2. The Chorus(es) of Magnesia

The gods assigned to mortals the Muses, Apollo, and Dionysos both as fellow-celebrants (συνεορταστάς 653d4; συγχορευτάς 654a1, 665a4) and leaders of their choral performances (χορηγεῖν 654a3; χορηγούς 665a4). Magnesia's (male) citizens[50] will be split into three choruses, all of them having as their primary function that of "enchanting with song the souls of the children, still young and tender" (664b2–3 ἐπᾴδειν ... ἔτι νέαις οὔσαις ταῖς ψυχαῖς καὶ ἀπαλαῖς τῶν παίδων). The content of this choral ἐπῳδή will be the divine truth (ὑπὸ θεῶν ... λέγεσθαι) that the "best" (ἄριστος) life is also the "most pleasant" (ἥδιστος: 664b8).[51] This form of persuasion through choral songs is deemed the most effective by the Athenian Stranger: "we shall be saying what is most true and we shall persuade those who must be persuaded better than if we uttered a sound speaking in some other way" (ἀληθέστατα ἐροῦμεν ἅμα, καὶ μᾶλλον πείσομεν οὓς δεῖ πείθειν ἢ ἐὰν ἄλλως πως φθεγγώμεθα 664c1–2). Who are these three choruses? In what sense may they be seen as true representatives of Magnesia's civic *ethos*?[52] On what is the authority of their choral voice based? The Athenian Stranger introduces them at 664c4–d4 in the following way:

> First then it would be most right [ὀρθότατα] for the chil-
> dren's chorus dedicated to the Muses [ὁ Μουσῶν χορὸς ὁ
> παιδικός] to come forward first [εἰσίοι πρῶτος], to sing

[49] D'Alessio forthcoming (see above, n. 6).

[50] For the necessity of different kinds of songs for the different sexes, cf. 801e–802e.

[51] Cf. already 659e1–5.

[52] On Plato's tripartite choral world and its possible relationship to the Spartan *trichoria*, see Schöpsdau 1994 (see above, n. 19), 305–6. A useful assessment of the ancient sources about the Spartan *trichoria* and its alleged link to the Gymnopaidiai may now be found in J. Ducat, *Spartan Education: Youth and Society in the Classical Period* (trans. E. Stafford, P.-J. Shaw, and A. Powell), Swansea 2006, 268–73.

such songs publicly with the utmost eagerness and in front of the whole city [τὰ τοιαῦτα εἰς τὸ μέσον ᾀσόμενος ἁπάσῃ σπουδῇ καὶ ὅλῃ τῇ πόλει]. Second [δεύτερος δέ] will come the chorus of those under thirty [ὁ μέχρι τριάκοντα ἐτῶν], invoking [ἐπικαλούμενος] Paean [that is, Apollo] as witness of the truth of what been said, and praying [ἐπευχόμενος] that he may be propitious [ἵλεων . . . γίγνεσθαι] toward the young [τοῖς νέοις][53] and persuade them [μετὰ πειθοῦς]. Then a third group of men must sing [ᾄδειν], those who are over thirty and up to sixty. Those who come after these [τοὺς δὲ μετὰ ταῦτα][54]—for they are not able to endure the songs any longer [οὐ γὰρ ἔτι δυνατοὶ φέρειν ᾠδάς]—are left [καταλελεῖφθαι] to tell stories about the same kinds of moral characters [μυθολόγους περὶ τῶν αὐτῶν ἠθῶν] out of their divine inspiration [διὰ θείας φήμης].

A first matter-of-fact observation is that the three choruses are organized on the basis of age-classes.[55] If we make an exception for the chorus of the elders (about whom more later), this way of conceptualizing civic choral performances by age-class is entirely traditional and in keeping with what we know about Athenian contemporary practices. The most immediate term of comparison for fourth-century BC Athens is the dithyramb.[56] The dithyrambic choruses

[53] The text as it is does not make clear whether the νέοι here mentioned include those under thirty or refer only to the παῖδες. England 1921 (see above, n. 19), vol. 1, 309 favors the latter hypothesis ("the words ἵλεων μετὰ πειθοῦς . . . look more like a prayer for others than for the suppliants themselves") but later on at 951e3–4 νέοι are those aged between thirty and forty, and at 961b1 the νέοι who have to join in the nocturnal council must be no less than thirty years old: see A. Larivée, "Du vin pour le Collège de veille? Mise en lumière d'un lien occulté entre le Choeur de Dionysos et le νυκτερινὸς σύλλογος dans les *Lois* de Platon," *Phronesis* 48 (2003), 50, n. 83 and L. Brisson, "Le college de veile (nukterinòs súllogos), in Lisi 2001 (see above, n. 34), 165. For νέοι in Athenian inscriptions from the late fourth century BC referring to "those under thirty," see J. Davidson, "Revolutions in Human Time: Age-Class in Athens and the Greekness of Greek Revolutions," in S. Goldhill and R. Osborne (eds.), *Rethinking Revolutions Through Ancient Greece*, Cambridge 2006, 48. It seems to me more probable that τοῖς νέοις of 664c8 comprises both παῖδες and young ἄνδρες.
[54] Cf. England 1921 (see above, n. 19), vol. 1, 309, "this can mean nothing but those who are beyond that age."
[55] On the possibility of a subdivision of the third chorus in two sub-choruses, see Schöpsdau 1994 (see above, n. 19), 308–9, Larivèe 2003 (see above, n. 53), 49–50, Mouze 2005 (see above, n. 6), 212, n. 2.
[56] On the growing popularity of dithyrambic performances in the fourth century BC, see P. Wilson, "The Politics of Dance: Dithyrambic Contest and Social Order in Ancient Greece," in

performing at the Great Dionysia were recruited on the basis of both geopolit-
ical (*phylai*) and age-class-based criteria: each *phylê* had to provide two choruses
of fifty members, one of "children" (παῖδες) and one of adult men (ἄνδρες).[57]
Plato does not make mention here of the geographical criterion. Magnesia is,
of course, no historical city and it would be wrong to transpose "real" societal
standards on it, yet some observations may be made all the same. Later on we
learn that Magnesia's citizens will be divided in twelve *phylai* consecrated to the
twelve gods (745d–e) and there are some passages that may lend themselves
to the suggestion of choral performances organized on a phyletic basis, even if
admittedly there is no explicit textual clue in this direction.[58] At 828c we are
told that every year there must be twelve *heortai* (one each month) to the twelve
eponymous gods of the twelve *phylai*, and that these festivities will entail "choruses
and musical contests and also gymnastic ones" (χορούς τε καὶ ἀγῶνας μουσικούς,
τοὺς δὲ γυμνικούς 828c2–3). Nothing more precise is said about the organiza-
tion of these choruses and musical/sporting contests: what is clear is that the
whole civic body is meant to take part in them. In a society so obsessed with
hierarchy based on biological seniority,[59] it seems likely that at these *heortai* the
age-class criterion would certainly have been respected. As to the possibility of
intraphyletic competition, it cannot be proven but it cannot be ruled out either.
It is true that Magnesia's city must be as much as possible "one *polis*." Occasions
that foster inner divisions are *a priori* unwelcome, and competition between
phylai could be seen in this respect as a disturbing factor. Yet Magnesia's society
is anyway highly agonistic: public praise and blame (also for, among other activi-
ties, choral and athletic performances) are positively encouraged within certain
limits by the laws.[60] Collective performances may be competitive without utterly

D. Phillips and D. Pritchard (eds.), *Sport and Festival in the Ancient Greek World*, Swansea 2003,
164–67 (on Athens, pp. 165–66).

[57] See P. Wilson, *The Athenian Institution of the Khoregia: The Chorus, the City and the Stage*,
Cambridge 2000, 75–76. According to Wilson 2000, 75, the category of παῖδες "presumably repre-
sented a band of about five to seven years of age (c. 11–17)," while "the men's category will have
been some four times as broad (c. 18/20–45+?)."

[58] At 771d the law establishes that each citizen will take part in two *heortai* every month, one in
honor of the eponym of his/her tribe and one celebrating the eponym of his/her deme (I follow
here Saunders' interpretation of this much discussed passage: see T. J. Saunders, "Notes on Plato
as a City Planner," *Bulletin of the Institute of Classical Studies* 23 [1976], 25, and Schöpsdau 1994
[above, n. 19], 447).

[59] See Schofield 2003 (see above, n. 6), 4–6.

[60] Cf., e.g., 801d–802d, 822e–23a, 829c–e, 835a (ἅμιλλαι χορῶν: a Dionysiac expression? cf.
Sophokles *Tr.* 219–20 βακχίαν … ἅμιλλαν, Philod. *Paean to Dionysos CA* p. 169, ll. 133–34 χορῶν τε
… κυκλίαν ἅμιλλαν). For both musical and agonistic competitions, cf. also 764dff. On the rhetoric

undermining the sense of social solidarity:[61] if the prize to be won is a prize in civic excellence and communal ideals, the overall unity of a community may, after all, be reinforced.[62] Be this as it may, what is interesting to point out is that the recruitment of Magnesia's choruses does not follow the procedure of Athens for selecting the choreuts of either tragic or comic choruses, where the age-class distinction "was less of a defining criterion in the general perception of the genre."[63] Their social composition is much more strictly related to what we know about choral lyric performances: "the ritual essence of the choral lyric performance is that it is *constitutive* of a society in the very process of *dividing* it."[64]

Of particular interest are the second and third choruses, especially those of Apollo and Dionysos. As to the second chorus, those of men up to thirty, it will invoke (ἐπικαλούμενος) Apollo as "Paean" ("Healer") and will pray (ἐπευχόμενος) the god to be gracious (ἵλεως) to the young and to show his benevolence through persuasion (μετὰ πειθοῦς). The celebratory song to Apollo is presented at the same time as a *request* for divine persuasion and as an *act* of persuasion toward the same god, whose persuasion is requested in turn (the invocation of Paean as witness of the truth of what is sung). D'Alessio has amply shown how this network of reciprocal πειθώ is a typical feature of choral lyric and has its roots in the specificity of its cultic context.[65] It seems to me that this pattern of reciprocity may help us to understand also the repeated insistence with which Plato *wants* Magnesia's choral songs to be prayers as well (700b1–2; 801e1–2).[66] These two last passages have often been interpreted as reliable evidence for an early generic categorization within lyric poetry,[67] yet ὕμνος-related words in both Pindar and Bacchylides refer without distinction to men

of praise and blame as targeted by Plato in the *Lysis* and *Symposion*, see A. W. Nightingale, "The Folly of Praise: Plato's Critique of Encomiastic Discourse in the *Lysis* and *Symposium*," *Classical Quarterly* 43 (1993), 112–30.

[61] Cf. P. Wilson, "Performance in the *Pythion*: The Athenian Thargelia," in P. Wilson (ed.), *The Greek Theatre and Festivals: Documentary Studies*, Oxford 2007, 175, n. 96, on "theoric" and "competitive" choruses.

[62] Cf. Wilson's comments on how "a vision of a unified city—over and above its individual tribes—may have been promulgated in Athenian dithyrambs" (Wilson 2003 [see above, n. 56], 169).

[63] Wilson 2000 (see above, n. 57), 76–80 (the quotation is from p. 77).

[64] Nagy 1990 (see above, n. 10), 367.

[65] D'Alessio forthcoming (see above, n. 6).

[66] 700b1–2 καί τι ἦν εἶδος ᾠδῆς εὐχαὶ πρὸς θεούς, ὄνομα δὲ ὕμνοι ἐπεκαλοῦντο; 801e1–2 μετά γε μὴν ταῦτα ὕμνοι θεῶν καὶ ἐγκώμια κεκοινωνημένα εὐχαῖς ᾄδοιτ' ἂν ὀρθότατα.

[67] Bibliography would be endless here: cf., e.g., W. D. Furley and J. M. Bremer, *Greek Hymns: Selected Cult Songs from the Archaic to the Hellenistic Periods*, vol. 1, Tübingen 2001, 11–12. For a

and gods alike,[68] and if a hymn may be a prayer, a prayer need not necessarily be a hymn.[69] If Plato *wanted* a hymn to be, at least at Magnesia, a "sung prayer to the gods," this has more to do with his particular agenda than with literary classification: the citizens of the "second best" city must spend their live "in a dialogue with the gods by means of prayers and supplications" (887e1–2 ὡς ὅτι μάλιστα οὖσιν θεοῖς εὐχαῖς προσδιαλεγομένους καὶ ἱκετείαις). This is also why song and dance can be seen as virtual sacrifices to the gods: the "correct way" of living is to go through life "playing some plays, sacrificing, singing and dancing, so as to propitiate the gods toward oneself" (παίζοντά ἐστιν διαβιωτέον τινὰς δὴ παιδιάς, θύοντα καὶ ᾄδοντα καὶ ὀρχούμενον, ὥστε τοὺς μὲν θεοὺς ἵλεως αὑτῷ παρασκευάζειν δυνατὸν εἶναι). This equivalence between choral performance and sacrifice is already present in the language of choral lyric: for the image of hymns as offerings to the gods, see, for example, Philodemos *De Mus.* 4 col. 135. 10–13 Delattre (= Pindar fr. *86a Maehler) on Pindar offering a dithyramb as sacrifice (θύσων ποιεῖσθαι διθύραμβον).

With the first and second chorus of Magnesia's citizens, we are within a mode of experiencing the dimension of song and dance that we have called, for brevity's sake, "lyric" mimesis: the members of chorus of the Muses and Apollo are characterized as being "themselves," a group representative of the *polis* performing how to be proper citizens. The choreuts of the Muses and Apollo are both speakers and recipients of the views that they promulgate, and it is because of this identity between performer and audience that they are able to reach the entire city. The ideal χορεία should involve the imitation of states of character and actions that are proper of the good citizen (655d5–656a5): its aim is to educate toward virtue (πρὸς ἀρετήν) the "children of law-abiding citizens and the young" (656c5–6 καὶ τοὺς τῶν εὐνόμων παῖδας καὶ νέους ἐν τοῖς χοροῖς). Psychological and behavioral assimilation through mimesis are for the experiencing person a state of being as "true" as that of empirical reality: "Plato's approach to the psychology of mimesis is grounded on the assumption that there is continuity,

different approach, see D. Fearn, *Bacchylides: Politics, Performance, Poetic Tradition*, Oxford 2007, 186–88.

[68] For *hymnos* referring to men, cf., e.g., Pindar *Isthm.* 2.3, Bacchylides 6.11.

[69] See S. Pulleyn, *Prayer in Greek Religion*, Oxford 1997, 43–50 (esp. 44–45 with n. 18 on 801e1–2), A. Willi, *The Languages of Aristophanes: Aspects of Linguistic Variation in Classical Attic Greek*, Oxford 2003, 13–15. However, I cannot agree with Pulleyn when he claims that hymn is "a kind of negotiable commodity" that generates χάρις, whereas the prayer does not (55). The difference between prayer and hymn is in the context and modality of utterance. Prayer is a speech-act, hymn a *mode* of performing a speech-act.

even equivalence, between our relations to people and things in the real word and to people and things presented in mimetic art."[70] This is why the process of self-likening (ὁμοιοῦσθαι) through mimesis must be limited to "the artistic performance that possesses a resemblance to the imitation of the beautiful" (668b1–2 μουσικὴν . . . ἐκείνην τὴν ὁμοιότητα τῷ τοῦ καλοῦ μιμήματι).[71] The guardians of Kallipolis are not allowed to be μιμητικοί (394e) because mimesis (and in the *Republic* the main concern is with "tragic" or "dramatic" forms of mimesis: that is, with imitating "otherness") "leads us to discover other lives, and, in the process, to make them psychologically our own."[72] In the *Laws*, the way to save the psychagogic force of artistic mimesis and at the same time avoid "being necessarily in contradiction with oneself" (ἀναγκάζεται . . . ἐναντία λέγειν αὐτῷ 719c6–7)[73] is to equate mimesis to an absolute identity between performer and performed, actor and audience,[74] and it is here that the model of "lyric" mimesis represented by choral cultic poetry offers obvious advantages over the "tragic" form.[75] By adopting forms of "lyric" mimesis in their choral performances Magnesia's citizens can endlessly reenact their own self-likeness.[76]

[70] Halliwell 2002 (see above, n. 6), 76. Halliwell 2002, 72–85, provides an excellent exploration of Plato's psychology of mimesis in both *Republic* and *Laws*. While I agree with his magisterial demonstration that Plato's view of mimesis, already in the *Republic*, Halliwell allows for "a series of grades of imaginative absorption in the mimetic world that extends from the adoption of a quasi-participant point of view to the holding of an attitude of critical detachment" (Halliwell 2002, 80), the "lyric" way of experiencing mimesis that constantly emerges in Magnesia's choruses seems to me to level the distinction between performers and audiences in the *Laws* more than Halliwell is disposed to admit (cf. Halliwell 2002, 78, on 655b–56b). This is particularly the case for 657d1–6 where "watching the *heortē*" (θεωροῦντες) means taking part in it; see below.

[71] For the assimilation of the performers to the object they imitate, see Lavecchia 2006 (see above, n. 3), 236–45.

[72] S. Halliwell, "Plato and the Psychology of Drama," in B. Zimmermann (ed.), *Antike Dramentheorien und ihre Rezeption*, Stuttgart 1992, 68. Cf. also Panno 2007 (see above, n. 6), 171–73.

[73] On 719c1–d3, cf. Panno 2007 (see above, n. 6), 87–88.

[74] Comedy is allowed in Magnesia only inasmuch as *performed* by hired foreigners and slaves (816d–e): civic purity is preserved by distancing performers from their audience. On mimesis, strangers, and comedy in the *Laws*, see Panno 2007 (see above, n. 6), 48–49, 201–5 and Halliwell 2002 (see above, n. 6), 82–83. On how the Spartan "concept" of comic performances (enacted by helots and slaves) may have influenced Plato's thought in the *Laws*, see E. David, "Laughter in Spartan Society," in A. Powell (ed.), *Classical Sparta: Techniques Behind her Success*, London 1989, 10.

[75] On tragic and lyric mimesis, see W. Mullen, *Choreia: Pindar and Dance*, Princeton, NJ 1982, 52–55.

[76] Cf. Panno 2007 (see above, n. 6), 56. "la mimesi viene recuperata, al contrario, per riconvertire lo sguardo dell'uomo allo *stesso* attraverso l'*altro*."

The official language of the *polis* tells us that in fifth- and fourth-century BC, the dramatic performances of Athens, both tragic and comic, were regarded fundamentally as *choral* performances.[77] In this broader sense, tragic choruses may certainly be said to reflect a collective, communal voice. Most of the time tragic choruses represent socially marginal groups: often women, old men, captives and foreigners and much more rarely men of military age who might literally be taken as representatives of the active civic body.[78] Yet tragic choruses may embody on stage what we can call a civic voice and identity, even if only a partial one (the elders of Aischylos' *Agamemnon* are the most famous instance). But the authority of the tragic choral voice, even when representative of a civic community, is always limited: to quote Goldhill, "[the tragic chorus] sets in play an authoritative collective voice, but surrounds it with other dissenting voices. [It] both allows a wider picture of the action to develop and also remains one of the many views expressed."[79] This limited authority of the tragic chorus is a key element of tragic representation: the tragic chorus can never reach the all-encompassing inclusiveness and authority of the choral lyric voice.[80] With the exception of comedy, the communal space of Magnesia's theaters (779d5) will become a second version of "Sparta's theatre,"[81] the recipient of nondramatic forms of choral performance enhancing social cohesion and stability.[82]

[77] Cf. H. Foley, "Choral Identity in Greek Tragedy," *Classical Philology* 98 (2003), 3 with n. 9, P. Wilson, "Euripides' 'Tragic Muse'," *Illinois Classical Studies* 24–25 (1999–2000), 429.

[78] See, especially, Foley 2003 (see above, n. 77), 1.

[79] S. Goldhill, "Collective and Otherness: The Authority of the Tragic Chorus," in M. Silk (ed.), *Tragedy and the Tragic: Greek Theatre and Beyond*, Oxford 1996, 255.

[80] The literature on the authority of the choral voice in tragedy is vast; suffice it to refer here to the recent treatments by R. Rutherford, "Why Should I Mention *Io*? Aspects of Choral Narration in Greek Tragedy," *Cambridge Classical Journal* 53 (2007), 1–39 (esp. 16–20), Foley 2003 (see above, n. 77), D. J. Mastronarde, "Il coro euripideo: Autorità e integrazione," *Quaderni Urbinati di Cultura Classica* 60 (1998), 55–80, Goldhill 1996 (see above, n. 79), and J. Gould, "Tragedy and Collective Experience," in Silk 1996 (see above, n. 79), 217–43. Cf. also Lada-Richards, "Reinscribing the Muse: Greek Drama and the Discourse of Inspired Creativity," in Spentzou and Fowler 2002 (see above, n. 6), 78–79, on how the chorus of tragedy may be seen as the "paradigm image for performance in the Greek *polis*" only inasmuch as the members of a tragic chorus can perceive themselves as "the human equivalent" of the Muses in moments of choral projection.

[81] For the θέατρα as the likely venue for the performances of the chorus of the Muses and Apollo, cf. Larivée 2003 (see above, n. 53), 49.

[82] For the absence of tragedy and comedy in Sparta's religious and social life, cf. Plutarch *Mor.* 239b (= *Inst. Lac.* 33) κωμῳδίας καὶ τραγῳδίας οὐκ ἠκροῶντο, ὅπως μήτε ἐν σπουδῇ μήτε ἐν παιδιᾷ ἀκούσωσι τῶν ἀντιλεγόντων τοῖς νόμοις ("[the Spartans] used not to attend either comedy or tragedy so that they may not hear anyone speaking against the laws either in earnest or in jest"). For Sparta's theater as venue of public nondramatic *heortai*: Herodotos 6.67 (Gymnopaidiai);

3. Dionysiac mimesis: The third chorus

How does the third chorus of the elders, with its special link with Dionysos, the Athenian god of the theater par excellence, fit into this rescue of an educational, nondramatic mimesis where "correctness" (ὀρθότης), "benefit" (ὠφελία), "pleasure" (ἡδονή), and "truth" (ἀλήθεια) are intimately interwoven with each other (667c5–7)? And how is it that Dionysos, a god eternally young and new, has his truest representative in the elders?

Let us go back to the broader context that frames the discussion on the "correct education." As early as 636e, the Athenian Stranger starts his pedagogical inquiry into the benefits of drunkenness in general (637d4 περὶ ἁπάσης μέθης) and introduces the *symposion* as the replica, on a smaller scale, of the civic macrocosm of the *polis*: a peaceful community of friends joining in reciprocal acts of φιλοφροσύνη (640b6–8).[83] At 641b1–c2 a direct link is established between a properly "educated" *symposion* (συμποσίου δὲ ὀρθῶς παιδαγωγηθέντος 641b1) and the "correct" education of youth (641b3–4). In terms of expression and imagery it is remarkable that the Athenian Stranger replies to Kleinias' question ("what would be the benefit of a correct sympotic practice for the polis and the individual?") by explicitly *assimilating* the educative process of the *symposion* to that of the training of a chorus of youths (χοροῦ παιδαγωγηθέντος).[84] Finally, at 642a3–6 the Athenian Stranger states that a "correct" treatment of sympotic practice (ἡ κατὰ φύσιν . . . διόρθωσις) necessarily presupposes the preliminary

Athenaios 14.631c (Gymnopaidiai); Polykrates *FGrH* 588 F1 (Hyakinthia); Plutarch *Ages.* 29.3 (Gymnopaidiai), Pausanias 3.14.1 (the later marble theater erected in Hellenistic times, 32–30 BC: see G. B. Waywell, J. J. Wilkes, and S. E. C. Walker, "The Ancient Theatre at Sparta," in W. G. Cavanagh and S. E. C. Walker (eds.), *Sparta in Laconia: The Archaeology of a City and its Countryside*, London 1998, 97–111). On the absence of canonical theatrical plays (tragedies and comedies) in Sparta's theater up to the late Hellenistic/early Roman period (tragedies were first introduced under the Roman domination), see I. K. Loukas, "Λακεδαιμόνιοι Διονυσιακοὶ τεχνίτες," *Horos* 2 (1984), 149–60.

[83] For the image of the *polis* as a mixing-bowl at 773c8–d4, see E. Belfiore, "Wine and catharsis of the emotions in Plato's *Laws*," *Classical Quarterly* 36 (1986), 430–31. On Magnesia's *symposia* and their relationship to the Spartan *syssitia* and the Athenian (public and private) *symposia*, see P. Schmitt Pantel, *La cite au banquet: Histoire des repas publics dans les cites greques*, Rome 1992, 234–37, N. R. E. Fisher, "Drink, *Hybris* and the Promotion of Harmony in Sparta," in A. Powell (ed.), *Classical Sparta: Techniques Behind Her Success*, London 1989, 28–30, 36–38, and 41, E. David, "The Spartan *Syssitia* and Plato's *Laws*," *American Journal of Philology* 99 (1978) 486–95. On Plato's attitude toward wine and *symposia* in the *Laws*, see also M. Tecusan, "*Logos Sympotikos*: Patterns of the Irrational in Philosophical Drinking. Plato Outside the *Symposium*," in O. Murray (ed.), *Sympotica: A Symposium on the* Symposion, Oxford 1990, 244–57.

[84] On the meaning of παιδαγωγέω in this context, cf. Schöpsdau 1994 (see above, n. 19), 216.

definition of the "correctness of music" (μουσικῆς ὀρθότης), and this in its turn involves a discussion of the "correct" form of the whole education (παιδεία ἡ πᾶσα). The strict link between the chorus of Dionysos, intoxication, and the *symposion* as formulated at *Laws* 665b–671b has received copious attention in recent scholarship. The focus has usually been either on the "allopathic catharsis of emotions" caused by wine, Dionysiac inspiration and its role in Plato's physiology of pleasure (a way of educating the young through a reeducation of the elders),[85] or on the institutional affinities between the chorus of Dionysos ("the best part of the city": 665d1 τὸ ἄριστον τῆς πόλεως) and the Nocturnal Council and their complementing of each other.[86] More generally, the reintegration of Dionysos and the Dionysiac in the Apollonian cosmos of Magnesia, both in terms of social and cultic practices, has very recently received a thorough book-long treatment by Panno.[87] While relying on these important studies, I would like to contribute to the discussion by addressing the subject from a different perspective. I shall pay attention to the *forms* of expression and patterns of performance staged or imagined to be staged by the chorus of the elders and show how the discursive rhetoric enacted by the chorus of Dionysos is one of the most fascinating ways in which Plato manages to reinscribe the collective "I" of choral lyric into tragic discourse.[88] Through an intertextual dialogue with opportunely selected voices of tragic "civic" choruses, Plato's chorus of Dionysos is competing with tragedy's own appropriation of the lyric discourse of civic identity. This negotiation will reveal once again how Plato's vision of chorality is deeply indebted to the religious, cultic frame of the *polis* in general, and Athens in particular.

Let us then go back to Plato's first introduction of the Chorus of Dionysos (664d1–4). Dionysos will be the patron of the chorus of "old" men (cf. 665b4

[85] "Allopathic catharsis of emotions": Belfiore 1986 (see above, n. 83), 432. Cf., e.g., Panno 2007 (see above, n. 6), 154–70, Mouze 2005 (see above, n. 6), 168–73 and 247–71.
[86] Cf., e.g., Panno 2007 (see above, n. 6), 150–54, Larivée 2003 (see above, n. 53), Brisson 2001 (see above, n. 53).
[87] Panno 2007 (see above, n. 6), esp. chs. 3 and 4.
[88] It will be clear by now that I do not think that the "singing" (664d2 ᾄδειν) and "dancing" (665b6 χορεύσουσιν) of the third chorus is purely metaphorical (for this view, cf., e.g., Morrow 1960 [see above, n. 11], 313–18, and more recently, C. Schefer, *Platon und Apollon: Vom Logos zurück zum Mythos*, Sankt Augustin 1996, 226–28, Larivée 2003 [see above, n. 53], 39–40). To deprive the chorus of its καλλίστη ᾠδή seems to me utterly to undermine Plato's physiology of pleasure as formulated in the *Laws* and to impoverish significantly the interpretative payback we can get by contextualizing Magnesia's choral performances within the choral practices of the ancient Greek *polis*.

Διονύσου πρεσβυτῶν χορός). The age requirement (especially the lower limit) for belonging to the third chorus oscillates throughout the *Laws*,[89] and it has been rightly explained, I think, with Plato's "exploratory character of the inquiry."[90] It is also worth noticing that the direction of this "inconsistency" is in itself coherent: through the fictional time of the *Laws* the members of the Chorus of Dionysos grow older and older, and it is not unlikely that this progressive movement may reflect Plato's growing awareness of the necessity of "containing" as much as possible the Dionysiac component of Magnesia's citizenship. Be this as it may, the age limits identified by Plato for Magnesia's elders are broadly consistent with what we know about age-classes in classical Athens: the dividing line between πρέσβυς and νέος could be as low as thirty.[91] Dionysos' chorus is thus a chorus whose members may legitimately be conceptualized by Plato's readers as being "old," as having authority that is "divinely inspired" (διὰ θείας φήμης 664d4), and (with the exception of the over-sixty) as expressing its authority in the persuasion exercised through its songs (665d1–4).[92]

Two elements are most interesting here in terms of poetic self-representation. First, D'Alessio has already shown how the form of authority claimed by the chorus of Dionysos is strongly reminiscent of the parodos of the *Agamemnon* (104–6), where the problematic status of the choral voice finds its first, for us, tragic dramatization.[93] There the chorus of the elder citizens of Argos asserts its authoritative voice as a community group on the basis of both its old age

[89] Cf. 664d1–4 (thirty to sixty; the over-sixty will be μυθολόγοι divinely inspired), 665b3–6 (30–60: οἱ ὑπὲρ τριάκοντα καὶ πεντήκοντα δὲ γεγονότες ἔτη μέχρι ἑξήκοντα), 666b2 (τετταράκοντα δὲ ἐπιβαίνοντα ἐτῶν, i.e., "when a man is rising forty," that is "enters the fourth decade": England 1921 [see above, n. 19], vol. 1, 313; cf. also Schöpsdau 1994 [see above, n. 19], 312), 670a4–b2 (oscillation between thirty and fifty at 670a4–5 and only fifty at b1), 671d9–e2 (over sixty: τοῖς ἡγεμόσιν τοῖς τοῦ Διονύσου, τοῖς ὑπὲρ ἑξήκοντα ἔτη γεγονόσιν), 812b9–c1 (sixty: τοὺς ἑξηκοντούτας ᾠδούς).

[90] Morrow 1960 (see above, n. 11), 318. Cf. also Panno 2007 (see above, n. 6), 148 with n. 33. D. Nails and H. Thesleff, "Early Academic Editing: Plato's *Laws*," in S. Scolnicov and L. Brisson (eds.), *Plato's* Laws: *From Theory into Practice: Proceedings of the VI Symposium Platonicum. Selected Papers*, Sankt Augustin 2003, explain factual inconsistencies in the *Laws* as mainly due to the editorial process.

[91] Cf. Davidson 2006 (see above, n. 53), 48, N. B. Crowther, "Old Age, Exercise and Athletics in the Ancient World," *Stadion* 16 (1990), 171.

[92] In particular at 665d2–3 the chorus of Dionysos is described as the "part of us that is best at persuading those in the city because of its age and intelligence" (ἡλικίαις τε καὶ ἅμα φρονήσεσιν πιθανώτατον ὂν τῶν ἐν τῇ πόλει) and as bestowing the greatest benefits on the citizens "by singing the most beautiful songs" (ᾄδον τὰ κάλλιστα).

[93] D'Alessio forthcoming (see above, n. 6).

(σύμφυτος αἰών 106) and its divinely inspired persuasion (θεόθεν . . . πειθώ 105–6), voiced through the vicarious "strength" now represented by their singing (μολπᾶν ἀλκάν 106).[94] That is, the chorus of the old Argives claims its authority "not only *qua* elderly citizens, but, more specifically, as performers of lyric poetry."[95] What is most fascinating is that Plato is drawing here on one of the passages in ancient Greek drama where a chorus of elders "appropriates" and "inverts" a fundamental *Leitmotiv* of lyric poetry (choral and monodic): the "lyric" I of the speaking voice describes himself/herself as too old for dancing but not for singing and directing the song from outside.[96] D'Alessio has rightly detected in the unusual turn of phrase of 664d3 (οὐ γὰρ ἔτι δυνατοὶ φέρειν ᾠδάς)[97] a reference to the "my-knees-cannot-bear-me" motif, with explicit reference to dance (cf., e.g., Alkman fr. 26 *PMGF* οὔ μ' ἔτι . . . γυῖα φέρην δύναται and Sappho P.Köln 429 col. ii l. 1 ⌈= fr. 58. 15 Voigt] γόνα δ'[οὐ] φέροισι).[98] It is interesting that the same theme clearly reappears (or, better, makes its first appearance within the compositional time of the *Laws*) also at 657d 1–6.[99] In this last passage, Magnesia's trichoria has not yet been mentioned, yet the (elderly) Athenian Stranger is preparing the ground for it. The young, he says, are always more disposed to dance (χορεύειν ἕτοιμοι), whereas the elders believe that it is "proper" for themselves (πρεπόντως) simply to look on at the performances of their juniors (ἐκείνους αὖ θεωροῦντες), delighting (χαίροντες) at their plays and festivals. The reason for that is that "agility" (τὸ . . . ἐλαφρόν) has abandoned the old men, yet they feel an intense nostalgia for it (ποθοῦντες καὶ ἀσπαζόμενοι) and for that reason they establish festivals (ἀγῶνας) for those who are more capable to rejuvenate them through memory (τοῖς δυναμένοις ἡμᾶς ὅτι μάλιστ᾽ εἰς τὴν νεότητα μνήμῃ ἐπεγείρειν). The "agility" the old men long for is clearly

[94] I follow here West's Teubner second edition. For the numerous interpretative problems raised by ll. 104–6, cf. E. Fraenkel, *Aeschylus: Agamemnon*, vol. 2, Oxford 1955, 62–65.

[95] D'Alessio forthcoming (see above, n. 6).

[96] For dancing choruses of old men in tragedy and comedy, cf. Euripides *Herakles* 673–94 (on which, see further below), fr. 370. 9–10 Kannicht (*Erechtheus*: for the text, see the recent reconstruction by M. Sonnino, "Per la ricostruzione di un corale dell'Eretteo di Euripide: PapSorb 2328," *Zeitschrift für Papyrologie und Epigraphik* 166 [2008], 9–21), Aristophanes *Wasps* 1066–67, *Lysistrate* 670, *Wealth* 757–61 (an imaginary chorus of elders rejoices with dances at the return of Wealth: ll. 759–60 ἐκτυπεῖτο δὲ/ἐμβὰς γερόντων εὐρύθμοις προβήμασιν [probably a tragic quotation: see A. H. Sommerstein, *Aristophanes: Wealth*, Warminster 2001, 184] and then at 760–61 the actual chorus of elder on stage is encouraged by Karion to dance [ὀρχεῖσθε]), *Peace* 334.

[97] On the unidiomatic nature of the collocation φέρειν ᾠδάς, cf. England 1921 (see above, n. 19), vol. 1, 309 *ad loc.*

[98] D'Alessio forthcoming (see above, n. 6).

[99] Cf. F. Ferrari, *Una mitra per Kleis: Saffo e il suo pubblico*, Pisa 2007, 183, n. 5.

the nimbleness of limbs in dancing that the lyric *persona* so often regrets to have lost (cf., e.g., Sappho P.Köln 429 col. ii l. 2 τὰ δή ποτα λαίψηρ᾽ ἔον ὄρχησθ᾽ ἴσα νεβρίοισιν, "[my knees] that once a time were nimble for dancing as fawns").[100] Paradoxically, the eldest citizens of Magnesia decline to dance by rehearsing what is one of the standard motifs of the performing I in ancient Greek lyric. But there are further considerations to be made. The elders take part into the performance as "observers" (θεωροῦντες). The importance in Plato's works of the religious and civic institution of θεωρία as a paradigmatic template on which to construe the idea of philosophic speculation has already been the subject of close scrutiny.[101] What is interesting in this particular instance is that while staging a programmatic refusal to join in dancing and singing, Plato's elders are appropriating a *mode* of experiencing the feast that is distinctively proper of the civic institution of the θεωρία itself. As has been observed, "the term and practise of *theôria* aligns most closely the aspects of viewing with participation:" to watch the dance and song *is* a way to participate in it.[102]

Furthermore, the way in which this "awakening" to a vicarious form of youth is phrased (657d6 εἰς τὴν νεότητα μνήμη ἐπεγείρειν) is such as to distinctively recall a Dionysiac experience. Christiane Sourvinou-Inwood has shown that Plato's metaphorical use of ἐγείρειν (especially but not exclusively in the collocation ἐγείρειν ψυχήν) bears clear bacchic resonances,[103] and rejuvenation through the experience of dance is troped as a typically Dionysiac experience in Aristophanes' *Frogs* 345–49.[104] Dionysos and his rejuvenating power, though both are so far unmentioned, are already subtly creeping in.

[100] Cf. the use of ἐλαφρότης in 795e3 with reference to the type of dance that is not proper of "those who imitate the words of the Muse" (Μούσης λέξιν μιμουμένων: on the meaning of this expression, cf. K. Schöpsdau, *Platon: Nomoi (Gesetze) Buch IV–VII*, Göttingen 2003, 526) but that is performed "for the sake of fitness, agility, and beauty" (εὐεξίας ἐλαφρότητός τε ἕνεκα καὶ κάλλους).

[101] See A. W. Nightingale, *Spectacles of Truth in Classical Greek Philosophy: Theôria in Its Cultural Context*, Cambridge 2004, and A. W. Nightingale, "The Philosopher at the Festival: Plato's Transformation of Traditional *Theôria*," in J. Elsner and I. C. Rutherford (eds.), *Pilgrimage in Graeco-Roman and Early Christian Antiquity: Seeing the Gods*, Oxford 2005, 151–80.

[102] A. Kavoulaki, "Processional Performance and the Democratic Polis," in S. Goldhill and R. Osborne (eds.), *Performance Culture and Athenian Democracy*, Cambridge 1989, 311. For the possible etymology of *theôria* ("to watch"), see I. C. Rutherford, "*Theôria* and *Darsan*: Pilgrimage and Vision in Greece and India," *Classical Quarterly* 50 (2000), 137 with n. 22.

[103] C. Sourvinou-Inwood, *Hylas, the Nymphs, Dionysos and Others: Myth, Ritual, Ethnicity*, Stockholm 2005, 237–38 (esp. on *Phaidros* 245a ἐγείρουσα καὶ ἐκβακχεύουσα κατά τε ᾠδὰς καὶ κατὰ τὴν ἄλλην ποίησιν).

[104] *Frogs* 345–49: γόνυ πάλλεται γερόντων/ἀποσείονται δὲ λύπας/χρονίους τ᾽ ἐτῶν παλαιῶν

At the same time the expression φέρειν ᾠδάς at 664d3 ("to endure the songs") also activates the lyric image of "the labors of the choruses" (πόνοι χορῶν) that literally equates the "toils" of the young dancing choruses and the joy they bring through the performance to an offering to the god (cf., e.g., Alkman fr. 1 ll. 88–89 πόνων γὰρ/ἄμιν ἰάτωρ ἔγεντο, *PMGF*, Pindar fr. 52h l.22 Maehler [= Paean C2 Rutherford] ἀθάνατ[ο]ν πόνον, 70c l.16 Maehler [a dithyramb] πόνοι χορῶν and *TrGF* II fr. 646a l.23 τραγικῶν παρὼν πόνος ὕμνων).[105] Here again, it is interesting to observe that the expression "the toils of the choruses" is very often associated to a specifically Dionysiac context.[106]

The second element of interest in this complex mediation of tragic and lyric voices operated by Plato is the striking similarity of the chorus of Dionysos with the self-representation of the chorus of elder Thebans in the second stasimon of Euripides' *Herakles* ll.654–94.[107] At 666a–c the Athenian Stranger praises the positive effect of wine as a φάρμακον given by Dionysos to old age so that the elders may become young again and dance and sing in a renewal of the παιδεία they enjoyed while young. Those who have entered the fourth decade of their lives will join the *syssitia* (which, within the discursive frame of the *Laws*, are, remarkably, presented as part of a festival in honor of Dionysos)[108] and "invoke the other gods and especially Dionysos to join in the initiation rite and play of the old, which he bestowed to men as an ally and medicine [i.e., the wine] against the dryness of old age, so that we may become young again" (666b3–7 καλεῖν τούς τε ἄλλους θεοὺς καὶ δὴ καὶ Διόνυσον παρα-καλεῖν εἰς τὴν τῶν πρεσβυτέρων τελετὴν ἅμα καὶ παιδιάν, ἣν τοῖς ἀνθρώποις ἐπίκουρον τῆς τοῦ γήρως αὐστηρότητος ἐδωρήσατο [τὸν οἶνον] φάρμακον, ὥστε

ἐνιαυτοὺς/ἱερᾶς ὑπὸ τιμῆς ("the knee of old men leaps in dance; they shake off the long seasons of grief and old age under the holy worship").

[105] On the *ponos* of the songs bringing joy to both the performers and audiences, see the passages quoted by Lavecchia 2000 (see above, n. 33), 226–27. On the close relationship between choruses and sacrifices, see B. Kowalzig, "Mapping out Communitas: Performances of *Theoria* in their Sacred and Political Context," in Elsner and Rutherford 2005 (see above, n. 101), 48–49.

[106] Cf. Lavecchia 2000 (see above, n. 33), 227 and L. Battezzato, "La fatica dei canti: Tragedia, commedia e dramma satiresco nel frammento adespoto 646a *TrGF*," in E. Medda et al. (eds.), *ΚΩΜΩΙΔΟΤΡΑΓΩΙΔΙΑ: Intersezioni del tragico e del comico nel teatro del V secolo a.C.*, Pisa 2006, 55.

[107] To the best of my knowledge, the affinities of the second ode of Euripides' *Herakles* with Magnesia's third chorus have been mentioned (en passant) only by Wilson 1999–2000 (see above, n. 77): 435, n. 29. See now also D'Alessio forthcoming (see above, n. 6).

[108] Cf. Belfiore 1986 (see above, n. 83), 434–36. See also Tecusan 1990 (see above, n. 83), 245–46, n. 17 and 247, n. 22 on the use of the term συσσίτια at 666b2: "the word συσσίτια here has the full meaning of *symposia*; it is the only occurrence of this kind and it comes in the Athenian's speech. The word συμπόσια is also used by him only once (639d3)."

ἀνηβᾶν ἡμᾶς).[109] In the second stasimon of *Herakles*, the elders of Thebes wish that they could be young again (646 τᾶς ἥβας ἀντιλαβεῖν) and that the gods would bestow a "second youth" (δίδυμον ... ἥβαν 657) on good men as a visible sign of their virtue (φανερὸν χαρακτῆρ' ἀρετᾶς 659). But since this is not possible, they will be rejuvenated through song in their lifelong dedication to the Charites and the Muses (673–76): though they are "old singers" (γέρων ἀοιδός 678; cf. also 109),[110] they will never cease to sing and dance (685–86 οὔπω καταπαύσομεν/ Μούσας αἵ μ' ἐχόρευσαν) in the presence of Dionysos, "giver of wine" (παρά τε Βρόμιον οἰνοδόταν 682), the lyre, and the *aulos*. In the immediately following lines (687–94) the chorus's self-referentiality takes the form of choral projection: the Theban elders explicitly compare their present "epinician" performance for Heracles to the paean of the Delian Maidens in honor of Apollo.[111] The Dionysiac music of the previous stanza finds its ideal mirror and counterpart in paeans in honor of Apollo at Delos. This projection should certainly have reminded the Athenian audience of the civic *theôria* with a chorus of male dancers regularly sent to Delos by Athens. Furthermore, a testimony from Theophrastus' *On Drunkenness* (fr. 576 Fortenbaugh = fr. 119 Wimmer) attests to the fact that in Athens Apollo Delios was identified with the Apollo Pythios of the Thargelia[112]

[109] I follow England 1921 (see above, n. 19), vol. 1, 314 *ad loc.*, in considering τὸν οἶνον of the manuscript tradition an interpolated gloss of the following φάρμακον. Though unnoticed by commentators, it seems to me remarkable that the positive "mollifying" power of the wine is described in such a way as to be strongly reminiscent, in terms of diction and imagery, of the "positive" effects to be gained by moderate use of the *aulos*, Dionysos' musical instrument *par excellence*, at *Republic* 411a9–b1: the first effect of the "soft" music (*Republic* 411a7–8 μαλακὰς ... ἁρμονίας ~ *Laws* 666b7 μαλακώτερον) of the *aulos* on a soul that is θυμοειδής is that of softening it, like (heating) iron (*Republic* 411a10 ὥσπερ σίδηρον ἐμάλαξεν ~ *Laws* 666b7–c2 μαλακώτερον ... καθάπερ εἰς πῦρ σίδηρον ἐντεθέντα γιγνόμενον), and of making it malleable and useful instead of useless and rigid (*Republic* 411a10–b1 καὶ χρήσιμον ἐξ ἀχρήστου καὶ σκληροῦ ἐποίησεν ~ *Laws* 666b7–c1 γίγνεσθαι μαλακώτερον ἐκ σκληροτέρου). Plato's reevaluation of Dionysiac chorality in the *Laws* already has its seeds in the *Republic*.

[110] The affinities between the chorus of elder Thebans in *Herakles* and the old Argives in the *Agamemnon* have long been noticed: see already U. von Wilamowitz-Moellendorff, *Herakles*, 2nd ed., Berlin 1909, 357–58, and Fraenkel 1955 (see above, n. 94), vol. 2: 63–64.

[111] Fundamental on the whole passage is A. Henrichs, "Dancing in Athens, Dancing on Delos: Some Patterns of Choral Projection in Euripides," *Philologus* 140 (1996), 48–62.

[112] On the Athenian Thargelia in honor of Apollo Pythios and their conciliation of Dionysiac and Apollinean elements, see Wilson 2007 (see above, n. 61). Matthaiou has recently made a strong case for identifying the Athenian Python with the temple of Apollo Delios: see A. Matthaiou, "Ἀπόλλων Δήλιος ἐν Ἀθήναις," in D. Jordan and J. Traill (eds.), *Lettered Attica: A Day of Attic Epigraphy*, Athens and Toronto 2003, 85–93; cf. also Wilson 2007 (see above, n. 61), 176–77. For the close link between Apollo Pythios, Delios, and Patroos at Athens, see also K. Karila Cohen,

and this joint worship well reflects the Thargelian influence on the choral contest held at the Delia under Athenian control.[113] Apollo Delios, in Athens, was thus strictly linked to the Delphic Apollo, the brother of Dionysos.

The thematic and verbal affinities of *Laws* 666a–c with the second stasimon of *Herakles* are startling:[114] in his attempt at integrating Dionysos' songs into Magnesia's social and religious organization, Plato has significantly echoed one of the few tragic passages where Dionysos and Apollo, the *aulos* and the lyre are not seen as mutually exclusive.[115] Dionysos and Apollo Delios/Pythios of *Herakles* are already συγχορευταί, and this within the cultic landscape of the Athenian *polis*.[116] Plato's decision to echo this passage is all the more telling if we think that Euripides' *Herakles* as a whole is pervasively permeated by images of destructive Dionysian music, a tendency that has been rightly related "to a broader religious anxiety concerning a perceived inefficacy or irrelevance of traditional ritual forms—including most importantly musical forms."[117] Within the plot of *Herakles* the second stasimon is but an "ode of premature rejoicing" and as such only an illusory moment of peace. By deliberately selecting this very passage in which Dionysos and Apollo are fellow-celebrants, Plato is implicitly commenting on the musical heritage left by the New Dithyramb and its descendants. Magnesia's third chorus of elders will "rescue" Dionysos (cf. τὴν τῷ τοῦ Διονύσου χορῷ βοήθειαν 671a2–3) from both dramatic mimesis and New Musical intoxication.[118]

Once again, Plato's idea of chorality and his construction of an ideologically communal voice for Magnesia find their building blocks in the wider lyric world of the ancient Greek *polis*. The "second best city" will indeed perform and enact

"Apollon, Athènes et la Pythaïde: Mise en scène "mythique" de la cite au IIe siècle av. J.-C.," *Kernos* 18 (2005), 224–35.

[113] See Wilson 2007 (see above, n. 61), 175–78.

[114] Cf. especially *Herakles* 646 τᾶς ἥβας ἀντιλαβεῖν and 663 δίδυμον ἂν ἥβαν ἔφερον ~ *Laws* 666b7 ὥστε ἀνηβᾶν ἡμᾶς; *Herakles* 682 παρά τε Βρόμιον οἰνοδόταν ~ *Laws* 666b4–6.

[115] See Wilson 1999–2000 (see above, n. 77), 435.

[116] At 828a–835a, the Athenian Stranger says that the Delphic Apollo must be considered the νομοθέτης of every kind of ἑορταί, which include athletic and poetic/musical contests.

[117] Wilson 1999–2000 (see above, n. 77), 439.

[118] On the "Apollonian" Dionysos of the *Laws*, cf. also Schefer 1996 (see above, n. 88), 225–29, though I do not agree with her purely metaphorical interpretation of the χορεία of the third chorus.

"the best and most beautiful" tragedy,[119] but its cathartic effect[120] will find in lyric, nondramatic patterns of chorality its truest ways of expression.[121]

[119] Cf. Murray 2002 (see above, n. 6), 44: in advocating that his is the best tragedy, Plato "was creating a new and specialized discipline which had to define and legitimize itself against the genres of discourse that had authority and currency in democratic Athens." See also Halliwell 2002 (see above, n. 6), 98–117; cf., in fact, 658d3–4: almost everyone (σχεδὸν ἴσως τὸ πλῆθος πάντων), if asked, would assign the first prize to tragedy over other literary genres.

[120] Panno 2007 (see above, n. 6), 105–6, significantly remarks how the catharsis of Magnesia is not described as a *theatrical* catharsis: the word κάθαρσις in the *Laws* is confined to the penal sphere. The cathartic process is enacted in Magnesia in two ways: "da un lato la catarsi viene sostituita, ad un altro livello e con un'altra semantica, da musica e banchetti, dall'altro proprio lo sposta-mento alla sfera del diritto penale le può far acquisire una dimensione *religiosa* che, a teatro, aveva perduto."

[121] My sincerest thanks to Peter Agocs, Salvatore Lavecchia, Richard Rawles, Ian Rutherford, and David Sedley for having commented on an early draft of this chapter. A special debt of grati-tude is wholeheartedly owed to Giovambattista D'Alessio and Malcolm Schofield without whose generous criticism and encouragement this chapter could not have been conceived. I alone am responsible for what I have written.

Chapter Five

Music, Politics, and Diplomacy in Hellenistic Teos

Andrew Barker

I SHOULD EXPLAIN BEFORE SETTING OUT on this chapter that I am no sort of expert on the ecology and topography of the scholarly forest in which we shall be wandering. We shall be entangled in some quite complicated episodes in political history, and as a guide through the maze I shall be drawing almost exclusively on inscriptions.[1] Since the science of epigraphy is a highly complicated area for a classical scholar or a historian of ancient Greek music, I am bound to blunder off the track, though I hope I have taken enough precautions

[1] An extremely convenient and thorough collection of inscriptions has been compiled by the Packard Humanities Institute, and can be found on their fully searchable and publicly accessible website at http://epigraphy.packhum.org/inscriptions. The website is organized by regions; and the pages for each region begin with a list of the principal published sources, which can then be selected and searched. In my notes the first source mentioned for each inscription can be accessed in that way (or of course in print or in some cases on CD; see below), and in most cases the on-line text is preceded by details of other publications of the same document. There are no translations or commentaries, but the website contains the full ancient Greek texts, usually with an indication of their dates. I have been able to locate there all except one of the inscriptions to which I refer in this chapter (for the exception, see n. 11 below). The following abbreviations are employed in this chapter: *CIG* (= A. Boeckh, *Corpus Inscriptionum Graecarum*, Berlin 1828–77); *FD* (= *Fouilles de Delphes III: Épigraphie*, Paris 1909–); *IG* (= *Inscriptiones Graecae*, Berlin 1873–); McCabe, Iasos (= D. F. McCabe, *Iasos Inscriptions: Texts and List*, Princeton, NJ 1991 [Packard Humanities Institute CD no. 6]); McCabe, Magnesia (= D. F. McCabe, *Magnesia Inscriptions: Texts and List*, Princeton, NJ 1991 [Packard Humanities Institute CD no. 6]); McCabe, Miletos (= D. F. McCabe, *Miletos Inscriptions: Texts and List*, Princeton, NJ 1984 [also on Packard Humanities Institute CD no. 6 (1991)]); McCabe, Teos (= D. F. McCabe, *Teos Inscriptions: Texts and List*, Princeton, NJ 1985 [also on Packard Humanities Institute CD no. 6 (1991)]); *SEG* (= *Supplementum Epigraphicum Graecum*, Leiden 1923–71/Amsterdam (1979–); *Syll.*[3] (= W. Dittenberger, *Sylloge Inscriptionum Graecarum*, 3rd ed., Leipzig 1915–24.

to avert complete disaster. It seems to me, at any rate, that there are questions here that are worth exploring, and perhaps this chapter will help to open them up. Its purpose is to stand back from the intellectual constructions of ancient Greek political and musical theorists, and to put on display one scenario in which musical enterprises impinged directly on the world of practical politics.

There are two main characters in the story I am going to tell, and both are what we might call "corporate individuals." The first is one of the associations of the people called the *technitai* of Dionysos, and the second is the ancient Greek city of Teos in Asia Minor. It will be worth spending some time introducing them, to put the essential background in place, though some readers will already be familiar with the relevant facts.

The associations of *technitai*, which in English we usually call "guilds," were large and complex organizations of performing artists, mainly actors and musicians. There were four of them in the period we are considering, each covering its own geographical area. The first two were formed early in the third century, and were based in mainland Greece; they were the guild of the *technitai* of Athens and the guild of the *technitai* of the Isthmos and Nemea. A guild based in Egypt came rather later; and the last was the one we shall be focusing on here, the guild of the *technitai* of Ionia and the Hellespont, founded in about 235 BC. These guilds became remarkably influential in the social, political, economic, and religious life of the Hellenistic kingdoms, and their impact on current affairs was still felt in the time of the Roman empire.

In order to form an idea of what these organizations were, why they were invented, and what they were designed to do, we need to consider some general features of the situation around 300 BC. In the fourth century, and still more in the third, the cities, royal courts, and religious centers of the Greek world made ever-increasing demands on the services of musicians and other performers, mainly to provide music for the progressively more crowded calendar of public festivals. One result of this was that public performance became more and more reliant on professionals, sometimes even for choral singing, which had previously been for the most part the preserve of amateurs. This increasing professionalism was a response to pressures from various sources: the greater complexity and technical sophistication of the music itself; the growing tendency of cities and rulers, especially the monarchs and other potentates of the Hellenistic kingdoms, to seek prestige through public display; and—as a consequence of that—the sheer increase in the number of prominent festivals, which required musicians to be constantly on the move, as individuals or in small groups, all

over the Mediterranean area. It was clearly impossible for much of this to be done by amateur part-timers.

The continual movement of musicians from place to place created problems both for the musicians themselves and for the cities or other authorities who employed them. For the musicians, the main issue was personal security. The traveling life was dangerous, and visitors in a foreign city or state had good reasons for being uncertain about their standing in the eyes of the local law. In addition to the ordinary risks of shipwrecks, of meeting robbers or pirates, and so on, there was the possibility of being caught by the strange but widespread institution called *sylê*, according to which a person or his goods could be seized as a hostage or a substitute for debts owed by one of his fellow-citizens, or by the authorities in his city; or he could be made to pay or be punished in some other way for an offense that one of his fellow-citizens had caused. There might be anxieties of a more professional sort, too; for instance, about the rules governing a festival's competitions or the financial terms of the musician's employment.

On the employers' side the same factors were worrying, too, since a place that gained a bad reputation in these respects would find it difficult to attract the performers it needed. The employers were also troubled by performers failing to do what was asked of them—not turning up at all, arriving but finding some excuse for not performing, performing but not making any effort to do it well, and so on. Our most eloquent evidence about this in the period before the guilds were formed comes from a long inscription recording a decree of the cities of Euboia, around the beginning of the third century, that tried to put in place a most complex system of rules, conditions and penalties to govern the employment of performers anywhere on the island.[2] We can infer that the guilds had not yet been formed or were not yet fully effective from the fact that it does not refer to them; the performers are treated merely as individual members of a necessary but disorganized and thoroughly awkward profession.

The guilds were devised to address these problems, with the active encouragement of the cities, and above all of the authorities at the most important religious center in the Greek world, Delphoi. From that time on, negotiations about the terms and conditions of musicians' employment and the rules of the festivals were conducted between the people in charge of the festival and the officials of the relevant guild; and so too, crucially, were negotiations dealing with the musicians' right to safe-conduct, *asphaleia*, their *asylia*, immunity from the seizure of

[2] *IG* XII.9 207 = A. W. Pickard-Cambridge, *The Dramatic Festivals of Athens*, 2nd ed., rev. by J. Gould and D. M. Lewis, Oxford 1988, 306–8.

their persons or property under the institution of *sylê*, and a good many other matters of that sort.[3]

In theory at least, the guilds were religious bodies, headed by a priest and dedicated to the service of Dionysos. They ran their own festivals and conducted their own ceremonies as well as providing performers for others. In practice they were organized in much the same way as the cities, with their own ranks of officials—treasurer, secretary, disciplinary officers, and the rest—and their own general assembly, the *koinon* of the *technitai*. In many respects they behaved very like autonomous political states, passing decrees, sending ambassadors to kings and cities and receiving embassies from them, granting honors to prominent individuals, even mediating in disputes between cities, and sometimes provoking them. They had no army or navy, of course, but they had other ways of making their influence felt, and they were serious players in the international politics of the period.

Let us turn now to the city of Teos. It stood on the coast of Asia Minor, due south of Klazomenai across the neck of the peninsula that projects toward Chios, with Ephesus not far away to the southeast. It had a moderate amount of land that could be cultivated, and it had two good harbors. Not much is known of its early history. It was founded in pre-classical times by colonists from the Greek mainland, and though we hear of one or two episodes involving Teos in the Classical period, it played no prominent part in international affairs; probably the best known fact about it is that the poet Anakreon was born there. It apparently made no attempt to exercise political or military power or to dominate others, and this may be part of what lies behind a story in Herodotos; he attributes to Thales the suggestion that it should be the base for a center of government shared by the Ionian cities,[4] a plan that of course came to nothing. Teos took part in the largely commercial enterprise of founding the city of Naukratis in Egypt, and this probably points to its general character; it was an unambitious and moderately prosperous city dedicated principally to commerce and trade. But it was also dedicated, in a different sense, to the god Dionysos, the city's patron in much the same way as Athena was at Athens or Hera at Argos, and it was to Dionysos that the city's main festivals and civic ceremonies were devoted. This fact will be of some significance later in our discussion.

[3] Such documents are common; I refer here to just two good examples: *IG* II2 1132 = Pickard-Cambridge 1988 (see above, n. 2), 308, especially lines 1–39, and *FD* III.1.351 [1] = Pickard-Cambridge 1988 (see above, n. 2), 309–10, especially lines 30–39.

[4] See Herodotos *Histories* 1.170.

Between the 230s, when our story begins, and 188 BC, Teos, like much of coastal Ionia, was caught uncomfortably between the spheres of influence of two ambitious powers, the Seleukid kingdom of Antiochos to the east and south and the steadily maturing domain of the Attalid dynasty at Pergamon to the north, which enjoyed the favor of Rome. There were occasional alarms from the direction of Makedonia, too, as Philip V of Makedonia tried from time to time to extend his power into the eastern and southern Aegean, encouraged the piratical adventurers of Crete, and made moves against the cities around the Hellespont. I have done my best to grasp the outlines of the chaotic comings and goings of this period, though I cannot be sure that I have understood them fully; fortunately, we shall not need to pursue many of their intricacies. All I need say for the present is that after being a tribute paying subject of Pergamon for several decades from the 230s onward, Teos came under threat from Antiochos in the last five years of the third century and eventually fell into his hands, probably in 197 BC. But only a few years later, in 189 BC, the alliance between Eumenes II of Pergamon and Rome against Antiochos finally produced results, with the defeat of Antiochos at Magnesia; and by the treaty of Apameia, brokered by Rome in 188, Teos became an integral part of Eumenes' domain. The treaty gave the area a period of relative stability, and Teos remained a satellite of Pergamon for the fifty-five years between 188 and 133 BC, when the last Attalid king, Attalos III, bequeathed his kingdom to Rome.

The two main members of our *dramatis personae* now come together, since it was at Teos that the *technitai* of Ionia and the Hellespont made their home, at a date around 235 BC. Strabo, who records their movements, implies that the guild was based in Teos from the start;[5] and the date is given by a decree of the Aetolians, conferring on it the same privileges of *asphaleia* and *asylia* that they had granted, forty years earlier, to the guild of the Isthmos and Nemea.[6] On the likeliest reading of the record, the guild stayed in Teos during the political confusions of the next forty-five years and all through the long reign of Eumenes II of Pergamon, who died in 158 BC; and was probably still there well into the reign of his successor, Attalos II. In that case the guild was there for about a century, give or take a few years.

It is easy to guess (though a plausible guess is all we can achieve) why the *technitai* chose to make their headquarters in Teos. It was a moderately prosperous place that had no aspirations to political power, and would not cause

[5] Strabo *Geography* 14.1.29.
[6] *IG* IX.1², 1:175 (Delphoi).

them to be identified unnecessarily with any particular side in the quarrels of these turbulent times. It had a long tradition of devotion to their patron god Dionysos. More practically, it was centrally placed in their area of operations, with good communications by sea and many friends and contacts in faraway places. A more difficult question is why the city wanted them, since it could certainly have refused to allow them to settle there if it had chosen. Presumably the Teians thought that the arrangement would bring them some practical advantage, though of course they may have represented themselves as acting entirely out of respect for the god and devotion to the civilized arts. They may have hoped that these wandering musicians would make commercially useful connections abroad. There is also clear evidence in one of the documents that at some stage the guild agreed to make direct financial payments to the city, since the decree in question suspends their financial obligations for a period of five years.[7] But none of this is secure enough for us to build on; we simply do not have enough evidence about the situation when the decision was taken.

About thirty years later, however, the mists begin to clear. We have a number of substantial and relevant inscriptions dating from the last years of the third century and the beginning of the second, and more again for the years after 188 BC. Thus, although we must set aside the question why the Teians chose to welcome the *technitai* in the first place, we can ask instead, with reasonable prospects of finding an answer, what advantages they found in the relationship once the guild's presence in the city had become well established. The relationship was not always comfortable, as we shall see, but they allowed it to go on for a considerable time, and I shall try to show that they had shrewd political reasons for doing so.

We need to consider first what the guild's presence would have meant in terms of sheer numbers of people. A treasury and a few bureaucrats and secretaries would have made little impact on the city; but an influx of hundreds of alien musicians and actors would have been quite another matter. It is hard to be sure about this, but we have some indications of what was involved. One inscription is a decree recording the city's gift of some land for the guild's use, and it seems to have been a substantial site.[8] I shall say a little more about this inscription toward the end of the chapter. There is another document that may provide

[7] McCabe, Teos 24 = *SEG* 2.580, *SEG* 4.617.

[8] This is the inscription referred to in note 7 above. I shall give some reasons later for questioning the opinion expressed in *SEG* about its date (in the range 229–205 BC), and for preferring a date in the 180s.

a useful parallel. In one of a fascinating series of inscriptions about a person called Kraton, a prominent member of the guild in the second century, we find that he was responsible for setting up and partly financing a much smaller organization of musicians in Pergamon itself, and that as part of the operation he provided a building in which musicians could find places to live.[9] We do not have to conclude that the parent organization in Teos needed living space for the whole, much larger mass of its members, but it does make that seem possible.

Another suggestive hint in our evidence relates to the procedures by which musicians were hired to perform at the various festivals. As far as we can tell, when the guilds were first formed, contracts for performers were still negotiated directly between the authorities in charge of the festivals and the individual musicians and actors, even when other matters were already being handled by the guilds. But this seems to have changed. At least two inscriptions from the late third century or the second, one of which records the decision of the *technitai* of Ionia and the Hellespont to provide performers for a festival in Iasos, speak of the performers explicitly as those designated by the guild.[10] Now if it had become normal for the guild to nominate the people who would perform at the festivals, the musicians and actors would naturally have tried to make their homes as close as possible to the center of operations, the Head Office of the guild, so that they could make themselves available to be chosen and to receive their contracts. This makes very good sense from the point of view of the organizers of the festivals, too. It would be much easier to apply for performers to a single secretariat in a fixed place, and to negotiate the contracts with them, than to try to hunt down individual artists who might be about their business anywhere in the ancient Greek world. If that was the situation, Teos would have been fairly humming with members of this footloose and never entirely respectable profession.

A couple of other points about this can be gleaned from the remains of a letter from Eumenes II to the guild, probably written in the 170s, that survive in an inscription that, unfortunately, is very badly broken.[11] First, it shows that the guild held its own major festival in Teos, and that this attracted shiploads

[9] The relevant inscription is McCabe, Teos 26 = Pickard-Cambridge 1988 (see above, n. 2), 315–16. The other main inscriptions referring to Kraton are McCabe, Teos 25 and 58; McCabe, Iasos 140; *IG* XI.4 1036 and 1061 (Delos).

[10] McCabe, Iasos 65 = Pickard-Cambridge 1988 (see above, n. 2), 316–17; see also L. Robert, *Études anatoliennes*, Paris 1937, 445–50.

[11] C. B. Welles, *Royal Correspondence in the Hellenistic Period: A Study in Greek Epigraphy*, New Haven, CT 1934, 237–55, including detailed discussion. I have not been able to find this document on the Packard website (see above, n. 1).

of potentially unruly visitors; we might think of what happens when a town is invaded by football fans. There were difficulties, which Eumenes tries to resolve, about policing the crowds and maintaining public order, and about who was responsible for investigating incidents, conducting court cases, and imposing fines and other penalties when there had been trouble.

Second, it adds substance to some intriguing remarks in Strabo that indicate that during the second century serious and repeated disputes occurred between the city and the guild and eventually led to quite drastic consequences. Strabo writes of unrest amounting to *stasis*, which in the end provoked the expulsion of the *technitai* from the city; and he makes it clear that the Teians still reckoned that the *technitai* posed a real threat to their security even after their expulsion, when they tried to establish themselves in the nearby city of Myonessos.[12] None of this makes sense unless the number of *technitai* involved was really quite large; and in fact Strabo uses language that plainly implies that what the *technitai* did, first in Teos and later (after their abortive attempt to settle in Myonessos) in Lebedos, was to make their homes there. The same conclusion is suggested by the form of the guild's own decrees, which regularly speak of decisions made by the *koinon*, that is, the whole body of its members. This evidently means that decrees of this sort were ratified by a general assembly of the *technitai*, modeled on the pattern used in democratic cities, and that all the guild's members were entitled to be present and to vote on the proposals. Perhaps a good many of them actually did so.

If these conclusions point in the right direction, then the Teians, by allowing the *technitai* to make their base in the city, had entangled themselves in a large-scale, complex, and potentially problematic situation. They had accepted into their community not only another, partly independent organization, a parallel or divergent axis of power and influence, but also a shifting multitude of rootless individuals with no inherited loyalty to the city. It sounds like a recipe for trouble; yet the Teians allowed it to continue, as we have seen, for something like a hundred years. We must suppose that for quite a long time they felt that they were getting an adequate reward for their pains. What kinds of benefit, then, can the arrangement have brought them?

One point worth noticing is that except during the decade when they were subject to Antiochos, the presence of the *technitai* gave Teos a special relationship with the rulers of Pergamon, especially with Eumenes II after 188 BC. This was certainly useful; the Attalids had their own reasons for fostering the

[12] See note 5.

performing arts. We shall come to this later period in due course, but let us look first at the situation in the last years of the third century, when our inscriptional material begins to multiply. There are several useful documents dating from around 203 BC, when the influence of Pergamon, which had been dominant during the previous thirty years, was beginning to be threatened by the Seleukid king Antiochos III. In 203 BC he invaded Karia, and though he probably did not reach Teos till a few years later, his ambitions were already clear, and the city's position was becoming decidedly insecure.

All of the documents in this group are dated fairly securely to the years between 205 and 202 BC, and all of them record decrees by various authorities granting privileges to Teos, of which two are particularly important; the city is declared both inviolable, *asylos*, and sacred. There are decrees, for example, from the Aetolians, from the Amphiktyons at Delphoi, from the city of Delphoi itself, and from Allaria.[13] If we take them at face value, these honorific documents look very impressive, but here we have to be extremely careful. Grants of privileges of similar sorts were dispensed in large numbers in this period; there are dozens of inscriptions recording them, most of them expressed in almost identical terms. A person coming to this material for the first time might easily get overexcited by the apparent importance of the honors given; but a little more reading in the documents shows that these high-sounding declarations were in fact very ordinary commonplaces of interstate relations in Hellenistic times, little more than routine pieces of diplomatic politeness, and we should not assume that they always meant a great deal in practice.

We should not automatically assume, on the other hand, that they invariably meant nothing at all, especially in cases where the privileges conferred have unusual features; and this turns out to be true of those awarded to Teos. One privilege granted is *asylia*, immunity from the seizure of persons or goods and from other financial impositions. Now this appears repeatedly in decrees; but it seems to have been granted rather sparingly to whole cities. More often the beneficiary is a single individual, or sometimes a religious precinct or temple. Second, these decrees declare the city of Teos to be sacred in its role as the property of Dionysos. This again is not unique, but it is certainly uncommon.[14] A

[13] McCabe, Teos 1 = *CIG* 3046 (Aetolians); *FD* 134 (Amphiktyons); McCabe, Teos 2 (Delphoi), Teos 3 (Allaria).

[14] F. Piejko, "Antiochus III and Teos reconsidered," *Belleten* 212 (1937), 23, suggests that references to grants of *asylia* to cities in the inscriptions automatically imply that the city is also recognized as "sacred." But it is not clear whether he means this to apply in all cases, or only in cases like the one he is immediately concerned with (Teos in 197 BC), where we know from other relevant

comparison with one of the few similar cases I have found may be helpful. Here the place declared sacred is another city in Asia Minor, Magnesia on the river Meander. Once again we have an impressive collection of inscriptions recording privileges granted to it by communities around the Greek world, and they include the provision that Magnesia will be treated as sacred.[15] But this case is clearly exceptional. For one thing, the decrees from the cities state explicitly that they are granting the privilege in conformity with an oracle from Delphoi. No such thing is mentioned in the case of Teos, and the oracle would certainly have been mentioned if it had pronounced on the matter. The favors granted to Teos must have a different basis. We should notice, however, that the reason for the oracle about Magnesia is known and is explained clearly in the inscriptions. What gave Magnesia a special claim was the fact that the goddess Artemis had appeared there in visible form—there was an *epiphaneia*—and the oracle was a response to reports of this divine apparition. There is no doubt, then, that what justified Magnesia's claim to be a sacred place was this very remarkable happening; and as far as I can see, this form of recognition was never given to a city just on the basis of general goodwill. It took something quite out of the ordinary.

Evidence of these kinds gives reasons for thinking that Teos was also being treated as a very special case, and we must clearly ask why. What we should be looking for is some other unusual piece of phrasing in the relevant inscriptions. For the most part, their language is just routine bureaucratic and honorific jargon, whose ornate battery of clauses and subclauses is highly formulaic; the same provisions in exactly the same words are repeated over and over again in the inscriptions, recombined to suit the occasion. Oral poetry does not have a monopoly on recycling set verbal formulae. This can make reading the inscriptions a tedious task, but it can also be useful, since when a completely new clause turns up in familiar surroundings, or a regular phrase has been significantly changed, the fact leaps to the eye, and we can be confident that it is not just an accident. This applies even more strongly when we are dealing with several decrees from different sources, all of which show the same peculiarity.

If we leave the "sacredness" clause on one side, most of the language of the Teos inscriptions comes straight from the bureaucrats' book of routine formulae.

inscriptions that the most important agents conferring the grant (e.g., Antiochos, Delphoi), whose examples the others are following, included a recognition of sacredness explicitly in their decrees. If he means the second, he may well be right; but if he means the first, he offers no evidence to support his thesis, and I cannot agree.

[15] See for instance McCabe, Magnesia 6, 14, 19, 22, 27, 28, 32, 49, 67; and there are more.

But one phrase does not; it appears in the Aetolian, Amphiktyonic, and Delphic decrees mentioned above, and in some of the Cretan ones we shall consider shortly. What it says is that the Teians are to be given their privileges "according to the provisions laid down for the *technitai* of Dionysos." So far as I know, this form of words appears nowhere else among the many inscriptions of this general sort that we have. No other city is granted privileges in these terms. It seems a very reasonable conclusion that Teos was granted its privileges because it not only was a city whose chief god was Dionysos but also was the home of the *technitai* devoted to his service.

We turn now to the document that records a personal visit to Teos by Antiochos III after his acquisition of the city. This visit used to be dated, like the inscriptions we have just been discussing, to about 203 BC, but considerations put forward more recently by F. Piejko suggest that 197 BC is a good deal more likely.[16] In this document the Teians say that Antiochos found them "completely exhausted" as a result of the continual wars and the financial burdens laid on them by Attalos of Pergamon; and he agreed to declare the city and its land sacred and inviolable, *asylos*, and free from financial demands. These hypothetical demands are presumably ones that might have been made by Antiochos himself, but he also declares them free of the impositions made previously by Attalos. He did all this, so the rhetoric of the inscription says, out of piety toward the city's god, Dionysos, and also out of goodwill toward both the Teian people and the guild of the *technitai*. The two constituencies are linked together as though they were equal partners, equally deserving of Antiochos' respect. He extends his favor "both to the people and to the *koinon* of the *technitai* of Dionysos," and the esteem in which he holds the *technitai* is apparently part of his motive for releasing the city from financial burdens.

Now a point I have not yet explicitly mentioned is that the grant of privileges to a city was normally a response to a request from the city itself, and this is certainly true in the case of Teos, as the inscriptions I have cited make clear. If we take that fact together with the unusual phrasing of the Teian inscriptions, what it suggests is that in a situation of some difficulty, "exhausted" by wars and financial burdens and caught between the forces of several much stronger

[16] McCabe, Teos 30; see also the studies of P. Hermann, "Antiochos der Grosse und Teos," *Anadolu* 9 (1965), 29–159 (an editorially meticulous examination of the document, giving 204–203 BC as the probable date) and Piejko 1991 (see above, n. 14) (acknowledging Herrmann's work with great respect, but arguing for the later date of 197 BC). The part of the document that is most relevant here (lines 10-21) is also transcribed in R. E. Allen, *The Attalid Kingdom: A Constitutional History*, Oxford 1983, 50.

powers, the Teians suddenly realized toward the end of the third century that they had a substantial, uncashed political asset on their hands, and made a request for special privileges, probably in the first instance to Delphoi, which they supported by pointing out that their city was the home of the *technitai* of Dionysos. This strategy seems to have impressed the authorities at Delphoi and elsewhere. Antiochos, a few years later, seems to have thought it would be politically prudent to follow their example, to the extent that he not only declared Teos sacred and inviolable, as the Greek cities had done, but freed the Teians from their financial obligations to Pergamon and imposed none on them himself.

There are interesting features of a different sort in the inscriptions recording decrees from the cities in Crete. Here the ambassadors who travel around making these requests are not only prominent citizens of Teos; they also include representatives of much more powerful interests. One of them, the Rhodian Hagesandros, is a spokesman for Antiochos, who had apparently convinced himself that it was good policy to promote the Teians' claim to special status. This suggests that these embassies took place after Antiochos' visit to Teos in 197 BC, but it does not prove it beyond doubt. Antiochos was clearly interested in this area already in 203 BC; perhaps he was trying to gain support from the Teians even before he actually arrived there. And that is not all: Hagesandros was accompanied by Perdikkas, who was a citizen of Teos but also an emissary of Philip V. Thus two very significant powers with ambitions in this part of the world, Antioch and Makedonia, were apparently prepared to take time off from more obviously serious matters to support this little piece of Teian diplomacy, and even to cooperate with one another in doing so, though in other respects their interests often conflicted.[17] The Teians seem to have hit on an idea, odd though it may seem to us, that struck these big-league players as a perfectly plausible enterprise with which they were keen to be identified; and their efforts did not stop there. From 193 BC, only a few years later, we have an inscription recording a similar grant of privileges by the senate in Rome; and the person who negotiated the agreement on behalf of Teos was a representative of Antiochos.[18]

There are even more curious features, as it seems to me, in our records of a second diplomatic mission from Teos to Crete, which visited several of the same Cretan cities, perhaps all of them.[19] This time, no representatives of other

[17] For the complete collection of inscriptions relating to this embassy, see McCabe, Teos 4–15. On Perdikkas and Hagesandros, see for instance numbers 11 = *CIG* 3048 and 9 = *CIG* 3047, respectively.

[18] McCabe, Teos 53 = *CIG* 3045.

[19] The full series of surviving inscriptions from this episode is at McCabe, Teos 16–23.

powers seem to have been involved. There are uncertainties about the date of this episode; while earlier scholars apparently assumed that it came very soon after the first, McCabe (n. 17 above) suggests a range of between 170 and 140 BC. There are certainly good reasons for believing that there was a substantial gap between the first and second missions. The aim of the second, as is made clear in most of the surviving decrees, was to remind the Cretan cities of the earlier agreement, to make sure that it had been properly recorded and inscribed in some prominent place, and in general to freshen up relations between them and Teos. Hence most of these inscriptions refer back to the first mission; and in one of them, the decree of the city of Erannos,[20] the first agreement is said to have been made by "our forefathers" or "ancestors" (*progonoi*). This expression can hardly refer to people who set up a very recent arrangement. For this and other reasons, it seems more probable that since the most important figure in the first round of talks had been a representative of Antiochos, this second visit was designed to make sure that the agreement still held in the new situation that followed the Treaty of Apameia in 188. Teos had been detached from the Seleukid sphere of influence and was now firmly tied to Pergamon, and the Teians may well have been anxious to confirm that the change in their allegiance had not undermined the arrangements made under a different dispensation.

Let us assume that a date around 185 BC or perhaps rather later is correct. The new ambassadors, Herodotos and Menekles, went around as their predecessors had done before, and got the agreements they asked for. In some cases, in fact, they got more. As we can see from their decree, the citizens of Erannos also extended to the Teians citizenship of their *polis*, exemption from tax, and the right to own land and homes there. These courtesies are over and above those the Teians had requested. They come in a separate part of the decree, and in most of the other inscriptions in this group they do not appear at all. They may not have meant much in practice; but they are a free expression of this Cretan city's goodwill. The ambassadors seem in fact to have made an excellent impression wherever they went. Most of the inscriptions make a point of complimenting them personally, giving them the status of *proxenoi*, inviting them to civic banquets, and complimenting them in various other ways; and it is interesting to note that no features of this sort appear in the records of the previous visit.

Two of these later inscriptions stand out from the rest, in two respects; they are those from the cities of Knossos and Priansos.[21] First, though both of them

[20] McCabe, Teos 19.
[21] McCabe, Teos 21*5 = *CIG* 3053 (Knossos); McCabe, Teos 23 = *CIG* 3056 (Priansos).

refer to Herodotos and Menekles as ambassadors of Teos, and some official business was evidently conducted, neither decree responds directly to any official request such as those to which the other cities' decrees reply. This is rather odd. It is unlikely to mean that the people of these cities received the request but rejected it, since they make it clear that they are very well disposed toward Teos. Perhaps it was because they had stayed in closer contact with the Teians than the other Cretan cities had done, and had already reaffirmed and ratified the earlier decree in the way that the Teians were seeking elsewhere.

Second, one of the ambassadors, Menekles, did something quite different from what one might expect in the course of routine diplomacy. He gave musical recitals, several of them in each of the two cities. The bulk of each inscription, in fact, is devoted to describing these performances and expressing the cities' gratitude for them. It is clear that we are dealing here with performances of a substantial sort, not just a bit of song-singing at *symposia*, for example. Menekles played the *kithara* and gave *epideixeis*, which in this context we might translate as "recitals," of pieces by Timotheos and Polyeidos. That is, he presented a program of famous two-hundred-year-old "classics" dating from the late fifth century and the fourth, in two different styles, as we know from a remark in the treatise *On Music* traditionally but falsely attributed to Plutarch, where the styles of these two composers are explicitly contrasted.[22] He also performed pieces by Cretan composers of the past, presumably as a graceful compliment to his hosts. The inscription from Priansos adds more. Menekles, it says, went on to introduce a whole cycle of Cretan stories, tales of a legendary and heroic sort, in spoken prose as well as in verse, which he may have sung. It tells us also that he did not merely recite the contents of some well-known Cretan compilation of stories but made his own collection, "from many poets and chroniclers"; it sounds as if he had done some research of his own into the repertoire.

We may wonder why he did all this, and what it had to do with his diplomatic mission. It would be natural enough, perhaps, for an ambassador who happened to be a musical enthusiast to look at the local material, and even to do a little singing when he was off duty. But the evidence points to something much more elaborate and formalized than that, something more like full-scale public performances. On the other hand there is nothing to suggest that Menekles was a professional, one of the *technitai* themselves. When official documents mention such a person they usually identify him explicitly as a musician and refer to the branch of the art he practices; he will be described as "so-and-so

[22] Pseudo-Plutarch *On Music* 1138b.

son of so-and-so, *kitharistês*" or "*aulêtês*," or whatever he was. Neither of these inscriptions describes Menekles in those terms; and no more does any of the others. Nor do the Cretans congratulate him, as one might expect, on the brilliance of the skills he displayed in his performances. On the contrary, what they exclaim about is the "education" or "culture" that Menekles and the Teians in general possess; and the decree from Erannos proves what we would in any case assume, that Menekles was a Teian citizen. In fact the statement in the Knossos inscription, that he performed "well and as befits a man of culture," more or less guarantees that he was not a professional, since the trade of a musician and the character of a "man of culture," an *anêr pepaideumenos*, had been reckoned barely compatible with one another since the fourth century.[23]

This may give us a useful clue about one aspect of the Teians' political strategy. We should hold on to the fact that their main aims are likely to have been perfectly hardheaded and practical; their "cultural diplomacy," if we may call it that, was no doubt undertaken with a shrewd eye to their commercial interests and especially the security of their trade routes. It is worth remembering that ships traveling between Teos and Egypt would most probably have passed through the gap between Crete and Rhodes, and both were notorious for their pirates. It made very good sense for the Teians to stay on good terms with the cities of Crete. But the means by which they chose to advance their interests are worth examining a little further.

Menekles was commended for his culture and education, and for the efforts he made to present the Cretans' own culture to them in a civilized and edifying way. It is significant that when these doings were reported back to the Teians, they did not treat the communications from Knossos and Priansos lightly; they had them inscribed in the same public place as all the other messages from Crete, whose contents may well seem to be a good deal more politically important. It appears that what Menekles did at Knossos and Priansos was done in pursuit of Teian public policy just as much as what he and Herodotos did in the other cities. He had achieved successes that the civic authorities thought highly satisfactory, and worth recording along with the others on the official monument. Yet all he had done was to present himself and his fellow citizens to the people of Knossos and Priansos as persons of education, style, and sensibility.

This evidence makes it at least a plausible hypothesis that the Teians deliberately set out, as a matter of official public policy, to make the city appear to the world as a beacon of civilization and aesthetic culture. We might guess also that

[23] See for instance Aristotle *Politics* 8, 1340b–1341b.

one of the means by which they sought to gain this reputation was to try to make sure that they actually deserved it. In order to support that suggestion more firmly than we can from single episodes like the musical exploits of Menekles, what we need is first some evidence for the existence of something like an official "cultural policy" in Teos, and second some indication of what it was like. What we can use here are the records of the Teian system of education in this period, since as it happens we know a certain amount about it. I do not mean to exaggerate its merits as a fountain of wisdom and enlightenment, since it may well have been no such thing. It has become well known to modern specialists in educational history more because of the accidental preservation of inscriptions recording some of its details than because of any reputation for excellence that it may have had in ancient times. But it has some interesting features, and ones that are relevant to the issues I am trying to discuss.

The main document we have records quite elaborate provisions for the education of all Teian citizens' children.[24] Girls as well as boys are to be taught to read and write by the *grammatodidaskaloi*, but girls are not mentioned again, and perhaps this was as far as their education went. The system was funded by a large donation made by a private individual to pay the teachers' salaries. There is at least one significant point here that needs to be emphasized. Education is provided for all children of citizens; and we should certainly not assume that this degree of "universal education" was the norm in Greek cities of the Hellenistic period. On the contrary, the inscription gives the impression that it was something entirely new. Otherwise there would be little sense in the preliminary statement that the money is being given "in order that all the free children may be educated in the way worked out and explained to the people by Polythrous son of Onesimos." The system had been thought up by Polythrous himself, and had to be "explained" to the *dêmos*; and this suggests that it was a new departure, and not a continuation of traditional practices or an assimilation of customs that were familiar in other cities.

The fact that the scheme was funded by a private donation, as was a rather similar venture in Miletos,[25] need not undermine the idea that it was intended to promote official policies of the city itself. The money was given to the city and the city administered it, and we may reasonably assume that the enterprise fit well into a publicly agreed ordering of financial priorities. As for when the system was put in place, it is impossible to be sure. Modern estimates of the date

[24] McCabe, Teos 41 = *CIG* 3059, *Syll.*³ 578.
[25] McCabe, Miletos 42 = *Syll.*³ 577.

vary between the later third century and some time in the second, and there is nothing in the provisions or, so the specialists assure us, in the lettering of the inscription that would settle the matter beyond doubt. But it seems obvious to me that it would have made much more sense shortly after 188 BC, in the relatively stable and culturally ambitious reign of Eumenes II, than in the troubled years at the end of the previous century. At that time, we may recall, the city was worn down by wars and external financial impositions, and it is hard to imagine that it would have diverted scarce resources to purposes that were not of immediate practical use.

When we look more closely at the details of the scheme, we discover that music, in various forms, was given a prominence that goes well beyond what we find elsewhere. There is much more of it in the Teian curriculum than in the Milesian one, for instance; and in Teos the music teachers are to be paid higher salaries than any of the others. Three details of the curriculum are worth mentioning. First, the musical education to be given to all free children of Teos, or at least the boys, clearly went further than the traditional kind of instruction in singing and playing the lyre. Something called *ta mousika*, though we do not know exactly what it was, occupied a separate and apparently major place in the program in the years after children had learned to play the lyre. Second, education in *ta mousika* continued even after the normal years of schooling, into the ephebate, as no other nonathletic disciplines did. It was not just something for juveniles. The third point is particularly remarkable. Another inscription, one of a group recording the names of winners in various school competitions,[26] shows that they included contests in a pair of disciplines called *melographia* and *rhythmographia*, which look as if they mean the writing of melodies and rhythms. Nothing of these sorts appears in the records of other cities.

Let us pause to consider *melographia* and *rhythmographia* a little further. These words do not mean "melodic and rhythmic composition," which are always *melopoiia* and *rhythmopoiia*; the prizes were not being awarded for efforts in the composition of original pieces of music. What these children seem to have been tested on was their competence in writing down melodies and rhythms as exercises in melodic and rhythmic dictation; that is, they were learning to set out in a written notation the tune or the rhythm of a piece of music that was played to them by the teacher. Music students nowadays still have to do things of that sort. But in the ancient Greek context, we may very well wonder why the children of ordinary citizens, not budding professionals, were being taught

[26] McCabe, Teos 82 = *CIG* 3088.

these tricky skills and these cumbersome and difficult notations, as the Greek notations unquestionably were. We have no evidence that anyone in this period, even professionals, regularly played music from a written score, though professionals sometimes kept written archives of pieces they had performed, so that they could go back and refresh their memories of them. We hear nothing, at any period, of the use of notations by nonprofessionals except for one purpose; and that was as an adjunct to the theoretical analysis of musical systems in the science of harmonics, with all its ferociously technical paraphernalia of *harmoniai* and *genê* and *tonoi*. It would be surprising if this formidable stuff was introduced to children in school, though a few treatises from the Roman imperial period seem to indicate that it was.[27] But the fact that instruction in these notational skills was part of the curriculum, even though we cannot be sure why it was thought appropriate,[28] shows beyond doubt that the scheme adopted by the Teians for their children's education called for instruction in musical skills at a surprisingly technical and sophisticated level.

We have come a long way from the *technitai*, but it will be obvious that within the frame of reference I have been sketching, these unusual educational provisions fit rather well alongside the Teians' willingness to let the guild make its home in the city. Both pieces of policy can be construed as elements in a deliberate and coherent strategy, designed to give the city a particular kind of cultural identity that distinguished it from others, and that could give it the right to claim exceptional status and particularly favorable treatment. The exploits of Menekles in Crete are offshoots of the same policy; and in the various inscriptions recording privileges granted by the authorities in other places, we have seen what I interpret as traces of the Teians' deliberate exploitation of their cultural image in the context of serious political and commercial diplomacy. Teos was

[27] Examples of essays in harmonic theory that seem to be designed as school textbooks include those by Bacchius and Gaudentius, printed in K. Jan, *Musici Scriptores Graeci*, Leipzig 1895, and again in L. Zanocelli, *La Manualistica Musicale Greca*, Milan 1990, and perhaps also the short texts known compendiously as the *Anonyma Bellermanniana* (see D. Najock, *Anonyma de Musica Scripta Bellermanniana*, Leipzig 1975).

[28] A competence in *melographia* and *rhythmographia* would have made it possible for a person to record items in a musician's repertoire in written form. Given the presence of the *technitai* in Teos, such skills may therefore have had a straightforward practical application, offering a few young citizens the chance of profitable employment as secretaries or assistants to professional musicians. But I must emphasize that this is only a hypothesis; when I suggested it at a seminar in the Music Department of the Ionian University in Kerkyra [Corfu], it was not greeted with unanimous enthusiasm.

not in a position to achieve prosperity and respect on the basis of military might, and this was its ingenious attempt to find a viable alternative.

Before drawing this discussion to a close, let us briefly consider one piece of evidence that clearly demonstrates the city's intention to consolidate its relations with the *technitai*. I have already mentioned it in passing.[29] This document records arrangements for the purchase, by the city, of a block of land that is to be given to the *technitai* for their use. A large amount of money is involved—6000 drachmas, to be precise. It used to be supposed, for fairly obvious reasons, that this transaction dates from the 230s, when the guild first arrived in Teos. But detailed arguments put forward by R. E. Allen suggest that a date in the 180s is much more likely; and I think he is right.[30] He draws attention, in particular, to the decision to take half of the money from a donation from the royal treasury, which came regularly to help with the general administration of the city; all that is made quite clear by the inscription. There is no evidence for the existence of this regular grant of money from any royal treasury before the reign of Eumenes II, and the history of the preceding period makes such an arrangement very unlikely; certainly under the Attalid administration before 197 BC, as we have seen, the city was subject to financial demands from its overlords, rather than receiving subsidies. I should like to add another point to the ones Allen makes. The other half of the money for the purchase is to come from a fund that had originally been intended to maintain the city's fortifications but had later been transferred to the different purpose of buying supplies of grain. People who know a bit about the finances of modern states or towns or businesses or universities will be amused to see that even in those days, money for certain enterprises had to be found by shuffling funds from one account to another, in this case twice. But neither of these pieces of imaginative bookkeeping fits well into the period of wars and financial difficulties before 197 BC, or into the turbulent years between then and the treaty of Apameia. They make good sense only in a time when fortifications are unnecessary and food supplies are plentiful; and that is true only of the period after 188 BC.

What I am suggesting, then, is that the gift of land to the *technitai*, the new school system with its extensive musical curriculum, and the second wave of embassies to the cities of Crete are all clustered in the 180s, and fit together as pieces of the same policy. Its general outlines had of course been settled much earlier, perhaps back in the 230s when the *technitai* first arrived, and certainly

[29] See notes 7 and 8.
[30] Allen 1983 (see above, n. 16), 53–55.

by 203 BC, when Teos was granted its privileges by Delphoi and other Greek cities. But it was in the years following the treaty of Apameia that it was properly consolidated.

The story has many twists and turns in the following half century. We have a rich dossier of inscriptions that illustrate the developing three-way relations between the *technitai*, the city of Teos, and the royal court at Pergamon, and the benefits they received from Pergamon must have done a good deal to persuade the city's authorities that their arrangement with the guild was worth preserving. Eumenes II, in Pergamon itself, was strongly supportive of the performing arts and had a large entourage of musicians at his court. It is possible that he had motives that went beyond his personal enjoyment of music and a monarch's normal liking for self-advertisement. This is a period in which schools of philosophy aspired to real influence in the world of practical politics. We know in particular that there was a school of Stoics in Pergamon, and the Stoics were particularly prominent in this enterprise; they had also inherited from Plato and Aristotle, and had developed further on their own account, ideas about the essential social role of music in generating social harmony and well-being. It was just at this time that the Stoic Diogenes of Babylon was writing his own major treatise on the subject, a work that became famous enough to be the major target, in the next century, for the criticisms of the waspish Epicurean opponent of such theories, Philodemos of Gadara, in his treatise *On Music*.[31]

It would be possible to tell a plausible story about the relation between these high-minded theories and the educational and cultural policies of Teos; and it is true that the ideas of the Academy, the Lyceum, and the Stoa would provide a very suitable background to the events recorded in our documents. But any steps we might take along that road would be entirely speculative and, if taken very seriously, would take us much too far from the realities of life and decision-making in a small and politically insignificant community, dependent for its survival on the goodwill of more powerful states and essential trading partners. It would be absurdly unrealistic to suggest that the Teians were motivated by a pure, missionary zeal to bring civilization, harmony, and refined culture to their citizens and the world at large. Their choices were much more probably based on hardheaded political and commercial calculation. My hypothesis is only that

[31] See, e.g., A. Barker, "Diogenes of Babylon and Hellenistic Musical Theory," 353–70 and D. Delattre, "Vers une reconstruction de l'esthétique musicale de Philodème," 371–84, both in C. Auvray-Assayas and D. Delattre (eds.), *Cicéron et Philodème: La polémique en philosophie*, Paris 2001.

they perceived, perhaps for the first time in the difficult years around 203 BC, that a reputation for being champions of the arts, and especially music, might bring them real benefits, both in consolidating their own society and in their dealings with communities elsewhere. If the documents we have considered are a good guide, the strategy worked.

Or at least it worked for a time; but in the end, as the saying has it, the chickens came home to roost, as chickens will. Music may indeed be a wonderful thing, full of beauty and infused with the power to bring peace, concord, and civilization. But not all musicians are paragons of virtue. They are as mixed a bunch as any other group, and it seems all too likely that many of the *technitai* of Dionysos were less committed than the respectable citizens of Teos to the values of a stable society. Musicians and other performing artists can often be obstinately obsessed with their own peculiar enterprises and priorities, which may have little to do with civic harmony and prosperity. Perfect perpetual concord between the musicians and actors and the civic authorities would have been too much to expect, and there were bitter disputes that no one was able to resolve. Perhaps, apart from anything else, the special favors the *technitai* received from Eumenes of Pergamon eventually gave them too high an opinion of their own importance. But I shall not go back to the dismal catalogue, which I mentioned earlier, of quarrels between the city and the guild that arose later in the second century, of appeals by both sides to Pergamon, of temporary settlements imposed by royal decrees and threats of more drastic action in the future, of more quarrels culminating in disruptions so violent that Strabo describes them as *stasis*, what we would call anarchy, and finally the expulsion or flight of the *technitai* from the city. Years after that, the Teians seem still to have regarded the *technitai* as their deadly enemies. The moral of the story is clear. A city's reputation as the home of culture and the arts is a strong political card, and music is the queen of the arts; but cities require order and conformity, and music, unfortunately, requires musicians, who do not always take well to such constraints. The mixture is guaranteed to be explosive.

Contributors

Andrew Barker is Professor Emeritus of Classics at the University of Birmingham, a Fellow of the British Academy, and President of the International Society for the Study of Ancient Greek and Roman Music (Moisa). He is the author of six books on ancient Greek music, musical theory, and philosophy, including *The Science of Harmonics in Classical Greece* (2007), *Psicomusicologia nella Grecia antica* (2005), *Euterpe: Ricerche sulla musica greca e romana* (2002), *Scientific Method in Ptolemy's Harmonics* (2000), *Greek Musical Writings* (2 vols., 1984–9), together with numerous articles on musicological and philosophical topics. He is currently preparing a commentary and revised text of Porphyry's *Commentary on the Harmonics of Claudius Ptolemaeus*.

Eric Csapo is Professor of Classics at the University of Sydney, Australia. He is an expert in ancient Greek literature and cultural history with a special interest in ancient Greek drama and theater history. His books include *Actors and Icons of the Ancient Theater* (2010), *The Origins of Theater in Ancient Greece and Beyond* (2007, co-edited with M. C. Miller), *Theories of Mythology* (2005), *Poetry, Theory, Praxis* (2003, co-edited with M. C. Miller), and *The Context of Ancient Drama* (1995, co-authored with W. J. Slater). His current project is a multi-volume history of the Classical Greek theater (in collaboration with P. Wilson).

After holding posts at Cambridge, Oxford and Durham Universities, **Edith Hall** took up a Research Chair at London University in 2006. She is the co-founder and remains co-director of the Archive of Performances of Greek and Roman Drama at the University of Oxford, and has authored, co-authored, or co-edited nineteen books, including *Reading Ancient Slavery* (2011), *Greek Tragedy: Suffering under the Sun* (2010), *Theorizing Performance* (2010), *The Return of Ulysses* (2008), *The Theatrical Cast of Athens: Interactions between Ancient Greek Drama and Society* (2006), *Greek Tragedy and the British Theatre, 1660–1914* (2005), *Greek and Roman Actors* (2002), *Aeschylus' Persians* (1996), and *Inventing the Barbarian* (1989).

Egert Pöhlmann is Professor Emeritus of Classics at Friedrich-Alexander-Universität Erlangen-Nürnberg. He is an expert in ancient Greek drama and theater history,

ancient Greek music, and the transmission of ancient Greek literature. His books include *Gegenwärtige Vergangenheit* (2009), *Documents of Ancient Greek Music* (2001, co-authored with Martin L. West), *Studien zur Bühnendichtung und zum Theaterbau der Antike* (1995), *Einführung in die Überlieferungsgeschichte und in die Textkritik der antiken Literatur* (1994), *Beiträge zur antiken und neueren Musikgeschichte* (1988), *Denkmäler altgriechischer Musik* (1970), *Griechische Musikfragmente: Ein Weg zur altgriechischen Musik* (1960).

Lucia Prauscello, educated at the Scuola Normale Superiore in Pisa, Italy, is Lecturer in Classics at the University of Cambridge and Fellow of Trinity Hall. She is the author of *Singing Alexandria: Music between Practice and Textual Transmission* (2006) and has variously published on ancient Greek music, ancient Greek lyric poetry, drama and performance criticism.

INDEX

UNIVERSITY OF ST. THOMAS LIBRARIES

UST
Libraries

DATE DUE